Archer M. Huntington

Archer M. Huntington

Founder of the Hispanic Society of America

Patricia Fernández Lorenzo

Syracuse University Press

Copyright © 2025 by Syracuse University Press
Syracuse, New York 13244-5290

All Rights Reserved

First Edition 2025

25 26 27 28 29 30 6 5 4 3 2 1

∞ The paper used in this publication meets the minimum requirements of the American National Standard for Information Sciences—Permanence of Paper for Printed Library Materials, ANSI Z39.48-1992.

For a listing of books published and distributed by Syracuse University Press, visit https://press.syr.edu.

ISBN: 9780815604839 (hardcover)
 9780815657255 (e-book)

Library of Congress Cataloging-in-Publication Data

Names: Fernández Lorenzo, Patricia, 1969– author.
Title: Archer M. Huntington : founder of the Hispanic Society of America / Patricia Fernández Lorenzo.
Description: First edition. | Syracuse : Syracuse University Press, 2024. | Series: New York State and regional studies | Includes bibliographical references and index.
Identifiers: LCCN 2024022207 (print) | LCCN 2024022208 (ebook) | ISBN 9780815604839 (hardback) | ISBN 9780815657255 (ebook)
Subjects: LCSH: Huntington, Archer M. (Archer Milton), 1870–1955. | Hispanic Society of America—History. | Hispanists—United States—Biography.
Classification: LCC PS3515.U64 Z683 2024 (print) | LCC PS3515.U64 (ebook) | DDC 818/.5209 [B]—dc23/eng/20241024
LC record available at https://lccn.loc.gov/2024022207
LC ebook record available at https://lccn.loc.gov/2024022208

Manufactured in the United States of America

Contents

List of Illustrations and Graphics *vii*

Foreword
 by Antonio Garrigues Walker *ix*

Acknowledgments *xiii*

Introduction *xv*

A Note on Sources *xxix*

Part One. Huntington "in Progress," 1870-1898 *1*

 1. The Awakening of the Vocation of a Young Hispanophile *3*

Part Two. Huntington "in Motion," 1898-1930 *51*

 2. A Hispanist in Regenerationist Madrid *53*

 3. A Patron of the Arts in the City of Skyscrapers *136*

Part Three. Huntington "in Crisis," 1930-1947 *201*

 4. A Humanist in a World in Crisis *203*

 5. The Tribulations of Mr. Huntington *271*

Part Four. Huntington "in Memory," 1947-1955 *305*

 6. The Ageing Hispanist and Franco's Spain *307*

 Bibliography *371*

 Index *403*

Illustrations

1. José López Mezquita, portrait of Archer M. Huntington, 1930 xxx
2. Archer M. Huntington, 1890 1
3. Archer M. Huntington traveling in Spain, 1892 25
4. Archer M. Huntington, 1900 51
5. Joaquín Sorolla, *Meeting of the Patronato of Casa-Museo del Greco*, 1912–20 69
6. Joaquín Sorolla, sketch for *Meeting of the Patronato of Casa-Museo del Greco*, 1912 70
7. Exhibition of plans and the model of the University City of Madrid, Sorolla Room, Hispanic Society of America, 1928 80
8. Archer M. Huntington and the marquis de la Vega-Inclán, c. 1929 89
9. Facade of the Hispanic Society of America, c. 2010 139
10. Main hall of the Hispanic Society of America, 1911 154
11. Anna Hyatt in her studio, c. 1910 169
12. Archer M. Huntington, c. 1934 201
13. Watchtower, Huntington residence in South Carolina, 1935 238
14. Archer M. Huntington, 1935 240
15. Archer M. Huntington at the Hispanic Society of America, c. 1940 281
16. Archer M. Huntington, c. 1953 305
17. Unpacking of the sculpture *The Torch Bearers* at the University City of Madrid, 1955 327
18. Inauguration of the sculpture *The Torch Bearers* in the University City of Madrid, May 15, 1955 333
19. Anna Hyatt Huntington, *The Torch Bearers*, University City of Madrid, 1955 335
20. Juan de Ávalos, sculpture of Archer M. Huntington and Anna Hyatt for the proposed Huntington Monument, 1964 356

21. Juan de Ávalos, scale model of the Huntington Monument, 1964 357
22. Pascual Bravo, drawing of Huntington Monument in Madrid, 1965 361

Graphics

1. Archer Huntington's networks of sociability in Spain, 1898–1930 62
2. Map of institutional relations of the Hispanic Society of America, 1898–1930 188

Foreword

Antonio Garrigues Walker

International jurist and son of Antonio Garrigues Díaz-Cañabate, Spanish ambassador to the United States, 1962–64

To read the most complete and far-reaching biography yet written on Archer M. Huntington is a privilege. Patricia Fernández Lorenzo has completed an exceptional work of research. To describe it only as exhaustive would not be correct. This book goes further than that and, indeed, though this might seem exaggerated, is close to being definitive.

Since this is her first book, one can anticipate without fear of being mistaken that there will be many more. There are, in effect, many more figures like Huntington and many more subjects in the field of culture and values that will benefit from the author's love for realism and objectivity as well as from her immense, omnivorous curiosity.

In reading this book, we see before us all the historical debates and concerns expressed regarding the image that we Spaniards present of ourselves to the rest of the world and alongside them our very special way of disregarding this whole subject and ignoring the importance it has for our interests. Despite the enormous efforts and progress made in recent years, and despite the fact that there is now a generalized awareness of our position as part of the outside world, something in our personality and our character still leads us (via an intricate interplay of both inferiority and superiority complexes, operating simultaneously and equally intensely) to isolate ourselves from other countries, contentedly shutting ourselves away in our own peculiarities and our own vices or signs of greatness. Many Spanish intellectuals have analyzed this attitude—*La mirada del otro*

(How Others See Us, 2016), a collection of essays edited by José Varela Ortega (who is currently immersed in a wide-ranging survey of this gaze from abroad), Fernando Rodríguez de la Fuente, and Andrea Donofrio, is one magnificent example—but nevertheless it continues to represent unfinished business, politically, economically, and sociologically. We cannot fall into the irresponsible foolishness of assuming that this task has essentially been concluded or be so ingenuous as to permit a situation in which foreigners will bring it to a conclusion.

An analysis of the birth and evolution of Archer Huntington's passion for Spain is of special interest. He, too, was inspired by notions of the romantic and the exotic, but Patricia Fernández Lorenzo points out that "with his travel book Archer offered his fellow Americans an image of Spain in 1898 that was very different from the one currently circulated in the American press" and demonstrated that he wished to encourage "a serious approach to and erudite appreciation of Spanish history and culture." She adds, moreover, that Huntington felt "concern at the weakness of national consciousness in Spain" and that he "foresaw the difficult future coexistence of the different national sensibilities that existed in Spain."

Archer Huntington loved and understood Spain from many points of view, and this led him to breathe life into his idea for an exceptional museum and institution: the Hispanic Society of America, the central subject of Fernández Lorenzo's book. It was said of our protagonist that he liked museums so much he would have been happy to live in one, and it is very possible this was the case. The persistence, tenacity, and even obstinacy with which Huntington developed his great project for Spanish culture amid all kinds of difficulties, including several international financial and political crises, demonstrate that he was a person with a clear conviction: that a museum is the most effective means of keeping constantly alive all those elements and artifacts that are worthy of being passed on between generations.

The Hispanic Society of America undertook and continues to carry out a major task of researching and spreading knowledge of our Spanish realities in the worlds of culture and art, a labor that Spain has taken a long time to recognize and accord its due merit. The recent exhibition in

the Prado Museum in Madrid of only some examples from the collection of this New York institution will have served at least in part to generate a new interest in the society and its creator.

The dramatis personae of this narrative and the plot developments traced by Fernández Lorenzo also deserve special attention because the relationship between Huntington and the political and cultural elites in Spain during the Spanish Civil War and the Franco era was truly surprising. Hence, the story is full of anecdotes that masterfully reflect the atmosphere of that time as well as the American art patron's ability to comprehend it and penetrate its complexities.

His wife, Anna Hyatt Huntington, was the creator of the sculpture *The Torch Bearers*, which she donated to the city of Madrid and is the perfect symbol of the transmission of knowledge. It stands amid the Moncloa campus of the Universidad Complutense of Madrid, and several copies can be found in different cultural institutions in the United States. However, Archer Huntington still does not have a statue dedicated to him in our country, and perhaps the publication of this book may help in reviving this idea. Many years ago, the sculptor Juan de Ávalos was already well advanced in his work on such a monument but, for the very Spanish reasons that are explained in these chapters, found it impossible to conclude this task.

Finally, we must thank the author of this book for the extensive bibliography she has provided, the objectivity and passion with which she has analyzed her subject, and her continuous emphasis on the role of culture and human values. This is a great book.

Antonio Garrigues Walker
June 26, 2018

Acknowledgments

My first encounter with Archer Huntington took place in the halls of the beautiful Museo de Bellas Artes in Bilbao, where I was able to see the impressive panels of *Visions of Spain*, painted by Joaquín Sorolla between 1911 and 1919 to decorate the library of the Hispanic Society of America. The vision of the colorful giant canvases portraying the cultural differences that survived between the various regions of Spain at the beginning of the twentieth century was so stimulating that my curiosity regarding the American Maecenas who had issued this commission was aroused in that moment.

In the course of my work since then, I have had the good fortune to get to know many people and institutions on both sides of the Atlantic who have kindly given me their assistance and often been an inspiration to me in carrying on my work and ensuring that it is published. I express my sincere thanks to all of them, whether they can be named in the brief space available here or not. Special mention should be made of Antonio Garrigues Walker, Antonio Moreno Juste, Juan Pablo Fusi, Javier Moreno Luzón, Lola Jimenez-Blanco, Antonio Niño, Antonio López Vega, Richard Kagan, Philippe de Montebello, Fernando D'Ornellas, Blanca Pons-Sorolla, Santiago Saavedra, and my Spanish editors, Carlos Pascual del Pino and Mariana Salvador. To them, I must add Nick Rider for his excellent job with the translation of the manuscript into English; the charming members of the Asociación de Amigos de la Hispanic Society of America in Spain; the conservators of the Hispanic Society of America; the staff of the Department of Contemporary History of the Universidad Complutense de Madrid; the patrons of the Fundación Alfonso Martín Escudero and the Fundación Consejo España–Estados Unidos; and all

the librarians and archivists who have attended to my requests in the numerous archives I have consulted. Of special importance, because of the wealth of its holdings and the importance they have had for the present study, has been the Special Collections Research Center at Syracuse University Library, where my intensive research visits have been particularly enjoyable. Finally, I especially thank Syracuse University Press for considering that Archer M. Huntington deserved to be part of the library's collection and so for publishing this book.

Introduction

I

Whoever takes the time to look through the excellent catalogs of the collections of the Hispanic Society of America will easily come across some of the portraits from the "gallery of illustrious Spaniards" that Archer M. Huntington assembled in New York. Rendered for posterity by the best Spanish painters of the era, they represent one of the most personal endeavors within his collection of contemporary painting. As tends to be said when one stands in front of a well-executed portrait, "All that's missing is for them to talk." It is truly a pity they do not speak because they would have been the most reliable sources for bringing us closer to Huntington's personality. As an alternative resource, we have his letters, messages that have served us as a guide in our journey through the life of this great Hispanist and have revealed, more than expected, the singular significance that Archer Huntington had in Spain.

These portraits have been exhibited in New York since the beginning of the twentieth century, and many visitors will have observed them with curiosity, attempting to extract some information about their subjects from their postures or gestures. Did Huntington often stop to look at them as well? After all, he personally knew most of their subjects. In some cases, they had met at dinners or in long discussions at *tertulias* (social gatherings), or he had read their novels or owned some of their paintings. With others, he had been interested by their academic work, had published some of their poetry, or had even honored them with one of the Hispanic Society's medals.

It is easy to imagine Huntington looking at these portraits in the early decades of the century, when the Hispanic Society was the chief focus for the dissemination of scholarly Hispanism in New York, a form of Hispanism committed to the presentation of Spanish culture internationally in the most professional manner possible. España was in vogue, and the lines of New Yorkers who waited to enter the Joaquín Sorolla exhibition of 1909 provided the best possible platform for extending its popularity. The portraits Huntington had collected represented the cream of the "Silver Age" of Spanish culture, which in those years was at its most effervescent. Despite the ideological differences there might have been between these figures—or perhaps precisely because of them—they all proudly personified contemporary Spain.

It is more difficult to think of him walking among these same paintings during the Spanish Civil War, anguished at the fate that awaited some of his Spanish friends, harried by the partisan propaganda that abounded in New York, and deeply concerned at the irresponsible destruction of Spain's historical and artistic heritage. The unshaken presence of these men and women, smiling and dressed as cultivated cosmopolitans enjoying the fruits of success, must have made a painful contrast with the realities of Spain in the 1930s and 1940s. Many of the portraits had been painted only a short time earlier, and their subjects were still alive, but they represented a world that was disappearing, a world that Huntington had wished to preserve as a way of sidestepping the pressures of modernity.

Possibly there has never been so much silence at the Hispanic Society as during the years in which it had to close its doors to the public, when Huntington chose to remain mute as the only means of maintaining the institution's neutrality regarding the Civil War. The Hispanic was, as Vicente Blasco Ibáñez inscribed on its walls, "Spain in America, thanks to the noble and generous love of Spain of this great American," and therefore the society had to admit both of the two Spains in conflict. Fortunately, the portraits did not meet the same fate as many of the individuals they portrayed, who ended their lives in exile far from Spain. If King Alfonso XIII had been the first, many others were soon obliged to emulate him, albeit for different reasons: artists, poets, writers, musicians,

and teachers. Some were members of the Hispanic Society of America. Who could have imagined only a few years earlier that this could happen?

II

The small and compact Spanish museum the young Huntington had dreamed of became a reality more than a hundred years ago and today continues to surprise visitors to its exhibitions by the breadth of its artistic repertory. It is not surprising that his record as an art collector is the best-known aspect of his life and that in examinations of his career, one often sees an almost unidimensional identification between Huntington and his Hispanic museum, despite his cultivation of other disciplines. However, there can be no doubt that many key elements needed to comprehend the style of Hispanism he sought to promote can be found in the sheer variety of aesthetic interests, often rooted in anthropology, reflected in his collections: his attraction to popular culture, to customs that had been maintained despite the influence of modernity, to the Muslim roots of Spanish culture, and to regional diversity as an intrinsic element in the Spanish nation. His approach as a collector was innovative in his time, but still more so was his decision to display his collections in a museum and library open to the public, something that was still not common in 1904.

Moreover, there was a point in his life after which it was not enough to continue labeling him a "collector of Hispanic art" to explain his world. It is not that Huntington ceased to collect but that this phrase was no longer sufficient to comprehend all that he came to be in the following decades. He noticed that something was changing when he wrote in 1918, "The museum is taking the place of a collector, it *is* the collector in a sense."[1]

Huntington had begun to be aware of the unstoppable process that was taking place in the cultural world and in which he himself was

1. Diary entry, May 17, 1918, Archer Milton Huntington Archives (AMHA), Hispanic Society of America, New York, quoted in Mitchell, Codding, "Archer Milton Huntington, Champion of Spain in the United States," in *Spain in America: The Origins of Hispanism in the United States*, ed. Richard L. Kagan (Urbana: Univ. of Illinois Press, 2002), 163–64, emphasis in original.

immersed: the displacement of his own identity by that of a museum that today has outlived its founder by more than six decades. The initial symbiosis between collector and collection, so characteristic in his case, has been followed over the years by a process in which the multifaceted, diverse identity of the man has been supplanted by the monolithic image of the genial collector-founder of the Hispanic Society of America. For this reason, it is necessary to reaffirm the value of the individual beyond that of his collection and despite the significance of his collection.

Placing him in the context of his time, among the people he knew, the collective mentalities among which he lived, and the conflicts he was confronted with over the eighty-five years of his life, has been of decisive importance in counteracting the limitations of this monotone image that, a priori, has obstructed any possibility of gaining a complete overview of his contributions to cultural history. Consider, for example, the Mariners' Museum and Park, the Golf Museum, and Brookgreen Gardens, all of which he founded in the early 1930s. These three ventures tend to confuse those who know only the Hispanic Society because they represent a radical departure from the museographical model of a New York institution in neoclassical style devoted to the study and classification of a single scholarly discipline. To put it simply, they were not in the script. However, they make perfect sense if one places them in the context of the years of the New Deal because the philosophy that inspired them connected impeccably with the mentality and altruistic spirit of the time. By then, Huntington perhaps understood that the civic value of the new cultural philanthropy did not depend on the creation of an exclusive and distinctive collection to be shown to the public in a museum but rather on the creation of a museum with a theme and subject matter that interested the public—a public that was acquiring a new power in its ability to demand culture that was accessible and art that it could comprehend.

III

The image of the traveler-adventurer with aristocratic manners in search of objects and works of art that could reflect the soul of Spain has come down to us today surrounded by an aura of romanticism that makes it very

attractive. If to this we add Huntington's knowledge of Castilian Spanish and Arabic, his travels through Spain on muleback following the route of El Cid, his archaeological excavations, his long *tertulias* in Seville, and his encounters with the Spanish aristocracy, we have a very engaging picture of him, but one that is entirely anchored in the years of his youth. However, if we also look at his actions and omissions and read his letters with modern eyes, we can see that Huntington was also a man open to the influences of his time. Although the sources of his devotion to Hispanism were profoundly rooted in the nineteenth century, he was also very conscious of the changes taking place in society in later decades. This dichotomy produced in him an ambivalent attitude toward the increasing democratization of culture, and whenever he had to face a choice between cultural proselytism and erudition, he preferred the latter, even at the cost of relinquishing a broader public.

In this regard, he remained consistent, maintaining a scholarly conception of culture even when the new forms of cultural consumption were pointing in other directions, which he also nevertheless explored. Despite all the changes around him, he did not cease to follow his instinct: he was a philanthropist "from birth" and an art patron by conviction. He did not consider himself the proprietor of the inheritance that he had received but rather its executor, charged with the responsibility of making good use of it, and in his chosen field he followed the dictates of his conscience with complete autonomy.

This same sense of responsibility to manage his fortune for philanthropic ends prevented him from pursuing his own career as a scholar as much as he would have wished, which had begun with his translation of the *Cantar de mio Cid* (*Poem of the Cid*) in 1897. However, when he began to publish his own extensive poetry production thirty years later, he amply demonstrated that he was a true man of letters. He was a scholar but not an intellectual in the usual sense of the term, for at no time did he attempt to influence society through the press and other media. On the contrary, he was extremely reserved in his opinions and in his public image. He did not give interviews—except for the one encounter in 1896 on the developing crisis over Cuba and another by letter in 1934 (see chapter 1)—and his aversion for the photographic reproduction of his face was such that

he issued only one photo to the press, taken in 1900, which features in the opening pages of part two of this book. In the absence of any others, this one photograph has been so widely used that it has become the semi-iconic image of him that has come down to us today.

IV

Of the many reflections that could be drawn from the chapters of this book, one in particular stands out: our observation of a willingness to act as a conciliator that underlay the many initiatives with which Huntington contributed to the formation of a special cultural relationship between Spain and the United States—a frame of mind that reveals that his abilities as a creator of cultural infrastructure were paralleled by his complementary abilities as a builder of cultural bridges.

The years 1898 and 1953, two years with special significance in the history of diplomatic relations between Spain and the United States, mark the beginning and end points in this analysis. The fifty-five years between them make up a period in which political contacts between the two countries were in general of little importance. Because of this, Huntington and the Hispanic Society occupied almost virgin territory and acquired a public prominence in Spain that went well beyond what would normally be accorded to a collector and his museum.

A brief overview of the relevant history begins with the Spanish-American War of 1898, which naturally represented the moment of maximum difficulty in bilateral relations. Despite the experience of war, its outcome did not significantly mark the two countries' respective populations. Although Spaniards retained a generalized feeling of antipathy toward the young American republic, the Spanish elites also saw the United States as more of a model for the modernization of the country than as an enemy.

In the victorious power, which in the preceding years had seen a deliberate revival of the "black legend" of Spanish cruelty that had dogged Spain abroad for three hundred years, the war of 1898 was curiously followed by an entirely contrary trend in the shape of an unheard-of fascination with Spanish art, architecture, music, dance, clothing, and culture in

general that flooded the United States with aromas of Spain. Huntington, as a privileged observer from both sides of the Atlantic, did not allow himself to be carried along by the anti-Spanish rhetoric of the war and continued to foster the appreciation of Hispanic culture in his country, giving priority to a serious approach to the realities of Spain rather than to the habitual clichés and offering a more welcoming image of the country by contrast with the notions commonly offered in the American press.

The foundation of the Hispanic Society in 1904 was the materialization of a dream but also had its connections with American authorities' desire to rebuild relations with Spain after the war. Although it emerged out of a personal initiative by a young millionaire, the success it achieved after its inauguration progressed in the cultural sphere in line with decisions taken in Washington to encourage reconciliation and establish a new framework for bilateral relations. Moreover, the participation of the Hispanic Society in the first Advisory Council of John M. Hay, secretary of state in the Theodore Roosevelt administration, was a symbolic demonstration of the government's support for this new form of public promotion of Hispanic studies.

Culture set the tone for the incipient extraofficial relations with Spain. In Spain itself, the first facsimile editions of rare and antiquarian Spanish books from the "opulent New Yorker" were received with surprise and gratitude, and Huntington's New York exhibitions of the work of Sorolla and Ignacio Zuloaga were celebrated as landmarks in the process of making Spanish culture known on the international stage. The financial support he gave to the Casa-Museo del Greco and the Casa-Museo de Cervantes as well as the assistance he gave to Spanish intellectuals in New York demonstrated to the Spanish authorities and the circles around King Alfonso the sincere concern of the "rich yankee"—as he was referred to in the Spanish press—to bring about a positive reappraisal of Spain's cultural heritage.

World War I marked a turning point. The entry of the United States into the war in 1917, in contrast to Spain's continued neutrality, increased interest in Spain among American diplomats. The Wilson administration wished to deploy all possible means of propaganda to project a positive image of the Allies in Spain and, in doing so, did not hesitate to call upon

the leading figures of American Hispanism. Huntington was asked to take part as an official representative in the negotiation of a bilateral trade agreement with Spain in 1918, the first time he ever took on an official role.

For its part, the Instituto de las Españas at Columbia University, where Federico de Onís had already begun his work, also sought to strengthen its collaborative links with Huntington to attract Spanish intellectuals to give lectures in the United States, in part at the suggestion of State Department officials. The State Department's intention was that these respected figures on their return to Spain would pass on a positive image of the United States and its people. As a good patriot, Huntington responded positively to these requests, but once the war was over, he resisted the shift in American Hispanism toward a "Pan-Americanism" that owed more to political considerations than to intellectual and cultural concerns.

The great crisis for Huntington came with the outbreak of the Spanish Civil War. The US government's decision to impose an embargo on arms sales to the government of the Spanish Republic encouraged Huntington to maintain the neutrality of the Hispanic Society as an institution that could easily have been compromised by the two warring camps' propaganda appeals. He aligned himself publicly with the greater part of American Hispanists, who similarly avoided making public pronouncements, even while millions of Americans were moved to a degree seen on few other occasions by a conflict in which their own country was not involved. As before, his sense of institutional responsibility prevailed over his personal feelings of disappointment and despondency, which were scarcely reflected even in the intimacy of his letters to his friends.

The outcome of Spain's civil war and the victors' ideological closeness to the Axis powers increased distrust once again between the United States and Spain. The new Spanish regime of General Francisco Franco openly rejected American liberal democracy, while governments in Washington collaborated with businessmen and philanthropists to promote a policy of brotherhood and "good neighborliness" with the republics of Latin America to extend US influence and limit the infiltration of fascism in the region. During this same period, however, and despite the adverse circumstances in Spain, Huntington still demonstrated that his commitment to American Hispanism remained alive by financing the creation of

the Hispanic Reading Room at the Library of Congress. This was his last great contribution to Hispanism in the United States.

Contacts between Spain and the United States were seriously weakened after the end of World War II, and Spain was consigned to international isolation. The American people rejected the totalitarian character of the Franco regime, while the Spanish authorities focused their diplomatic attention on Hispanic America. Huntington could do little in such circumstances. Nevertheless, at the end of the 1940s and in the early 1950s he rewarded with medals from the Hispanic Society several Spanish exiles who were then working in American universities, while at the same time presenting similar awards to others who had remained in Spain after the war, some without the recognition they deserved. Amid the reigning intolerance, Huntington's awards were a breath of fresh air sent from New York, a gesture of conciliation that recognized talent independently of political affiliations and that was acknowledged in the tributes paid to him in 1950 by prestigious Hispanists at Wellesley College.

The initiation of the Cold War aroused Washington's interest in military cooperation with the Franco regime, and in 1953 the signing of the Pact of Madrid opened the way to the establishment of US military bases in Spain. By then, Huntington was an old man of eighty-three, stricken by arthritis, who devoted his time to writing poetry at his farm in Connecticut; at the same time, however, a campaign was beginning in the Spanish press for him to be rediscovered as a dear friend of Spain. Opportunistic propaganda and sincere feelings of gratitude were combined in unequal proportions in the initiatives instigated by the Franco regime's Ministry of Foreign Affairs and Institute of Hispanic Culture, which sought to counteract any attempts by exiled anti-Francoist intellectuals to claim him as their own "property."

The US ambassadors in Spain took part in all the various events organized in Spain in the next few years to pay tribute to Archer Huntington and his wife, Anna, from the unveiling of a monument to them in the Pedralbes gardens of Barcelona to the inauguration of Anna's statue *The Torch Bearers* in Madrid's Ciudad Universitaria in 1955. In their speeches on these occasions, the ambassadors expressly stated that Huntington had for years been an extraofficial ambassador, dedicated to strengthening the

ties between the two countries. If the absence of foreign ambassadors in Spain between 1945 and 1951 had been one of the clearest signs of its international isolation, this reference to him as a form of ambassador constituted an eloquent recognition by senior representatives of the US government that he had been a valuable link between his country and Spain.

Viewed from the perspective of time, one can see that Huntington and the Hispanic Society were able to fulfill a public function of smoothing tensions and promoting a rapprochement between the Spanish and American peoples at two important moments. After the war of 1898, the creation of the Hispanic Society opened up new channels for cultural collaboration between the United States and Spain; and in the 1950s, after the signing of the Madrid Pact, the presentation of *The Torch Bearers* to the Ciudad Universitaria was a symbol of friendship between the two peoples after a period of diplomatic confrontation.

From this point of view, Huntington emerges as a symbol of cordiality in the two countries' bilateral relations, a man who spared no effort throughout his life in his desire to bring the cultures of Spain and the United States closer together, two different worlds that experienced both periods of greater proximity and greater estrangement as well as periods of collaboration and confrontation owing to political and cultural circumstances beyond his control.

He stands out, moreover, as an individual who did not passively accept the status quo presented to him but through friendship and cooperation contributed to breaking down barriers and connecting cultures by seeking to alter the images of each other that existed in both Spain and the United States. Hence, he cannot be properly understood from either an exclusively Spanish or an exclusively American standpoint, but only within an international, transnational perspective.

V

In the twenty-first century, the portraits in the Hispanic Society continue to capture the interest of all those who recognize in them, through their subjects, a piece of modern Spanish history. These canvases provide graphic evidence of the fleeting nature of the existence of the figures who

posed for them, but at the same time, however paradoxical this may seem, they also perpetuate for posterity the historical significance of the man who commissioned and acquired them. Beyond their unquestionable artistic value, they present us with a panoramic vision of the social and intellectual world that poured forth Spanish colors and accents into the life of Archer Huntington, a complex personality full of subtle nuances, whose contributions to Spanish culture deserve to be recognized in all their diversity.

Using, beyond his early years, Huntington's friendships in Spain as a guiding thread, this book is structured in four parts, indicating layers that were progressively laid on top of each other through his eighty-five years on earth. The title given to each part defines his stance as a Hispanist and a man in a particular period, and the sum total of these four parts broadly traces the vital trajectory of his life. "Archer Huntington 'in Progress,'" "Archer Huntington 'in Motion,'" "Archer Huntington 'in Crisis,'" and "Archer Huntington 'in Memory'" evoke four different experiences of life in the same person, which gradually accumulated upon each other in an unbroken continuum.

The opening chapter of "Archer Huntington 'in Progress'" deals with the first twenty-eight years of his life, from 1870 to 1898. It brings to the fore the influences he received from his background, both from his own family and from the privileged class to which they belonged, and traces the origins of particular social practices that expanded notably in the United States in this period, such as philanthropy and art collecting. This chapter goes on to examine his first contacts with the Spain of the last years of the nineteenth century, revealing a variety of situations, not without contradictions, in which his encounters and confrontations with different attitudes to life provided fertile ground for the development of his youthful intellect. This was a time of discoveries, of intergenerational tensions, and of meetings of minds with new acquaintances in Spain. While the United States was experiencing the era of massive-scale economic expansion known as the "Gilded Age," characterized by the formation of immense fortunes, Spain was living through a period of decline that culminated in the Desastre, represented by the loss of its last major colonies in the war with the United States in 1898.

In chapters 2 and 3, "Huntington 'in Motion'" presents the adult Huntington and his career roughly between the ages of thirty and sixty. This was the period between 1898 and 1930, years during which the defining features of his personality became clear and his professional activities reached their height. We examine the best-known image of Huntington and how he developed to become the prominent figure committed to the international dissemination of Hispanic culture who for some thirty years was the leading proponent of Hispanism in New York. This figure was the great collector, the founder and president of the Hispanic Society of America, who helped create new museums in Spain, promoted the work of Spanish artists and scholars in the United States, and took part in the Ibero-American Exposition in Seville in 1929. This period was divided by the outbreak of World War I, which brought a change in social mentalities and in the regard for Hispanism in the United States, and concluded in 1930, immediately after Huntington's last visit to Spain and the great stock market crash in New York. These three decades are examined in two chapters that are thematically distinct but run parallel in time. Chapter 2 provides a wide-ranging survey of Huntington's encounters with a great many figures from Spanish life, making both intellectual and emotional contact during the so-called Silver Age of Spanish culture, while chapter 3 deals with his role as the art patron who set his great cultural projects in motion in New York City.

"Huntington 'in Crisis'" examines the experience of the mature Huntington between 1930 and 1947. This was a man who in his sixties witnessed the disintegration of the foundations upon which his life up to that point had been built. If in the United States the economic system that had made his country the industrial and financial engine of the world appeared to be falling apart, in Spain the monarchy was collapsing with the king's departure into exile. Two contrasting worlds confronted in parallel a profound crisis of identity, which they would navigate very differently. These were the years of the Great Depression and the New Deal of Franklin Roosevelt and then of the Spanish Civil War and World War II. This third part consists of two chapters. In chapter 4, we consider the circumstances that Huntington lived through at this time in his life, together with those of his friends in Spain, and his continuing activities as a patron of

the arts. In this chapter, the letters he received in succession from Spain build up a narrative of the 1930s from disparate voices, while at home Huntington was initiating new philanthropic schemes substantially different from those he had undertaken earlier. In chapter 5, in contrast, his own words and the emotions they allow to be seen take center stage. Here one can see the Hispanist of subtle nuances, a man who reflected aloud, the man in the later stages of his life who reconsidered and meditated upon the conditions of a world at war and sought to understand the changes taking place in the world of culture.

Last, "Huntington 'in Memory'" covers in the final chapter the brief but intense period between 1947 and his death in 1955, which coincided with the first years of the Cold War. By this point, Archer Huntington was an octogenarian living disconnected from New York life and chiefly occupied with his poetry when the Madrid Pact was signed in 1953, reestablishing diplomatic and political relations between the United States and Franco's Spain to hold back the spread of communism. Using extensive material from official archives, this part reveals the various approaches to both Archer and his wife, Anna Hyatt Huntington, initiated by the Spanish authorities during and even after these years; it also observes the Huntingtons' final legacy to Spanish culture and the symbolic significance attributed to Archer Huntington as the great friend of "eternal Spain."

Four periods and four faces of Huntington, which, thanks to the use of archival material, can be identified with the four photographs that open each part of the book. The first has the frank and impetuous look of an ambitious young man; the second shows the confident, determined face of a man at the peak of his abilities; the third emphasizes the grave, thoughtful aspect of a mature man reflecting on his life; and the fourth shows the calm face of someone who in old age knew that his time was coming to an end and was ready to pass the baton on to others.

Four identities constructed by means of an introspective examination of Huntington's perceptions of the world around him that he revealed through his letters and his actions and delineating an intellectual profile in constant evolution. We simultaneously also see the profile that some sought to impose upon him from Spain, the mask of the icon that some of his associates wished to make of him and that, as such, underwent its own

changes and adaptations in accordance with political vicissitudes. Overall, the different, complementary faces of Archer Huntington break down the apparent homogeneity of his image and provide new elements to incorporate into our efforts to comprehend his legacy for Hispanic culture.

A Note on Sources

Archer M. Huntington's own surviving writings and correspondence are an essential source for our knowledge of his life and career. He kept extensive diaries from the age of twelve but later destroyed many of them. However, in 1920, when his mother, Arabella, reached her seventieth birthday, she asked him to collect their abundant correspondence—they wrote each other continually—and his own diaries for the purpose of writing a memoir of their relationship. This task was never completed, but his partial memoir and the documentation he collected have since been held in the archives of the Hispanic Society of America. This material, which has never been fully published, forms what are commonly referred to as Huntington's "diaries." However, because of the way the documents were collected, the texts often do not carry dates for each day but rather are filed roughly chronologically for each year, and some entries have dates and page references, but others do not. The same occurs in many letters. Not all of them have been preserved, and some are filed within the diaries. As a result, it is sometimes not possible to give exact dates for particular documents or to identify the precise addressee of a letter. All documents from the Hispanic Society collection are referred to in this book as the Archer Milton Huntington Archive (AMHA). In addition to my own research in the archive, I have also made use of the extensive documentary articles published by the executive director of the Hispanic Society of America, Dr. Mitchell Codding, and his staff, as indicated in the relevant notes.

Letters held in other archives, such as those of the Palacio Real in Madrid and Syracuse University, however, carry their correct dates and the name of the person to whom they were sent.

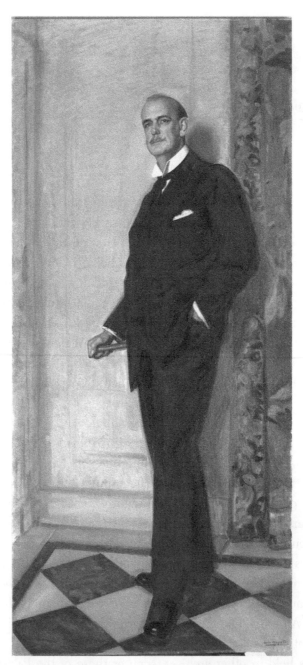

1. José López Mezquita, portrait of Archer M. Huntington, 1930. *Source*: Courtesy of the Hispanic Society of America, New York (A3071).

Archer M. Huntington

Part One • Huntington "in Progress" • 1870-1898

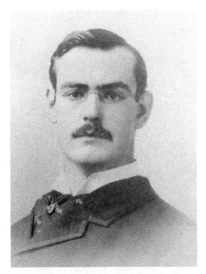

2. Archer M. Huntington, 1890. *Source*: Box 95, "Photographs Family Huntington, Archer," Anna Hyatt Huntington Papers, Special Collections Research Center, Syracuse University Libraries. By permission of Syracuse University Libraries.

Extremely tall in stature, with a build to match, an expressive face very typical of his race, hair short and a well-trimmed moustache in the style they favour over there, and eyes that were lively and sparkling behind the large lenses of his spectacles.... Our language was familiar to him, and he spoke it fluidly and correctly, though not without the accent or distinctive tone of a foreigner.

—Francisco Rodríguez Marín, account of a meeting with Archer M. Huntington in Seville in 1898, August 8, 1907

1
The Awakening of the Vocation of a Young Hispanophile

The Huntingtons: A Family of Collectors and Philanthropists

A well-known saying describes in a few astute words the best legacy any child can receive from their parents: "roots to grow and wings to fly." It seems hard to add anything to the wisdom distilled in this short phrase, and only someone with the genius of the Nobel Prize–winning poet Juan Ramón Jiménez was able to provide them with extra meaning when he wrote in 1917 with a poetic subtlety that was certainly much to the taste of his friend Archer Huntington, "pero que las alas arraiguen y las raíces vuelen" (so long as the wings take root and the roots fly).[1]

There can be no doubt that Archer Huntington flew and that he made prolific use of his wings: one need only see the legacy he left for Hispanic culture. It is more difficult to identify the roots of all his activities because in general they were hidden from the view of others. The family, society, values, and circumstances among which Archer Huntington entered the world and spent the first years of his youth made up the fertile ground from which some of the most characteristic features of his personality emerged already well defined—features that it is essential to consider because in one way or another they remained with him his entire life.

1. Juan Ramón Jiménez, *Diario de un poeta recién casado* (Madrid: Casa Editorial Calleja, 1917), 22. Jiménez received the Nobel Prize for Literature in 1956, while exiled in Puerto Rico because of the Franco regime in Spain.

Archer was born in New York on March 10, 1870, amid the first years of the so-called Gilded Age.[2] The US Civil War had ended five years earlier, and the United States had entered a period of peace and prosperity propelled by industrialization, the construction of communications infrastructure on a massive scale, and an extraordinary level of economic growth, all of which encouraged the formation of immense fortunes. Americans had to confront the reconstruction of the country and the configuration of a body of civic and moral values for the new postbellum society. It is precisely in this period that one can locate the origins of two of the characteristic elements that were highly valued in the United States in the late nineteenth century: philanthropy and art collecting. These two practices would be intimately related in the life of Archer Huntington and his family.

A study by the art historian Shelley M. Bennett examines the profile of four members of the Huntington family as Gilded Age collectors: Collis Potter Huntington (1821–1900) and his second wife, Arabella Duval Yarrington (1850–1924); their son, Archer Huntington (1870–1955); and Henry Huntington (1850–1927), Collis's nephew and Archer's cousin.[3] These four made up two generations of the same family, which, after amassing a huge fortune, dedicated a great part of their wealth to philanthropic causes and to the acquisition of works of art in order to make them available to the American public. Their family relationships, their shared status as millionaires, and their devotion to collecting made them a real lineage despite the fact that Archer had neither brothers nor sisters nor descendants—a lineage that was therefore short-lived but one whose members shared for some years the same historical period and certain values.

Archer Huntington was the youngest of them and the one who had the most impact in Spain because in his case his philanthropic activity

2. Mark Twain and Charles Dudley Warner coined the name "Gilded Age" in their novel *The Gilded Age: A Novel of Today* (1873; reprint, New York: Penguin Classics, 2001), satirizing the creation of great fortunes and political corruption in the United States in the later decades of the nineteenth century.

3. Shelley M. Bennett, *The Art of Wealth: The Huntingtons in the Gilded Age* (San Marino, CA: Huntington Library Press, 2013).

and dedication to collecting were filtered through his vocation as a Hispanist. His importance in American Hispanism in the twentieth century is unquestionable, and tracing the origins of his later activities is of great interest in helping us comprehend the singular aspects of his personality. Hence, the question arises regarding just what the childhood of Archer Huntington with his family was like.

One aspect springs to our attention: the question of his fatherhood. The importance of this point extends beyond simple speculation over whether Collis P. Huntington was his biological father or not. In effect, no one today seems to doubt that Archer was the millionaire's natural son, born as the result of an extramarital relationship that Collis Huntington maintained with Arabella, a beautiful young woman of humble origins whom he had met sometime around 1867. In her first years in New York as a single mother, she used the name "Arabella Duval Worsham," in reference to her supposed marriage to a John Worsham, who could thus be portrayed as Archer's deceased father. For his part, Collis had been married since 1844 to Elizabeth Stoddard. They had no children—although they did adopt Elizabeth's niece, Clara—and after his wife died in 1883, Collis married Arabella on July 12, 1884, when she was thirty-four years old and he was sixty-three. Arabella's son, Archer, was then fourteen. Although no formal adoption took place, the correspondence between Collis and Archer demonstrates that they regarded each other with affection as father and son.

The subject of his legitimacy, however, was a concern for Archer all his life. According to Alpheus Hyatt Mayor, nephew of Archer's second wife, Anna Hyatt, and president of the Hispanic Society after his death, the question of his paternity led Archer to be extremely reserved regarding both his private life and his projects.[4] His mother, Arabella, avoided giving any explanations on the subject, and all those who have concerned themselves with this story have acknowledged the difficulties they encountered in uncovering any part of it.[5] Given these family precedents, surrounded

4. Alpheus Hyatt Mayor, introduction to *A Century of American Sculpture: Treasures from Brookgreen Gardens*, ed. Walton H. Rawls (New York: Abbeville Press, 1981), 29.

5. Stephen Birmingham, *The Grandes Dames* (New York: G. K. Hall, 1982). Birmingham gives us an overview of the lives of the great American society ladies who from

by half-truths amid a society marked by strict Victorian morality, it is not difficult to imagine the tensions the young multimillionaire had to face when he entered public life in New York high society.

By the time Collis married Arabella, he was enormously rich. He had come from a modest farming family in Connecticut but through hard work and the right friendships had succeeded in making himself a highly influential figure in business. With a strong entrepreneurial spirit, he had built up a giant fortune when he joined with three other businessmen—Mark Hopkins, Leland Stanford, and Charles Crocker—to found the Central Pacific Railroad Company in 1861. These four partners began the construction of the western end of the transcontinental rail line that would unite the eastern states of the Union with California, a feat achieved in 1869. Known as the "Big Four," with their rapidly growing power and influence they were seen as pioneers in the modernization of America. Collis Huntington also founded other rail companies and the port and shipyards of the Newport News Shipbuilding and Drydock Company in Virginia and continued expanding his wealth to become part of the country's social elite.

The business practices Collis and his partners employed in their railroad companies have been made manifest in a recent study, which does not hesitate to brand them as corrupt, fraudulent, and even immoral.[6] In fact, Collis P. Huntington was investigated for corruption in his own time by the US Congress and was seen as a prominent example of the "robber barons," a pejorative label applied to the wealthy and powerful industrialists and bankers who enriched themselves with enormous opulence in the last decades of the nineteenth century.[7] This image of a businessman without scruples contrasted, however, with the profile of a philanthropist and art collector that he also set out to cultivate.

1880 to 1939 stood out for both their wealth and their philanthropic activities. The chapter on Arabella Huntington is subtitled "A Woman of Mystery."

6. Richard White, *Railroaded: The Transcontinentals and the Making of Modern America* (New York: Norton, 2011).

7. On the origin of the term *robber baron*, see U.S. History.org, "The Gilded Age. The New Tycoons: John D. Rockefeller," at https://www.ushistory.org/us/36/asp.

In the final third of the nineteenth century, the idea of helping one's neighbor underwent a redefinition in the United States in practical terms. On the basis that a systematic approach to the act of giving could achieve more lasting effects on society in the medium term than purely individual charitable actions, a new concept of philanthropy was developed in which it was endowed with new forms of management and increasingly seen as a means of exercising public virtue, while those who sustained philanthropic initiatives were regarded as virtuous and admirable citizens.[8] During this period, leading business figures and ladies from high society initiated the first philanthropic projects with an institutional structure. Collis Huntington, who had been a committed abolitionist during the US Civil War, stood out for the support he gave to the education of African Americans, financing educational institutions, creating libraries, and improving facilities to provide access to culture for the very poor.

Many American millionaires also saw it as a civic duty to dedicate part of their fortunes to art collecting, which also expanded on an enormous scale in the United States in the last thirty years of the century. After the Civil War, American painters of landscapes and historical scenes contributed with their works to forging the values of the new society, and patriotic leaders of commerce and industry were the first to acquire their canvases. Like the Vanderbilts, Rockefellers, and Carnegies, Collis Huntington began by buying the work of American artists. These budding collectors soon looked to Europe and European art in search of indicators of social prestige, and their fortunes were redirected toward the acquisition of artworks by recognized old masters for the purposes of decorating their mansions, filling the new art museums that were emerging in the great cities of the country, and avoiding criticism from art experts regarding the vulgarity of their taste. In the mentality of the era, bringing objects obtained in Europe to the United States to make these collections available to the American public appeared as the proper conduct of a good citizen. The success of Henry James's novel *Roderick Hudson* (1875) had a certain

8. Lawrence J. Friedman, "Philanthropy in America: Historicism and Its Discontents," in *Charity, Philanthropy and Civility in American History*, ed. Lawrence J. Friedman and Mark D. McGarvie (New York: Cambridge Univ. Press, 2002), 9–10.

influence in spreading this view in that the character of Rowland Mallet, a collector and art lover who tours Europe, helped to popularize the idea that to collect European artworks and bring them to the United States constituted an act of patriotism.[9]

As part of the same trend, in New York high society the idea of cultivating an artistic sensibility also led many business figures to take part in cultural associations. Collis Huntington did not stand aside from all these activities and sat on the committees of the Metropolitan Museum of Art, the American Museum of Natural History, the American Fine Arts Society, and the Union League Club, opening up pathways that his son, Archer, would follow him down a few years later. Shared membership of this kind offered those who took part in these committees a social identity, a sense of belonging, and a certain feeling of camaraderie as well as the possibility of extending their professional contacts and so their influence and "networking" in general. In this manner, wealth, philanthropy, and art collecting all came together in the United States in a process of singular importance for the world of art and culture in the last years of the nineteenth century.

What is evident in general terms from this period is that the figure of Collis P. Huntington fitted a then common American model: he was a patriot, business pioneer, art collector, and philanthropist who triumphed in his country at a time when the characteristic contradictions of the Victorian mentality still dominated society in the United States.

Arabella Huntington, for her part, did not stay in the background in any way but played an indispensable role both in raising her own public profile and in shaping the image of her husband. From the moment the young Arabella had arrived in New York as Arabella Worsham in the 1870s, she had taken great pains to cultivate herself, studying French and acquiring a broad knowledge of art and antiquities, and she developed an exquisite taste in domestic decor. In the Virginia Museum of Fine Arts,

9. Richard L. Kagan, "The Spanish Craze: The Discovery of Spanish Art and Culture in the United States," in *When Spain Fascinated America*, ed. Ignacio Suárez-Zuloaga (Madrid: Fundación Zuloaga, Ministerio de Cultura del Gobierno de España, 2010), 41.

one can still see today in the Worsham–Rockefeller Bedroom the original furnishings of her room with its Oriental-inspired decoration and ebony-wood furniture from her first house in New York, a residence that she sold to magnate John D. Rockefeller after her marriage to Collis Huntington. The society columns of the day highlighted the interest that the decoration of her homes aroused among her compatriots, especially the luxurious neo-Moorish salon extending over nearly ten thousand square feet, decorated in accordance with the mode for the exotic that had begun to spread through American society with the publication of Washington Irving's *Tales of the Alhambra* in 1832.[10] In addition, she also revealed herself to be an astute investor in real estate and with Collis's financial backing set about acquiring land and property in New York, to the point where she accumulated a considerable fortune of her own. By the late 1870s, at only twenty-seven and a single mother, she was already the owner of buildings in the city worth, by present-day values, around $6.5 million.[11]

After her marriage to Collis in 1884, Arabella had a considerable influence in fostering greater refinement in the artistic tastes of her husband and altering the approach of his collecting. In 1887, they made a journey to London and Paris, which for Collis represented his first contact with the continent and European art in situ. Two years later, he and Arabella began to purchase works of European historic art in Paris, among them a Vermeer and three paintings by Spanish artists—a portrait of the third duke of Alba by Antonio Moro and two portraits attributed to Claudio Coello.[12] Although their main priority in acquiring art was to decorate their opulent new home off Fifth Avenue, at 2 East Fifty-Seventh Street, it is curious to note that they did not have a ballroom or a dedicated picture gallery in which to show off their new paintings, as was the case in

10. Claudio Remeseira, "A Splendid Outsider: Archer Milton Huntington and the Hispanic Heritage in the United States," in *Hispanic New York: A Sourcebook*, ed. Claudio Remeseira (New York: Columbia Univ. Press, 2010), 452.

11. Bennett, *The Art of Wealth*, 22.

12. During the same visit to Europe, they also organized the wedding of Collis's adopted daughter, Clara, to the German aristocrat Prince Franz von Hatzfeldt-Wildenburg, which took place in London in 1889.

the homes of other millionaires, such as the Vanderbilts, who habitually received visitors to view their collections. Collis considered himself a lover of home—"I'm a home man" was how he put it in an interview—and told the press that his intention was to build a house for his family and so did not expect to set part of it aside just for "show and company."[13] Nor did Arabella pursue an intensive social life because in spite of her having become Mrs. Huntington in 1884, she was still not accepted in the most exclusive social circles of New York, and the hostesses of some of the most prestigious residences of the era still closed their doors to her.

In addition to managing her own holdings and collecting art, Arabella also involved herself personally in philanthropic causes in the same way as other wealthy American ladies of the time. In the last decades of the nineteenth century and first years of the twentieth, women from high society acquired a particular social role and a degree of political influence by taking active part in volunteer work, thus creating parallel power structures in the public arena.[14] Although the law made them politically invisible, reality contradicted this principle. The new models of institutionalized philanthropy provided them with an opportunity to intervene in the public sphere through a range of associations, to the extent that for women philanthropy had effects that complemented those of the cultivation of public virtues in general, serving as a training camp that prepared participants for later campaigns, such as those in favor of women's suffrage.

The purpose of the initiatives pursued by Arabella Huntington was to continue support for the social causes favored by her husband and to assist the cultural activities of her son, Archer. She also lent her support to the demands of women's organizations to improve labor rights for women and children.[15] Although she spent a fortune on jewelry and luxurious living,

13. Collis Huntington, interview, *New York Tribune*, 1889, Henry E. Huntington Collection, Huntington Library, San Marino, CA, quoted in Bennett, *The Art of Wealth*, 82.

14. Kathleen McCarthy, "Women and Political Culture," in *Charity, Philanthropy and Civility*, ed. Friedman and McGarvie, 178.

15. Although Arabella never openly declared herself a supporter of the campaign for women's suffrage, in an interview she gave to the *New York Herald* on November 3, 1909,

when she died on September 16, 1924, obituaries in the press emphasized her dedication to philanthropic causes and lauded her activities as a collector because her works of art and all her furniture were to be donated, on Archer's instructions, to public institutions such as the Metropolitan Museum of Art, the Yale Museum, the Legion of Honor in San Francisco, and the Huntington Museum near Pasadena, California.

Another question is just what the relationship between Archer Huntington and his parents was like. During his early childhood, Archer was raised in a house without any paternal influence, living with his grandmother and Arabella's sisters in San Marcos, Texas, until he moved to be with his mother in New York at the age of twelve. Very possibly because of an awareness of the deficiencies in her own education, Arabella involved herself very personally in the education of her only son, engaging private tutors and encouraging his interest in art and French literature, so that she had enormous influence on his subsequent aesthetic and artistic concerns. Mother and son traveled to Paris and London together in 1882, where she accustomed him to visiting the major museums and galleries. Archer learned to appreciate European art, while his mother bought works and objects for her incipient collection. It was precisely in Britain in 1882 that a chance purchase of a book by George Borrow on Spanish "Gypsies" (Roma), *The Zincali* (1841), aroused his interest in Spain, and on his return to New York Archer began to learn Spanish with a woman teacher from Valladolid.[16]

His mother enthusiastically supported his fascination for all things Spanish. The relationship between them was very close and based on an unconditional love. The voluminous correspondence that passed between them over the following years has become the principal documentary source for our knowledge of his thoughts and motivations and for our efforts to follow his transformation into a prestigious Hispanist and collector.

she did say that she believed that women should be given the right to vote on questions related to property rights and education, and three months later she expressed her support for a strike by New York seamstresses. See Bennett, *The Art of Wealth*, 178.

16. Beatrice Proske, *Archer Milton Huntington* (New York: Hispanic Society of America, 1963), 1.

In his letters to his mother, Archer wrote at length about the impressions made upon him by his visits to Spain as well as about his schemes, his dreams, his acquisitions, and his opinions, with a freshness and frankness that are difficult to find in his correspondence with others. His letters to Arabella contain an abundance of sincere demonstrations of devoted love for his mother and illustrate the more emotional side of the young Archer. It was Arabella herself who in 1920, when she was seventy years old, aware of the legacy these letters contained, asked her son to collect them together in an archive now held by the Hispanic Society of America (see "A Note on Sources").

The relationship between Archer and his father, Collis, was based on feelings of respect and admiration, although on occasion one can see in their letters a degree of incomprehension in the father regarding his son's attitudes. There are few sources with which to document this divide, but a long letter that Archer sent on June 7, 1934, in answer to a journalist from the *Pasadena Star News,* who hoped to write an article on the Huntington family's role in art collecting, helps us discern some of the aspects around which the great admiration Archer felt for his father revolved. It should be said that this letter was written when Archer was sixty-four years old and at a time of great political, economic, and social instability when some of the foundations of society in the United States and Spain appeared to be teetering: the United States was undergoing the Great Depression, and in Spain the Second Republic had brought an end to the Bourbon Restoration monarchy established in 1874. One can see in this letter a certain idealization of the figure of his father, the product of time having passed, and a need to strengthen bonds with the past, perhaps to reaffirm more solid bases for life in the present.

In this letter, Archer emphasized several aspects of his father's personality that he felt few people were aware of, such as his intuitive taste when buying pictures and his great love for poetry. These aspects contrasted with the image of a rough-edged, uneducated tycoon habitually presented of him by the press in earlier decades. Archer had had the inspiration, as he pointed out, to note down some of the phrases that Collis Huntington had regularly used among those closest to him and that indicated the cultivated sensibility for art and literature that he strove to develop during the

last years of his life in the 1890s. In statements such as "a great work of art is the highest expression of Life" and "a nation devoted to the gaining of money or power at the expense of art is dead,"[17] Collis had extolled the value of art above that of money, recognizing the importance of artistic expression not only for the individual but also for an entire nation.

As an art aficionado, the older Huntington equally did not fail to leave behind phrases on the sense of mission he accorded to collectors, asserting that "collectors feed museums" and that "art museums are human tributes to inspiration." Statements of this kind reflected a profound belief in the civic value that lay in providing the museums of the United States with major works of art as sources of inspiration for an eminently positivist society. Influenced by the relative cultural renaissance that the country was experiencing at the end of the century,[18] Collis admiringly observed the social importance artists had acquired in society in comments asserting that poets were "rich"—because "poets need little money because of their wealth"—and recognizing the value of artistic immortality—"artists survive; businessmen die."

Although Archer clearly wrote this letter in 1934 as a tribute to his father—which could make one doubt the literal accuracy of everything Archer recounted and which evidently had a great deal to do with the fact that the recipient was a journalist—one can see that in it Archer strove to highlight aspects of Collis Huntington that linked him to the interests and passions they had in common. In effect, although it does appear that Collis's ideas on art were strongly influenced by the cultural interests of his wife and son, one can equally see that the collection of phrases

17. Archer M. Huntington to Robert O. Foote, June 7, 1934, box 51, Anna Hyatt Huntington Papers (AHHP), Special Collections Research Center (SCRC), Syracuse University Libraries, Syracuse, NY. The quotations of Collis Huntington's statements in the next paragraph also come from this letter.

18. At the same time as the economy was expanding, arts and literature were also enjoying a moment of splendor. J. M. W. Whistler, John Singer Sargent, Mary Cassatt, and Thomas Eakins in painting, Mark Twain and Henry James in the novel, Walt Whitman in poetry, and Louis Comfort Tiffany in the decorative arts are only some of the most celebrated names of the Gilded Age cultural renaissance.

Archer quoted from his father made up a real guide to life for Archer, who dedicated his own life to cultivating literature, collecting art, and writing poetry without concerning himself excessively with increasing his wealth and fortune, one aspect in which he was completely different from his father.

This letter helps us to understand from a modern perspective the fact that Collis accepted and supported Archer's decision to dedicate himself to Hispanism, undertake repeated journeys to Spain, and create a museum of Spanish art. It perhaps also aids us in comprehending the manner in which Archer, too, accepted his own commitment to these interests and set out to pursue them with the backing and support not just of his devoted mother but also of his strict and demanding father.

Although less important but not for this reason insignificant, Archer's relationship with his cousin Henry had an impact on him, above all because Henry would eventually become Archer's stepfather. Collis's nephew and twenty years older than Archer, Henry Huntington had begun to work with his uncle in his railroad businesses in 1881 and became his trusted aide. A clever businessman, he succeeded in expanding his own fortune with investments in land and railroad companies in California. After Collis's death in 1900 and Henry's divorce from his own first wife in 1910, he married his aunt Arabella in Paris in 1913, when they both were sixty-three, having apparently been in love with her for several years. This marriage provoked a major scandal at the time, but by then Arabella was the richest woman in America, and gossip about her life mattered little to her. Nevertheless, until the outbreak of World War I, they stayed in a mansion on the outskirts of Versailles, the Château de Beauregard. With Arabella's help and assistance, Henry became another of the most important art collectors in the United States, even though years earlier he had laughed at his cousin Archer's collecting obsessions, considering them of little use. In 1919, Arabella and Henry founded the celebrated Huntington Library, Art Collections, and Botanical Garden in San Marino, near Pasadena, California, the lavish collections of which were donated to the State of California after their deaths.

Marriage between family members was not something unusual in the Huntington family. In 1895, Archer married his cousin Helen Gates,

The Awakening of the Vocation of a Young Hispanophile 15

daughter of one of Collis Huntington's sisters. Helen Gates had previously been married to a senior manager of one of Collis's rail companies. Her rapid divorce and subsequent marriage to Archer Huntington barely a month later, on August 6, 1895, was another family event that aroused great interest in the press and New York high society. It seems reasonable to suggest that the endogamous nature of the Huntington clan stemmed from matrimonial strategies aimed at keeping the family fortune together, with the added observation that it was also simultaneously a means of sustaining the symbolic capital of the family name.

Whatever the causes, the Huntington family formed a powerful closed circle that permeated every area of Archer's life and gave him a very clearly defined identity. If to all this we add the fact that Archer never studied at a university but continued his education with tutors at home, one can see that equally he did not have the opportunity to enjoy the company of a group of friends of the same age and similar interests with whom he could have socialized in his formative years. Hence, it was within his family that the structures that conditioned the manner in which he would relate to the world—his own particular habitus, to use Pierre Bourdieu's term—were unbendingly assembled, without many external influences. The family was the primary ambit of his socialization, and it was within the family that the principal hierarchies of values were formed into which he incorporated his later social experiences. This social environment was broadly that of the family of millionaires, philanthropists, and art collectors among which Archer Huntington lived in New York.

As to his relations with the rest of American society, we have very little information beyond some reports of his initial reluctance to take part in events of New York social life. Nevertheless, some comments he made in a diary indicate his appreciation of the social gatherings he enjoyed in 1895 together with his new wife, Helen, at the home of the editor of the magazine *The Century*, Richard Watson Gilder.[19] These notes serve as a record

19. Richard Watson Gilder (1844–1909) was the managing editor of *Scribner's Monthly*, 1870–80, and editor in chief of *The Century*, 1881–1909. He was a preeminent figure in New York literary circles, and he and his wife became famous for their weekly gatherings attended by artists and writers.

of the interest Archer Huntington felt for the kind of friendly relationships that could be established in intellectual circles.

> The Friday evenings at the Gilders' were charming. Mrs. Gilder was the soul of those gatherings and everyone worthwhile in Arts and Letters was there. Everyone loved Mrs. Gilder, and the crowded rooms were always full of compliments and her charm. The talk was far better than at the Players. Gilder was a sort of royalty, and his power as editor of a great magazine was wide. I went regularly when I was in New York, and not a few friendships grew out of meetings there. These were the days when I came to know Mark Twain and to admire him. The slow deliberate old man had a power of his own, and one admired his simplicity and quick replies. Everyone talked of Mark Twain, and he had a host of friends.[20]

Friendships and social connections with a markedly cultural tone had the potential to converge in interesting combinations, and this seems to have been a lesson that Huntington drew for himself from these gatherings, although in the context of the 1890s this observation also has to be seen as curiously naive. Friendship was a species of code in the Gilded Age, a chain of mutual favors densely entwined in loyalties and disloyalties among politicians, business figures, and journalists, and the line that separated friendship from corruption in some fields of business—such as railroads—was extremely thin. To be successful in business, it was not just necessary to have friends but also crucial.

From a historical viewpoint, one can see across the course of the nineteenth century in the United States an evolution in the meanings attributed to friendship and the means by which it was demonstrated, especially friendship between men. The early nineteenth-century model of male friendship, based on intimacy and sentiment—a friendship between men

20. Diary, AMHA, quoted in Codding, "Archer Milton Huntington, Champion of Spain," 152. The perception of looking back on past events in this diary entry most likely stems from Huntington's reediting of his diaries when his mother, Arabella, asked him to do so.

that can appear overly affected by modern standards—was replaced during the final third of the century by a more pragmatic and contained style of contact that reflected the dictates of the business culture of the Gilded Age. In these circumstances, friendships could arise merely out of shared social or professional interests.

One might think that a virtuous friendship, in the sense of *virtuous* given it by philosophers throughout history, was a rara avis in such a world because the influence of theories of social Darwinism made men look upon their contemporaries as competitors more than as potential friends. Despite this view, as the literary critic Peter Messent argues in his book on Mark Twain and male friendship in the Gilded Age, relations of friendship did exist, even if in many instances they were also conditioned by financial or social self-interest.[21] In this regard, it is interesting to consider the manner in which the first social experiences of Archer Huntington took place because the interrelationship between culture and social connections was one of the chief foundations upon which his lengthy career as a Hispanist would be built.

Collis and Arabella Huntington laid the basis of a spiritual legacy that in terms of philanthropy, artistic taste, way of living, and collecting art was passed on to Archer and that he in turn dedicated himself to cultivating throughout his life thanks to the large financial inheritance he also received from them. In accordance with changing times and his own views, Archer established his own models of philanthropy and style of art collecting, which differed in certain essential ways from those of his parents. The cultivation of friendship and his own system of relationships were, moreover, one area that Archer was obliged over the years to construct because of the apparent lack of reliable points of reference in his family background.

This limitation aside, his philanthropic concerns, his devotion to art collecting, and the friendships that he did eventually establish were also conditioned by the passionate attraction for Hispanic culture that he felt

21. Peter Messent, *Mark Twain and Male Friendship: The Twitchell, Howells, and Rogers Friendships* (Oxford: Oxford Univ. Press, 2009), 132.

from his youth. This passion would make him the greatest American collector of Spanish art and culture of any era.

The World of Hispanic Studies at the End of the Nineteenth Century

Where did Archer Huntington's passion for Hispanic culture come from? What influenced him? Why Spain? Understanding the origins of the passions of men and women who have stood out through their contributions to history is a question of enormous interest because, in the search for answers, more or less casual encounters, situations, and circumstances emerge that connect the past and the future in apparently accidental relationships that become very gratifying discoveries for those who detect them.

The chance reading of a book, a glimpse of a picture, a journey, and the experience of spending several years of adolescence in a house with a whole room decorated to evoke the descriptions in Irving's *Tales of the Alhambra*, as was the case for Archer Huntington, may perhaps have left traces in the child's subconscious so that when he reached adulthood, they developed in one or another way. However, it was also indispensable that there should have been a breeding ground around him sufficiently rich and fertile so that a mere individual interest could grow into the project of a lifetime, one that, moreover, would connect with a cultural movement that was international in scope.

We can see that this was so in the case of Archer Huntington and that the seedbed of his own incipient hispanophilia was the Hispanist intellectual current that had arisen in the United States in the early decades of the nineteenth century. Washington Irving, George Ticknor, William Hickling Prescott, and Henry Wadsworth Longfellow were its principal representatives. All these men had in common an interest in Spain, its history and literature, and through their books and teaching they became the pioneers of Hispanism in the United States. The growth of their interest coincided in time with the events through which the greater part of the Hispanic American republics emancipated themselves between 1810 and 1824, which also offered new commercial and political opportunities

to the citizens of the United States. An initially pragmatic concern for the possibilities of new markets gave way to a growing interest in learning the everyday language of Spanish America. And because to study Spanish one had to turn to Spanish books, Spanish culture and literature became a primary source of knowledge and a new academic field: Hispanic studies.

These intellectuals also progressed beyond their early interest in Hispanic America and were strongly attracted by the possibility of discovering keys to the construction of American national identity by making use of lessons that could be found in the rise and subsequent decline of the powerful Spanish Empire.[22] As a result of their research into Spanish history and literature, Spain was perceived throughout the nineteenth century as the antithesis of the United States, an "other" that one could look toward to copy its successes but, above all, to avoid falling into its errors.

The American Hispanist Richard Kagan has used the concept of "Prescott's paradigm" to characterize the manner in which historians, beginning with W. H. Prescott, established a correspondence between the decadence of Spain and the advances of the United States, locating the roots of this connection in an opposition between the divergent values of the two societies: if the United States was a nation that was Protestant, republican, democratic, and progressive, Spain was Catholic, monarchical, authoritarian, and reactionary.[23] Like Prescott in his historical works, George Ticknor, first holder of the Smith Chair in Spanish Literature at Harvard University in 1819, used his classes in literary history to point out aspects of the Spanish national character that contrasted with those of North Americans, presenting his audience with a model to avoid in the creation of a "Golden Century" for the United States. Always concerned to identify the features of the Spanish national character through literature, Ticknor brought together the results of his research in his three-volume *History of Spanish Literature* in 1849, which, translated into

22. Iván Jaksic, *Ven conmigo a la España lejana: Los intelectuales norteamericanos ante el mundo hispánico, 1820–1880* (Santiago de Chile: Fondo de Cultura Económica, 2007), 15–27.

23. Richard L. Kagan, "El paradigma de Prescott: La historiografía norteamericana y la decadencia de España," *Manuscrits: Revista d'història moderna*, no. 16 (1998): 229–53.

Spanish shortly afterward by Pascual de Gayangos, was the most serious study of Spanish literature published up to that point in the United States.

To understand Ticknor's ideas, it is necessary to take into account that at the beginning of the nineteenth century Americans still carried with them stereotypes of Spain they had inherited from the British: on the one hand the "black legend" of the cruelty and religious fanaticism of the Spaniards in their conquest of the Americas—a legend formed during the sixteenth and seventeenth centuries—and on the other the idea of the proud but lazy character of the Spanish people, an image that had been shaped in the course of the next two centuries up to 1800.[24] The new century would add a fresh stereotype, one to which the pioneer Hispanists contributed through their works: the myth of romantic Spain, which European and North American travelers began to disseminate. The books of Washington Irving were the most successful of this kind among a wide public and the first to present a picturesque and exotic image of Spain that delighted their readers. Irving's long periods of residence in Spain beginning in 1826 and his diplomatic postings at the US legation in Madrid enabled him to acquire a deep knowledge of Spanish culture and to reflect this knowledge in his famous writings. Like Irving, the poet Longfellow—another Smith Professor at Harvard beginning in 1834—also traveled to Spain and took a special interest in Spanish medieval literature as a source for the essential values of the Spanish character. These American authors, with their romantic, captivating image of a Spain strongly colored by orientalist influences, helped to moderate the previously negative conception their fellow citizens possessed of Spain and encouraged an interest in traveling to the country.

Another group that contributed to generating an atmosphere favorable to an interest in Spain and its culture, closer in time to Archer Huntington, was that of the visual artists who had a significant influence in defining the image of Spain in America.[25] The paintings of Mary Cassatt, John

24. Stanley G. Payne, "The Reencounter between the United States and Spain after 1898," in *When Spain Fascinated America*, ed. Suárez-Zuloaga, 11.

25. Elizabeth M. Boone, *Vistas de España: American Views of Art and Life in Spain, 1860–1914* (New Haven, CT: Yale Univ. Press, 2007), 1–11.

Singer Sargent, Samuel Colman, William Merritt Chase, and Thomas Eakins—all of whom traveled to Spain in the years after 1860—were full of typically picturesque subjects, ignoring the incipient economic development in Spain's largest cities and perpetuating a view of Spain as a country of exotic landscapes teeming with priests, beggars, "Gypsies," and dark-eyed women. Overall, they painted the Spain that Americans wanted to see and were a great success in the art market. On their journeys to Spain, they also discovered sources of inspiration for their own work in the paintings by Spanish masters such as Velázquez, Murillo, El Greco, and Goya and thus contributed to making Spanish art fashionable among the collectors of the Gilded Age.

This attraction to Spain and things Hispanic that had been developing among artists and intellectuals over the course of the nineteenth century subsequently spread into wider American society with the popularization of a taste for *lo español*. This tendency culminated in the period between 1890 and 1930 in the shape of a rare fascination for Spanish art, music, and dance, which paradoxically was only further increased by the Spanish-American War of 1898. Archer Huntington was not untouched by this influence. If the opening year of this trend, acknowledged in history as the "Spanish Craze," has been placed as 1890,[26] this was also the year in which Archer Huntington, having reached the age of twenty, first outlined his wish to dedicate himself to the study—and collecting—of Spanish culture.

In the figure of Archer Huntington, one can see synthesized in one precise moment a diverse body of broadly Hispanic influences and references that coexisted in the United States at the point when the fashion

26. Richard Kagan points to 1890 as the initial year of the "Spanish Craze," on the grounds that three events coincided: the rebuilding of Madison Square Garden in New York, crowned by a tower that imitated the Giralda tower in Seville; the great success of the flamenco dancer la Carmencita after her first performance at the studio of William Merritt Chase; and the beginning of a visible demand in the United States for the paintings of great Spanish masters. Richard L. Kagan, *The Spanish Craze: America's Fascination with the Hispanic World, 1779–1939* (Lincoln: Univ. of Nebraska Press, 2019), 83–167.

for Spanish culture began timidly to emerge from intellectual circles to spread throughout society. Huntington appears as a sensitive young man, open to a wave of Spanish influences that reached him in the last years of the century, imbued with an aura of romanticism and exoticism that made them irresistible for the aesthete he had become. Spain was, as the first Hispanists had claimed, the polar opposite of the United States, which gave it an attraction hard to resist.

His "Imaginary Spanish *Sombrero*"

José García-Mazas, a journalist who befriended Archer Huntington during the last two years of Archer's life and published a substantial book on him in 1963, wrote that Archer had inherited several physical and temperamental characteristics from his father and gave an assessment of these two strong personalities, who from their similarities appeared to have shared more than just a name. "The same gigantic height; the same corpulent build; the same strength," he wrote. "The tenacity and dedication the father had shown in business, the son showed in *museísmo* [museum building]. If the father was called the titan of the railroads, the son was called the titan of *museísmo*."[27]

Despite these similarities, Archer's diaries from 1890 reveal the first major strain in the relations between father and son. In these diaries, Archer recorded the depth of his feelings on the day he went against the will of his father, who had offered him the opportunity to take charge of the shipyards Collis Huntington had created in Newport News. At the age of twenty and after two years gaining experience working at the yard, Archer made a decision not to carry on working in the family businesses but to dedicate himself to his real passion, Hispanic culture. In March 1889, during a business trip he and his parents made to Mexico to examine the possibilities of extending their rail lines into the country, Archer had had his first opportunity to come into direct contact with a Hispanic culture,

27. José García-Mazas, *El poeta y la escultora: La España que Huntington conoció* (Madrid: Revista de Occidente, 1963), 388.

and this contact convinced him. It was, he recorded, a voyage of discovery, a revelation, the inspiration for what he called his "museum dreaming."[28]

Archer was conscious of the disappointment this decision would represent for his father and of how important it was to the older man to have a descendant to whom he could entrust his businesses, but Archer opted to follow his instincts. Perhaps the fact that by this time his cousin Henry was working hand in hand with Collis in the management of their companies was an inducement for his father to reduce pressure on Archer regarding his future. As Archer wrote in his diary, "A young fool like myself, who is chiefly interested in Spanish and museums, is not quite the person to launch a thousand ships."[29]

One curious point is the very graphic language with which Archer was able to describe the situation he faced and, above all, to analyze his own decision, alluding to the casting off of a uniform, a disguise, that had not allowed him to develop his true self. "I took off piece by piece my spiritual maritime clothing," he wrote, "put on an imaginary Spanish *sombrero* and began working in earnest."[30] With his imaginary Spanish hat firmly on his head, he took his first major step toward breaking with the imposition of his family's professional inheritance, but he still had to convince his father and others around him of the value and importance of his project to create a Spanish museum. From the first moment he announced his aspirations to his relatives and friends, he had to face sarcastic and mocking opinions on the pointlessness of his ambitions. In his diary, he particularly recorded the scornful remarks of his cousin Henry Huntington. Nevertheless, after a meeting of Archer, his father, and Morris K. Jesup, the president of the American Museum of Natural History in New York, at which the latter sought to persuade Archer to give up the study of a civilization that was already dead and finished, Collis Huntington was satisfied by the answers

28. "And my museum dreaming became clear and took on new forms." Diary of 1889, AMHA, quoted in Codding, "Archer Milton Huntington, Champion of Spain," 148.

29. Diary of 1890, AMHA, quoted in Codding, "Archer Milton Huntington, Champion of Spain," 148.

30. Diary of 1890, AMHA, quoted in Codding, "Archer Milton Huntington, Champion of Spain," 148.

Archer gave and said, "Archer, I can see that you know what you want, and I believe you can do it. Go on as you like, and do the thing well."[31]

By this age in his life, Archer Huntington formed part of a new generation of young men and women who had made a sudden appearance in the life of the United States, all seeking to give some sense of transcendent meaning to their existence that went beyond the mercantilist mentality that had molded their country up to that point. They were interested in art and culture not just as something additional to their busy lives or as a sign of social distinction, but as the motor of their professional activity. This American aesthetic movement arose in response to the unstoppable economic development, technological progress, and immense generation of wealth that focused the aspirations of the country's ruling class. In contrast to the life of a man of business based on a strict Victorian morality of hard work, these aesthetes upheld a cult of art, literature, handmade artisan objects, and the sensibility contained in unique and beautiful things, and they viewed Europe as a destination to which to travel. In reaction against industrialization and mechanical mass production, they felt attracted to medieval culture, which they felt represented values that were the direct opposite of the reality they experienced in the world's greatest industrial power.[32] Their romantic and passionate approach to the world meant that in their quest many came to see in Spain a country that in its landscapes, its people, its way of life could combine the kind of appeal to the spirit they were seeking, one that contrasted radically with their conventional reality. Archer Huntington was one of these young aesthetes, and his first choice was to travel to Spain.

On June 22, 1892, he set out on his first visit to the Iberian Peninsula in the company of William Ireland Knapp, professor of Spanish literature at Yale. This was a voyage of initiation in which he intended to travel through northern Spain following the route of El Cid Campeador, the

31. Diary of 1890, AMHA, quoted in Codding, "Archer Milton Huntington, Champion of Spain," 149.

32. Teresa Prados Torreira, "Archer Milton Huntington y el movimiento estetico americano," in *El tesoro arqueológico de la Hispanic Society of America*, ed. Manuel Bendala, Constancio del Álamo, Sebastián Celestino, and Lourdes Prados (Madrid: Museo Arqueológico Regional, 2009), 64–87.

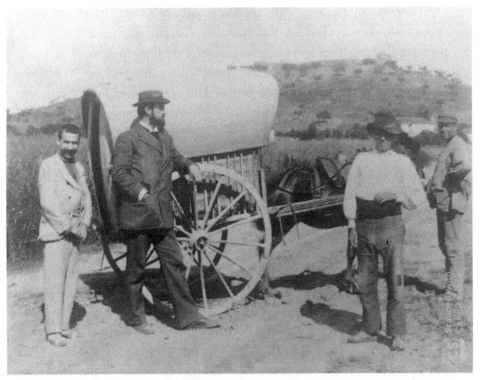

3. Archer M. Huntington traveling in Spain, 1892. *Source*: Courtesy of the Hispanic Society of America, New York (HSA GRF 32253).

great hero of medieval Spanish epic poetry, who had aroused his interest. Huntington arrived in Spain with a particular idea in mind, a romantic stereotype of the country, although he was also conscious that it was a false image of Spain. As he wrote in his diary, "Surely the thing I am about to find will be quite unlike what I have built up. I can see Spain ahead dotted with palaces and fortresses, with cathedrals and walled cities, with bearded warriors and great ladies. Of course it is all wrong. Isabella the Catholic will not be in Madrid and I am sure to miss Visigoths and Almanzor. But there will be footprints."[33]

33. Diary entry, Feb. 9, 1892, AMHA, quoted in Codding, "Archer Milton Huntington, Champion of Spain," 151.

Traveling by mule or carriage along atrocious roads gave him the opportunity to see close-up the customs of each region, each village, their vocabulary, their ways of living, their clothing—in sum, their singular character. "This journey!" he wrote. "This is the best way to study. Here, on the ground, amid these people who are humble, but have their pride.... This is not taught in any university in my country."[34]

He arrived in Spain with a good knowledge of the Spanish language and even Arabic, which he had also studied in New York, convinced as he was of the importance that Arab roots had to have in Spanish culture in view of the Arabs' more than eight-hundred-year presence on the peninsula. Spain fascinated him and unleashed his passion for the Hispanic world. His travels through the country presented Huntington with scenes that stayed in his memory as the best kind of living lessons on Spain. He was interested not only in its art and architectural monuments but also and very particularly in the typical characters of the country, whose customs and physical features made them living evidence of the historical past.[35]

Because the part of him that matched the figure of a romantic traveler in Spain was closely influenced by all the American Hispanists who had preceded him in his adventure, he decided to put his knowledge and capacity for research into practice by undertaking an English translation of the great twelfth- and thirteenth-century *Cantar de mio Cid*, or *Poem of the Cid*, an epic poem that occupied a central role in the emergence of Spanish literature. Archer was a lover of poetry and had gained some facility in the use of poetic language, so this project attracted him enormously. Over the following four years, he completed his translation of the *Cantar*

34. From an interview by José García-Mazas in 1954, quoted in García-Mazas, *El poeta y la escultora*, 18, ellipses in original. In subsequent quotations throughout the book, ellipses have been inserted to indicate omissions of text unless otherwise noted, as in this case.

35. Priscilla E. Muller, "La España amada de Huntington en América: Los tipos, los trajes y el pueblo," in *De Goya a Zuloaga: La pintura española de los siglos XIX y XX en the Hispanic Society of America* (Madrid: Fundación BBVA, 2000), 15–26.

de mio Cid, and the first volume of three was published in 1897. He not only worked on the poem but accompanied the translation with a glossary that included all the vocabulary used in the verses, together with complementary notes on the history and customs of the period. This study won him the recognition of major American universities; in 1897, Yale awarded him a master of arts degree, and Harvard extended him the same honor in 1904. Similarly, he was also made an honorary doctor of letters by Columbia in 1907. With his work on *El Cid*, Archer Huntington entered the exclusive circle of American Hispanists, who had been the intellectual inspiration for his efforts, and initiated his career as a promoter of Hispanic studies in the United States.

Face to Face with the Spain of the Desastre

After marrying his cousin Helen in 1895, Archer embarked on his second visit to Spain. He arrived in Madrid in 1896, determined to seek out books to add to his collection. During this stay in Spain, he was able to witness the belligerent climate that was developing because of the tensions generated between Spain and his own country by the independence movement in Cuba. The atmosphere in the streets of Madrid, through which Huntington walked in search of bookshops and historic manuscripts, was also reflected in the Spanish press, which poured contempt on the North Americans for their arrogance. There was similarly no lack of appeals to the honor and good name of Spain, which had to be resoundingly defended by the country's armed forces.

Thanks to his reading and his contacts with Spaniards from different levels of society, Huntington had come to appreciate in all their complexity the feelings of decline, decadence, and pessimism that ran through the Spain of the Restoration era, feelings entirely the opposite of the optimism so common in the thriving republic of the United States.[36] Such

36. The Restoration, or Bourbon Restoration, is the name given in Spain to the period that began on December 29, 1874, after a coup d'état by General Martínez Campos, which brought the First Spanish Republic to a close and restored the Bourbon monarchy

sentiments were fully justified in political terms, given all the difficulties Spain was encountering in an era when the growing vigor of the new Great Powers overshadowed and belittled Spain's own already-diminished capacities. The Cuban insurrection of February 1895 had made it evident to the government in Madrid that the Cubans could call upon support from the United States to gain their independence from Spain. The communities of Cuban immigrants in the United States had become a potentially revolutionary force, and Archer had already noted in New York that the Cuban cause aroused obvious sympathies in public opinion. In a confused situation, the passing of a joint resolution by both Houses of Congress requesting that President Grover Cleveland grant belligerent rights to the Cuban rebels and offer the mediation of the United States to negotiate autonomy for the island curiously coincided with an unusual occurrence. On the very same day, April 6, 1896, the *New York Herald* published a statement made by Archer Huntington from Madrid that questioned his country's posture toward Cuba.

A. M. Huntington's Views
He Thinks Spain Right and the United States Wrong in the Cuban question (by the commercial cable to the Herald).

The Herald's *European edition publishes the following, from its correspondent.*

Madrid, April 5, 1896—Archer M. Huntington, son of Mr. C. P. Huntington, on being interviewed today, said—

"I am positive in my belief that Spain is right, and that her course is perfectly justifiable in the Cuban affair. In case of war my sympathies would be with my native land, yet I earnestly believe that the United States is entirely wrong. Our interference in the Cuban rebellion is exactly parallel with the interference of England in our civil war. A Cuban republic is an impossibility. The best class of citizens are Spaniards, and the natives could never govern themselves."

under King Alfonso XII, and ended on April 14, 1931, with the proclamation of Spain's Second Republic and the exile of King Alfonso XIII.

What do you think would be the result of a war?

"The United States would win ultimately, but Spain would make a good fight. I don't think Americans have a right to discuss even the advisability of annexing Cuba at present."

—George R. Miner[37]

According to the journalist George Miner, Archer thus not only declared openly and publicly that US policy was misguided on the Cuban question but also suggested that his country had no right to intrude into a war between Spain and its colonies. He also appeared to equate the role the United States was seeking to play with the actions of Great Britain during the American Civil War—a comparison that did not please his compatriots—and labeled the Cubans incapable of governing themselves, which did not please the Cubans. He was correct in prognosticating that if there were a war, the United States would eventually win, but he was mistaken in thinking that Spain would offer strong resistance. To evaluate these words correctly, however, it is necessary to point out that the document held in the archives of the Hispanic Society of America includes not only the original press clipping but also a wistful handwritten note, apparently by Archer himself, with the date of publication and the following claim: "while I did not say the above it seemed useless to protest."[38]

Whatever he actually said, the motivation for any such declarations of this kind had a great deal to do with the circles that the young Huntington had entered into in Spain and to some extent with the tendency visible across Europe for intellectuals to emerge into public life. Although the word *intellectual* did not enter into common usage until after the Dreyfus Affair, which reached its climax in France in 1898, one can see that Archer's behavior was comparable to that of many prominent figures from the cultural world who acquired a significant social role by expressing their ethical commitments to society through the communications media. In effect, his attitude appears explicable only as the result of a

37. *New York Herald*, Apr. 6, 1896, clipping, Correspondence of 1896, AMHA.
38. Handwritten note, Correspondence of 1896, AMHA.

passionate contagion from the Spaniards that he listened to in the *tertulias*, informal conversations, and heated debates in the cafés of Madrid. Equally, however, it was a stance that offers interesting insights into the extent to which Huntington involved himself emotionally in the conflict, adopting a critical view of his own country.

Across the Atlantic, his controversial declarations to the press were not well received either in the country at large, where a powerful wave of patriotic feeling was gaining pace, or, it seems, among his own family because his father had close connections with many members of Congress, where a majority was then urging intervention upon President Cleveland. A brief note in Archer's diaries later recorded the astonishment his words had caused.[39] Although this incident had no greater consequences, his statements on Cuba are nevertheless of great value in highlighting the growing sense of hispanophilia within Archer at a time when the American press and his own government were engaged in campaigns to discredit everything represented by Spanish history and culture.

Archer was obliged to face a contradictory situation in which one can see for the first time a rather affected young man who divided his sentiments between the United States and Spain. After all, he was a privileged observer who had the benefit of an overview from both sides of the Atlantic regarding a conflict that was growing in intensity little by little and that reached some of its climactic moments during the time of his second stay in Spain. However, it was this statement to the press, more than his private writings, that revealed an Archer who was passionately involved in the circumstances Spain was undergoing. What these comments indicate is a paradoxical bifurcation between American patriotism and hispanophilia, a feature that to most of his fellow citizens may perhaps have appeared as merely one sign of the typical eccentricity associated with a young millionaire.

The comments reported by Miner were the only statements Archer Huntington ever made to the press. From that moment on, his opinions

39. "His statements about the Government were a bit staggering." Diary entry, Dec. 1, 1896, AHMA. Archer Huntington sometimes referred to himself in the third person in his diaries and letters.

were consigned only to his diaries or his letters, the only means of appraising them left to researchers.

This second journey to Spain also had the consequence of making manifest the differences between the mentality of his father the businessman and the behavior of the young aesthete that Archer had become. To understand the situation, one has to take into account that in 1896, although Collis had already traveled to Europe several times and had acquired works by old masters for his residence on Fifty-Seventh Street at the prices then current in the booming European art market, he had still not fully absorbed the idea of the institutional value of art as a means of inspiring and educating the public, something he would not do until the very last years of his life. In effect, the influence of Archer and his conception of a museum as an instrument of education would be a determining factor in subsequently changing the old man's opinions. Prior to this, however, it is not hard to understand that a conflict should arise between the two regarding financial responsibility and, especially, the use Archer was making of his money in Spain, acquiring books and objets d'art for his collections. This conflict was shown in a letter Collis sent to Archer on January 21, 1896.[40] It was not a common occurrence for his father to write to him because his mother was the family member with whom he kept in most regular contact by letter, but on this occasion his father, obviously concerned, wished to give Archer some advice and life lessons that would influence his subsequent efforts.

Collis Huntington made his point very directly: "I write this to you, Archer, hoping you will stop and think a moment every time you spend my money." Collis did not approve of the excessive expenses that his son was incurring in Spain and recriminated Archer for the fact that in only two months in Spain he had spent more than he himself had spent in his first ten years of marriage. He demanded that the younger man consider how much he was capable of accumulating before simply spending to avoid losing the savings that he, Collis, had amassed over more than half

40. Collis P. Huntington to Archer M. Huntington, sent from the Hotel Normandie, Washington, DC, Jan. 21, 1896, Correspondence of 1896, AHMA; subsequent quotations in the chapter text are from this letter.

a century. He reminded Archer of the joy that he himself felt every day through his devotion to his work and emphasized that the greatest reward for such self-sacrifice was to know that thousands of workers depended on his labor and that through his efforts he also aided the hundreds of thousands more represented by their families. "I go to my office in the morning and return home in the evening and this I do each weekday as it comes and goes," Collis wrote. "But this is not a hardship to me, but a pleasure, as some seventy-five thousand wage-workers depend largely upon me for their work and their wages support some three hundred thousand people. That is my reward, for what I have done for others has given me more gratification than any profit I have made out of the work I have done."

The father attributed the supposed lack of initiative among Spaniards to the kind of wasteful scattering of money that his son was falling into in attempts to mitigate the surrounding poverty, when what was needed was to teach people how to work and maintain exemplary behavior, as he had done for so many years in front of his own workers. In a manner typical of American modes of thought in the nineteenth century, he sought to inculcate in his son by his own example as a tireless worker a sense of the importance of avoiding indiscriminate charity if one were ever to solve the problem of poverty in the world. "I think more people are harmed than helped by giving them bread without their working or paying for it. Indiscriminate charity is demoralizing the world. As soon as people find they can live without work they will adopt the easiest way to live; and they are led to think this largely by seeing the extravagance of the rich."

His father made it clear to Archer that he respected his son's decisions but made his point equally clearly that as he understood it, a dedication to the arts and letters needed to be pursued with the same rigor as he and many others displayed in their businesses. It was a question of principle, and his son, still young, had to learn the value of money. He concluded with this appeal: "I do not want you to change your work, but I do want you to work with the same steady hand that I do, doing nothing except that which will be a good example, giving good advice to all, for such is better than giving of money."

Six years after Archer had put on his "imaginary Spanish *sombrero,*" Collis felt that his son still needed to learn how to live and how to spend

his money, shunning the eccentricities of the rich—the kind of behavior, overall, that Collis clearly believed Archer had fallen into while in Spain. Still more, he warned him of the catastrophic consequences of continuing with the same style of life, suggesting that if "the extravagance of the rich and the indolence of the poor" continued in the same way for another sixty years, the world not only would be bankrupt but also would collapse into barbarism.

Collis's letter of January 1896 incorporates a series of arguments that reflect a philosophy maintained in this same period by another multimillionaire, Andrew Carnegie. In his famous article "Wealth," popularly known as "The Gospel of Wealth," first published in July 1889 in the *North American Review*, Carnegie had argued that wealthy business leaders had a responsibility to distribute the surplus of their riches among philanthropic causes.[41] In opposition to ostentation, he urged that people with money should lead modest lives, guided by moderation, without amassing personal treasures and with a goal of improving access to culture for the least fortunate, something he himself did by building public libraries across the United States and the British Empire and by creating the Carnegie Foundation for the productive distribution of his wealth. His gospel of wealth and radical philanthropy took hold among other magnates of turn-of-the-century society, and Collis Huntington made it clear that he shared Carnegie's opinions by admonishing his son for the excessive and irresponsible spending that in his view Archer was exhibiting.[42] Overall, this letter was a call to attention and a lesson for Archer in his developing career as a collector.

Nevertheless, neither the tense political situation between Spain and the United States nor the differences with his father discouraged the younger Huntington, who returned to Spain for a third time in 1898 intent on continuing with the plan he had sketched out six years earlier. As he

41. Andrew Carnegie, "Wealth," *North American Review* 148, no. 391 (1889): 653–64, at https://archive.org/details/8906CarnegieWealth.

42. Collis P. Huntington and Andrew Carnegie knew each other personally because both were members of the Union League Club. In 1887, Huntington had also sold Carnegie his New York home on West Fifty-First Street.

had written in his diary in early 1892, "The first trip must be cities, the country and the people. Then book collecting and library work and last History and Archeology. They will overlap of course but it is best to go with a plan to cover several trips."[43]

With these objectives in mind, Archer took an active part in the archaeological circle that gathered in Seville at the end of the 1890s. He became friends with two of its leading members, the Franco-British archaeologist George (or Jorge) Bonsor and the Frenchman Arthur Engel, and collaborated with them on different projects. He took over the tenancy of a plot of land that Engel had rented but was about to give up near Santiponce, north of Seville, the site of the Roman city of Italica, to continue the excavations. Huntington went to the diggings every day, joined in the work, observed the laborers and their families, took notes, made drawings, and even documented with photographs every find that appeared in the area. During the more than four months in which he gave vent to his adventurous side as an archaeologist, he discovered a substantial number of artifacts and relics and did not skimp on spending when it came to bringing in more workers to accelerate the speed of the excavations. His archaeological venture gave him great personal satisfaction and a new field of interest through which he opened up a new area of research for Hispanic studies in the United States.

However, he had not taken into account the possibility that during this third stay in Spain, in addition to having the opportunity to visit the celebrated library of a Spanish aristocrat, the marquis of Jerez de los Caballeros, or to embark upon his archaeological investigations at Italica, the United States might also declare war on the country, so that he would have to leave immediately. The scandal caused by a leaked letter from Enrique Dupuy de Lôme, the Spanish ambassador in Washington, insulting President McKinley and the subsequent explosion that sank the US warship *Maine* in Havana harbor on February 25, 1898, precipitated

43. Diary entry, Feb. 9, 1892, AMHA, quoted in Codding, "Archer Milton Huntington, Champion of Spain," 151.

events. An outburst of popular and political feeling was unleashed across the United States against Spain, which was accused, without proof, of causing the explosion. This tidal wave of accusations against everything Spanish was especially visible in the American press, where the confrontation between Joseph Pulitzer's *New York World* and William Randolph Hearst's *New York Journal*, legendary rivals, provoked a ferocious struggle to provide ever more scandalous headlines that inflamed the mood of the American people in favor of military intervention.[44]

In notes and in an exchange of telegrams with his mother, Archer made brief references to the news arriving from home. In them, he passed on the climate of concern that had developed in Spain since the destruction of the *Maine*.[45] The Spanish press had also entered into a rising spiral of demagoguery and megalomania, driven by an explosion of patriotism, and its headline articles irresponsibly maintained the idea that Spain could win a war against the United States relatively easily.[46]

Events came to a head on April 20, when President McKinley ratified a joint resolution of Congress calling for Spanish withdrawal from Cuba. Hostilities were initiated the next day. The rest of the story is well known,

44. For more detailed analyses of the conflict, see David F. Trask, *The War with Spain in 1898* (Lincoln: Univ. of Nebraska Press, 1996); Ivan Musicant, *Empire by Default* (New York: Holt, 1998); María Dolores Elizalde Pérez-Grueso, "Las relaciones entre España y Estados Unidos en el umbral de un nuevo siglo," in *España y Estados Unidos en el siglo XX*, ed. Lorenzo Delgado Gómez-Escalonilla and María Dolores Elizalde Pérez-Grueso (Madrid: Consejo Superior de Investigaciones Científicas, 2005), 19–56.

45. Correspondence of 1898, AMHA.

46. Two typical quotations are sufficient to illustrate the situation: "There will be no solution to the Cuban problem so long as we do not send an army to the United States" (*El País*, Feb. 23, 1898, quoted in Ingrid Schulze Schneider, "1898: Apuntes sobre la diplomacia internacional y la opinion pública," *Historia y comunicación social* no. 3 [1998]: 225); "The superiority of the United States fleet over ours is not as big as they say, nor does their navy have the disciplined spirit and esprit de corps that distinguish our forces at sea" (José María Carretero Novillo, *El Tiempo*, Mar. 16, 1898). Carretero Novillo's predictions were not accurate: the Spanish-American War broke out on April 25, 1898, and ended with a decisive victory for the United States on August 12, 1898.

along with the outcome it had for the Spanish nation. As an accident of fate, some of the US Navy ships that took part in the war had been built in the shipyards of Archer's father.[47]

Archer returned to New York with profound feelings of frustration, which he expressed in his diaries. The outbreak of a war had put a halt to his projects in Spain, he lamented. "And so war brings to a close my archaeological adventure," he wrote, "yet I find that I have obtained something of what I had hoped to obtain. . . . That I did not finish my work was a great disappointment. I wanted to make a monumental presentation of this place [Italica]. No one else will probably attempt it now for years to come—if ever. For in the meantime come changes, and it is not the same."[48]

It was at this time that he set down his first written reflections on what soon became known in Spain simply as "El Desastre," the Disaster of 1898. In the notes left in his diaries, one can see the thoughts of a hispanophile who questioned his own position regarding the causes of the war and was influenced by opinions he received from a variety of sources, in particular the writings of his fellow Americans. Anti-Spanish rhetoric had been a feature of the American press throughout the years leading up to the war, and in 1898, to incite feelings still further, a new edition was published of the historic denunciation of the Spanish Conquest of the Americas, Bartolomé de las Casas's *Brevísima relación de la destrucción de las Indias* from 1552, with the sensationalist subtitle *An Historical and True Account of the Cruel Massacre and Slaughter of 20,000,000 People in the West Indies by Spaniards*. Journalists, writers, and historians revived the clichés of the "black legend" of Spanish brutality and identified among the causes of the current military defeat an inherent connection between

47. A cargo ship built for the Southern Pacific Railroad and originally christened *El Sud* was pressed into navy service as the USS *Yosemite*; the steamer *El Norte* became the USS *Yankee*; and *El Río* was transformed into USS *Dixie*. García-Mazas, *El poeta y la escultora*, 25.

48. Archer Huntington, "Italica," unpublished manuscript, AHMA, quoted in Constancio del Álamo, "Las excavaciones de Archer M. Huntington en Itálica," in *El tesoro arqueológico de la Hispanic Society of América*, ed. Bendala et al., 166, ellipses in original.

Spain's national decadence and the Spanish temperament. Henry Charles Lea, a historian who had gained a reputation through his research into the influence of the Inquisition on Spanish character, published the essay "The Decadence of Spain" in the *Atlantic Monthly* in July 1898, in which he argued that the principal cause of the current situation on the Iberian Peninsula was the Spaniards' inability to adapt to the industrial nature of the modern world because of a conservative spirit that rejected all innovation and, at a distance, the pernicious influence of the Inquisition.[49]

Influenced by Lea and other American writers, Archer Huntington also lamented the dangers that would beset an "unbusinesslike Spain" lacking in commercial spirit and considered that this characteristic, in the final analysis, was the principal factor in Spanish exceptionalism. He observed in his book of travels *A Note-book in Northern Spain*, published the same year, 1898, that "pride, a weak monarch, a dissolute court, religious intolerance, all these are admirable starting points from which to prove a nation's decline. . . . In fact, all these are mere effects, the cause is the absence of that which has developed the great nations of the earth, the cause on which civilization rests, the great primitive developing agency—trading spirit."[50]

In contrast to some of the comments made by others, however, Huntington's thoughts regarding the future that presented itself for Spain did contain a certain note of optimism, which distanced him both from the majority view in North America and most other European countries and from the pessimism that had invaded Spain with the spirit of *noventayocho*, '98. His optimism was based on his confidence in the inherent character of Spaniards: as he wrote, "of so excellent a nature have I found

49. Henry Charles Lea, "The Decadence of Spain," *Atlantic Monthly*, July 1898. Henry Charles Lea (1825–1909) was an American historian, civic reformer, and political activist known for his books on the Spanish Inquisition. His *Atlantic* article highlighted Spain's stagnation, and rather than attribute this backwardness to any particular features of the Spanish character, he insisted on the negative effects that clericalism and the Inquisition had had on the country's economic and intellectual development.

50. Archer Milton Huntington, *A Note-book in Northern Spain* (New York: Putnam, 1898), 5.

the Spaniard when one knows him, that I cannot help believing in his ultimate development."[51]

Critical views of Spain were also heard from Europe. The belief in the existence of "living" and "moribund" nations, widespread in Britain and Germany at the time and vividly expounded by Lord Salisbury in a speech he gave in May 1898, had apparently been vindicated by reality in the outcome of the Spanish-American War.[52] Like his contemporaries, Archer had absorbed these ideas and interpreted events within the framework of a much broader scenario of a Europe-wide crisis of national identity, notable especially in the Latin countries, which in his opinion continued to think in terms of conquest rather than trade.

Beyond the question of the greater or lesser validity of his reflections, these brief extracts from his early writings accord us an opportunity to assess to what extent Huntington was capable of surpassing the superficial gaze of the romantic traveler, setting aside some of the stereotypes of an idealized Spain that he had come in search of, and understanding the national upheaval that the war of 1898 represented for the country. The Disaster, with all the ills that came with it, had the virtue, in fact, of stimulating still further his passion for Hispanism, which took a qualitative step forward by incorporating not just past history but also the debates that he witnessed in contemporary Spanish society.

In parallel to his ideas of eminently American origin and thanks to his visits to Spain, Archer Huntington was also absorbing influences from Spanish thinkers. Focused around the group of writers known as the Generación del 98 (Generation of 1898)—especially Miguel de Unamuno, Pío Baroja, Antonio Machado, Ramiro de Maeztu, and José Martínez Ruiz, who wrote under the pen name "Azorín"—intellectuals had embraced

51. Huntington, *A Note-book in Northern Spain*, 6.

52. Speech given at the Royal Albert Hall, London, May 4, 1898, reported in *The Times*, May 5, 1898. The third marquess of Salisbury (1830–1903) was a Conservative politician and the British prime minister three times. In his Albert Hall speech of 1898, he used the idea of social Darwinism as an ideological foundation for a defense of Great Britain's imperialist policies, distinguishing in his argument between nations that were "alive" and others that were "moribund."

the social responsibility of analyzing the causes of the debacle from a viewpoint that was characteristically pessimistic, and they turned to the Spanish landscape, incidents of everyday life, and the characteristics of popular, rural, local, and *castizo* ("pure" or "well-rooted") traditions and customs to find the roots and essences of Spanish identity.[53] Their veneration for Castile as the austere heart of Spain and their admiration for the culture of Spain's Siglo de Oro, "Golden Century," from around the 1550s to the 1650s, coexisted with a generalized critique of the political system of the post-1874 Restoration, religious dogmatism, the deficiencies in education, and the chronic backwardness of the nation by comparison with its European neighbors. These intellectuals, far from directing their attacks against the alien power that had won the war, became the spokesmen for a Spanish mea culpa, and in fact many maintained a lively admiration for the United States, a feeling that was particularly common among the members of the Institución Libre de Enseñanza (Free Institute of Education), founded in Madrid in 1876 to promote progressive education in Spain, and among followers of Spanish republicanism.[54] Hence, there were many who "refused to join in the chorus of anti-American protests proffered by the Spanish press in the spring and summer of 1898."[55]

Defeat at the hands of the United States was turned into an opportunity to rebuild the country and reconstruct its own identity. In this process, however, these Spanish intellectuals were also influenced by the perspectives of foreign travelers and painters, who had centered their gaze upon everything in Spain that appeared so different from the rest of Europe and made the country so singular. It is no surprise that Archer Huntington felt

53. The "Generation of '98" is the name traditionally used to group together Spanish writers, poets, and essayists whose work was profoundly affected by the moral, political, and social crisis detonated by the military defeat of Spain in the Spanish-American War of 1898. All the writers included in this "literary generation" were born between 1864 and 1876.

54. Sylvia Hilton, "República e imperio: Los federalistas españoles y el mito americano, 1895–1898," *Ibero-America Pragensia*, no. 34 (1998): 11–29.

55. Antonio López Vega and José Antonio Montero Jiménez, "España–Estados Unidos: 200 años de miradas cruzadas," *Revista de Occidente*, no. 389 (2013): 71.

a chord in common with the Generation of 1898 and found references in their writings that he recognized. These writers' approaches appealed to him, in particular their evocations of the landscapes of Castile and the spirit of the Spanish soul that still survived in its culture—themes that he alluded to in *A Note-book in Northern Spain* of 1898. "Look deep enough into its heart [of the landscape]," he wrote, "and you may read the heart of the Spaniard."[56]

In his travels through Spain, he wrote in this book, he had felt the same sensations that other romantic travelers had felt years earlier, letting his imagination carry him away into legends and the imagery of romantic literature. "The imagination has wings in this place," he claimed. "Soon one is breathing the unreal. Fanaticism is natural, chivalry a necessity. The boom of the outside world dies away and a new world arises—one of fanciful shapes." In the men who populated Spain, too, he found traces and reminders of their historic past: "For the Spaniard of today and his ancestor of yesterday, Iberian, Roman, Goth or Arab, are like all humans, true brothers under the skin, and the spirit-whispers of the departed still linger in eyes and form, in gesture and pattern of thought, in faith and superstition, in dress and dreams. And just as today you may encounter a troglodytic person on Broadway or Piccadilly, so in Galicia you may meet a Suabian, or lunch in Sevilla with a reclad spirit of one of Abencerrages' men."[57]

In his descriptions of villages, in the words that he put into the mouths of some of the characters from among the ordinary people he encountered in *tabernas* or at the roadside, and in his love of relating monuments to their past history, one can see in *Note-book* an effort to discover the Spanish soul in the landscapes and daily routines of Spanish life.

With his travel book, Archer offered his fellow Americans an image of Spain in 1898 that was very different from the one currently circulated in the American press and demonstrated that he was a direct successor to the pioneer American Hispanists who had encouraged a serious approach to and erudite appreciation of Spanish history and culture. Like them,

56. Huntington, *A Note-book in Northern Spain*, 1.
57. Huntington, *A Note-book in Northern Spain*, 2.

he emphasized admiration for this history rather than criticism as well as scholarship and knowledge over clichés. His appreciation of Spanish realities led Huntington to express his concern at the weakness of national consciousness in Spain, which he described as a nation of nations that was difficult to understand as a whole because of the differences in character and identity among its regions, pointing out that "Cataluña, Aragon, Castile, Andalucía, are not mere geographical terms. Each presents its distinct national and special character. Traditions, habits, sports, costume, have all their peculiar expression and local difference."[58]

In his diaries, he developed this idea in greater depth, writing of the regionalist conflicts that he believed were approaching because he thought that in a Spain deprived of an external enemy, the antagonisms between provinces would intensify once again, which, in his view, would have a negative influence on any consistent or stable policy of national unity.[59]

Of this accumulation of influences, opinions, and revelations stemming from the Spanish-American War and Spain's Disaster, what is most important for us here is the encounter that this accumulation provoked between two different dimensions: the war as a historic event and the character that Huntington revealed in response to it. This conflictive encounter helps us understand better the manner in which the young Archer's hispanophilia had begun to evolve into a lasting commitment to Hispanic studies.

A Museum on the Hook

Archer Huntington used the metaphor of a fisherman several times in his writings in describing certain purchases, especially of books, that he made during the 1890s, when he was taking his first steps as a collector of Hispanic culture. In 1891, after a visit to Cuba, he wrote in his diary, "Another shoal of gleaming first editions has swum into my ken: I have sat on the bank and baited my hook with little golden certificates for some

58. Huntington, *A Note-book in Northern Spain*, 3.
59. Diaries of 1898, AMHA.

time and cast near where I saw them last and behold, bites!"[60] In 1898, he again used the same image regarding his plan to acquire a large library in Seville: "Frankly, I'm tired of angling in the shallow streams of the north [of Spain]. Perhaps I may this time catch something larger than a *merluza* [hake]."[61]

Huntington enjoyed his first experiences as a buyer of books and artworks, indicating that by comparison with a style of American collector he was very familiar with—the one exhibited by his millionaire parents—he preferred to devote himself to a search for pieces to create his collections in a different way, noting, "It is pleasanter indeed to do one's hunting alone on one's own accord, rather than to sit in stuffy auction rooms waiting for jewels to gleam."[62]

In his writings of 1898, Archer already saw himself as a collector, but not just as one among many because in his own mind he had begun to plan a scheme for an ambitious Spanish museum in New York, where he wished to exhibit a collection of art and other objects that would comprehend the whole of Spanish culture. The fact that he was thinking of the creation of a museum when he had scarcely begun to assemble his first collections denoted, as he saw it, a significant difference between himself and other collectors. "We collectors!" he wrote. "The fish line is baited with a museum, and at least some crabs are even now trying to crawl into my net."[63]

Given these statements, it is worth looking again at the established milieu of American collecting as a point of reference in our examination of the young Archer. This milieu formed a contextual framework—as did American Hispanism—that enables us to examine the most prominent

60. Diary of 1891, AMHA, quoted in Codding, "Archer Milton Huntington, Champion of Spain," 150.

61. Diary of 1898, AMHA, quoted in Codding, "Archer Milton Huntington, Champion of Spain," 153.

62. Diary of 1898, AMHA, quoted in Codding, "Archer Milton Huntington, Champion of Spain," 153.

63. Diary of 1898, AMHA, quoted in Codding, "Archer Milton Huntington, Champion of Spain," 153.

features of the intellectual and material culture of the men and women who shared with Archer a desire to obtain unique art objects and had a similar financial capacity to compete for the most desirable pieces in the growing art market. This framework allows us to detect similarities but also to note differences between Huntington and other collectors.

The first great difference in Archer Huntington was that he concentrated his collecting exclusively upon Spanish books and art. As he wrote to his mother in 1898, "I am collecting with a purpose and that purpose you know quite well. That small compact Museum of Spanish culture will take all the time left me in this world."[64]

This project began its course in the golden era of collecting, when competition was fierce and works of art were in growing demand as symbols of social prestige. Wealthy Americans, after years during which they had above all collected French or Italian art, gave themselves over unreservedly to an admiration for Spain and its culture, and Spanish art began to win a privileged position in the collective imagination of the United States. Whereas the peculiarities of Spanish art had previously been considered a deviation from the European norm, after 1890 these same differential features played in its favor because they were seen as synonymous with freedom, a value that fit together very well with the aspirations of the American nation in its search for a place in history. Hence, Americans set their attention upon a Spain that was notably underselling its artistic treasures.

The paintings of Diego Velázquez, foremost representative of Spain's Siglo de Oro, were the most sought after. He was appreciated above all others by American artists and collectors, who competed for his portraits and scenes of everyday life, and an abundance of admirers bid for his works. This is why today the United States hosts one of the greatest concentrations of works by this great Spanish painter outside Spain—second only to the thirteen Velázquezes in Great Britain—and why all of them were acquired precisely between 1880 and 1914. The works of Francisco Goya and El Greco (Doménikos Theotokópoulos) soon also drew the attention

64. Archer Huntington to Arabella Huntington, included in Diary of 1898, AMHA, quoted in Codding, "Archer Milton Huntington, Champion of Spain," 154.

of collectors. Husband and wife Henry O. and Louisine Havemeyer, possessors of one of the finest art collections in New York, including numerous examples of French impressionism acquired when this style had still not become fashionable, acquired their first El Greco in 1905, opening up the American market for his works.

Collectors, commonly operating through adroit intermediaries based in Spain, Paris, or London, such as Joseph Duveen and Jacques Seligmann, launched into a race to obtain works and art objects of Spanish origin: paintings, tapestries, furniture, textiles, and architectural fragments featured among the treasures that caught the attention of the world's new magnates. Surrounding the millionaires in their mansions, these items evoked the opulence of European palaces and re-created at the dawn of the twentieth century the lavish taste of the great European royal courts by means of "an iconography of power that they [the American magnates] believed contained within it everything they lacked in their own history."[65] However, despite the existence of this large-scale market in artworks from the Iberian Peninsula, Archer Huntington had already stated in 1898 his desire not to acquire works of art in Spain itself: "Moreover, as you know, I buy no pictures in Spain, having that foolish sentimental feeling against disturbing such birds of paradise upon their perches. Let us leave these beloved inspiration builders where they were born or dwelt, for to Spain I do not go as a plunderer. I will get my pictures, outside. There are plenty to be had."[66]

Archer's letters indicate that art dealers and Spanish friends, among them such well-known figures as Joaquín Sorolla and George Bonsor, urged him on several occasions to buy examples of art within Spain, but he said he preferred to acquire works that had already left Spain and entered the international market, where there was more than enough to choose from. More recently, however, the complete accuracy of this statement

65. María José Martínez Ruiz, "Gusto cortesano de los magnates estadounidenses: El impulso para el comercio de tapices antiguos entre España y Estados Unidos," in *Nuevas contribuciones en torno al mundo del coleccionismo de arte hispánico en los siglos XIX y XX*, ed. Immaculada Socias and Dmitra Gkozgkou (Gijón: Trea, 2013), 217.

66. Archer Huntington to Arabella Huntington, included in Diary of 1898, AMHA, quoted in Codding, "Archer Milton Huntington, Champion of Spain," 154.

has been put in question. The first person to sow doubt regarding the strict truth of this assertion—almost certainly without intending to—was Huntington's friend Francisco Javier Sánchez Cantón, the Spanish art historian and deputy director of the Prado in Madrid, in an obituary in memory of Archer Huntington written in 1956.

Sánchez Cantón wrote that some dealers, aware of Huntington's reluctance to buy art in Spain, would buy artworks in Spain but then export them before offering them to Huntington, so he could then buy them. "One should take note that his love for Spain inspired the order he gave to those who bought works of art for him, that they should only acquire works that were already outside the peninsula; although it would not be rash to suspect that, in some cases, these items were taken abroad with the intention of offering them to him, a ploy that agents and dealers would consider an innocent contrivance."[67]

In recent years and in the light of such claims, Huntington's acquisitions and his relations with art dealers have been studied in the context of broader and more detailed research into the destruction of Spain's artistic heritage, generating a divergent range of critical evaluations that have sparked controversy. This debate not only touches upon Archer Huntington but also extends to many of his contemporaries and associates in Spain, who devoted themselves to enhancing the reputation of Spanish culture and to collecting its creations while at the same time acting as intermediaries in the large-scale sale and export of Spanish art to foreign collectors.[68] However, we should be aware that this sale and export took place against a background in which there was not yet the same level of awareness or the same critical outlook that there is today regarding the protection of any country's or people's artistic heritage.

Controversies aside, from 1898 Archer demonstrated in his letters and diaries his desire to adopt a singular stance by comparison with other art

67. Francisco Sánchez Cantón, "Necrológica: Mr. Archer Milton Huntington," *Academia: Boletín de la Real Academia de Bellas Artes de San Fernando*, no. 5 (1956): 15.

68. Richard L. Kagan, "El marqués de la Vega-Inclán y el patrimonio artístico español: ¿Protector o expoliador?," in *Nuevas contribuciones*, ed. Socias and Gkozgkou, 193–203.

collectors. Differences emerge immediately when one looks more closely into his motivations, his relationships with art dealers, and the interest he showed in extending public knowledge of his own collections. All these aspects made him an atypical collector of the Gilded Age.

In the first place, he qualified what he understood to be the idea of "collector," writing, "As I have often said I venture to flatter myself that I am not a 'collector,' rather than an assembler for a given expression. . . . One must almost be a Spaniard to understand him—almost! And if you do not understand him how can you feel the story of his culture, how know what to use and what to discard?"[69]

In rejecting the label *collector*, in reality he was resisting being linked with a style of behavior that he did not share because he sought to disassociate himself from the amateur and snobbish manner in which other Americans made their collections. Hence, he embarked upon a task of studying and selecting objects from an anthropological viewpoint to help him discover the essence of Spain in each and every one of the pieces in his collection. As he put it, "I wish to know Spain as Spain and so express her—in a museum. It is about all I can do. If I can make a poem of a museum it will be easy to read."[70]

Second, his goal in collecting was to succeed in creating a coherent and continuous narrative from the earliest origins of the different civilizations that had left traces on the Iberian Peninsula to the twentieth century. To do so, he needed progressively to complete each of the different fields in his collections without leaving any historical era uncovered. Again, he expressed his wishes in a very distinctive style: "It must not be a heaping of objects from here or there or anywhere until the whole looks like an art congress—half-dead remnants of nations on an orgy. [What I want is] one outline of a race."[71]

69. Archer Huntington to Arabella Huntington, included in Diary of 1898, AMHA, quoted in Codding, "Archer Milton Huntington, Champion of Spain," 154.

70. Archer to Arabella, included in Diary of 1898, AMHA, quoted in Codding, "Archer Milton Huntington, Champion of Spain," 154.

71. Archer to Arabella, included in Diary of 1898, AMHA, quoted in Codding, "Archer Milton Huntington, Champion of Spain," 154.

His primordial interest was therefore not in accumulating an assortment of beautiful things out of a desire to possess what others then could not possess because of the unique character of each work of art; nor was it a matter of pure pleasure, as another great collector of the era, Isabella Stewart Gardner, suggested when asked about her museum at Fenway Court, replying, "C'ést mon plaisir."[72] It was a conviction that became gradually more evident in his reflections and his actions. In effect, when Archer involved himself personally in the excavations of Roman Italica in 1898, he had already been conscious of the fact that he was not likely to find any great treasures or other special relics but rather an evocation of the people who had used them. "But it is not the dishpans and arms of the past I am seeking but the thinking of the men who used them," he recorded at the time. "A thing which cannot be had in college!"[73] His great ambition to decipher and reveal the Spanish soul through the works of art and objects he acquired was therefore the central idea that underlay his zeal for collecting.

A third distinctive characteristic was that, faithful to his ideas, Huntington did not strive solely to acquire objects of the first quality, like other collectors, but also to find items that when viewed from a cultural standpoint fitted together as links in a historical sequence.[74] With this idea in mind, he ventured to acquire the works of artists such as Juan Carreño de Miranda, Antonio Pereda, and Mateo Cerezo, whose worth has since been recognized but were then ignored or little known, so that their purchase, as the Hispanist Jonathan Brown has observed, required both knowledge and courage at the time.[75] For the same reason, his relations

72. *C'ést mon plaisir* is inscribed as a motto on the crest above the central portal of Fenway Court, now the Isabella Stewart Gardner Museum.

73. Huntington, "Italica," AMHA, quoted in Álamo, "Las excavaciones de Archer M. Huntington," 162.

74. See Constancio del Álamo, Manuel Bendala, and Jorge Maier, "Archer Milton Huntington, hispanista y coleccionista," in *El tesoro arqueológico de la Hispanic Society of America*, ed. Bendala et al., 27.

75. Jonathan Brown, "Los cuadros de la Hispanic Society, 1550–1800," in *The Hispanic Society of America: Tesoros*, ed. Patrick Lenaghan, Mitchell Codding, Mencía Figueroa Villota, and John O'Neill (Madrid: El Viso, 2000), 71.

with dealers in art and antiquities did not follow the pattern usual among collectors in this era. He worked with only a few well-qualified intermediaries who were familiar with his collection and knew the gaps that needed to be covered with new acquisitions to present a broad panorama. As he wrote, "I collect always with the view to definite limitations of the material to be had, always bearing in mind the necessity of presenting a broad outline without duplication . . . and I often astonished my dealer friends by refusing an object which most collectors would have seized upon with enthusiasm."[76]

A fourth feature that differentiated Archer Huntington from other collectors was the educational purpose he wished to give his Spanish museum. He sought not just to show the public his artistic collections. He also wished to encourage the study of Spanish literature in the United States and to introduce the general public of his country to the art and literature of a culture that was then scarcely known outside it. He expressly acknowledged that the museum he had in mind was to be an instrument of education for a group of learned scholars working in collaboration, an ambition that went far beyond the simple desire to collect.[77]

The last of his particular aims was to perpetuate a Spain that was on the point of disappearing at the dawn of the twentieth century, a desire that was reflected in the purchases he made of works by contemporary Spanish painters such as Joaquín Sorolla, Ignacio Zuloaga, Martín Rico, Miquel Viladrich, José López Mezquita, and many others as well as in the large photographic collection he assembled, whether by buying pictures

76. Diary entry, Jan. 4, 1904, AMHA, quoted in Codding, "Archer Milton Huntington, Champion of Spain," 158.

77. The first declaration of principles of the Hispanic Society of America in 1904 established that "the Hispanic Society of America will be a free public library, museum, and educational institution," and its purpose would be "the advancement of the study of the Spanish and Portuguese languages, literature, and history, and advancement of the study of the countries wherein Spanish and Portuguese are or have been spoken languages." Hispanic Society of America Foundation Charter, 1904, quoted in Hispanic Society of America, "Mission Statement," n.d., at https://hispanicsociety.org/about-us/mission-statement/.

or by sending photographers on commissions to tour the geography of Spain and Hispanic America, camera at the ready. His objective was to document the daily life of Spain in this era, to leave a visual record as a means of saving that life from future oblivion—a project that became a recurrent leitmotif in his activities in the first decades of the new century.

Archer Huntington was a younger contemporary of a generation of his compatriots who chose to spend large fortunes on European art: figures such as Henry and Louisine Havemeyer, Andrew Mellon, Henry Clay Frick, Isabella Stewart Gardner, Benjamin Altman, Philip Lehman, and William Randolph Hearst (for whom Archer had very little respect).[78] Archer formed part of this group of collectors who coincided in the same time and space, shared a series of forms of behavior, and felt close to each other in many aspects of their lives—a select social grouping that was homogeneous enough to form a mirror in which the young Huntington, still a beginner in the world of collecting, could see himself reflected.

However, Archer also distanced himself from these contemporaries in the intrinsic meaning he wished to give to the act of collecting. He was a different kind of collector in his own country because he conceived of a new model of museum in which the central goal, between romantic and utopian, would be to enclose within four walls the soul of a nation as exhibited by its artistic manifestations throughout its history. It was an idea that might have appeared odd in the United States at the end of the nineteenth century but was not so strange if, instead of looking to North America, one turned instead to Spain and in particular to the teachings of the writers and intellectuals of the Generation of 1898, with their wish to locate the essence of Spain in its artistic and cultural creations as a pathway to regenerating the country without renouncing the elements of identity that made it unique.

78. A note in Huntington's diary from October 24, 1913, indicates his feelings toward Hearst: "[The architect Ogden] Codman and I went over to Schultz's 'Spanish patio' which is for sale. A piece of plunder of some interest. Not for me however. Hearst would be quite fool enough to buy it I think. The old age of Hearst should be given up to the elimination of an unclean spirit. But Saint Cyriacus is no longer with us!" Diary entry, Oct. 24, 1913, AMHA, quoted in Codding, "Archer Milton Huntington, Champion of Spain," 163.

After 1898, Archer Huntington began a new phase in his career, building on his dual background as, on the one hand, the heir to a particular family lineage and inheritance and, on the other, the possessor of a distinct awareness as a member of his generation. The extraordinary nature of his family origins and the fin de siècle atmosphere in which he emerged from his youth had contributed to defining a highly attractive personality. Only the combination of unlikely circumstances that ran through his family background could have led anyone to anticipate the emergence of such an unorthodox figure. This individuality was combined with the collective circumstances in which he was immersed, as José Ortega y Gasset, the most significant Spanish philosopher of the twentieth century, would have put it—a tumultuous moment in history in which he discovered his vocation as a philanthropist, collector, and Hispanist.

Part Two ✦ Huntington "in Motion" ✦ 1898-1930

4. Archer M. Huntington, 1900. *Source*: Box 95, "Photographs Family Huntington, Archer," Anna Hyatt Huntington Papers, Special Collections Research Center, Syracuse University Libraries. By permission of Syracuse University Libraries.

In the range of his talents, the strength of his enthusiasm, and how he has chosen to use his wealth and power, there is something in Mr. Huntington that suggests a humanist prince of the Renaissance. Tall, dignified, massive of build, he dominates without being domineering over whatever group he may join. Friendly, democratic, and buoyant, his mind and imagination work at high speed, often enigmatically. He is at times a bit baffling, especially when, with tongue in cheek, he comes forth with a truly outrageous question or comment to see how it will be taken. He knows men in and out, and sees through pose, pretense and insincerity with a probing eye.

—John Kirtland Wright, *The History of the American Geographical Society*

2
A Hispanist in Regenerationist Madrid

Huntington's Social World in Spain

The first vacillating steps taken by Archer Huntington into the exclusive social circles of New York did not suggest that he would ever stand out as a man who was eminently sociable. Nevertheless, from his first visits to Spain, Huntington was notable for the relationships he established with representative figures from the worlds of politics, art, and letters in a Spain that was entering its cultural "Silver Age." Beyond question, few other foreigners and still fewer North Americans managed to gather together in their immediate circle such a diverse collection of individuals from Spanish public life.

The brief account of its founder published by the Hispanic Society in 1963 pointed to this aspect of Huntington's life in Madrid, where he began friendships that would accompany him throughout his life. "He broke his journeys at Madrid, where he met the men who were to be his lifelong friends, the men to whom preservation of the arts was a vital matter."[1]

In a letter to his mother in February 1898, Archer referred to the importance he gave to the first friendships he formed in Spain and the nature of them.

> In Seville, I have come to have more friends than even in Madrid, and the work at Santiponce has brought me closer to these friends than I could have hoped. The kindly scholarship I meet is endless and the

1. Proske, *Archer Milton Huntington*, 4.

generosity and courtesy of everyone without limit. These leisurely students and poets seem to have gathered something of the Arabic traditions of departed conquerors and scholars. The literary atmosphere is charged with an eager, half-expressed sense of a Moorish past of culture which could not be forgotten, and which seems almost reborn. . . .

This growing friendship seems to fill me with an even greater enthusiasm for the work I am at, while the intimate contact with keen and encouraging friends gives me a vague belief in its importance. I wish you were here to encourage this belief![2]

If in 1895 he had appreciated the gatherings in the home of the Gilders in New York for the opportunity they gave him to initiate friendships, in 1898 he found in Spain some genuine and subsequently very dear friends with whom he could share the passion he felt for Spanish literature, art, and archaeology. These friendships were forged around a common interest in the preservation of Spain's cultural heritage, a subject that we must now examine to gain a multidisciplinary view of Archer Huntington's role in Spanish public life.

His knowledge of Spanish culture, his interest in every form of artistic expression, his purchases of objets d'art, and his fortune helped open doors for him in the aristocratic residences of turn-of-the-century Spain. Despite the anachronistic nature of the Spanish aristocracy in a society in the midst of modernization, this social group still retained a position of undoubted social prestige. They were a forceful element in the economy, and a large part of their social preeminence was owing to the active role they still played in the country's public life in the first two decades of the new century.[3] In their salons, Huntington had the opportunity to share tables and reading matter with writers and politicians, gaining entry to the most exclusive social circles in Spain. Some of these contacts became closer still through personal affinities or intellectual bonds and developed

2. Archer Huntington to Arabella Huntington, Feb. 1898, included in García-Mazas, *El poeta y la escultora*, 386.

3. José Miguel Hernández Barral, *Perpetuar la distinción: Grandes de España y decadencia social, 1914–1931* (Madrid: Ediciones 19, 2014).

into the sincere, life-long friendships that his letters have enabled us to trace, as in the cases of the marquis of Vega-Inclán, the duke of Alba, and the artists Joaquín Sorolla and Ignacio Zuloaga, to name only some of the best known. Others were more the products of chance, such as his friendship with the marquis of Jerez de los Caballeros, and as such were only segments in an intricate network of enriching relationships that developed and interlinked around a common concern and set of ideas, a belief in the value of Spanish culture.

Many of these early contacts took place in a country that after the Desastre of 1898 felt an overriding need for national regeneration, a sentiment that enervated an intellectual movement with extraordinary influence during the opening years of the new century. While literary figures embraced the new aesthetic currents in poetry and the novel influenced by modernism, and philologists studied the origins of the Hispanic languages and went deeper into the study of classics such as the *Cantar de mio Cid* and the works of Cervantes, visual artists dedicated themselves to giving physical expression to the Spanish soul from fresh perspectives often based on folklore and folk traditions. At the same time, a new generation of art historians had begun to reevaluate the works of painters such as El Greco, Velázquez, and Goya, while Spanish archaeology also began to gain an international reputation, and progressive intellectuals had initiated their efforts to change long-established inflexible systems of education, calling for a new focus on science and empirical research.

While in the more industrialized regions such as Catalonia and the Basque Country changing societies generated new cultural ambitions that were expressed in distinctive intellectual conceptions of their own, the Madrid of the regenerationist years reflected the aspirations of a diverse range of institutions and individuals, all of which wished to drag Spain out of its nineteenth-century isolation and integrate it into the cultural currents of the most advanced countries of the new era. Artists, intellectuals, leading aristocrats, and even King Alfonso XIII himself were committed to this mission, albeit from different points of view and in some cases from contradictory but complementary positions.

This long period of thirty years was marked by the outbreak of World War I, which coincided with the consecration of a further generation of

intellectuals, dubbed the Generación del 14 (Generation of 1914), who saw the solution to Spain's problems in Europe. Writers, philosophers, and scientists such as José Ortega y Gasset and Américo Castro argued for the "Europeanization" of Spain through science and, sometimes with the support of governments, laid down the basic structures of the means to achieve it.

The center of inspiration for a great many reforming projects in Spain at this time was the Institución Libre de Enseñanza (Free Institute of Education), established in Madrid in 1876 by a group of academics—most of whom had been expelled from the official universities for refusing to accept dogmatic restrictions on teaching—led by Francisco Giner de los Ríos (1839–1915). Greatly influenced by the German idealistic philosopher Karl Krause, Giner and his colleagues emphasized rationalism, free thinking, and, above all, the improvement of a liberal education that treasured intellectual and scientific curiosity as the most important steps toward broader progress in society. Known as *institucionistas*, the staff and alumni of the Institución Libre would have an extraordinary influence in a remarkable range of areas of Spanish life over the following decades.[4]

By the early 1900s, amid the new preoccupation with regeneration and modernization, these reformers were being listened to by governments, and with official support the *institucionistas* inspired the creation of an impressive number of new and imaginative public institutions in a short time, beginning in 1907 with the Junta para Ampliación de Estudios e Investigaciones Científicas (Council for the Extension of Studies and Scientific Research), a special body set up to support postgraduate studies and other research of all kinds. Under its auspices, a string of additional institutions were established in turn, such as the Centro de Estudios Históricos (Center for Historic Studies), which oversaw research in history, art, and philology; the Instituto Nacional de Ciencias Físicas (National Institute for Physical Sciences), which administered several scientific laboratories;

4. Antonio Jimenez-Landi Martínez, *Breve historia de la Institución Libre de Enseñanza, 1896–1939* (Madrid: Tebar D.L., 2010).

and the Residencia de Estudiantes, the "Student Residence" opened in Madrid in 1910 that became a major center of cultural life and liberal education in the following twenty-six years.[5] However, the growing political instability and the support given by King Alfonso to the dictatorship of Prime Minister Miguel Primo de Rivera opened up a rift between the liberal intelligentsia and the king that was evidenced by a clear distancing of most Spanish intellectuals from the monarchy after the mid-1920s.

Nevertheless, despite the government's drift into authoritarianism, cultural life continued to flourish, giving rise to yet another "generation," the Generación del 27 (Generation of 1927), with poets such as Federico García Lorca, Luis Cernuda, and Jorge Guillén, who embraced the artistic and literary avant-garde with renewed energy and a high degree of experimentation. All the figures who took the leading roles in these decades of cultural splendor formed part of an elite and conceived of a modern Spain very different from the one that lived on in the remotest villages and regions of the country.

In 1898, Archer Huntington had said he had encountered the authentic elements of Spanish character preserved precisely in the most rural and arid regions, "out there where the blood that runs through the veins of the peasants had not been contaminated by outside contacts."[6] Nevertheless, he soon became aware that it was only through the country's elites that he could gain a complete understanding of the essence of Spanish culture because the artifacts and manuscripts that formed the underlying core of this culture, which had remained intact for centuries, were found in the locations that brought together, around their libraries and bibliographical treasures, scholars and aristocrats who shared his own passion for the subject.

The Austrian writer Stefan Zweig's description of the French author Romain Rolland and his growing interest in Germany at the beginning of the twentieth century could well be applied to the young Huntington in

5. Margarita Saenz de la Calzada, *La Residencia de Estudiantes: Los residentes* (Madrid: Residencia de Estudiantes, 2011).

6. Quoted in Muller, "La España amada de Huntington en América," 15.

his approach to Spain: "One should not look at nations from below, from the atmosphere of tourism, from the small hotels, from casual collisions and encounters, but from above, from the vision of great men, of those with a decisive and creative nature."[7] Thus, by getting close to the great men and women of Spain during his intermittent and often short visits to Spain, Huntington was able to go beyond an anthropological knowledge of the Spanish "race"—a term habitual at the time—to enter the terrain of the social structures that sustained institutional and interpersonal relationships in early twentieth-century Spain.

The questions we need to answer at this point are: Just who were his friends? With whom was he in contact in Spain? In what ways and to what extent did they influence his subsequent efforts to promote Hispanic studies? Equally, we must also ask, To what extent did Huntington himself play a role in this Silver Age of Spanish culture? Answering these questions leads us to look at a series of individuals in sufficient detail to be able to offer an overview of Huntington's social life in Spain—in the knowledge, nevertheless, that although this sample might be significant and representative, it can only with difficulty be all-embracing.

Between 1900 and 1914, Archer Huntington and his wife, Helen, traveled to Europe, principally France, nearly every spring, although perhaps surprisingly, given his interests, he did not always continue on to Spain. He often met Spanish friends such as Sorolla and Vega-Inclán in Biarritz or just across the border in San Sebastián and sometimes traveled on to Madrid and southern Spain. After 1914, the world war and then Huntington's own personal depression provoked by the collapse of his first marriage in 1918 reduced first his ability and then his willingness to travel as frequently, although he did manage to visit Madrid in 1918. He visited Spain again two or perhaps three times in the late 1920s, the last of them an extended visit with his second wife, Anna, to coincide with the Ibero-American Exposition in Seville in 1929. After that, personal and political reasons dissuaded this always-retiring figure from ever attempting to visit

7. Stefan Zweig, *El legado de Europa*, translation of Zweig, *Europäisches Erbe*, by Claudio Gancho (Barcelona: Acantilado, 2008), 113.

the country again. However, he was an assiduous correspondent, and so many of his Spanish friendships and other contacts were carried on to a considerable extent by letter.

Clearly, not all the social contacts that Huntington established in Spain extended into subsequent correspondence, but many did, fortunately for historical research. In effect, the intermittent nature of his visits to Spain and his long absences from the country meant that many conversations have been preserved in writing that otherwise would have been part of face-to-face discussions unrecorded by history.

Because of his very private nature, he habitually expressed emotions in his letters that did not form part of his public language, so that today they can open for us, perhaps involuntarily, small windows into the personal world of this very discreet American. Hence, the letters that have survived are of extraordinary value. We must not forget that the early twentieth-century world operated through letters and thanks to letters; they were the means of communication par excellence and had the capacity to make the distance between sender and recipient disappear, a factor of great importance in relationships across frontiers.

Although his letters are the primary documentary resource for any study of Huntington, he also established a series of formal rituals through which he sought to give visible form to his relationships with his contemporaries. Formal presentations were made of membership to the Hispanic Society of America, while some of his associates received special honors as honorary or founder members, and the society also awarded medals for special merit.[8] All these ceremonies served as instruments through which Huntington could demonstrate the extent of his "networking" in Spain in

8. Between 1906 and 1950, the Hispanic Society of America established six medals to be awarded to distinguished figures in different areas of the arts and intellectual life: the Membership Medal (1906) and the Medal for Arts and Literature (1907), both designed by Emil Fuchs; the Sorolla Medal (1910) for distinction in art, designed by Victor Brenner; the Mitre Medal (1921) for distinction in arts and letters related to Hispanic America, designed by Anna Hyatt, Archer Huntington's second wife; the Sculpture Medal (1941), designed by Herbert Adams; and the Cervantes Medal (1950) for poetry and music, designed by Gertrude K. Lathrop.

an institutional manner and establish a hierarchy of professional esteem in his relationships.

Equally, one should not forget that throughout this time he was also creating a gallery of portraits of illustrious figures from Spain in New York. The portraits that make up this gallery, part of which is now in the Hispanic Society's reading room, were painted mostly by Joaquín Sorolla, but some were done by Ignacio Zuloaga, and others were produced by José López Mezquita after Sorolla's death in 1923. They represent the foremost figures among the Spanish elites of this brilliant Silver Age. Huntington knew many of them in person and insisted on some of the inclusions and commissions, but it appears that to some extent Sorolla also set about the portrait project according to his own criteria and painted a varied range of names with the idea that Huntington could then choose which he wished to acquire for the Hispanic Society.[9] It is important to note that the selected individuals most highly regarded by Huntington, such as Vega-Inclán, were also given the additional honor of a bust in bronze commissioned from the most prestigious Spanish sculptor of the time, Mariano Benlliure y Gil.

The eminent doctor and writer Gregorio Marañón recalled in a letter to José García-Mazas two years after Huntington's death the significance that these signs of distinction had in Spain. This appreciation by one of the leading intellectuals who shared evenings with Archer Huntington and his closest friends in Madrid helps us understand the high regard that he and his Hispanic Society came to enjoy in Spanish public life during these years. "Every Spanish intellectual admired him, and aspired to be a member of the Hispanic Society, a distinction that figured proudly on the visiting cards of many," wrote Marañón. "The most ambitious hoped to be included in the collection of illustrious Spaniards, which Huntington was creating with the portraits of those selected, nearly all of them masterworks

9. Priscilla E. Muller, "Sorolla y Huntington: Pintor y patrono," in *Sorolla y la Hispanic Society: Una vision de la España de entresiglos* (Madrid: Museo Thyssen-Bornemisza, 1998), 126–28.

executed in oils by Sorolla, and after he died by López Mezquita and others, and also with sculptures in bronze, carried out by Benlliure."[10]

A Cartography of Transatlantic Friendship

An image is said to be worth a thousand words, so the possibility of representing in visual form the complex spiders' web of interconnecting contacts that constructed itself around Huntington in Spanish cultural life is highly attractive. The epistolary web that emerges from a reading of the different sets of correspondence allows one to imagine a collective text that reveals how his contemporaries perceived Huntington and how they interpreted him from the point of view of their own experience. Transforming this collective text into a sound presentation would produce something like a choir of criss-crossing voices.[11] Transforming it into an image, as in graphic 1, creates an overview of Huntington's social world in Spain that resembles a map, a cartography of Huntington's friendships that crossed frontiers, interconnecting the lives of personalities on either side of the Atlantic for more than three decades.

In this proposed "map," not all the points are the same because not all the stories they indicate were the same. Broadly, the larger circles closer to Huntington represent friendships of greater emotional proximity. Some of these friendships led to the formation of smaller subgroups of interconnected names who had access to Huntington via one of his close friends. This was the case, for example, with Alfonso XIII in relation to the marquis of Vega-Inclán or with Benlliure and Manuel Bartolomé Cossío through Joaquín Sorolla. The smaller circles farther from the center, in contrast, indicate more distant relationships that in many cases were merely cordial. Nor is the nature of all lines of interconnection the same because some

10. Gregorio Marañón to José García-Mazas, Sept. 5, 1957, reproduced in García-Mazas, *El poeta y la escultora*, 475.

11. Sabina Loriga has described life stories reconstructed from interconnections and encounters as "choral biographies." Sabina Loriga, "La biographie comme problème," in *Jeux d'échelles*, ed. Jacques Rével (Paris: Gallimard, Le Seuil, 1996), 230–31.

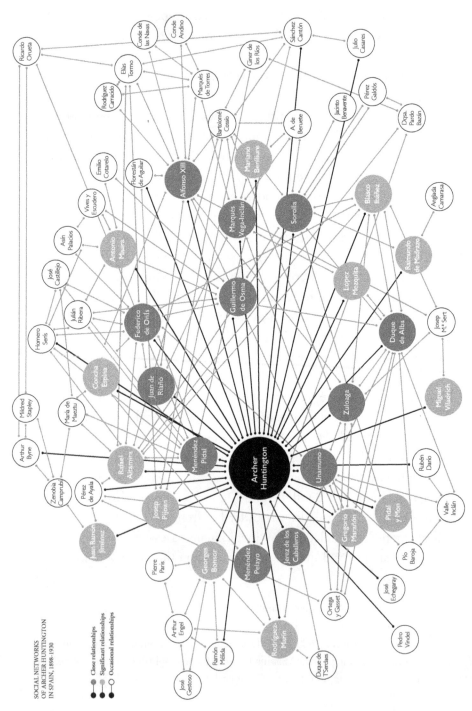

1. Archer Huntington's networks of sociability in Spain, 1898–1930. Copyright © Patricia Fernández Lorenzo, 2022.

refer to long-lasting relationships of real affection, such as those between Huntington and the duke of Alba and Ramón Menéndez Pidal, whereas others indicate more intermittent contacts in which the participants met or wrote each other only occasionally. Nevertheless, nearly all the principal figures named here were awarded honorary memberships in the Hispanic Society, were presented with one or other of its medals, and had portraits of them commissioned by Huntington to add to the society's gallery in New York.

It is also important to bear in mind that social relationships are dynamic and vary constantly, evolving and changing according to circumstances. Some lose intensity, while new ones begin, and, overall, all friendships adapt to each individual's life cycle. If we were to make a map only of Huntington's contacts from 1910, many figures in graphic 1 would still not have come into contact with him, so the network would be less extensive; similarly, after 1939 this same network would be drastically reduced owing to the death of some of its members, the exile of others, and the interruption in Huntington's visits to Spain. The period between 1898 and 1930 was when he traveled most often to Spain and established the greatest range of contacts and therefore the period when this network was at its densest.

Despite its limitations, this chart gives us enough information to conclude that Huntington moved with most ease in two major social circles: that of the court and aristocracy and that of the literary and artistic world. The type of relationships he established in each of them was different, for with the former he shared social status and philanthropic aspirations, but with the latter he shared his interests as a serious student of Spanish art, literature, archaeology, and history. Both Archer Huntington the wealthy art patron and Archer Huntington the scholar of Hispanic culture had their place in Spanish social life, and in pursuing each of these facets of his character he was also able to develop complementary skills. The fact that several members of the aristocracy were regularly in contact with many of the leading artists and intellectuals of the era and often coincided with them in fashionable gatherings also facilitated interaction between the two groups, as it did the status of Archer Huntington as a figure who had a personality of his own but a foot in both camps.

Cicero said in his treatise on friendship that one has to try to reach one's goal with the same people with whom one began the race, at least if one is to practice friendship as a virtue.[12] If we look at Huntington's life metaphorically as a race, graphic 1 would represent a single, photo-finish image of his most brilliant and productive period, one in which he reached fulfillment in his professional projects and consolidated his many connections. However, it is also a point of departure for an analysis of the subsequent periods in his life, during which, despite the fact that he did not return to Spain, he remained in contact by letter with many of his earlier friends and associates. For them, Archer Huntington continued to be an iconic friend of Spanish culture.

A Royal Friend

Huntington's social world and contacts in Spain cannot be understood without the figure of Benigno de la Vega-Inclán, Marqués de la Vega-Inclán. His contemporaries and subsequent historians agree in viewing him as the one person who maintained the closest and most affectionate friendship with the American, and he was also the key figure in the relationship between Huntington and King Alfonso XIII. As Marañón put it, "Vega-Inclán put Huntington in contact with the Spaniards who could do most to help him in his work in Hispanic studies. In first place with the King, who felt a great love for the Hispanist, in part because he knew that few foreigners loved his fatherland with such generosity and warmth."[13]

The relationship that gradually formed between Huntington and the monarch could be described as an "epic friendship." Its progress was marked by particular landmarks, apparently unconnected situations that when placed in chronological order trace a course full of particular gestures that evoked values such as chivalry, honesty, and loyalty. This was such a singular relationship that it is difficult to equate it with any other in

12. Cicero, *On Old Age, On Friendship, On Divination* (Cambridge, MA: Loeb Classical Library, Harvard Univ. Press, 1923).

13. Marañón to García-Mazas, Sept. 5, 1957, reproduced in García-Mazas, *El poeta y la escultora*, 475.

Spain. To assess its significance correctly, it is necessary to bear in mind the power of attraction the figure of King Alfonso possessed in a country of deep-rooted republican traditions, such as the United States, for it was the monarchy that filled a large part of whatever news reports were published about Spain in the American press during the first decades of the century.[14]

The contrast between the two men was evident: Alfonso de Borbón (1886–1941, r. 1886–1931) was born a king in a country in international decline, while Huntington was educated like a prince at the heart of the new power whose light had begun to dazzle the world. Both had lived through the war in Cuba that pitted their respective nations against each other, and then, once this enmity was overcome, both coincided in a concern to promote Spanish culture around the world, the former out of love of his country and the latter because he wished to show his American compatriots images of the Spain that he had come to know and that departed in so many respects from the "black legend" that still pursued the image of Spain in the United States. Huntington was sixteen years older than the king, but this encounter between two theoretically contrasting individuals gave rise to a warm meeting of minds around the central theme of Spanish culture.

The story of this atypical friendship between the king and the American Hispanist began with an incident that could have come from a novel: the robbery of some books from the library of Alfonso XIII, which by 1905 had found their way into Huntington's hands after he bought them in Paris from the Spanish bookseller Pedro Vindel.[15] Huntington was already a well-known and respected figure in Spain, and so it was not surprising that, despite the delicate nature of the matter, the count of Las Navas,

14. Rafael Sánchez Mantero, "La mirada americana: La evolución de un estereotipo," in *La mirada del otro*, ed. Ismael Saz (Madrid: Marcial Pons, 1998), 234; Javier Moreno Luzón, *El rey patriota: Alfonso XIII y la nación* (Madrid: Galaxia Gutenberg, 2023), 181–82.

15. Jean François Botrel, "Los libreros y las librerías: Tipologías y estrategias comerciales," in *Historia de la edición en España, 1863–1914*, ed. Jesús Martínez Martín (Madrid: Marcial Pons, 2001), 135–64.

head librarian to the king, wrote to him directly. Huntington replied promptly: "I learned with surprise and regret of the robbery.... On reading the names of the volumes given in your letter I at once realized them to be identical with those I had purchased from Vindel in Paris.... I think I need scarcely assure you that nothing will give me more pleasure than to return these volumes to His Majesty's library."[16]

Huntington not only returned the stolen items but also presented the monarch with a complete set of the facsimiles, the Huntington Reprints, with which since 1897 he had been spreading the literary treasures of Spanish culture around the great libraries of the world. Huntington's response to the king's request was that of a gentleman and equally demonstrated his respect for the country's highest institution, the Crown. Consequently, on October 29, 1906, the king's tutor, the count of Andino, asked the Ministerio de Instrucción Pública (Ministry of Public Instruction) to grant Huntington a distinction from the Royal Household:

> The opulent bibliophile, Mr. Archer Huntington of New York . . . has returned to His Majesty the rare books removed from the Royal Library and acquired by him in good faith in Paris from the Spanish bookseller Vindel for a sum not less than 25,000 pesetas, meeting absolutely all the costs of transportation to the extent of bringing them to the door of the Royal Library, and in addition has presented [the library] with a complete collection of the facsimiles already mentioned. His Majesty the King believes therefore that the merit and services [demonstrated by] Mr. Huntington make him deserving of the award of the Grand Cross of Alfonso XII.[17]

It is interesting to note that the count of Andino gave such importance not only to Huntington's gracious gesture but also to the money involved. In the next paragraph, in setting out Archer Huntington's merits,

16. Quoted in María Luisa López Vidriero, "La biblioteca de the Hispanic Society of America," in *The Hispanic Society of America*, ed. Lenaghan et al., 44.

17. Conde de Andino to the Minister of Public Instruction, Oct. 29, 1906, R. Alfonso XIII, 12422/8, Archivo General de Palacio (AGP), Madrid.

he included among them the fact that Huntington had founded in New York "an institution named the Hispanic Society of America, on whose building, constructed from the ground up, more than 1,000,000 pesetas has [sic] been spent." The insignia of the Grand Cross of Alfonso XII, Spain's highest civilian honor at the time, was sent to New York to "Arquero Huntington" (*arquero* is Spanish for "archer"), the name with which the count of Las Navas referred to him in his letter.[18] In this slightly heroic manner, the life of the American collector became interlinked with that of the monarch Alfonso XIII and the library of the Hispanic Society of America with the Royal Library.

This would not, however, be the only opportunity for Huntington to demonstrate to the king his readiness to act as a philanthropic patron of Hispanic art. Another presented itself in 1909 with the famous exhibition of the work of Joaquín Sorolla at the Hispanic Society. Huntington had first seen the painter's work in London in 1908 and, enthralled by Sorolla's dexterity and use of color, had decided to inaugurate the museum and library he had built in New York, the Hispanic Society of America, with a large-scale Sorolla exhibition. By telegram in early February 1909, Huntington requested that Alfonso XIII should extend royal patronage to the exhibition, and the king's private secretary informed him that the monarch accepted the proposal on this occasion "as a special favor to the Hispanic Society."[19] Huntington's behavior toward the king over the robbery from the Royal Library had left a reserve of gratitude that Alfonso returned in this symbolic manner. One should add, too, that the king had a special predilection for the work of Joaquín Sorolla, an artist with whom he formed a friendship of a kind unusual between a monarch and a painter.[20]

Huntington in turn awarded the king a Gold Medal of the Hispanic Society of America, to be delivered by hand by Sorolla in December

18. Conde de las Navas to Conde de Andino, Dec. 1, 1906, R. Alfonso XIII, 12422/8, AGP.

19. Archer Huntington, telegram, Feb. 9, 1909, R. Alfonso XIII, 12428/3, AGP.

20. Javier Tusell, "Joaquín Sorolla en los ambientes politicos y culturales de su tiempo," in *Sorolla y la Hispanic Society*, 29.

1911.[21] This was the highest honor the Hispanic Society could offer, and in presenting it Huntington wished to show the king his own appreciation of Sorolla's painting *España de la luz* (Spain of Light), an image that thousands of visitors in New York had admired.

This mutual exchange of honors culminated in the king's commissioning of Sorolla to paint his portrait to present as a gift to "that *simpática* Hispanic Society," as Alfonso XIII called it, as a demonstration of his regard for Huntington.[22] The portrait of Alfonso XIII in military uniform was completed on March 13, 1910, and since then has formed part of the Hispanic Society collection.

Between 1910 and 1912, Huntington embarked upon two further projects connected with the king. He gave financial support to the creation of the Casa-Museo del Greco in Toledo, a reconstruction of the home of El Greco, the original of which had been lost, with attached museum. This initiative was associated with the growing movement to reassert the value of the artist's work led by the painters Ignacio Zuloaga and Santiago Rusiñol and supported by the research done by the art historian Manuel Bartolomé Cossío. To understand the role Huntington played in this project, one only has to look at Sorolla's painting of the members of the *patronato*, or trust, set up to administer the Casa-Museo del Greco, also now on display in the Hispanic Society. The prominent position of Huntington to the king's left, the king, and the marquis of Vega-Inclán to his right indicates a central triumvirate that stands out from the rest.[23]

21. Joaquín Sorolla to Emilio María de Torres, Dec. 1911, R. Alfonso XIII, 12423/8, AGP.

22. "I now have the King's permission for the portrait I have to paint for Mr. Huntington, His Majesty tells me that he is very happy to serve as a model for that *simpática* Hispanic Society." Joaquín Sorolla to Archer Huntington, Nov. 10, 1909, in "Apéndice. Correspondencia entre Sorolla, Huntington y la Hispanic Society, con selecciones del diario de Huntington," in *Sorolla y la Hispanic Society*, 382.

23. The museum *patronato* was initially made up of the painters Aureliano de Beruete and Joaquín Sorolla; the count of Cedillo, a historian and member of the Real Academia; the art historian Manuel Bartolomé Cossío; the archaeologist and art historian José Ramón Mélida; and José Villegas, the director of the National Museum of Painting

5. Joaquín Sorolla, *Meeting of the Patronato of Casa-Museo del Greco*, 1912–20. Oil on canvas. *Source*: Courtesy of the Hispanic Society of America, New York (A3061).

According to Priscilla Muller, curator emeritus of the Hispanic Society, both this painting and the Casa-Museo del Greco itself were almost certainly commissioned and paid for by Huntington.[24] This view is supported by the recent conclusions of another curator at the society, Patrick Lenaghan, on the role taken by Huntington in the creation of

and Sculpture. It was later extended with the incorporation of the marquis of Vega-Inclán as chairman and Archer Huntington as patron.

24. Muller, "Sorolla y Huntington," 129.

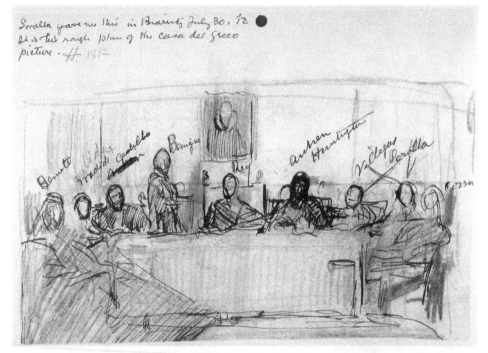

6. Joaquín Sorolla, sketch for *Meeting of the Patronato of Casa-Museo del Greco*, 1912. *Source*: Courtesy of the Hispanic Society of America, New York (A3339).

the Casa-Museo del Greco.[25] The Hispanic Society of America thus contributed to giving international support to the process through which El Greco was "nationalized" and made a part of Spain's national heritage.

In the case of another project undertaken immediately afterward, the Casa-Museo de Cervantes in Valladolid, the collaboration between the Hispanist and the king was more public. After Huntington acquired two of the buildings known to have been occupied by Cervantes in the city, the Hispanic Society donated them to the Spanish state.[26] The local

25. Patrick Lenaghan, "El Greco de Toledo en la Nueva York de Archer Huntington," in *El Greco: Toledo, 1900* (Madrid: Ministerio de Cultura, 2009), 145.

26. Although the purchase was made by Huntington himself, he then donated the two properties in Valladolid to the Hispanic Society so that the latter would be their official owner and therefore the institution that subsequently donated them in turn to the

newspaper *El Norte de Castilla* reported the news on its front page on October 25, 1912: "Yesterday the house at number 14 in the Calle del Rastro, where the immortal Miguel de Cervantes y Saavedra lived and in which he wrote a large part of *Quijote* and some others of his works, was bought by His Majesty the King Don Alfonso XIII. At the same time the two adjoining houses have been acquired by the Hispanic Society of America, founded and headed by Mr Huntington, the illustrious Hispanophile."[27]

Miguel de Cervantes and his great work *El ingenioso hidalgo Don Quijote de la Mancha* (1605/1615) had taken on a particular prominence in the first years of the twentieth century. Several commentaries had helped make *El Quijote* a fresh source of mythology for the Spanish nation; standing out among them were Miguel de Unamuno's *La vida de Don Quijote y Sancho* from 1905 (translated as *Our Lord Don Quixote*) and José Ortega y Gasset's *Meditaciones del Quijote*, published in 1914. A restored house of Cervantes and its museum therefore connected with the intellectual concerns of the leading figures in cultural life, while the king and Huntington once again emerged as principal protagonists in the project. The grateful king sent Huntington a telegram: "I have just been informed of the acquisition of the house of Cervantes in Valladolid. I am delighted to inform you of this auspicious news and to send you my congratulations. I reiterate my sincere gratitude for the so important and valuable role you have taken in this cultural enterprise, which I hope to assist with the greatest enthusiasm."[28]

It may seem harder to understand at first why Huntington, with the Hispanic Society, also financed the building of the church of Our Lady of Esperanza as a place of worship for the Hispanic community in New York during these same years, despite the fact that he was not a Catholic.

Spanish state. This transaction converted a personal donation into cooperation on an institutional basis with the corresponding Spanish official bodies. See the telegram from the Spanish ambassador, France José María Quiñones de León, to the king's private secretary, Emilio María de Torres, Apr. 10, 1918, R. Alfonso XIII, 15630/5, AGP.

27. *El Norte de Castilla*, Oct. 25, 1912, R. Alfonso XIII, 15630/5, AGP.

28. Alfonso XIII to Archer Huntington, telegram, undated, R. Alfonso XIII, 15630/5, AGP.

Moreover, he did so with additional support from some of his most influential compatriots, such as J. Pierpont Morgan, Frederick Vanderbilt, and other illustrious names—most of whom were also Protestants. These millionaires' attitude cannot be understood without associating it with a search for a spirituality that seemed lacking in modern American life, which led them to look sympathetically upon Catholicism. This was not a question of faith but rather an intellectual disposition that appreciated the elaborate rituals and religious artifacts in Catholic worship, in contrast to the ever more secular society in which they lived. With this initiative, Huntington once again conquered the hearts of Spaniards and of their king. Alfonso XIII, proud of Huntington's achievement, donated to the new church a reproduction of the altar lamp that hangs from the ceiling in the church of San Antonio de la Florida in Madrid, made by the celebrated liturgical craftsman Félix Granda.

Huntington offered the king a stage with international prominence upon which to play a part he so enjoyed, that of the monarch of one of the nations with the most profound Catholic beliefs in Europe, who was at the same time a great lover of art and culture. Despite the image of a liberal modern man that the king liked to project in his earlier years, Huntington was no doubt aware of the profound religious feelings held by Alfonso XIII, the result of the strict Catholic education he had received from early childhood in the atmosphere of the Royal Palace.[29] In addition, Huntington's own contacts with contemporary Spanish life must have kept him informed on the debate taking place in Spain between secularization and confessionalism and on the pressure that secularist forces had exercised since the first years of Alfonso's reign. It was therefore extremely pleasing to the king to be able to respond to Huntington's generosity as the occasion merited.

The Sunday art supplement of the French-language edition of the *New York Herald* led its front page on March 24, 1912, with the news of the king's gift to the New York church under the headline "Un don précieux

29. Julio de la Cueva Merino, "El rey católico," in *Alfonso XIII: Un político en el trono*, ed. Javier Moreno Luzón (Madrid: Marcial Pons, 2003), 277–306.

du Roi d'Espagne." An extensive article explained that the king had frequently demonstrated the appreciation he felt for Archer Huntington and that, moreover, he had always shown great interest in the affairs of the Hispanic Society.[30]

Not only was the king's gratitude toward and regard for Huntington now well known in the Spanish court, but, thanks to this initiative and reports of the church's inauguration in the international press, the special consideration and respect between them was also reliably confirmed in public. As a result of this mutual complicity, Huntington was invited to dine at the palace during his next visit to Spain, in the summer of 1912. As he recorded in his diary, "We lunched at the Palace today, and the King brought up the question of my purchase of Spanish art. I explained to him, although I am sure he already knew it, that I only purchased books in Spain, as I felt that Spanish paintings should remain where they were. So many had drifted abroad that it was perfectly easy for me to obtain all the necessary types without robbing Spain. The Queen seemed pleased with the idea."[31]

Their mutual understanding became more explicit still when Alfonso XIII agreed to allow an exhibition of Spanish tapestries at the Hispanic Society in 1917, in the middle of World War I. The king's act of courtesy toward Huntington made it possible for twenty-three tapestries that had never left the rooms of the royal palaces since they were made some two hundred years earlier to be shown in New York. Shipped under the personal supervision of the marquis of Valverde, the tapestries were exhibited at the Hispanic Society from February 4 to March 1, 1917, and then went on, under the society's auspices, to the Corcoran Gallery in Washington, DC, the Albright in Buffalo, New York, and the Copley Society of Art in Boston.

Tapestries had become very highly regarded as art objects at the time, and many American collectors wished to obtain them as a new symbol of prestige, so that an exhibition of articles of such quality in the United

30. *New York Herald* (French ed.), Mar. 24, 1912, R. Alfonso XIII, 12422/8, AGP.
31. Diary entry, June 17, 1912, AMHA, quoted in Codding, "Archer Milton Huntington, Champion of Spain," 163.

States had great impact. However, it is also important to note that this event coincided with the period just prior to the US entry into World War I.

In Spain, despite the country's official neutrality, the war had created a bitter split between *germanófilos*, primarily on the right, and pro-Allied *aliadófilos*, drawn mostly from liberal circles and from the left. King Alfonso generally succeeded in concealing his own sentiments during the war, notably in view of the fact that his mother was Austrian and his wife British, so both belligerent camps were represented in his own family. In addition, as one historian has put it, the king's "own feelings were divided. He admired the discipline and military competence of the Germans, but was conscious of the fact that the natural points of reference for Spain were in France and Great Britain."[32] Moreover, none of these circumstances interrupted his contacts with Huntington, and they maintained their friendly relationship on both a personal level and an institutional level, as Alfonso acknowledged in a letter where he sought to calm the art collector and let him know that events in other spheres had not in any way undermined their friendship. "When we see each other," wrote the king, "you will be assured that there is no reason for such a thing, so that you know, and never doubt, that I am your true friend."[33]

The relationship between Huntington and Alfonso XIII became closer through the organization of additional cultural projects and events in which each sought the support of the other and through which feelings of mutual gratitude steadily gave way little by little to more personal appreciation. The Spanish ambassador in Washington, Juan de Riaño y Gayangos (1865–1939), played a significant role in some of these exchanges. He had occupied the post of special envoy and minister plenipotentiary in Washington since 1910 and in 1913 became Spain's first full ambassador on the American continent. He was the son of the distinguished

32. Antonio Niño, "El rey embajador: Alfonso XIII en la política internacional," in *Alfonso XIII*, ed. Moreno Luzón, 266.

33. Alfonso XIII to Archer M. Huntington, c. 1917, reproduced in "Retratos de hombres ilustres. 83, Alfonso XIII, rey de España," in *Sorolla y la Hispanic Society*, 342.

art historian Juan Facundo Riaño y Montero, who was recognized across Europe as an authority on decorative arts and an influential figure among the alumni of the Institución Libre de Enseñanza. In addition, he was the grandson of Pascual de Gayangos, a scholar of Arabic who had been the friend and translator of the great Boston Hispanist George Ticknor.[34]

Huntington and Riaño were in frequent contact and became good friends. On several occasions over the years, the ambassador asked Huntington to receive distinguished figures from Spain who were visiting New York or to satisfy the wishes of Alfonso XIII, as in the case of the king's cousin Alicia de Borbón, who wrote to Riaño in 1923 asking to be put in contact with Huntington, explaining, "Perhaps you may know already from my cousin, His Majesty the King Don Alfonso, that I have come here to New York to sell some pictures and other things from among my property, and he has advised me to show them to Señor Archer Huntington."[35] At other times, it was Huntington who wrote to the ambassador and even shared with him in his letters reflections on family matters that Archer generally kept in the strictest privacy, such as the deaths of his mother, Arabella, in 1924 and his adoptive sister, Clara Hatzfeldt, in 1928.

In 1920, Riaño proposed to the king that the Hispanist should be awarded a doctorate honoris causa by the Universidad Central de Madrid (Central University of Madrid), a prerogative that the university had only recently been granted.[36] A slight controversy arose around this award, though, and it was Alfonso who intervened to resolve the matter discreetly but decisively.

The ambassador's proposal was answered by the rector of the Universidad Central, José Rodríguez Carracido. In his letter to the king's secretary, he indicated certain conditions that he considered necessary for such an

34. An interesting collection of letters sent by George Ticknor to Pascual de Gayangos was published by the Hispanic Society in 1927 under the title *George Ticknor: Letters to Pascual de Gayangos in the Collection of the Hispanic Society of America*.

35. Alicia de Borbón to Juan de Riaño, Feb. 1, 1923, (10) 2654/8248, Archivo General de la Administración (AGA), Madrid.

36. Juan de Riaño to Emilio María de Torres, Mar. 30, 1920, (10) 2654/8209, AGA.

award to be presented, chief among them the presence of the recipient at the relevant ceremony in Madrid.[37]

Huntington was then in the midst of a difficult moment in his personal life; two years earlier he had divorced Helen, a situation that left him in a state of depression, and so, although he sent the ambassador his thanks, he also informed Riaño that it would be impossible for him to attend the ceremony to receive the degree in person.[38] Aware of this difficulty, the ambassador made great efforts to find some means by which Huntington could still receive the award, pointing out in his support something that everyone was already aware of—that Huntington was a man who had always been reluctant to accept any kind of public recognition. In addition, he argued that in the United States it was quite common to receive an honorary doctorate without necessarily attending the official ceremony. As he wrote to the king's secretary, "As I understand it, the case is that Mr Huntington, whose excessive modesty of character is well known to you, since he never takes part in anything that has the nature of a public event or ceremony; and since he is a man very attached to his own ideas, I do not think there is the slightest probability of his modifying his views."[39]

For Riaño to send this request to Emilio María de Torres, Marqués de Torres de Mendoza, Alfonso XIII's private secretary and a man who enjoyed the monarch's absolute confidence, was equivalent to an appeal directly to the king. However, Rector Rodríguez Carracido's response was to point out that in the most prestigious European universities, degrees honoris causa were only ever awarded with the recipients present to accept them, adding the suggestion that in American universities honorary degrees were given away with excessive prodigality. He also added a paragraph referring to Huntington's similarly apparently ungrateful conduct

37. José María Rodríguez Carracido to Emilio María de Torres, Apr. 28, 1920, R. Alfonso XIII, 12422/8, AGP.

38. Archer Huntington to Juan de Riaño, June 21, 1920, (10) 2654/8209, AGA.

39. Juan de Riaño to Emilio María de Torres, June 23, 1920, R. Alfonso XIII, 12422/8, AGP.

when he had previously been awarded corresponding membership in the Real Academia Española (Royal Spanish Academy) in 1917.[40]

In his own defense against this apparent questioning of his conduct, Huntington declared that he had received the academy's diploma personally in Paris from Guillermo de Osma, the count of Valencia de Don Juan, and that in the same meeting he had given the count a letter of thanks addressed to the president of the academy, Antonio Maura.[41] Both Guillermo de Osma and Maura confirmed Huntington's account, as did Emilio Cotarelo, permanent secretary of the Royal Academy since 1913, as Torres reported back to Riaño in Washington.[42]

The king's secretary described this affair as a "lamentable error."[43] Despite all these apologies, however, the underlying issue remained unresolved: the apparent requirement for any recipient to be present in person at the appropriate ceremony to receive the Universidad Central's honorary doctorate.

In 1920, the dean of the Faculty of Philosophy and Letters in Madrid was Elías Tormo y Monzó, the first professor (*catedrático*) of history of art in Spain and a member of both the Real Academia Española de Historia (Royal Spanish Academy of History) and the Real Academia de Bellas Artes de San Fernando (Royal Academy of Fine Arts of San Fernando).[44] As dean, he was responsible for advancing the request to grant the honorary degree to Huntington and so put forward a series of considerations in

40. José María Rodríguez Carracido to Emilio María de Torres, Aug. 7, 1920, R. Alfonso XIII, 12422/8, AGP.

41. Juan de Riaño to Emilio María de Torres, Oct. 6, 1920, R. Alfonso XIII, 12422/8, AGP.

42. Emilio Cotarelo to José María Rodríguez Carracido, Nov. 15, 1920, R. Alfonso XIII, 12422/8, AGP; Emilio María de Torres to Juan de Riaño, Oct. 25, 1920, (10) 2654/8209, AGA.

43. Emilio María de Torres to José María Rodríguez Carracido, Oct. 26, 1920, R. Alfonso XIII, 12422/8, AGP.

44. Manuel Fernández Rodríguez, "Don Elías Tormo y Monzó: Un gran maestro," *Academia: Boletín de la Real Academia de Bellas Artes de San Fernando*, no. 76 (1993): 421–29.

his favor "so that Sr. Huntington may become the first honorary Doctor of Philosophy and Letters in all Spain."[45] The decision to award the doctorate was agreed unanimously by the faculty's members, the nineteen permanent professors. The press also reported on the matter, and the following day, November 21, 1920, *El Imparcial* carried news of the university's award under the headline "Homenaje obligado [A Required Tribute]: La Universidad Central y Mr. Huntington."[46]

The question of the requirement for him to receive the doctorate in person was nevertheless not ultimately resolved until 1926, when a letter from the rector to the king's secretary finally confirmed a decision in Huntington's favor "as an exceptional concession."[47] Such a decision seems to have been possible only because of the loophole that the rector himself had left open in 1920 regarding the obligation upon Huntington to attend, which was to defer to the wishes of the monarch. "Notwithstanding what has been said," Rodríguez Carracido had written to the king's secretary during the initial dispute, "if H.M. the King desires that the request from Sr. Riaño be satisfied, I am his unconditional servant, and in the Rectorate, as everywhere, I am entirely at his command."[48]

Huntington did not forget the support given by the king and found another opportunity to respond accordingly in connection with one of the "star projects" of Alfonso XIII: the construction of the Ciudad Universitaria, or "University City," in Madrid, one of the most important schemes of the 1920s. Madrid needed a university campus in which to locate buildings for all its different faculties, currently dispersed around various parts

45. Minutes of a meeting of the Faculty of Philosophy and Letters of the Universidad Central de Madrid, Nov. 20, 1920, R. Alfonso XIII, 12422/8, AGP. The nineteen voting professors included the count of Las Navas, José Ramón Mélida, Ramón Menéndez Pidal, José Ortega y Gasset, Miguel Asín Palacios, Manuel Gómez Moreno, and Emilia Pardo Bazán, all of whom were friends or associates of Huntington.

46. *El Imparcial*, Nov. 23, 1920.

47. José María Rodríguez Carracido to Emilio María de Torres, Mar. 29, 1926, R. Alfonso XIII, 12422/8, AGP.

48. José María Rodríguez Carracido to Emilio María de Torres, Apr. 28, 1920, R. Alfonso XIII, 12422/8, AGP.

of the city. The creation of the new campus was instituted by the Royal Decree of May 17, 1927, in response to an initiative from the king, and the district of La Moncloa, in northwestern Madrid, was chosen to be its location.[49] The architect, Modesto López Otero, proposed an imposing urban ensemble articulated around broad axial streets surrounded by extensive gardens, with the intention of creating a "city of knowledge" along the lines of the university campuses of other European countries and the United States. Work began on the scheme in 1928, and to obtain sufficient financing a varied program of cultural activities was initiated, including a fundraising gala at the Metropolitan Opera in New York.

Enthusiastically involved in the promotion of the new structures in the Ciudad Universitaria, King Alfonso sent the Spanish prima donna Lucrezia Bori with his personal recommendation to dine at the Huntingtons' New York residence. Her mission was to explain to Archer and his second wife, the sculptor Anna Hyatt Huntington, the plan for a gala performance to be held at the Metropolitan on November 15 to raise funds for the University City of Madrid, with a performance of *La Traviata*. On this occasion, Huntington made his first donation of $5,000 to the cause, the equivalent of around $75,000 at current values. This opera performance was one of the principal events held during the New York visit of Prince Alfonso de Orléans, King Alfonso's cousin, and his wife, Princess Beatriz. They were accompanied by their son, Álvaro de Orléans y Borbón, the marquis of Villavieja, and the marquis's daughter, Pomposa de Escandón.

The Huntingtons, in deference to the king, accompanied the royal party on various occasions during their stay in New York and hosted a reception in their honor at the Hispanic Society. In her diary, Anna Hyatt Huntington recorded some anecdotes about the princess and her husband and the good reaction the whole party seemed to show to the statue of El Cid she had sculpted to send to Spain for the Ibero-American Exhibition of 1929 in Seville. "They all seemed to like my *Cid* very much, which was

49. Carolina Rodríguez-López, ed., *Paisajes de una guerra: La Ciudad Universitaria de Madrid* (Madrid: Servicio de Publicaciones de la Universidad Complutense, 2015).

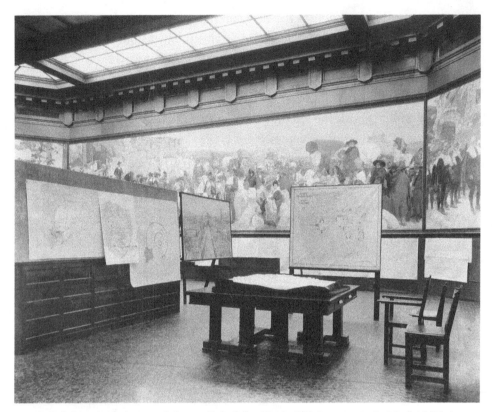

7. Exhibition of plans and the model of the Ciudad Universitaria de Madrid (University City of Madrid) in the Sorolla Room of the Hispanic Society of America, New York, 1928. *Source*: Courtesy of Blanca Pons-Sorolla.

a pleasure to me, as doing the heroes of another nation is rather uncertain if one is going to please the nation."[50]

In addition, Huntington also offered the use of the Hispanic Society building to the secretary of the Board of Construction of the Ciudad

50. Anna Hyatt Huntington, diary entry, Nov. 16, 1928, AHHP, SCRC, quoted in Mary Mitchell and Albert Goodrich, *The Remarkable Huntingtons, Archer and Anna: Chronicle of a Marriage* (Pawleys Island, SC: Litchfield, 2008), 39. As these authors indicate, the large bronze statue of El Cid Campeador on horseback was expressly designed for the Seville Exhibition of 1929, even though another full-size casting had already been installed and unveiled in front of the Hispanic Society building in New York in August 1927.

Universitaria, Florestán de Aguilar, to host an exhibition on the project when he visited New York. Huntington not only provided the Hispanic Society rooms and coordinated the exhibit's preparation with carpenters, electricians, and other technicians to ensure it would benefit from the best possible conditions but also held a dinner in the society's Sorolla Room—which by then already contained the series of giant paintings commissioned from the artist, *Las regiones de España*, better known since then as *Vision of Spain*—during Aguilar's visit so that the Friends of the Hispanic Society could have a special viewing of the eighty drawings and a model of the University City that Aguilar had brought with him. In accordance with his customary generosity and liberality in any initiatives promoted by Alfonso, Huntington also made use of the occasion to give the king a further demonstration of his fidelity to the Spanish cause by presenting Aguilar with another check for $100,000 toward the building of the Ciudad Universitaria, a not insignificant sum that today would amount to around $1.6 million.

This new gesture of friendship from Huntington was reported to Madrid by the new Spanish ambassador in Washington, Alejandro Padilla, who requested from the king's secretary that a further honor be awarded in recognition. "I believe that not just a Grand Cross, whether that of Isabel the Catholic or Alfonso XII, but also and above all some personal memento from the King would be very opportune," he wrote.[51] The new ambassador did not know that Huntington already had the Grand Cross of Alfonso XII, the Order of Carlos III, and the Order of Isabella the Catholic.

The Ciudad Universitaria and the availability of university education were two of Alfonso XIII's primary concerns, and, perhaps through emotional contagion, they also occupied Huntington's mind. Only a month after he made this major donation to the construction of the new campus, the Spanish press reported another, anonymous endowment for the creation of a chair (*cátedra*) of "American literature" at the Central University of Madrid, to the value of 631,000 pesetas (equivalent to around

51. Alejandro Padilla to Emilio María de Torres, Feb. 25, 1929, R. Alfonso XIII, 12422/8, AGP.

$1.15 million today).⁵² "It is the wish of the anonymous donor," *La Época* explained, "that this amount should be registered as a contribution to the Ciudad Universitaria from the 'Spanish Society' of New York."⁵³

There still remained one last opportunity for Huntington to support the king's projects in Spain. With the aim of reaffirming a spiritual and potentially commercial unity between Spain and Hispanic America, Alfonso XIII had been a prime mover behind the proposal to hold an "Ibero-American exposition" in Seville, which after many delays finally took place in 1929. As he had written in one of his diaries in his adolescence, "If the Kings of Spain had been the lords of South America, I now want to be their brother and friend."⁵⁴ For this purpose, he promoted the construction of large pavilions and new tourist infrastructure, such as the Hotel Alfonso XIII, to welcome the eighteen countries that would be represented in Seville, the United States among them.⁵⁵ Huntington could not fail to take part in this great royal project and arrived in Spain with Anna on March 30, 1929.

As their contribution to the exhibition, the Huntingtons presented to the city of Seville the superb statue of El Cid Campeador on horseback sculpted by Anna Hyatt Huntington.⁵⁶ Anna was a prestigious sculptor,

52. Miguel Fernández de Sevilla Morales, "Historia jurídico-administrativa de la Ciudad Universitaria de Madrid," PhD diss., Universidad Complutense, Madrid, 1995, 312.

53. *La Época*, Jan. 7, 1929. However, for reasons that are not entirely clear, no such chair of American literature was established in 1929, and the idea was not revived and put into practice until twenty-five years later, in 1954 (see chapter 6).

54. Quoted in Paloma Nogués Blasco, *Alfonso XIII: Biografía histórica* (Madrid: Sílex, 1995), 112.

55. In *El despertar de la gran potencia: Las relaciones entre España y los Estados Unidos (1898–1930)* (Madrid: Biblioteca Nueva, 2011), José Antonio Montero Jiménez gives a detailed account of the US participation in the Seville Exhibition (350–54). Although the Seville fair was directed primarily at the Spanish-speaking former Spanish colonies in the Americas—all of which attended except Nicaragua and Honduras, each with its pavilion—Portugal, Brazil, and the United States were also invited to take part and did so with their own pavilions. Other pavilions represented the provinces of Andalusia, different Spanish regions, and the city of Barcelona.

56. Archer Huntington to Marqués de la Vega-Inclán, Apr. 15, 1928, R. Alfonso XIII, 12422/8, AGP.

and after her marriage to Archer in 1923 they had decided to embark upon this project together, bringing together Hispanism and sculpture. Aware of the fascination the figure of El Cid aroused in her husband, Anna wished to create a large-scale sculpture of the medieval hero, a goal she successfully achieved.

King Alfonso decided the location for the statue, the square that welcomed visitors to the exhibition, and the Huntingtons attended its inauguration.[57] They also presented the city authorities with two paintings by the seventeenth-century Seville painter Juan de Valdés Leal and in return were named adoptive son and daughter of the City of Seville. For his part, in recognition of these gifts, Alfonso invited the Huntingtons to dine at El Escorial palace and awarded Anna the Grand Cross of Alfonso XII.[58]

In 1929, this "odd couple" made up of a sixty-year-old American philanthropist and a forty-three-year-old Spanish king enjoyed their last opportunity to meet face to face and collaborate in the support of Spanish culture, a task that both had taken up as their own from two different continents and around which they had built their friendship. Theirs was a very ritualized relationship, which enabled them to modulate and articulate their shared emotions not only through words but also through symbolic gestures and which over the years contained numerous demonstrations of respect for the institutions each represented as well as signs of personal appreciation and mutual gratitude. In contrast to the epistolary evidence of Huntington's other relationships, there are scarcely any surviving personal letters between the king and Huntington—they always contacted each other through third parties—but there are traces of personal meetings in which they lunched together and discussed projects at the palace or at the home of the marquis of Vega-Inclán, which offered a more relaxed atmosphere. Looked at more generally, their relationship can be seen as one

57. Rosario Márquez Macías, "Los Huntington en la España de 1929: Una crónica a través de la correspondencia privada," in *Diplomacia y acción cultural americana en la España de Primo de Rivera*, ed. Pilar Cagiao Vila (Madrid: Marcial Pons, Universidad Michoacana de San Nicolás de Hidalgo, 2020), 115–33.

58. Emilio María de Torres to Archer Huntington, Apr. 27, 1929, R. Alfonso XIII, 12422/8, AGP.

based in a series of exchanges and demonstrations of respect and power of a style characteristic of a broader framework of relationships between aristocrats and intellectuals that typified social life in the Spain of the monarchy in the first decades of the twentieth century.

Circles of Aristocracy

Huntington had a different relationship with many Spanish aristocrats, some of whom became his dearest friends. The most singular case was the marquis of Vega-Inclán, an affable and cultured figure whose personality had a powerful attraction for Huntington in good part because of the marquis's very different way of life. As Marañón recalled later, "I think I can state confidently that the Marquis of Vega-Inclán was the person who, among Spaniards, enjoyed the greatest intimacy with, and trust and affection from, the American art patron."[59] It is difficult to determine how and when Huntington and the marquis first met, although they could easily have initially encountered each other in one of the many aristocratic circles among which Huntington customarily moved in Spain.

The marquis not only became Huntington's friend and principal interlocutor in contacts with the king but also, as Vega-Inclán himself said in his letters, acted as the American's agent and proxy in Spain. "As many assignments as you entrust to me will be completed . . . for it gives me the greatest pleasure to be your proxy in this old world. If only for this, let us hope our dear Marañón can prolong my days and my nights."[60]

Benigno de la Vega-Inclán (1858–1942) was at different times a soldier, a politician, a member of both the Royal Academy of History and the San Fernando Academy of Fine Arts, a patron of the Prado Museum, a member of Spain's official archaeological authority (the Junta Superior de Excavaciones y Antigüedades, or Superior Council of Excavations and Antiquities), the creator of his own cultural foundation, a painter, poet,

59. Marañón to García-Mazas, Sept. 5, 1957, reproduced in García-Mazas, *El poeta y la escultora*, 474.

60. Marqués de la Vega-Inclán to Archer Huntington, Feb. 22, 1931, box 56, AHHP, SCRC.

collector, and antiquarian. These were all aspects of a restless personality who was "detached, without any desire for money, without family concerns, who lived austerely without regard for financial questions."[61] He lived in a rented apartment on the little Plazuela de los Afligidos in central Madrid, and his sources of income were not ample enough to sustain the same style of life as the friends with which he spent his time, whose financial resources were customarily much greater. Even so, between 1900 and 1905 he spent much of his time in Paris, London, and Berlin, which enabled him to establish contacts with artists and collectors and develop a role as an art dealer. The marquis sought "to ensure that these European visits, and any subsequent travels abroad after his return to Spain in 1905, coincided with the annual visits of the founder of the Hispanic Society of America, Archer Huntington, who came to France nearly every spring."[62] They sometimes toured the artistic centers of Europe together, the marquis often invited by his wealthier friend, to see the new artistic trends and observe the latest acquisitions of the era's principal collectors.

Vega-Inclán's closeness to Archer led the American to delegate to the Spaniard some of his undertakings in Spain. The most notable example was in the provision of financial support for the Casa-Museo del Greco in Toledo mentioned earlier, a museum in which cultural value was combined with a marked appeal for tourism, which combined perfectly with some of the marquis's other responsibilities as from 1911 Spain's royal commissioner for tourism. It was Vega-Inclán who in 1905 had acquired the near-ruined building that Bartolomé Cossío had identified as one that *could* have been the home of El Greco and donated it to the state. One successful aspect of the careful restoration of the house was that it re-created through delicate craftsmanship a typical building of Renaissance Toledo.

Huntington also wished to establish new links with Spain on an institutional level and was again inclined to seek to build alliances around the

61. Begoña Torres González, "El Marqués de la Vega-Inclán, coleccionista," *Goya: Revista de arte*, no. 267 (1998): 336.

62. Isabel Ortega Fernández, *Benigno Vega-Inclán, marqués de la Vega-Inclán: Mariano Benlliure Gil, 1931* (Madrid: Museo del Romanticismo, La pieza del mes, March 2013), 16.

projects promoted by the ever-active marquis. His letters to Sorolla and Vega-Inclán from 1911 indicate that he was then evaluating the possibility of creating a branch of the Hispanic Society of America in Spain. Once again it was Vega-Inclán who with great enthusiasm took the initiative of presenting the idea to Alfonso XIII and then to Prime Minister José Canalejas, reporting back to Huntington, "[The king] considered it highly suitable that such a bond should be created, in order to demonstrate effectively the friendly relations that should exist between the Hispanic Society and this fraternal association [a branch of the Hispanic Society in Spain]. His Majesty wished to know in detail the manner in which this idea could and should be developed, and charged me with undertaking whatever actions I consider convenient, after first presenting them to the government."[63]

However, the impossibility of Huntington traveling to Spain immediately to formalize the statutes and regulations of the new institution caused the project to be pushed back into the spring of 1912, not without expressions of regret from the marquis, who observed in the same letter, "I have always deplored not being able to do things immediately, due to how short life is and how rare are the occasions to achieve things. The date for the creation of this enterprise, which I consider of such importance, is, then, deferred."[64]

When Huntington next returned to Spain in June 1912, he discussed once again with his circle of close friends the idea of creating some sort of institution to represent the Hispanic Society within Spain. As he recorded in his diary, while he was with Sorolla, Vega-Inclán, and Guillermo de Osma, "I put my scheme of a small museum at Palos for the Sociedad Americana de España to manage."[65] The scheme for a museum in Palos, the small port in Andalusia from which Columbus had set sail in 1492, did not see the light of day, but Vega-Inclán helped Huntington redirect his desire for cultural collaboration toward the Casa-Museo de Cervantes in

63. Marqués de la Vega-Inclán to Archer Huntington, Nov. 10, 1911, R. Alfonso XIII, 15630/5, AGP.

64. Marqués de la Vega-Inclán to Huntington, Nov. 10, 1911.

65. Diary entry, July 1, 1912, AMHA, also in "Apéndice," in *Sorolla y la Hispanic Society*, 403.

Valladolid. A letter from the marquis in October 1912 confirms the financial contribution made by Huntington: "I have received the letter that you sent to me with a cheque for 50,000 francs [equivalent to $254,573 today] for the acquisition of the House of Cervantes in Valladolid. I accept the lofty mission with which you honor me, and with my best intent and all my enthusiasm I will seek to carry out and develop this idea of which we have spoken so much."[66]

In addition to acting as an institutional and personal liaison for Huntington, in his letters Vega-Inclán also shows himself to have been a loyal defender of Alfonso XIII. This can be seen, for example, in the letter he sent following the revolutionary general strike of August 1917—the impact of which endangered not just the Conservative government of Eduardo Dato but also the entire system of the Bourbon Restoration—with which he sought to calm Archer regarding the alarming reports that had appeared in the press.

> I suppose that news and notions of news will have reached you there, don't pay much attention to it, without this meaning either that we should just cross our arms [and do nothing] either. The King is today the same as he was yesterday, good and honest and an enthusiastic Spaniard and profoundly stimulating and with the qualities to win the love of his people. . . . Except for the same thing that I have been fearing for a long time, which is a big railroad strike, nothing serious or of transcendental importance has happened here, nothing that is not just the chronic disease of politics and politicians that Spain has been suffering for years and centuries.[67]

Vega-Inclán's observations had great influence on Huntington. Spain was experiencing political and social change on a dramatic scale, which accelerated in the course of the 1920s. The government of General

66. Marqués de la Vega-Inclán to Archer Huntington, undated, Correspondence of 1912, AMHA.

67. Marqués de la Vega-Inclán to Archer Huntington, undated, Correspondence of 1917, AMHA.

Miguel Primo de Rivera, who suspended the Constitution and established a dictatorial regime with the king's effective consent in 1923, was increasingly challenged by intellectuals, and the role of the monarch himself was called into question. The tensions in the country around the king rarely come through in the marquis's letters, however, which reveal above all an energetic man who stayed rooted in the immediate present or delighted in recalling past events he had shared with his American friend in their most productive years.

The familiarity between them can certainly be seen in their letters, particularly those written around the time of Archer and Anna Huntington's last visit to Spain in 1929. Vega-Inclán had once again acted as intermediary in the presentation to Seville of Anna's equestrian statue of El Cid and had been responsible for coordinating the creation of its supporting pedestal with Mariano Benlliure, paid for by Huntington with a transfer of $10,000 (approximately $130,000 today). He also supervised the preparation of the commemorative inscriptions with Ramón Menéndez Pidal. "At this very moment," he wrote to the king's secretary, "the inscriptions I entrusted to Menéndez Pidal, who is a wizard at preparing documents, are being engraved." In this same letter of April 1929, the marquis, who had taken charge of accompanying the Huntingtons in their visits around Spain, also gave an outline of their itinerary:

> I received the telegram [from the King] when we arrived at Algeciras, and it caused him [Huntington] the deepest emotion to receive the warm greetings from His Majesty. Afterward I left them quietly in Seville for a few days so they could do as they please, having offered them the hospitality of my home. Now I am about to go and look for them in order to return to Madrid via Extremadura. Since I have things to do in Mérida I prefer to wait for them there tomorrow, Saturday. We will sleep in Trujillo and then I expect to be in Madrid by Sunday afternoon. They will stay at the Ritz.[68]

68. Marqués de la Vega-Inclán to Emilio María de Torres, Apr. 5, 1929, R. Alfonso XIII, 12422/8, AGP.

8. Archer M. Huntington and the marquis de la Vega-Inclán, c. 1929. *Source*: Box 95, "Photographs Family Huntington, Archer," Anna Hyatt Huntington Papers, Special Collections Research Center, Syracuse University Libraries. By permission of Syracuse University Libraries.

Vega-Inclán gave Archer and Anna the use of his own house in Seville during their stay in the city and when accompanying them to their rooms apparently commented a little sarcastically, "Forgive us, Sr. Archer, but here in Spain cabinetmakers do not expect guys [tíos] as tall as you, and you are going to have to sleep with your feet over the siderail or between the footposts, otherwise you'll just have to sleep with your legs bent up."[69] The story went on that when Archer went to bed, he did actually break the bed and fell onto the floor, which led Vega-Inclán to add, "Now you will have to sleep on the floor, Don Archer, because our Spanish cabinetmakers equally didn't expect to have to make beds for individuals who weigh 300 pounds."[70] Comments like this, passed on in the conversations Huntington had with José García-Mazas during the last years of his life, indicate the kind of confidence that existed between the New York collector and Vega-Inclán.

Vega-Inclán also gave the king's secretary his immediate impressions of Huntington's second wife, writing that she was "very discreet, modest, and, it seemed to me, a woman of great understanding and culture."[71] Anna Huntington for her part recorded in her diary her first impressions of the marquis as a man who was "old-fashioned in appearance, surprisingly strong, animated and agreeable; he speaks French almost as badly as I do, but more fluently, and wears blue glasses."[72]

One could recount many other anecdotes as well because the correspondence that passed between Archer and Vega-Inclán was particularly abundant, but those already mentioned are sufficient to give an idea of the significance of the friendship between these two men in Restoration Spain. This relationship continued up to the death of the marquis in 1942, but in different circumstances marked by the exile of Alfonso XIII, the arrival of the Second Republic, and the outbreak of the Spanish Civil War.

Another aristocratic friend with an attitude who encouraged greater understanding between aristocratic and court circles and the intellectual

69. Quoted in García-Mazas, *El poeta y la escultora*, 467.
70. Quoted in García-Mazas, *El poeta y la escultora*, 467.
71. Marqués de la Vega-Inclán to de Torres, Apr. 5, 1929.
72. Quoted in Mitchell and Goodrich, *The Remarkable Huntingtons*, 45.

world was Jacobo Fitz-James Stuart y Falcó, Duque de Alba (1878–1953). The duke was perhaps the person with whom Huntington maintained the longest-lasting relationship in Spain, spanning from 1898 to 1953, fifty-five years of relations that were intermittent but grew in closeness and warmth. Thanks to Alba's charisma and the interests they shared, they continued to correspond with each other until the duke's death in 1953, two years before Huntington's.

A politician, diplomat, courtier, art patron, and historian educated in England, the duke of Alba published several books and was one of the most culturally active members of the Spanish aristocracy. Among many other institutions, he collaborated in joint ventures with the distinctly liberal Residencia de Estudiantes. He had a great regard for the Residencia's director, Alberto Jiménez Fraud, and served as chairman of the Comité Hispano-Inglés (Spanish-English Committee), founded by Jiménez Fraud in 1922 to improve cultural relations between Spain and Great Britain.[73] The stone bench dedicated to the duke of Alba that stands outside the Central Pavilion of the Residencia is the best evidence of the gratitude the institution showed him in his day.

Huntington met the duke in one of his first visits to Spain, in the *tertulias*, or informal gatherings, at the palace of the marquis of Jerez de los Caballeros in Seville in 1898; Archer mentioned Alba as one of those present in his diary.[74] The earliest surviving letters between them date from 1911. Since at this time Huntington was engaged in completing his collections of paintings, decorative arts, maps, and books, the letters between him and Alba often dealt precisely with items that seemed likely to be of interest to Huntington and that other Spanish aristocrats were seeking to sell. One example was the offer from the duke of Veragua of a set of documents

73. Despite his friendship with the duke, Jiménez Fraud was one Spanish cultural figure whom Huntington apparently did not know directly, nor did they meet during his visits to Spain. See Duque de Alba to Archer Huntington, Feb. 1, 1936, box 7, AHHP, SCRC, and the mention of Jiménez Fraud's visit to New York in chapter 4.

74. "The Duke of Alba had sent a batch of books from Madrid with new ideas and new attributions. But it was the books that added skylight with the sun to the room!" (Diaries of 1898, AHMA).

signed by Columbus and the Catholic monarchs Ferdinand and Isabella. Alba proposed to Huntington that their purchase by the Hispanic Society would be the best possible option because the Spanish state did not have the funds available to buy them, so the alternative was that they would be sold to the famous German bookseller Karl W. Heisserman. As Alba put it, "A natural feeling of patriotism would advise him [the duke of Veragua] to offer them to the Government so that they might not leave Spain, but he knows that unfortunately the resources of the State for acquisitions of this kind are very scarce. . . . However the Duke, if it is not possible for them to remain in Spain, would be distressed to see them go to Germany or any other nation rather than America, almost the second homeland of Columbus, and [within the continent], to you, such a lover of the glories of Spain and the generous founder of the Hispanic Museum, which you could greatly enrich by giving accommodation to such precious originals, worthy of their value."[75]

Actively involved in a great variety of cultural activities in the Spain of Alfonso XIII, the duke was equally acquainted with a range of scholars and intellectuals and so often kept Huntington informed on the latest research in science and the arts presented in lectures at the Residencia de Estudiantes, which invited to Madrid speakers of the stature of Marie Curie, Albert Einstein, and Howard Carter, the discoverer of the tomb of Tutankhamen. Another instance involved the newly published studies by the anthropologist Hugo Obermaier of the cave paintings at Altamira in Cantabria, which Alba recommended to Huntington in late 1926, adding, "I hope you will tell me that you will visit them [the caves] during your next visit to Spain."[76]

The duke's knowledge of the artistic scene in Spain was also substantial, so that after the death of Joaquín Sorolla in 1923 he was able to recommend to Huntington another painter, José López Mezquita, who from 1926 became a replacement for Sorolla and one of Huntington's closest

75. Duque de Alba to Archer Huntington, Feb. 14, 1911, Correspondence of 1911, AMHA.

76. Duque de Alba to Archer Huntington, Nov. 12, 1926, Correspondence of 1926, AMHA.

collaborators. "Many thanks for the cordial welcome you have given the painter I recommended, López Mezquita," Alba wrote subsequently, "who, in effect, is very satisfied with his stay in New York, and the reception and assistance given him by yourself."[77]

The duke and Huntington had in common that their wives suffered from the same disease, tuberculosis. However, whereas the duchess of Alba died after a long convalescence in 1934, Anna Huntington succeeded in making a near full recovery during the same period after time spent convalescing in sanatoriums in Switzerland and the United States. This appears to be one reason why, in the letters between the two men, beyond simple expressions of courtesy, there were always some more personal words from Alba asking about the health of Anna and from Archer some affectionate lines of concern for the duke's daughter, Cayetana.

Anna Huntington recorded in her diary some observations on the duke, whom she met for the first time during her visit to Spain in 1929. According to Anna, it appears that Alba, flattered by her promise that she would use his face as a model for one of the sculpted reliefs she was creating for the esplanade outside the Hispanic Society building, hurried to send her several photographs of himself.[78] Shortly afterward he also sent to New York a full-length portrait of himself by Fernando Álvarez de Sotomayor. While it was still en route, Archer Huntington wrote back, "Sotomayor is an excellent painter, and I am sure would have done his best on a portrait of you. We are all looking forward to seeing it with the greatest pleasure and anticipation."[79] The fact was, however, that Huntington had actually wished to acquire the portrait of the duke of Alba painted by Sorolla many years earlier, but Alba liked it so much he did not wish to give it up, and so a new portrait had to be commissioned from Sotomayor.[80]

77. Duque de Alba to Huntington, Nov. 12, 1926.
78. Anna Hungtington, diary, 1929, in Mitchell and Goodrich, *The Remarkable Huntingtons*, 48.
79. Archer Huntington to Duque de Alba, Jan. 3, 1930, box 7, AHHP, SCRC. Huntington and Alba most frequently wrote each other in Spanish, but this letter was in English.
80. The Sotomayor painting is shown in "Catálogo. Fernando Álvarez de Sotomayor, *El duque de Alba*, 1929" (painting), in *De Goya a Zuloaga*, 154.

Anna also recorded her emotions on attending the ceremony to admit the duke of Alba to the Order of Santiago, to which Alba invited the Huntingtons during their stay in Madrid in 1929 and where she was greatly impressed by the solemn rituals involved.[81] It seems clear that during this visit Anna won the appreciation of many of her husband's Spanish friends as he, in what would be his last visit to Spain, reaffirmed his own friendships with many of the prominent personalities that he had first met years earlier.

Guillermo de Osma, Conde de Valencia de Don Juan (1853–1922), was another aristocrat to whom Archer Huntington was particularly close. Educated at the Universities of Oxford and Paris (the Sorbonne)—he and Huntington nearly always wrote each other in English—he had performed a variety of roles as a diplomat and politician. He was also a member of the Real Academia Española Ciencias Morales y Políticas (Royal Spanish Academy of Moral and Political Sciences) and a great expert on archaeology, an interest he shared with his American friend.

Osma's collecting was directed toward artistic artifacts that were not usually a focus of interest at the time, such as ceramics, ivories, embroidery and other textiles, and objects in jet or bronze, and his erudition on these decorative arts led him to publish several books based on research into his collections. The purpose of the foundation and associated museum he and his wife created in Madrid in 1916 to house their collections, the Instituto Valencia de Don Juan, was to assist scholars and students, and he had no ambition whatsoever to "vulgarize" culture, regarding which his museum and the Hispanic Society were entirely in accordance. In fact, it seems possible that the Hispanic served as a model to Osma for his foundation.

The Catalan art historian Josep Pijoan best described the relationship between Huntington and the count. "Above all, his great friend was Osma," he wrote. "Both were tall, and if you saw them side by side they looked like twin brothers. Osma adored Huntington, and every year, for

81. Anna Hungtington, diary, 1929, quoted in Mitchell and Goodrich, *The Remarkable Huntingtons*, 48.

Christmas, Huntington sent him a present fit for a prince. I remember the emotion with which one year he received a Hispano-Arabic ceramic plate that Huntington had negotiated to buy in London."[82]

Thanks to the friendship and confidence between them, in early 1915 Huntington asked for Osma's advice on the appointment of a lecturer in Spanish at Columbia University: "He should be an outstanding scholar, a gentleman and a teacher. The salary is between $4,000 and $5,000."[83] Osma recommended a young philologist and literary scholar, Federico de Onís, for the post. After Huntington met Onís, he, too, wished for him to accept the position because he believed this position at Columbia could represent a first step in the improvement and development of Spanish-language teaching in the United States. "I am sure," he wrote back to Osma, "that Sr. Onís is just the man who could meet the requirements of Columbia, and be able to use his influence to improve the condition of the teaching of Spanish and Spanish literature in this country."[84] Federico de Onís, who would remain at Columbia for nearly forty years and become one of the great pillars of Hispanic studies in America, recalled many years later that he had first met Guillermo de Osma at Osma's house in Madrid, "which had already been converted into the foundation called Museo Valencia de Don Juan, and we talked about the possibility of my going to the United States in response to the request from Huntington and President [Nicholas Murray] Butler [of Columbia University]."[85]

In Huntington's letters to Osma, one can see the importance that Huntington gave to the collections of photographs received by the Hispanic Society as a means of documenting Spanish culture and providing

82. Quoted in García-Mazas, *El poeta y la escultora*, 499.
83. Archer Huntington to Guillermo de Osma, Jan. 3, 1915, quoted in María Ángeles Santos Quer, "La correspondencia epistolar de Archer M. Huntington con Guillermo de Osma y Javier García de Leaniz," *Cuadernos de arte e iconografía* 14, no. 47 (2015): 225.
84. Archer Huntington to Guillermo de Osma, May 24, 1916, quoted in Santos Quer, "La correspondencia epistolar," 226.
85. Federico de Onís, "Huntington y la cultura hispánica," in *Huntington, 1870–1955* (Washington, DC: Organization of American States, Comité Interamericano de Bibliografía, Pan-American Union, 1957), 19.

answers to the many questions about its different aspects. "We must have photographs and photographs and more photographs," he wrote in late 1920. "It is the very thing which reaches the general public and instructs it regarding Spain, and is of course of the greatest value to the real worker. We have 28,000, and should have 100,000 at least."[86] It was especially important, in his opinion, to have a collection of "photographs of distinguished men." "My idea regarding this is simple," Huntington wrote to Osma in the summer of 1920.

> The Society is continually asked by people to show [them] portraits of (living or dead) distinguished men of Spain. . . . Could not someone be employed to do this (with you all keeping an eye upon him), but without trouble to you? In that case he might be able to get the photographs in some cases signed by their subjects. I am anxious to furnish all possible information of this kind, because the French Societies and others do it, and it is so hard to get the Spanish information. While it is not nor was not my idea to give this material to the press, there are occasions when, as in the case of the death of a celebrated man, it would be well to have a portrait published.[87]

Despite Huntington's intentions and Osma's goodwill, this project did not come to fruition, but another joint initiative that was more successful involved the translation into English of several books that had first been published in Spain by the Instituto Valencia de Don Juan. In 1919, Osma had been awarded the Medal of Arts and Literature by the Hispanic Society of America, but his early death in 1922 interrupted a friendship that Huntington nevertheless perpetuated in some form as a member of the institute's board, an honor that he shared with the archaeologist and numismatist Antonio Vives y Escudero, the Arabists Miguel Asín Palacios

86. Archer Huntington to Guillermo de Osma, Nov. 29, 1920, quoted in Santos Quer, "La correspondencia epistolar," 236.

87. Archer Huntington to Guillermo de Osma, July 21, 1920, quoted in Santos Quer, "La correspondencia epistolar," 230.

and Julián Ribera, the politician Antonio Maura, and Huntington's other great friend, the duke of Alba.[88]

Last but by no means least among the members of the Spanish nobility who formed connections with Huntington was Manuel Pérez de Guzmán y Boza, Marqués de Jerez de los Caballeros (1852–1925). Although not strictly part of the political and court circles of Madrid, the marquis held literary *tertulias* at his house in Seville that were frequented by the cream of intellectual life in the 1890s. He was also a politician and a member of the Real Academia Sevillana de Buenas Letras (Royal Academy of Letters of Seville), but most particularly he possessed the finest collection of historic Spanish literature then in existence outside the Biblioteca Nacional (National Library) in Madrid. Both he and his brother, the duke of T'Serclaes, were noted collectors and bibliophiles.

Archer Huntington first met Jerez de los Caballeros in 1898 during his visit to Spain. He was invited to the select gatherings at the Pérez de Guzmán residence in Seville, which his contemporaries had described with admiration.[89]

The erudite atmosphere that the young Huntington experienced at these meetings must have had a strong attraction for him, and he wrote in his diary after one visit to the marquis's home, "As I sat in the high library, with the friends of Jerez, and we discussed these books, it seemed to me that the hero of every romance I have ever read floated out of some early edition and joined the group! . . . It was a wonderful *tertulia*."[90]

88. Guillermo de Osma, who had twice been finance minister in the first ten years of the twentieth century, probably facilitated the first contact between Huntington and the Spanish Conservative leader Antonio Maura (1853–1925), prime minister on five separate occasions between 1903 and 1922 during the reign of Alfonso XIII. The correspondence between Maura and Huntington is in Correspondencia Archer M. Huntington, 79/18, 47/26, and 237/2, Fundación Antonio Maura, Madrid.

89. Rosa Fernández Lera and Andrés del Rey Sayagués, *El marqués de Jerez de los Caballeros y el duque de T'Serclaes: Una broma bibliográfica* (Santander: Biblioteca Menéndez Pelayo, 2007), 14.

90. Diary of 1898, AMHA, quoted in Codding, "Archer Milton Huntington, Champion of Spain," 155.

Huntington had come to Spain in 1898 with the intention of buying books and acquiring something from the splendid collections that could be found there. Hence, he was pleasantly surprised a few years later when the financial demands of a political career led Jerez de los Caballeros, who was mired in debt, to decide to sell his collection in 1901. "Since none of my children have an interest in books, I have decided to sell my library," the marquis wrote to Huntington in 1901.[91] The sale was agreed for 592,500 French francs in 1902 (equivalent to nearly $3 million at today's values). "The books have been packed with the greatest possible care," wrote the marquis, "and every precaution I thought necessary has been taken so that they may arrive in the city [New York] without damage of any kind."[92]

In the years following the sale, Huntington maintained a special appreciation for the marquis. He wrote him on the occasion of the inauguration of the Hispanic Society in 1904, including with his letter a photograph of the main entrance, for which Jerez de los Caballeros thanked him affectionately.[93]

Huntington had achieved one of his dreams in acquiring this library and was convinced that ultimately this purchase would be beneficial for the whole field of Hispanic studies. After all, it meant that the collection would be kept together in the library of the Hispanic Society, without suffering the dismal fate of other important historic libraries in being randomly dispersed.[94]

91. Marqués de Jerez de los Caballeros to Archer Huntington, Sept. 10, 1901, Correspondence of 1902, AMHA.

92. Marqués de Jerez de los Caballeros to Archer Huntington, Feb. 18, 1902, Correspondence of 1902, AMHA.

93. Marqués de Jerez de los Caballeros to Archer Huntington, Dec. 9, 1904, Correspondence of 1904, AMHA.

94. One example was the library of the duke of T'Serclaes, the brother of Jerez de los Caballeros, which Huntington also wished to buy in 1902, but the duke did not agree. When the duke died in 1934, his library was divided into seven lots and split up in successive sales.

Nevertheless, this purchase did not escape controversy. The owners of Spain's artistic and bibliographical treasures were generally members of the aristocracy, who for a variety of causes quite often found themselves obliged to sell them. However, the intellectuals and scholars who had had access to these items could not stand idly by at the sight of them being sold abroad, as in this case. The sale of the marquis of Jerez's library divided opinion.

The Art of Cultivating Cultivated Friends

Among what could be called Huntington's "intellectual friendships" in Spain, two names stand out among his early acquaintances in the country: the multifaceted scholar, historian, and literary critic Marcelino Menéndez y Pelayo (1856–1912), who was perhaps the most eminent literary and academic figure in Spain at the time and who among many other roles would be the director of the Biblioteca Nacional from 1898 until his death in 1912; and Francisco Rodríguez Marín (1855–1943), a distinguished expert on Cervantes who would in turn be the national library's director from 1912 to 1930. It appears that both men first encountered Archer at the *tertulias* of Jerez de los Caballeros in Seville in 1898, and as witnesses to the relationship that had developed between the aristocrat and the collector, both men reacted with the same sorrow and indignation at the sense of loss represented by the sale of the marquis's superb library to Huntington. The correspondence between Menéndez y Pelayo and Rodríguez Marín between 1902 and 1908 is an indispensable source for understanding the impact this transaction had in Spain and then for tracing the change of attitude toward the millionaire Hispanist that could subsequently be seen among the Spanish intelligentsia.

According to Rodríguez Marín, he first met Huntington through the French archaeologist Arthur Engel one Sunday in February 1898, when the latter took him to Santiponce to meet an American who was undertaking archaeological excavations at Italica. "We surprised him in his shirt sleeves," he later recalled, "his big hands, as corresponded to his gigantic height [1.99 meters or 6-foot-6], covered in plaster as he was occupied in

joining together and carefully sticking down the fragments of a beautiful mosaic discovered the previous day."[95]

Yet the same Rodríguez Marín who had appreciated Huntington's knowledge of Spanish history and literature at Santiponce lamented four years later and with much greater emphasis, almost as a personal affliction, the departure of the marquis of Jerez's library for New York. "What a disaster!," he wrote to his friend Menéndez y Pelayo. "To have money is to have everything, and we are poor and the Yankees are rich. They took away our lands, and are taking away our understanding. . . . I loved those books more than their owner did. I am poor, and I would never have sold them. This Mr. Huntington has done us more harm just by himself alone than all his countrymen!"[96]

However, this acquisition began to be seen differently as time went by. Menéndez y Pelayo in particular, although he still considered the sale a disaster for Spain, began to value the gestures with which Huntington was gradually gaining his contemporaries' appreciation. The work of extending knowledge of historic texts that Huntington had initiated in 1897 through the publication of facsimiles of the jewels in his library as the Huntington Reprints and the subsequent creation of the Hispanic Society of America in 1904 as a public museum and library demonstrated that his intention was to make accessible to a wider public collections that until recently had been seen only by a very small elite. And while the Spanish scholarly community of the time might still throw up their hands at his purchases of books, they soon began to look at the practices of the American art patron with a certain interest. As Menéndez y Pelayo wrote candidly to Rodríguez Marín later in 1902,

> I have a great desire to possess the reproductions that Sr. Huntington has made of several Spanish books. [Copies] have arrived at the Biblioteca

95. Francisco Rodríguez Marín, in Víctor Espuny Rodríguez, "Una conferencia de Rodríguez Marín: M. Pierre Paris en Andalucía," *Cuadernos de los Amigos de los Museos de Osuna*, no. 11 (2009): 25.

96. Francisco Rodríguez Marín to Marcelino Menéndez y Pelayo, Jan. 15, 1902, letter 355, Epistolario de Marcelino Menéndez y Pelayo, vol. 16, Biblioteca Menéndez Pelayo (BMP), Santander.

Nacional, and the Academy of History as well, and they seem to me of a typographical perfection that cannot be surpassed.... I do not have any relations directly or indirectly with señor Huntington and I confess to you that I look upon him with deep antipathy, because he has come to Spain to deprive it of its best books, as a means of flaunting his wealth. But, in the end, we have to take whatever we can get; and if he gives us reproductions of some of the things he has carried off, we will at least have gained that.[97]

By 1903, these two scholars had begun to exchange correspondence directly with Huntington, of which they also informed each other. While in his letters to New York Menéndez y Pelayo lauded Huntington's translation of the *Cantar de mio El Cid*, Archer sent further facsimile editions to Madrid. "I have not heard anything from Huntington this summer," wrote the eminent historian; "the last things I received were the magnificent facsimiles of the documents from the British Museum."[98] Rodríguez Marín, for his part, wrote Huntington to ask for copies of the new facsimiles for the Spanish Royal Academy and commented to Menéndez y Pelayo, "I suppose you continue to receive the admirable bibliographical reproductions from Huntington. He is now traveling in South America; however, he wrote me from Lisbon that he will come to Andalusia before December."[99] As a result of Huntington's intelligent and generous initiative regarding the facsimiles, by 1904 attitudes toward him had changed greatly, and Menéndez y Pelayo wrote of him, "How well employed his activities are. When will there be capitalists here who imitate him!"[100]

The mutual admiration between Huntington and Menéndez y Pelayo culminated in an invitation to the latter to form part of the first Advisory

97. Marcelino Menéndez y Pelayo to Francisco Rodríguez Marín, Oct. 22, 1902, letter 362, Epistolario de Marcelino Menéndez y Pelayo, vol. 16, BMP.
98. Marcelino Menéndez y Pelayo to Francisco Rodríguez Marín, Oct. 1, 1903, letter 154, Epistolario de Marcelino Menéndez y Pelayo, vol. 17, BMP.
99. Francisco Rodríguez Marín to Marcelino Menéndez y Pelayo, May 22, 1903, letter 141, Epistolario de Marcelino Menéndez y Pelayo, vol. 17, BMP.
100. Marcelino Menéndez y Pelayo to Francisco Rodríguez Marín, May 11, 1904, letter 442, Epistolario de Marcelino Menéndez y Pelayo, vol. 17, BMP.

Council of the Hispanic Society of America in 1904.[101] This appointment was followed in 1908 by the commissioning of Sorolla to paint a portrait of the great scholar for the society, which Menéndez y Pelayo described with satisfaction in a letter to his brother. "Sorolla has done a magnificent portrait of me," he wrote, "as a commission from Huntington for his library in New York. He himself [Sorolla] will take it to the United States, where he is going to have an exhibition in January, with all his works. He has promised to paint another portrait of me on his return, and let us hope it comes out as well as this one, which seems like something from Goya, in the boldness and frankness with which it has been done."[102]

This change of attitude toward Huntington was also reflected in the Spanish press, with articles such as one from the Barcelona newspaper *La Vanguardia* in 1904:

> There exists a fervent lover of the time-worn history of Spain who at present is doing a great and growing service to the bibliography and literature of our nation with his determination to pursue the fertile proposition of making available, by means of photographic printing, a copious library of rare and curious books. . . . And who is this altruistic and noble spirit, our compatriots will ask as they read these words, this gallant figure who is setting such a beautiful course for Spanish literature? . . . This wealthy New Yorker differs entirely from the eccentric, avaricious, selfish bibliomane, in that he offers the bibliographical gems of his Spanish library, as extensive as it is select, without hesitation, reproducing and gifting them [to us] with a frank and open hand. . . . But on a smaller, more modest, scale, it would be desirable if our own grand and moneyed names took their orientation from this beautiful example offered, in dealing with our own Spanish matters, by this rich Yankee.[103]

101. Archer Huntington to Marcelino Menéndez y Pelayo, Sept. 25 and Nov. 11, 1904, letters 622 and 671, Epistolario de Marcelino Menéndez y Pelayo, vol. 17, BMP.

102. Marcelino Menéndez y Pelayo to Enrique Menéndez y Pelayo, Dec. 5, 1908, letter 5, Epistolario de Marcelino Menéndez y Pelayo, vol. 20, BMP.

103. *La Vanguardia*, Aug. 26, 1904.

The Spanish royal academies also recognized the value of his work, and in 1908 Huntington was appointed a corresponding member of the Real Academia de Buenas Letras de Barcelona (Royal Academy of Letters of Barcelona).[104] His work began to be valued in Spain as that of a philanthropist and truly knowledgeable lover of Spanish art, literature, and letters, who was collaborating with his initiatives through the Hispanic Society in the effort to free Spain from what was seen as its greatest burden: its isolation, in international terms, from the contemporary cultural world.

A vivid illustration of Huntington's regard for the treasures of Spanish literature was given by his rare visit around 1896 to the home of Alejandro Pidal y Mon (1846–1913), the eminent elderly politician, diplomat, and member of the Spanish Royal Academy, the Royal Academy of History, and the Royal Academy of Moral and Political Sciences. At the time, he was the owner of the original manuscript of the *Cantar de mio Cid*, which had only recently been discovered. Huntington had asked for permission to consult it at Pidal's residence, a request that the latter accepted, flattered by Huntington's great knowledge of Spanish literature.[105] His portrait was one of the first commissions Huntington gave to Sorolla, as the artist acknowledged in one of his letters in early 1909: "I have finally managed to get Don Alejandro Pidal y Mon to give me a moment to paint the portrait that in London you expressed a desire for me to paint, [and] I am happy with the portrait."[106]

Huntington's fame as an art collector and patron in Spain only grew, most particularly after he learned of the Valencian painter Joaquín Sorolla (1863–1923) in London in 1908. The two men established a dual-faceted relationship: to the conventional association of patron and painter was added a friendship that lasted until the death of the artist, the final outcome of a stroke that occurred precisely while he was preparing an exhibition for the Hispanic Society, which had been due to open in October

104. *La Vanguardia*, May 30, 1908.
105. García-Mazas, *El poeta y la escultora*, 137.
106. Joaquín Sorolla to Archer Huntington, Jan. 7, 1909, in "Apéndice," in *Sorolla y la Hispanic Society*, 375.

1920. Both shared the same passion for their work, as Huntington recognized in his diary in early 1909. "He [Sorolla] has only one earthly idea and that is his art," he wrote, "It is delightful. He works as I love to work, so all is well between us."[107]

Huntington acquired 272 paintings by Sorolla for the Hispanic Society and assisted very successfully and substantially in advancing Sorolla's reputation in the United States. The recognition Sorolla obtained and the numerous commissions he secured for portraits of wealthy and powerful Americans enabled him to build up a sizeable fortune. Added to this was the commission in 1911 from Huntington and the Hispanic Society for the famous panels presenting the life of Spain through picturesque traditional scenes from most of its regions, initially titled *Las regiones de España* but better known as *Vision of Spain*, which have since been among the society's most celebrated exhibits. For this project, Sorolla signed a contract with Huntington for $150,000, or around $3.5 million today.[108] Totaling more than 70 meters (300 feet) in length, with each panel 3.5 meters (11½ feet) tall, Sorolla's *Vision* represented Archer Huntington's greatest decorative project for the Hispanic Society, the "commission from a giant to a smaller man," as Sorolla described it.[109] With great effort he would devote the last years of his life to these paintings, completing them in 1919.

The relationship between patron and artist can again be followed through their letters: their meetings in Paris, New York, Biarritz, and Madrid and the visit Huntington made in 1912 to the house built for the artist in the center of the Spanish capital—which Sorolla called "his Hispanic Society"—are all recorded.

There is a consensus among historians that Sorolla was Archer Huntington's favorite modern painter, and this was why, among several other reasons, he was awarded the Hispanic Society's Medal of Arts and

107. Diary entry, Jan. 31, 1909, AMHA, quoted in Codding, "Archer Milton Huntington, Champion of Spain," 160.

108. Joaquín Sorolla to Archer Huntington, Apr. 30, 1911, AMHA, also in "Apéndice," in *Sorolla y la Hispanic Society*, 396.

109. Joaquín Sorolla to Archer Huntington, Dec. 10, 1912, AMHA, also in "Apéndice," in *Sorolla y la Hispanic Society*, 396, 404.

Literature as early as 1909. Such was his importance to Huntington that in 1910 Huntington established the Sorolla Medal in his honor as an award to artists and scholars who had distinguished themselves in the field of Spanish art.

Sorolla also played broader roles for Huntington. He acted as intermediary in the purchase of some pictures for the Hispanic Society—as in the case of several works by another modern Spanish painter, Emilio Sala—and his own growing proximity to Alfonso XIII meant that he included in his letters to Archer comments on his conversations with the king and on the interest Alfonso showed in everything related to the Hispanic Society.[110] One example was the episode in 1910 when the king offered Huntington via Sorolla the title *grandee of Spain*, the highest rank in the Spanish nobility, as Archer recorded in his diary. "Sorolla asked me whether I would consider being made a Grandee of Spain. I looked at him in some amazement, not being quite sure whether he was serious or not. He assured me that he was serious. And I had to explain that for an American this was out of the question. I rather think Sorolla did not know exactly what he was suggesting."[111]

Their letters enable us to perceive the degree of familiarity between the two. During their visits to the United States, Sorolla and his family became quite close to Huntington's first wife, Helen, for whom the artist always added some kind words. For his part, Archer reflected in his diaries the affection he felt for the Sorolla family, including his concern upon visiting the painter in Madrid in 1918. "Sorolla is not too well," he recorded. "He is thinner and softer and I am alarmed about him. He kept saying that the [Hispanic Society] had given him his great chance, but there is a general let down, and he is very tired. . . . Poor dear C [Clotilde, Sorolla's wife]. She has had all the trials of family and genius, and her thin

110. Javier Tusell analyzed the relationship between the painter and Alfonso XIII in some detail and asserts that no other artist exchanged letters with the king with the same assiduousness and regularity as Sorolla, "who despite his republican origins changed with the passage of time into an unequivocal monarchist." Tusell, "Joaquín Sorolla en los ambientes politicos," 31.

111. Diary of 1910, AMHA, also in "Apéndice," in *Sorolla y la Hispanic Society*, 388.

little body has put up quite as fine a struggle as that of her distinguished husband. Without her he might have got nowhere."[112]

Huntington also reflected in his diaries on the changes that were taking place in the world of art and, in referring to Sorolla and his work, acknowledged that he, like his Spanish friend, had no wish to adapt his taste to the new era. "In these days when the art pattern is changing for the worse S[orolla] feels the change but he is not discouraged or convinced of a better way. He is Sorolla and that is enough. Well, I agree."[113]

Both men also sometimes met at lunches and meetings with aristocratic friends of Huntington, such as Vega-Inclán and Guillermo de Osma,[114] but Sorolla, who was closer to the more liberal ideas of the Institución Libre de Enseñanza, also gave the American entry to a more intimate group of artists and intellectuals, many of them, like Sorolla, from Valencia. This became another of the significant points around which Huntington continued to broaden his network of friendships in Spain. One such contact was the most prestigious Spanish sculptor of the period, Mariano Benlliure y Gil (1862–1947). Huntington developed a strong relationship with Benlliure, who was also a friend of both Sorolla and the marquis of Vega-Inclán. A member of the San Fernando Academy of Fine Arts and the director of the Spanish Academy in Rome, Benlliure was another leading figure in Spanish cultural life.

Huntington invited Benlliure to show his medal work at the International Exhibition of Contemporary Medals organized by the American Numismatic Society in New York in 1910 and subsequently commissioned from him several bronze busts of significant cultural figures, among them Vega-Inclán, Sorolla, and Gregorio Marañón. When Huntington was in Spain in 1929, he paid a visit to Benlliure's workshop with Vega-Inclán, and together they went on to visit Sorolla's house, which had been left as is

112. Diary entry, Jan. 1, 1918, quoted in Codding, "Archer Milton Huntington, Champion of Spain," 164.

113. Diary entry, Jan. 1, 1918, quoted in Codding, "Archer Milton Huntington, Champion of Spain," 164.

114. Diary entries, June 17 and July 1, 1918, in "Apéndice," in *Sorolla y la Hispanic Society*, 402–3.

after his death. Benlliure was, along with Sorolla's widow, one of the principal champions of the preservation of the house as the Museo de Sorolla (Sorolla Museum) in memory of his friend.

Another artist close to Sorolla but from an older generation was Aureliano de Beruete (1845–1912), who had been a politician before concentrating on his work as an impressionistic painter of landscapes. Beruete's vision of Spanish landscapes connected with the poetic imagery of the Generation of 1898 as well as with regenerationism and the philosophical ideas of the Institución Libre, where he also taught. His book on Velázquez published in 1906, which included a chronological catalog of Velázquez's authenticated works, was very important in opening up new approaches to research and publication in the history of art.[115] Beruete was also one more member of the art world with close connections to Vega-Inclán because he was a member of the boards of the marquis's cultural foundations.

The fact that Huntington wrote to Sorolla asking for information about the death of Beruete in 1912 and that on hearing of it asked him to pass on his condolences to the family indicates once again that Sorolla acted as Huntington's interlocutor with many of his contacts in Spain.[116] We can say that the appreciation between Beruete and Huntington was mutual because the artist left instructions in his will for several of his paintings to be donated to the Hispanic Society, a bequest that was carried out by his son, Aureliano de Beruete y Moret, an art historian and subsequently director of the Prado. These paintings were among the artist's most emblematic works and included *Puente de Alcantara en Toledo* and *Vista del Guadarrama*.

Also a good friend of Sorolla and also from Valencia was Vicente Blasco Ibáñez (1867–1928), one of the most internationally famous of all living Spanish novelists at the beginning of the twentieth century. Although in Spain he had first become famous for his *costumbrista* novels evoking local life and traditional customs, his great success in the United

115. Aureliano de Beruete, *Velázquez* (Paris: Librairie Renouard, 1898), first English edition: *Velázquez*, trans. Sir Hugh Poynter (London: Methuen, 1906).

116. Archer Huntington to Joaquín Sorolla, telegram, and Sorolla to Huntington, letter, both Jan. 17, 1912, in "Apéndice," in *Sorolla y la Hispanic Society*, 401.

States came with later, more wide-ranging titles, such as *Los cuatro jinetes del Apocalipsis* (*The Four Horsemen of the Apocalypse*, 1916). Blasco Ibáñez was responsible for one of the best known of the phrases inscribed on the columns of the Hispanic Society in remembrance of his visit to New York: "A Temple raised to the glory of Spanish Civilization. If some cataclysm were to cause our peninsula to disappear, Spain would continue to exist in America, thanks to the noble and generous Españolismo of this great American."[117] According to letters from Sorolla, in 1910 Archer had also been interested in acquiring the rights for an English translation of one of Blasco Ibáñez's most successful novels, *Sangre y arena* (1908), a project that did not come to a successful conclusion, although it was translated into English later.[118]

Several other notable writers who were friendly with Sorolla also came to know Huntington, such as Pío Baroja (1872–1956), a novelist of the Generación del 98, and Jacinto Benavente (1866–1954), the playwright and future winner of the Nobel Prize for Literature, who after meeting the American collector asked Archer to send him some of his own poetry so that he could read it.[119] Both were among the many guests invited to a dinner in Huntington's honor at Sorolla's home in 1912—"an intimate artistic dinner dedicated to our great Huntington," as Sorolla described it.[120] Huntington also recorded this evening in his diaries: "Then, a grand dinner with the Sorollas. He had gathered half the literary men in Madrid, and some of them I had never met."[121]

Of the guests on this occasion, Huntington showed particular appreciation for José Echegaray (1832–1916), the venerable former politician,

117. Quoted in *A History of the Hispanic Society of America: Museum and Library, 1904–1954* (New York: Hispanic Society of America, 1954), 52.

118. Joaquín Sorolla to Archer Huntington, Dec. 24, 1910, AMHA, also in "Apéndice," in *Sorolla y la Hispanic Society*, 390. *Sangre y arena* was eventually published in English as *Blood and Sand* by E. P. Dutton in 1919 with great success.

119. Joaquín Sorolla to Archer Huntington, undated, AMHA, also in "Apéndice," in *Sorolla y la Hispanic Society*, 408.

120. Joaquín Sorolla to Marquis of Viana, undated, Archivo del Museo Sorolla, Madrid, courtesy of Blanca Pons-Sorolla.

121. Diary entry, June 19, 1912, Diaries of 1912, AMHA.

mathematician, engineer, and dramatist, who had received the Nobel Prize for Literature in 1904. Huntington admired his literary works, and, accordingly, Echegaray sent Huntington signed copies of his plays *El gran Galeoto* (1881) and *Mariana* (1892). Archer thanked him effusively, referring to the books as "two old friends of mine."[122]

Another prominent figure at Sorolla's dinner was Emilia Pardo Bazán, Condesa de Pardo Bazán (1851–1921), a novelist, literary figure, proponent of women's rights, and the "grande dame of Spanish nineteenth-century letters."[123] She received the Hispanic Society's Medal of Arts and Literature in 1913, a year after she had been refused admission as a woman to the Spanish Royal Academy for the third time.[124]

It is no surprise that the eminent historian Rafael Altamira (1866–1951) was another of the guests at Sorolla's dinner because he was a good friend of Pardo Bazán, Blasco Ibáñez, and of course Sorolla.[125] Internationally renowned as a jurist as well as a historian, Altamira was also a noted

122. Archer Huntington to José Echegaray, 1911, in "Catálogo. Retratos: 82. José Echegaray y Eizaguirre," in *Sorolla y la Hispanic Society*, 339.

123. Isabel Burdiel, "La construcción de la 'Gran Mujer de Letras Española': Los desafíos de Emilia Pardo Bazán (1851–1921)," in *La historia biográfica en Europa: Nuevas perspectivas*, ed. Isabel Burdiel and Roy Foster (Zaragoza: Instituto Fernando el Católico, 2015), 344.

124. Also a recipient of honorary membership in the Hispanic Society in 1911 and then of the Medal of Arts and Literature in 1919, Benito Pérez Galdós (1843–1920) was Spain's most prolific nineteenth-century novelist, although there is little evidence that his contacts with Huntington extended any further. In thanks for his award, however, he did send Huntington several signed copies of his books. Joaquín Sorolla to Archer Huntington, Jan. 11, 1911, AMHA, also in "Apéndice," in *Sorolla y la Hispanic Society*, 391.

125. The letters exchanged between Altamira and Emilia Pardo Bazán reveal the strength of their friendship. See *Rafael Altamira, biografía de un intelectual (1866–1951)* (Alicante: Instituto de Estudios Juan Gil-Albert, Diputación Provincial de Alicante, 1987). On Altamira's friendship with Sorolla, see Enrique Rubio Cremades, "Rafael Altamira, crítico literario de Vicente Blasco Ibáñez," in *Actas del XVI Congreso de la Asociación Internacional de Hispanistas: Nuevos caminos del hispanismo (Paris, 9 al 13 de julio 2007)*, ed. Pierre Civil and Françoise Crémoux, vol. 2 (Madrid: Iberoamericana; Frankfurt: Vervuert, 2010), online version at https://cvc.cervantes.es/literatura/aih/pdf/16/aih_16_2_197.pdf.

educationalist and in 1909 had traveled to Argentina under the auspices of the Junta para Ampliación de Estudios e Investigaciones Científicas with the aim of encouraging greater intellectual cooperation between Spain and Hispanic America. During this journey, he exchanged several letters with Huntington, who was very interested in commissioning an English translation of Altamira's major work *Historia de España y de la civilización española* (1900) and invited him to give a series of lectures at the Hispanic Society.[126] A few months later another letter sent in the name of the Hispanic Society and signed by three distinguished members—the Hispanist William R. Shepherd, the professor of political science L. S. Rowe, and Hiram Bingham, the discoverer of Machu Picchu—repeated the invitation more formally, adding that "a considerable number of our universities will avail themselves of the opportunity this affords to listen to one of the most eminent representatives of the new intellectual movement in Spain" and offering Altamira a payment of $50 for each of the seven lectures it was proposed he should give.[127] He was ultimately not able to accept this invitation for health reasons but expressed his gratitude in a notably emotional letter, writing, "This will be one more bond to draw closer my connection with the Hispanic Society, and an incentive for me to dedicate more and more of my limited energies to the work that you [gentlemen] so kindly suppose that it has fallen to me to undertake."[128]

At Sorolla's dinner in 1912, Altamira agreed with Archer that he would visit him in New York on his next journey to the Americas.[129] They also exchanged books by mail, and in 1914 Altamira even offered Huntington

126. Rafael Altamira to Archer Huntington, Apr. 11, 1909, and Archer Huntington to Rafael Altamira, May 30, 1909, Correspondence of 1909, AMHA.

127. Hispanic Society of America to Rafael Altamira, Sept. 10, 1909, Correspondence of 1909, AMHA.

128. Rafael Altamira to Archer Huntington, Jan. 1, 1910, Biblioteca Virtual Miguel de Cervantes, 2014, at https://www.cervantesvirtual.com/obra/carta-de-rafael-altamira-a-archer-milton-huntington-new-york-1-de-enero-de-1910/.

129. Rafael Altamira to Archer Huntington, June 26, 1912, Biblioteca Virtual Miguel de Cervantes, 2014, at https://www.cervantesvirtual.com/obra/carta-de-rafael-altamira-a-archer-milton-huntington-madrid-26-de-junio-de-1912/.

a stained-glass window owned by a relative of his who wished to sell it, pointing out, in view of Huntington's well-known reservations about such sales, "It is not from any church, nor foundation, nor trust, nor anything that looks like one."[130]

In 1913, Sorolla sent his portrait of Rafael Altamira to the Hispanic Society for its gallery of distinguished Spaniards, and Altamira took great interest in this picture, writing, "Would it be inconvenient for you to provide me with a photograph of it? As you will understand I am especially interested in possessing a photographic reproduction of this work."[131] Nine years later, in May 1922, he had the opportunity to see the portrait in person when he went "to take tea at the Hispanic Society."[132]

Sorolla had also painted a portrait several years earlier of another of his dinner guests, Manuel Bartolomé Cossío (1857–1935). Huntington bought this portrait in London in 1908 for £600 (around $66,500 today), and it appears that it was what gave him the idea of beginning his gallery of portraits of distinguished Spaniards.[133] An art historian and educationalist, Cossío was the leading disciple of Francisco Giner de los Ríos, founder of the Institución Libre, and the chief perpetuator of Giner's work and was for many years director of the Museo Pedagógico (Museum of Education), created as an offshoot of the institution in 1882 to act as a laboratory for innovative educational ideas. A close friend of Sorolla, Cossío had in 1908 published a major study of the life and work of El Greco, which represented an important step forward in the reevaluation of the artist. He subsequently also became a member, with Huntington, Vega-Inclán, and Sorolla, of the *patronato* set up to oversee the Casa-Museo del Greco in Toledo.

Huntington was a great admirer of El Greco. Thanks to the correspondence between him and Cossío, we also know of his interest in

130. Rafael Altamira to Archer Huntington, Mar. 12, 1914, Correspondence of 1914, AMHA.
131. Rafael Altamira to Archer Huntington, Dec. 20, 1913, Biblioteca Virtual Miguel de Cervantes, 2014, at https://www.cervantesvirtual.com/nd/ark:/59851/bmcqclx4.
132. Note from Rafael Altamira, May 11, 1922, Correspondence of 1922, AMHA.
133. Blanca Pons Sorolla, *Joaquín Sorolla: Vida y obra* (Madrid: Fundación de Apoyo a la Historia del Arte Hispánico, 2001), 313n196.

translating the latter's book into English and publishing it in the United States. "Pardon my long delay in communicating with you in regard to the plan for a translation of your *Greco*," Huntington wrote in June 1911. "But the matter has had serious consideration and I would like to suggest the preparation of such a translation to be issued by the Hispanic Society of America in the manner you have in mind, namely, in two volumes, one of text and one of reproductions." He proposed to publish a "careful translation" of the book "in a simple and dignified form" and asked the author for the photographic plates from the original edition to reduce costs. He warned Cossío, however, that "there is, I think, very little probability that any profit could be had in America from such a book."[134] The project seems to have eventually been abandoned.

In his efforts to locate and document all the paintings of El Greco, Cossío traveled extensively around Spain, the rest of Europe, and even the United States and mobilized a range of people in his support, among them Ignacio Zuloaga, a fervent admirer of the artist, and Sorolla, with whom Cossío shared the influence of the Institución Libre.[135] Cossío considered Huntington a "person of great value and competence," and Huntington made a special visit to Cossío in Spain in 1915 to give him his condolences on the death of Cossío's great master, Francisco Giner de los Ríos.[136]

134. Archer Huntington to Manuel Bartolomé Cossío, June 2, 1911, Correspondence of 1911, AMHA.

135. Javier Barón, "Cossío y Sorolla," in *El arte de saber ver: Manuel B. Cossío, la Institución Libre de Enseñanza y El Greco*, ed. Salvador Guerrero (Madrid: Institución Libre de Enseñanza, Fundación Francisco Giner de los Ríos, 2016), 193.

136. Cossío quoted in Ana María Arias de Cossío and Covadonga López Alonso, *Manuel B. Cossío a través de su correspondencia, 1879–1934* (Madrid: Fundación Francisco Giner de los Ríos, Publicaciones de la Residencia de Estudiantes, 2014), 821. There does not, however, appear to be any documentary evidence of a meeting between Huntington and Giner de los Ríos. Only a single letter from Ambassador Riaño to Archer from 1921 gives us any indication that Archer was aware of Giner's work and of his great influence on Spanish culture. Riaño asked Huntington if he would be interested in some papers of Francisco Giner de los Ríos because Giner's brother, Hermenegildo, had sent them to the ambassador asking for his help in getting them published in the United States and "in obtaining subscriptions for them in this country. I don't know if you will be

If Sorolla was the painter of light, Ignacio Zuloaga (1870–1945) was the painter of shadows. The Basque artist was one of the most controversial figures in the Spanish art world of the time because of his representations of *España negra*, or "dark Spain"—images of a bleak, mystical, often macabre traditional Spain that so fascinated foreigners but were often rejected with anger inside the country.[137] Huntington did not share this opinion and admired Zuloaga's work. In 1908, he had met the artist in Paris to arrange for an exhibition of his paintings at the Hispanic Society, which, although not achieving Sorolla's runaway success, opened doors for Zuloaga in the American market. After this show, in 1909 Huntington wrote to him, "In more than one sense, for me, you are Spain, because you are going to save that old Spain that is dying."[138]

Zuloaga's dedication to Spanish culture, moreover, extended beyond his own work, and in 1913 he took the leading role in an initiative to create a monument and museum devoted to Goya in the artist's birthplace in the Aragonese village of Fuendetodos, a project like those initiated by Vega-Inclán in tribute to El Greco in Toledo and to Cervantes in Valladolid.[139] Zuloaga bought the house in Fuendetodos and paid for its restoration. Huntington was also involved in this scheme, sending Zuloaga 1,000 francs ($3,500 today) as a contribution to the costs and in February 1916 promising to visit the museum.[140]

Zuloaga's brief relations with King Alfonso XIII were not as cordial as those between the king and Sorolla. In 1928, Alfonso XIII visited the

interested. Onís, who is in close contact with the Institución Libre de Enseñanza, will no doubt have done as much as posible." Juan de Riaño to Archer Huntington, Apr. 1, 1921, (10) 2654/8247, AGA.

137. The controversy generated by the "Zuloaga question" prompted comments and contrasting arguments from many leading intellectuals. See, for example, Miguel de Unamuno, "La labor patriótica de Zuloaga," *Cuadernos de Ignacio Zuloaga*, no. 1 (1995): 65–68, and José Ortega y Gasset, "Zuloaga," in *La pintura Vasca, 1909–1919* (Bilbao: Biblioteca de los Amigos del País, 1919), 13–40.

138. Quoted in Ignacio Suárez-Zuloaga, "Huntington, Zuloaga y divulgación de España en los Estados Unidos," *Cuadernos de arte e iconografía* 24, no. 47 (2015): 88.

139. "La casa de Goya," *El Heraldo de Aragón*, Apr. 30, 1915.

140. Suárez-Zuloaga, "Huntington, Zuloaga," 88.

artist's studio in his Basque hometown, Zumaia, for Zuloaga to paint his portrait. Problems arose, however, when artist and subject could not agree about the resulting painting, and Zuloaga refused to modify it or accept any payment for it and eventually kept it.[141] Zuloaga's house in Zumaia, the Santiago Etxea, was a renovated traditional Basque farmhouse overlooking the sea, with an area that he intended to make into a gallery for his own work. It became a meeting point for a variety of European intellectuals and political figures during the 1920s, when Huntington, too, left his signature in the visitors' book.[142]

Of all Huntington's Spanish friends and contacts, Zuloaga was one of those who in his letters communicated with him most frankly and directly. The artist's love of bullfighting and his stays in the mountain village of Pedraza in Segovia—where he bought the part-ruined castle to turn it into another museum—featured in the playful, enthusiastic letters he sent to Archer. The Hispanic Society has thirteen of his works in its collection, including a self-portrait from 1909 that Zuloaga presented to Huntington after being made a member of the society in June 1908.

Another illustrious Basque, the writer and philosopher Miguel de Unamuno (1864–1936), was also among the most important figures in Spain for Huntington. The American felt great admiration for this eminent Spanish thinker and teacher, who was for many years the rector of the University of Salamanca. In 1925, his portrait was painted for the Hispanic's gallery by Zuloaga, an artist who for Unamuno best represented the spirit of the Generación del 98 in paint. Huntington had previously commissioned a portrait from Sorolla, as Unamuno himself had announced in *La Nación* in the summer of 1912. "Sorolla, the great Valencian painter, who represents the opposite pole of the Spanish school [in painting], has a commission from Mr. Huntington to paint another portrait of me for the Hispanic museum that this wealthy and commendable Hispanophile has

141. Ignacio Suárez-Zuloaga, "Antonio Zuloaga Dethomas: Una vida entre Francia y España," in *Propagandistas y diplomáticos al servicio de Franco (1936–1945)*, ed. Antonio César Moreno Cantano (Gijón: Trea, 2012), 127.

142. Ignacio García Zabaleta, "Una gran obra de Zuloaga, Santiago-Echea," *Cuadernos de Ignacio Zuloaga*, no. 1 (1995): 98.

in New York, and I am keen to see how he leaves me when he comes here to do the painting in the fall."[143] Sorolla had already begun work on the portrait during a visit to Salamanca in the spring of 1912 and was expected to return there to complete it later the same year. However, in the interim some dismissive comments by Unamuno about Sorolla's work appeared in the press, and, according to the Sorolla experts Facundo Tomás and Felipe Garín, the artist was so irritated that he wanted nothing more to do with the painting.[144] Zuloaga, who was much more to Unamuno's taste, was then commissioned to provide a replacement.

Unamuno was one of the foremost representatives of the Generation of 1898 and an influential and controversial figure in Spain throughout the first decades of the new century. Huntington and Helen visited him in Salamanca in 1912, when Unamuno acted as their guide to the city and shared an animated dinner with them, at which, according to a subsequent letter of thanks from Archer, the great writer recited a poem that had a deep impact. "Let me add," Huntington wrote, "the deep appreciation and pleasure we have felt in having you read that splendid ode, to which your living voice has given an undying vitality in our memory."[145]

Archer wrote again to Unamuno a few days later from Biarritz, remembering his stay in Salamanca and adding some reflections on Spain, full of a romanticism drawn directly from the American aesthetic movement. "I too, through you, and to my own delight," he mused, "have in your city come to feel the inspiration of your wonderful Salamanca—but what is not wonderful in Spain? Spain, the land of dreams which became

143. Miguel de Unamuno, "De arte pictórica," *La Nación* (Buenos Aires), July 12 and Aug. 8, 1912. See also Felipe Garín and Facundo Tomás, "Joaquín Sorolla y la Generación del 98: El debate después de la modernidad," in *Sorolla y la Hispanic Society*, 60.

144. The Unamuno portrait was still unfinished when Sorolla died in 1923 and was acquired by a private collector. Since 1947, it has been in the Museo de Bellas Artes in Bilbao. On this portrait and the dispute with Unamuno, see Facundo Tomás and Felipe Garín, "Los retratos de Joaquín Sorolla en el Museo de Bellas Artes de Bilbao," *Boletín del Museo de Bellas Artes de Bilbao*, no. 5 (2010): 219–54.

145. Archer Huntington to Miguel de Unamuno, June 14, 1912, letter no. 1, 24/158, Casa-Museo Unamuno (CMU), Salamanca.

realities; the defender of Europe, the home of the ideal of chivalry." In the same letter, he also included some critical comments on the businessmen who, because of their lack of time, were incapable of stopping to observe the beauty that surrounded them.[146]

Unamuno had a great influence on the younger men of the so-called Generation of 1914, such as Gregorio Marañón and José Ortega y Gasset, who also, though several years younger than Huntington, came into contact with the American art patron as they made their way through the Spanish cultural scene.

The doctor, historian, and writer Gregorio Marañón (1887–1960) became part of the circle of Huntington's close friends in Spain through his contact with the marquis of Vega-Inclán. "I formed part of this group around Huntington, without, in reality, deserving to," he recalled in a letter to José García-Mazas in 1957. "I was introduced into the intimate circle of these gentlemen by the kindness of Vega-Inclán, who felt a paternal affection for me, with which he infected Huntington, who entrusted me with the care of his health in Spain, and showered me with signs of his appreciation."[147]

Marañón and Huntington shared a fascination for both the city of Toledo and El Greco. Archer entrusted Dr. Marañón with his and Anna's health during their last visits to Spain in the 1920s, while Marañón, for his part, organized a tribute to Huntington at the Ritz in Madrid in May 1929, attended by all the Hispanic Society members resident in the city, which would be Archer's last opportunity to meet many of his Spanish friends in person.

The American called Marañón a "man-mountain" because of the breadth of his knowledge and described him as "one of the greatest geniuses of our century in medicine, an art critic, historian, writer, philosopher, psychologist, who picks up a pen just as easily as a scalpel. . . . Men

146. Archer Huntington to Miguel de Unamuno, undated but sometime after June 14, 1912, letter no. 5, 24/158, CMU.

147. Gregorio Marañón to José García-Mazas, Sept. 5, 1957, reproduced in García-Mazas, *El poeta y la escultora*, 476.

like this only happen in Spain."[148] After Huntington's death, Marañón in turn made a similarly admiring comment on his friend. "Huntington was a giant, who physically and morally reminded one of Saint Christopher. I said this to him and he laughed, and when he asked me who he was going to carry on his back, as this Saint [was] accustomed to do [in the legend], I said, the love between Spain and America, separated by the shores of the great sea."[149]

The distinguished doctor was also well acquainted with many others among Huntington's circle of friends, beginning with Alfonso XIII, whom he accompanied on the king's famous visit to the region of Las Hurdes in 1922.[150] He was also in regular contact with Zuloaga, Cossío, and Unamuno, whom he defended in his column in the newspaper *El Liberal* when the great scholar was exiled to Fuerteventura in the Canary Islands by the regime of General Primo de Rivera.[151]

Marañón's small estate outside Toledo, the Cigarral de Menores, a seventeenth-century house that he acquired in 1921, became a meeting place for many of the most prominent figures in Spanish cultural life. He was visited there regularly by José Ortega y Gasset (1883–1955), the most influential Spanish philosopher of the early twentieth century. It is thought that Ortega and Huntington met at the dinner that Marañón organized in the art patron's honor at the Hotel Ritz in Madrid in 1929. It seems clear, however, that they already knew each other because the philosopher had written to Huntington in 1924 to request financial support

148. Quoted in García-Mazas, *El poeta y la escultora*, 478, ellipses in original.

149. Gregorio Marañón to José García-Mazas, Sept. 5, 1957, reproduced in García-Mazas, *El poeta y la escultora*, 477.

150. The mountainous district of Las Hurdes in the north of Extremadura had become notorious as one of the poorest areas in the country, known for chronic poverty, illiteracy, inbreeding, and endemic diseases, a symbol of the backwardness of "forgotten Spain." Alfonso XIII's visit was organized to demonstrate the monarch's concern for such poverty-stricken areas of the country.

151. The foremost source on the character and intellectual profile of Marañón is Antonio López Vega, *Gregorio Marañón: Radiografía de un liberal* (Madrid: Taurus, 2011).

for his magazine, the *Revista de Occidente* (Magazine of the West), and sent him one of its first issues:

> The interest with which you follow intellectual movements in Spain is a guarantee of a kindly and favorable reception for this truly arduous effort in publishing, which we have undertaken with a success that is, in truth, highly flattering. . . . However, the enthusiasm with which we are developing our project, ensuring that our publication reflects the most refined elements of western thought in all its aspects, is not enough, and so the magnanimous assistance of the most illustrious representatives of Hispanic thinking is indispensable[;] . . . with the benevolent support of your good self we can expect a considerable expansion of our work. With our deepest thanks, in view of how much we expect to achieve as a result of taking this step, in which we permit ourselves to request that you undertake in support of the *Revista de Occidente*, I remain your most obedient servant.[152]

The *Revista de Occidente* was the central cultural project initiated by Ortega y Gasset in his efforts to form a "select minority" in Spain. During these years, he argued that intellectuals should restrict their field of action and turn their backs on politics, an attitude that fitted well with Huntington's ideas.[153] As in the case of other publications that caught his interest, he agreed to support the *Revista*.[154]

Another member of the Generation of 1914 was the writer Ramón Pérez de Ayala (1880–1962), who considered Huntington "infinitely more Spanish than the majority of those who occupy preeminent places in the

152. José Ortega y Gasset to Archer Huntington, Mar. 20, 1924, in "José Ortega y Gasset (1883–1955)," slide 20, in *Generation of '98: Twelve Portraits, Twelve Texts* (New York: Hispanic Society of America, 1975), 13.

153. Santos Juliá, "Los intelectuales y el rey," in *Alfonso XIII*, ed. Moreno Luzón, 324.

154. "With this letter of 1924, Ortega sent one of the first issues of his *Revista de Occidente*, in the hope that the Society would support and encourage the new venture which, indeed, it was to do." Quoted in "José Ortega y Gasset (1883–1955)," slide 20, in *Generation of '98*, 13.

roster of honorary Spaniards."[155] Associated with the Institución Libre de Enseñanza, Pérez de Ayala traveled to New York in December 1919 to give a series of lectures at Columbia University sponsored by the Hispanic Society. His prestige as an essayist and poet continued to grow during the 1920s, and in 1927 he received Spain's national literature prize and in 1928 was admitted to the Royal Academy.

One more Spanish intellectual impossible to ignore in the circles around Huntington was Federico de Onís (1885–1966), who, as we have seen, arrived at Columbia University in 1916 through Huntington's mediation and long served the university as professor of Spanish literature. As Onís later recalled in his tribute after Huntington's death, Archer became his mentor: "Huntington, older than myself in age, dignity and demeanor, was my guide and mentor in everything regarding my university work and in my initiation into American life." He remembered, "My first knowledge of him, before coming to the United States, was through reading his poetry, which was recommended to me by my master at the University of Salamanca don Miguel de Unamuno, the greatest Spaniard of his time, who felt a great esteem for Archer M. Huntington as a poet in the English language, whom he knew and admired."[156]

Onís dealt frequently with Huntington because the professor taught some courses to his students in the Hispanic Society library. He often kept his former teacher Unamuno informed of Huntington's activities, writing in late 1917, "Mr. Huntington is now in Europe. Perhaps in Spain. You already know how highly he truly regards you."[157]

In 1920, Federico de Onís became the first director of Columbia's Instituto de las Españas (now the Hispanic Institute for Latin American and Iberian Cultures). In the institute, he began a new stage in his professional

155. Quoted in Isidro Sánchez Sánchez, "Contra el paradigma Prescott," in *Viaje de ida y vuelta: Fotografías de Castilla–La Mancha en the Hispanic Society of America*, ed. Esther Almarcha Núñez-Herrador, Patrick Lenaghan, and Isidro Sánchez Sánchez (Toledo: Empresa Pública Don Quijote de la Mancha, 2007), 52.

156. Onís, "Huntington y la cultura hispánica," 19, 20.

157. Federico de Onís to Miguel de Unamuno, Dec. 15, 1917, letter no. 39, 35/118, CMU.

life, taking a leading role, sustained by a frenetic level of activity, in the expansion of Hispanic studies in the United States and Puerto Rico and acting as a privileged interlocutor for visiting Spanish artists and intellectuals.[158] The fresh impetus that Onís gave to the whole field of Hispanic studies in the Americas through his work was of enormous importance. Nevertheless, in his correspondence with Huntington one can detect a certain concern in the latter that so much activity was taking Onís away from his research, which Archer regarded as a priority. A reply from Onís gives us an indication of the type of relationship that existed between them. "I write to you with complete sincerity and confidence," he wrote Huntington in 1920, shortly after the death of Onís's father, "you once said to me that you spoke to me like a father; now that I have lost my own for ever, I understand what it means to have the privilege of turning to another man with confidence to ask for advice."[159]

Along with Unamuno, another of Onís's mentors was Ramón Menéndez Pidal (1869–1968), the most important Spanish philologist and literary historian of his era and the director of Spain's Centro de Estudios Históricos from its creation in 1910. Menéndez Pidal and Huntington shared an interest in medieval Spain, the figure of El Cid in particular, so it is not surprising that they became friends. When Huntington published a facsimile of the *Crónica del Cid* (a thirteenth-century prose chronicle that complements the main verse epic, the *Cantar de mio Cid*) in 1903, he dedicated it to Menéndez Pidal—which indicates that they had already met—and a year later he sent him the special dual-language edition he had prepared of the *Cantar* with his English translation.

In April 1909, Menéndez Pidal gave two lectures at Columbia, sponsored by the Hispanic Society, on the *romancero*, the Spanish tradition of

158. Consuelo Naranjo, María Dolores Luque, and Miguel Ángel Puig-Samper, eds., *Los lazos de la cultura: El Centro de Estudios Históricos de Madrid y la Universidad de Puerto Rico, 1916–1939* (Madrid: Consejo Superior de Investigaciones Científicas; Puerto Rico: Centro de Investigaciones Históricas de la Universidad de Puerto Rico, 2002).

159. Federico de Onís to Archer Huntington, Mar. 28, 1920, quoted in Matilde Albert Robatto, "Federico de Onís entre España y Estados Unidos (1920–1940)," in *Los lazos de la cultura*, ed. Naranjo, Luque, and Puig-Samper, 241.

folk poetry that was one of the great sources of Spanish literature. The society published these lectures the following year as *El romancero Español*. He and Huntington wrote each other on several occasions to discuss different projects and publications. One in particular, sometimes referred to as the "folk-lore project," focused on the recording and study of all aspects of traditional Spanish customs and folklore (music, folktales, dress, and more), an area of research at the Centro de Estudios Históricos that was of great interest to Huntington. Several American researchers joined in these studies, with their travel to Spain financed by Huntington.[160]

In 1929, Huntington and Menéndez Pidal met again in person at the dinner organized by Marañón at the Ritz in Madrid. As Menéndez Pidal recorded ironically in a handwritten note, "Huntington looked at my wrists for marks left by the manacles, and entrusted me with sending him a link from my chains for the [Hispanic Society]."[161] He was referring to the controversy that had arisen following the publication in the daily *El Sol* of a letter from Menéndez Pidal opposing the educational policies of the Primo de Rivera regime. The spark had been a decree from Minister of Public Instruction Eduardo Callejo granting prerogatives to educational institutions associated with the Catholic Church that effectively

160. Huntington had already expressed his great interest in "Folk-Lore" research in a letter to Menéndez Pidal in early 1918 (Archer Huntington to Ramón Menéndez Pidal, Feb. 24, 1918, Correspondencia 1918, Fundación Menéndez Pidal [FMP], Madrid). In 1919, the musicologist Kurt Schindler visited Spain with Huntington's assistance to join research into Spanish traditional music and gather material for the Hispanic Society at the Centro de Estudios Históricos, and in 1920 the Stanford professor Aureliano Espinosa, who had already worked with Menéndez Pidal on the Spanish roots of Mexican music and would later become president of the American Folklore Society, also received support for research in Spain. Between 1924 and 1928, the photographer Ruth Matilda Anderson also made several trips to Spain under the auspices of the Hispanic Society to document traditional Spanish dress and customs. Carmen Ortíz García, "Raíces hispánicas y culturas americanas: Folkloristas de Norteamérica en el Centro de Estudios Históricos," *Revista de Indias* 67, no. 239 (2007): 125–62.

161. Quoted in Diego Catalán, *El archivo del Romancero: Patrimonio de la Humanidad. Historia documentada de un siglo de historia*, 3 vols. (Madrid: Fundación Menéndez Pidal, 2001), 1:133.

gave them equivalent status with the state universities. This legislation provoked a student strike, which Primo de Rivera attempted to crush by closing the Central University of Madrid, dismissing the rector and the dean, and imposing a range of sanctions on many students. Many liberal professors protested, but Menéndez Pidal's angry condemnation had the greatest impact.

The admiration Huntington felt for Menéndez Pidal's work also led in 1929 to the Hispanic Society providing a grant of 50,000 pesetas ($92,300 today) toward the costs of a program that Menéndez Pidal had begun at the Centro de Estudios Históricos for the publication of a full scholarly edition of his collection of Spanish folk poetry under the title *Epopeya y romancero*. This project would unfortunately be frustrated by the outbreak of the Civil War.[162] The correspondence between the two men would continue for many years, albeit, as with Huntington's other Spanish friends and intellectual contacts, in very different circumstances marked by the debacle of war.

The Catalan art historian and architect Josep Pijoan (1881–1963) was a close collaborator of Menéndez Pidal who also built up a long-lasting friendship with Huntington. According to Pijoan, he and Archer first came into contact in 1906–7, when Pijoan was involved in the creation of the Institut d'Estudis Catalans (Institute of Catalan Studies), one of several institutions newly founded to expand cultural and scientific knowledge and research in Catalonia. Pijoan and his colleagues needed to request financial aid from the American philanthropist in order to acquire the *Cançoner de Cerveri de Girona*, a manuscript of the poems of a thirteenth-century Catalan troubadour, for the future Catalan library, the Biblioteca de Catalunya and so prevent its sale to the French Bibliothèque nationale. Huntington obliged, sending a check for the $400 requested (slightly more than $10,000 today), and so the book stayed in Catalonia.[163]

162. Diego Catalán, "A propósito de una obra truncada de Ramón Menéndez Pidal en sus dos versiones conocidas: Notas históricas y críticas de Diego Catalán," introduction to Ramón Menéndez Pidal, *Reliquias de la poesía épica hispánica* (Madrid: Cátedra-Seminario Menéndez Pidal-Gredos, 1980), xiii–xiv.

163. García-Mazas, *El poeta y la escultora*, 498.

Pijoan later moved to Rome to head the newly created Spanish School of History and Archaeology in the city and then to North America, first Canada and then the United States, to teach art history at universities in Toronto, Los Angeles, Chicago, and New York. He also collaborated with the Hispanic Society in various fields, especially between 1915 and 1922. As a specialist in art history, he took charge of cataloging the marble sculptures in the Hispanic's collection; as a consultant, he assisted in organizing the collections in the library; and as an art dealer, he helped in localizing items for Huntington in London and Paris. Though Huntington and Pijoan were very different men, they shared certain features in common. As Immaculada Socias has put it in her study of Pijoan, "Both were poets, both had similar ideas on the world of art, and both were lovers of archaeology and anthropology." However, "perhaps the rich American collector, who was very cautious and discreet, found the character of Pijoan over-exuberant, and he was not receptive to [Pijoan's] desires to work at the Hispanic Society, which precipitated his departure in 1922."[164]

Pijoan's eclectic personality sometimes produced negative reactions in others, and he had his detractors in academic circles.[165] Nevertheless, he admired Huntington. He said of him after his death, "More than a collector he was a person in love with beautiful things. . . . Those who imagined that the great American potentates, whom they disparagingly called millionaires, are people without a soul, interested in nothing more than accumulating capital, would be surprised to see the spirituality that could be contained in a don Archer Huntington."[166] And, as chapter 5 shows, Huntington often revealed his feelings about the Civil War and the changing world in his letters to Pijoan more often than to others.

164. Immaculada Socias, "Contribución al conocimiento del período americano de Josep Pijoan Soteras (1881–1963)," in *Repensar la escuela del CSIC en Roma: Cien años de memoria*, ed. Ricardo Olmos Romera, Trinidad Tortosa, and Juan Pedro Bellón Ruiz (Madrid: Consejo Superior de Investigaciones Científicas, 2011), 259.

165. Trinidad Tortosa, "Josep Pijoan (Barcelona, 1881–Lausanne, 1963)," in *Repensar la escuela del CSIC en Roma*, ed. Olmos Romera, Tortosa, and Bellón Ruiz, 229–54.

166. Reproduced in García-Mazas, *El poeta y la escultora*, 500.

Despite their differences, they wrote each other a great deal, in part because from 1929 and for several years Pijoan did not cease in his efforts to set up a publishing project in association with the Hispanic Society or to collaborate in some other way in completing the society's collections. "I would like to have a foot in America," he wrote to Huntington in September 1929, "and be associated with an American institution, even though it were only for a semester every year. . . . Please be kind, and think over this last from your old friend."[167]

One more student of Menéndez Pidal and collaborator with the Centro de Estudios Históricos who arrived in New York was Homero Serís (1879–1969), a philologist and expert on Cervantes. He first visited the city in 1914 and discovered the Hispanic Society's splendid library. He began to study its collection of rare and unusual books as well as in Boston the collection of George Ticknor, which had been left to the Boston Public Library. As a result of his research, he was able to confirm that, aside from the Biblioteca Nacional in Madrid, the Hispanic Society possessed the most extensive and valuable collection of editions of *Don Quijote* in existence.[168] During his stay in the United States, Serís taught at the University of Illinois and became president of the Instituto de las Españas at Columbia and so was in close contact with Federico de Onís.

It was also in New York rather than Spain that Huntington first met the future Nobel Prize winner Juan Ramón Jiménez (1881–1958). He was a young poet of the Generation of 1914 who that year had achieved rapid fame in Spain with the publication of his lyrical Andalusian prose poem about a young man and a donkey, *Platero y yo* (*Platero and I*). In 1916, while he and his wife, Zenobia Camprubí, also a writer, were on their honeymoon in New York, they paid a visit to the Hispanic Society. They made a very favorable impression on Archer Huntington, who wrote in

167. Josep Pijoan to Archer Huntington, Sept. 23, 1929, box 51, AHHP.

168. Homero Serís, *La colección cervantina de la Sociedad Hispánica de América: Ediciones de* Don Quijote, *con introducción, descripción de nuevas ediciones, anotaciones y nuevos datos bibliográficos* (Urbana: Univ. of Illinois, 1918).

his diary, "They are a charming couple, and we had a most agreeable conversation."[169]

Huntington and Jiménez met again in the days following their first meeting to discuss the Hispanic Society's publication of a special edition of an anthology of the poet's work, which eventually appeared in 1917—in Spanish, not in translation—under the title *Poesías escogidas* (Selected Poems). In their conversations, "they examined the possibility of publishing modern novels that would be sold by subscription, and Juan Ramón showed interest in a possible post at the Hispanic Society."[170] This suggestion is not surprising because Zenobia had lived in the United States for several years during her adolescence, and when she and her family moved to Madrid in 1910, she had been called the "Americanita," the "Little American," and had complained that in Madrid she was allowed to go out only in company or with a chaperone.

By chance, one of the couples who had often escorted Zenobia was the Americans Arthur Byne and Mildred Stapley Bynes, correspondents of the Hispanic Society in Spain for many years up to 1920. Arthur Byne was an architect, and Mildred was an artist with a broad cultural education. They moved to Spain in 1914 and devoted themselves to touring the Iberian Peninsula, taking photographs of architectural details and writing articles for American magazines. Together they produced several illustrated books on Spanish architecture and decorative arts, which the Hispanic Society published between 1916 and 1920.

In Madrid, the Bynes frequented the circles of historians and art collectors and were known as scholarly hispanophiles, albeit over time they also turned to other, less well-regarded activities as art dealers.[171] In 1920,

169. Diary of 1916, AMHA, also in "Catálogo. Retratos: 87. Juan Ramón Jiménez," in *Sorolla y la Hispanic Society*, 352.

170. Diary of 1916, AMHA, also in "Catálogo. Retratos: 87. Juan Ramón Jiménez," in *Sorolla y la Hispanic Society*, 352.

171. José María Merino de Cáceres and and María José Martínez Ruiz have described Arthur Byne as the "gentleman plunderer" par excellence in Spain between 1921 and 1935, when he died in a road accident outside Madrid. José María Merino de Cáceres

Byne wrote to inform Huntington that he had dined with Ricardo de Orueta (1868–1939), an expert on Spanish sculpture who worked at the Centro de Estudios Históricos. Several years later, Orueta would become the director general of fine arts in the Ministerio de Instrucción Pública y Bellas Artes (Ministry of Public Instruction and Fine Arts) during the Second Republic and one of the figures most committed to the protection of Spain's artistic heritage.[172]

From 1921 on, the Bynes offered their services to William Randolph Hearst to assist in the export of hundreds of works of art and artistic and architectural artifacts from Spain, which led to a definitive breakdown in their relations with Huntington, as confirmed in a letter from Archer to Guillermo de Osma: "Mr. Arthur Byne reached New York some days ago, and his connection with the Hispanic Society has now been terminated.... There will be no relationship between the Society and himself. He therefore does not represent the Society in any way officially, even though he may be a corresponding member."[173]

In 1919, meanwhile, Huntington had received another distinguished Spanish visitor, José Castillejo (1877–1945), secretary of the Junta para Ampliación de Estudios e Investigaciones Científicas. On May 22–24, Castillejo made a rapid round of visits in New York, calling on the Rockefeller Foundation, the Carnegie Foundation, Columbia University, and Archer Huntington "to see if they wished to help us."[174]

and María José Martínez Ruiz, *La destrucción del patrimonio artístico español: W. R. Hearst, el gran acaparador* (Madrid: Cátedra, 2013), 265–74.

172. For a detailed account of Orueta's career, see Miguel Cabañas Bravo, "Ricardo de Orueta, guardián del arte español: Perfil de un trascendente investigador y gestor político del patrimonio artístico," in *En el frente del arte: Ricardo de Orueta, 1868–1939*, ed. María Bolaños Atienza and Miguel Cabañas Bravo (Madrid: Acción Cultural Española, 2014), 21–77.

173. Archer Huntington to Guillermo de Osma, June 10, 1921, AMHA, quoted in Santos Quer, "La correspondencia epistolar de Archer M. Huntington," 238.

174. José Castillejo, "Castillejo visita los Estados Unidos," in *Epistolario de José Castillejo*, vol. 3: *Fatalidad y porvenir, 1913–1937*, ed. David Castillejo Claremont (Madrid: Castalia, 1999), 421.

The same year also saw the first visit to New York of the educationist María de Maeztu (1882–1948). The sister of the Generación del 98 writer and essayist Ramiro de Maeztu, she had worked at the Centro de Estudios Históricos since 1913 and in 1915 had been appointed director of the Residencia de Señoritas (Ladies Residence) in Madrid, created by the Junta para Ampliación de Estudios to improve educational facilities for women.[175] She worked tirelessly to offer Spanish women new possibilities in education and in 1926 founded a women's social club, the Lyceum Club Femenino, on the model of similar clubs in other European countries, with Zenobia Camprubí as its secretary.[176]

Under the auspices of the Hispanic Society, María de Maeztu gave a series of lectures in the United States during the spring of 1919 and toured several women's colleges, such as Smith and Bryn Mawr, an institution with which Huntington also collaborated through the Hispanic Society. In the 1920s, the Residencia de Señoritas also received very punctually copies of all the books published by the Hispanic for its library so that its students would have access to them.[177]

In 1921, it was the modernist playwright Ramón del Valle-Inclán (1866–1936), inventor of the style and genre known as *esperpento*, or "ogre," based on a grotesque, exaggerated, absurd vision of reality—who came to the Hispanic Society. The society conserved from his visit his signature written on its walls, next to the lines left on January 8, 1915, by his friend the Nicaraguan modernist poet Rubén Darío (1867–1916):

175. Isabel Pérez-Villanueva Tovar, "María de Maeztu en la Residencia de Señoritas: Educación y feminismo," in *Mujeres en vanguardia: La Residencia de Señoritas en su centenario (1915–1936)*, ed. Almudena de la Cueva and Margarita Márquez Padorno (Madrid: Acción Cultural Española, Publicaciones de la Residencia de Estudiantes, 2015), 235–45.

176. Concha Fagoaga, "La relación del grupo de señoritas de la Residencia de Estudiantes con el Lyceum Club," in *Mujeres en vanguardia*, ed. de la Cueva and Márquez Padorno, 322.

177. Several letters in the archive of the International Institute of Madrid document the packages the Publishing Department of the Hispanic Society of America sent to María de Maeztu. For example, the letters of May 2 and July 16, 1929, Madrid, Correspondencia ref. 34/30/1 and ref. 34/30/2/, Archive of the International Institute, Madrid.

Paseante que pasas por esta casa egregia
Mira como la América noble y republicana
Da cabida a la gloria de la progenie hispana
Y a su espíritu eterno brinda acogida.

[Passer-by who passes through this great house
Look upon the way the noble and republican America
Finds space for the glories of the Hispanic progeny
And welcomes their eternal spirit.][178]

Huntington was an admirer of Darío.[179] As he had done with other contemporary Hispanic writers to make them better known in New York, he had sponsored a series of lectures by Darío at Columbia in 1915 and published in 1916 a short bilingual selection of his work with the title *Eleven Poems*. Huntington also helped Darío financially while he was in New York.[180]

A special mention is required for the prolific novelist, poet, and essayist Concha Espina (1869–1955), who became a particularly good friend of Huntington and had the distinction of being the only woman who maintained a notably close and friendly correspondence with him. In her case, too, this friendship extended to his second wife, Anna Hyatt Huntington, whom Espina admired deeply as a woman and an artist.

Concha Espina was a determined woman, a traveler and a professional writer at a time when very few women did such things. After separating from her husband in 1909, she had settled in Madrid, where, in

178. Quoted in *A History of the Hispanic Society of America*, 51.
179. Héctor Odín Fernández Bahillo, "Archer Milton Huntington y Cervantes: Esbozos de un hispanista norteamericano," in *La huella de Cervantes y del Quijote en la cultura anglosajona*, ed. José Manuel Barrio Marco and María José Crespo Allué (Valladolid: Universidad de Valladolid, 2007), 353–65; Héctor Odín Fernández Bahillo, "España en la vida y obra de Archer Milton Huntington, 1870–1955," PhD diss., Universidad de Valladolid, 2010.
180. "Unfortunately, the poet had come to New York with an insufficient supply of money. Mr Archer Huntington, president of the Hispanic Society of America, generously offered to help him, but Darío would accept only $500" (box 18, AHHP, SCRC).

addition to writing articles for newspapers and magazines, she focused on her literary work and began to host a weekly literary salon at her home on the Calle Goya, which was attended by leading writers, intellectuals, and members of the city's elite. A protégée and later a friend of Marcelino Menéndez Pelayo, she consolidated her reputation in Spain from 1914 on, above all during the 1920s, when, in addition to receiving two awards from the Spanish Royal Academy, her name was submitted three times for the Nobel Prize for Literature.[181]

Espina saw the Huntingtons during their visit to Madrid in 1929, meeting Anna Huntington for the first time, and a year later she visited them in New York and interviewed Anna for the magazine *La Esfera* during the short tour she made after being invited to speak about her most recent novel, *La virgen prudente* (The Prudent Virgin, 1929), at Middlebury College in Vermont. In New York, she visited Columbia University and was able to appreciate the work that Federico de Onís was undertaking to further Hispanic studies through the Instituto de las Españas, which had already hosted talks and readings by leading cultural figures, such as the historian Américo Castro and the young poet Federico García Lorca. She also held meetings with women from different ethnic backgrounds in the United States and Cuba and demonstrated her commitment to advancing the rights of women, ideas she shared in her letters with María de Maeztu.[182]

She also, naturally, visited the Hispanic Society and initiated a regular correspondence with Archer that through the years became a demonstration of affectionate friendship and admiration for the famous collector. In one of the articles from her trip later collected as the travel book

181. Concha Espina received two prizes from the Royal Academy, in 1914 for her novel *La efigie maragata* (translated into English as *Mariflor*, 1924) and in 1924 for a travel book, *Tierras de Aquilón*, and she was awarded Spain's National Literature Prize for the novel *Altar mayor* in 1927. She was proposed for the Nobel Prize by the United States and Sweden in 1926, 1927, and 1928.

182. Rosa María Capel Martínez, "El archivo de la Residencia de Señoritas," *CEE Participación Educativa*, no. 11 (2009): 160, at https://redined.educacion.gob.es/xmlui/bitstream/handle/11162/91?8100820113014342.pdf.

Singladuras (Voyages, 1932), she wrote of her enjoyment of "the illustrious Spanish museum of *our* Archer Milton Huntington. I say 'our,' given my Spanish nationality, because this man, modest and distinguished to an exceptional degree, belongs to two homelands: his own, through birth and bloodline, and mine, due to the fervent inclination of his spirit towards everything related to the art, literature and tradition of Spain."[183]

Two more albeit lesser-known Spanish intellectuals also visited Huntington in New York in 1930. One was Francisco Javier Sánchez Cantón (1891–1971), the art historian, member of the San Fernando Academy of Fine Arts, and associate of the Centro de Estudios Históricos. A student of Ramón Menéndez Pidal at the *centro*, Sánchez Cantón was a prolific writer on Spanish art. In 1919, he had begun cataloging the paintings in the Instituto Valencia de Don Juan and so had come into contact with Huntington's friend the count of Valencia de Don Juan, Guillermo de Osma. In 1922, Sánchez Cantón was appointed deputy director of the Prado, where he achieved significant improvements in reorganizing the exhibition halls.

Traveling with him to New York in 1930 was Julio Casares (1877–1964), the philologist, lexicographer, and later secretary for life of the Spanish Royal Academy. It is curious to note that Casares's celebrated *Diccionario ideológico* (Conceptual Dictionary) of the Spanish language (one in which words are grouped by concepts, not simply by the alphabet) was also connected to Huntington in that during this visit Casares promised Archer that he would dedicate it to him when it was published. In a subsequent letter written during the tumultuous spring of 1936, Casares apologized for not having been able to fulfill this promise because the project had been obstructed by both financial problems and the deteriorating political situation, but he still expressed confidence that he would be able to do so soon. "Forgive me for bothering you with these trivial personal details," he wrote, "[but] . . . [t]oday there can be no doubt that this work will see the light of day this same year, and as proof of this I am sending you the

183. Concha Espina, *Singladuras: Viaje americano* (1932; reprint, Madrid: Evohé, 2012), 47.

galleys of the alphabetical section. The rest has already been set and will be printed this summer."[184] However, despite Casares's conviction that his work would be published imminently, the Civil War frustrated his plans, and the *Diccionario ideológico* would not be published until 1942.

Of the many notable figures from Spanish life who visited the Hispanic Society at different times, several left a souvenir of their visits in words written on one of the pillars of its north facade, which Huntington reserved as a space for an informal record of his distinguished visitors. Messages were left for posterity by Federico de Onís, Ignacio Zuloaga, José López Mezquita, Juan Ramón Jiménez and Zenobia Camprubí, Rafael Altamira, José Camprubí, Miquel Viladrich, and the composer Enrique Granados, who in addition to his signature left a stave of music from his opera *Goyescas* after its New York premiere in 1916. All of them had the opportunity to see the Hispanic Society of America in its time of greatest splendor.

One visitor who in addition to admiring the society's rooms was able to fill them with new paintings was the artist José María López Mezquita (1883–1954) after he took over the role left by Sorolla on his death in 1923. A highly skilled painter of traditional scenes and customs, he arrived in New York in 1926 with a recommendation from the duke of Alba and began to work with the Hispanic Society. He traveled throughout Spain and Hispanic America painting portraits of prominent figures, among them Concha Espina, the Chilean poet and Nobel Prize winner Gabriela Mistral, and Manuel de Falla, and he even produced fresh portraits of Archer and Anna Huntington in 1927. The Hispanic Society has ninety-four paintings by López Mézquita in its collection.

López Mézquita also acted increasingly as a representative for Huntington in Spain, seeking to acquire pictures by more contemporary painters to complete the society's collection. Huntington trusted in López Mezquita's ability to find paintings with the kind of images of Spain the collector so much liked. Their initial relationship of patron and painter gradually developed into friendship, and López Mézquita also gained entry to Huntington's circle of friends in Spain.

184. Julio Casares to Archer Huntington, Apr. 1, 1936, box 18, AHHP, SCRC.

With López Mézquita, the Catalan painter Miquel Viladrich (1887–1956) contributed to extending the Hispanic Society's collection. Cultivating a slightly archaic style influenced by medieval art, Viladrich interested Huntington because of his ability to represent traditional Catalan dress in great detail. Huntington bought more than forty paintings by Viladrich during 1926 and in 1927 put them on show in a special, recently inaugurated room at the Hispanic Society. He had met Viladrich in Paris, introduced to him by another Catalan painter he already knew and some of whose work he had already bought, Hermenegildo Anglada Camarasa.[185] Paintings by nineteenth-century Spanish artists, such as Martín Rico, Mariano Fortuny, and Federico de Madrazo, were also added to the Hispanic Society collection thanks to the assistance and advice of Madrazo's son, Raimundo de Madrazo y Garreta, who was both a dealer and a painter and the latest representative of a dynasty of Madrazos in Spanish painting.

The work of another Spanish painter who was very successful in Paris and took part in the gatherings of Spanish artists in the French capital, the Catalan José María Sert (1874–1945), could not be exhibited in the Hispanic Society because his specialty was mural painting. As Huntington recorded in his diary as early as 1910, "We went over to see Sert's designs for the Cathedral of Vic. Tremendous affairs. He wanted the Hispanic Society to exhibit them, but I told him that it was impossible on account of their size."[186] Nevertheless, Sert's work later decorated the walls of the vestibule of another New York institution in the heart of Manhattan, the Rockefeller Center, with the mural *American Progress* (1937).

One cannot conclude this chapter without devoting some paragraphs to Huntington's connections with archaeologists and archaeology, an area in which he showed special interest. Standing out as his great friend in this field was the Anglo-French (though officially British by nationality) archaeologist George Bonsor (1855–1930), whom he had first met in Seville

185. For a painting by Viladrich, see "Catálogo. Miguel Viladrich Vilá: *Frutos de Fraga*, 1914–1923" (painting), in *De Goya a Zuloaga*, 122.

186. Diary of 1910, AMHA, also in "Apéndice," in *Sorolla y la Hispanic Society*, 388.

in the 1890s. Commonly known in Spain as "Jorge Bonsor," he lived and worked primarily in Spain from the 1870s until his death in 1930 and carried out a large number of archaeological excavations that led to several major discoveries, many of which were described in books published by the Hispanic Society.[187]

Huntington and Bonsor's relationship, which lasted from 1898 to 1930, can be described as a "scientific friendship" because their extensive correspondence, amounting to 152 letters, generally deals with the research Bonsor was undertaking through his excavations.[188] Jorge Maier Allende's detailed analysis of this correspondence has served to contradict the idea widely maintained for many years that Bonsor acted as a despoiler of Spain's heritage by selling artifacts from his excavations illegally to the Hispanic Society. As Maier explains, "Nothing could be more incorrect. This documentary evidence [provides] tangible and reliable proof that this was not the case at all. Both Bonsor and Huntington were always aware—in their letters they refer continually to this issue—of the legal framework in which they operated."[189]

Bonsor shared with Huntington the same approach to archaeology and collecting. In fact, he had created his own "Spanish museum" in the fourteenth-century castle Mairena del Alcor east of Seville, which he had bought, excavated, and then partially rebuilt as his residence and showcase for his collections, with many similarities, although on a smaller scale, to the Hispanic Society of America. In 1920, Bonsor also proposed to Huntington that the Hispanic Society should oversee and financially support the creation of an "Anglo-American School of Archaeology in Spain," to

187. These books include *Tartesse*, from 1922, as well as *The Archaeological Expedition along the Guadalquivir, 1899–1901* and *An Archaeological Sketch-book of the Roman Necropolis at Carmona*, both from 1931.

188. Jorge Maier Allende, "Archer Milton Huntington, Jorge Bonsor y la arqueología andaluza," in *El tesoro arqueológico de la Hispanic Society of America*, ed. Bendala et al., 108–33.

189. Jorge Maier Allende, *Epistolario de Jorge Bonsor (1886–1939)* (Madrid: Real Academia de Historia, 1999), 20.

be based in Seville and inspired by the French École des hautes études hispaniques in Madrid.[190] Through this new school, Bonsor hoped to discover and excavate the site of the semilegendary Bronze and Iron Age city of Tartessos, described by ancient Greek and Roman historians as the oldest civilization in the Iberian Peninsula. Huntington put forward $3,000 (around $32,000 today) to finance the initial studies and establish an Anglo-American school, but for various reasons no school was ever created.

The last time Huntington visited George Bonsor in his castle at Mairena was during the trip he and Anna made to the Ibero-American Exhibition in Seville in 1929, where Bonsor acted as director of the archaeological section. Huntington financed the production of photographs of the whole of Bonsor's collections so that they could be presented at the exhibition. The archaeologist died at Mairena only a year later.

Huntington, through his archaeological contacts in Andalusia, also had the opportunity to meet José Ramón Mélida (1856–1933), director of the country's foremost collection, the Museo Arqueológico Nacional (National Archaeological Museum). In addition to becoming members of the Casa-Museo del Greco board, they cooperated when the National Archaeological Museum wished to acquire a collection of bronzes that the independent collector and archaeologist Antonio Vives Escudero intended to sell in 1910. The museum opened a public subscription to gather funds, which secured contributions from many prominent figures, including King Alfonso with 1,000 pesetas ($3,800 today) and Archer Huntington with an unknown sum. When this effort did not raise enough to buy the whole collection, the Madrid museum bought half of it, while the other was to be sold through an antiquarian in Paris. However, Huntington, who had rejected a previous approach by Vives to sell him pieces from the collection and wished to avoid the possibility that these artifacts would be sold piecemeal and then dispersed outside Spain, subsequently bought

190. In 1917, Huntington had already financed, together with the Junta para Ampliación de Estudios of Spain and the Académie des inscriptions et belles lettres of France, the excavations of the Roman site of Baelo Claudia in the province of Cádiz, carried out by the École des hautes études hispaniques under the direction of Pierre Paris and George Bonsor.

the other half through the Hispanic Society.[191] This initiative won him the appreciation of the Spanish scientific community.

Huntington also came to know the head of the Museo Arqueológico Municipal de Sevilla (Municipal Archaeological Museum of Seville), the archaeologist José Gestoso y Pérez (1852–1917), who became a habitual associate of the Hispanic Society.[192] Huntington donated to the Seville museum several busts and two marble Roman capitals discovered during his excavations at Italica in the 1890s, and in 1916 the Hispanic Society sponsored the publication of Gestoso's biography of the seventeenth-century Seville artist Juan Valdés Leal.

According to a saying, "If you want to go fast, go alone. If you want to go far, go together." From this overview of the relationships Archer Huntington established in Spain over the first three decades of the twentieth century, it seems justified to say that he chose to travel together with a varied and diverse group of scholars, artists, politicians, and aristocrats in his career as a student of Hispanic culture. It is in the context of this social world and not just in terms of his singular personality that Huntington can be seen in his true dimensions. As Juan Pablo Fusi Aizpurúa has pointed out, "The cultural awakening of Spain in the first thirty years of the twentieth century was not just the sum of a series of isolated and occasional cases, or the appearance of a few unanticipated individuals with a greater or lesser degree of genius, but a social phenomenon, with considerable quantitative and qualitative substance."[193]

191. Sebastián Celestino Pérez, "El coleccionismo español de principios del siglo XX: Antonio Vives Escudero," in *El tesoro arqueológico de la Hispanic Society of America*, ed. Bendala et al., 97.

192. The letters between José Gestoso and Archer Huntington are quoted extensively in Immaculada Socias, "Archer Milton Huntington (1870–1955): Mecenazgo, coleccionismo y comercio de arte," *Cuadernos de arte e iconografía* 24, no. 47 (2015): 13–44.

193. Juan Pablo Fusi Aizpurúa, *Un siglo de España: La cultura* (Madrid: Marcial Pons, 1999), 16.

3
A Patron of the Arts in the City of Skyscrapers

Building to Spread Culture

The broad and dense network of friendships that Archer Huntington built up in Spain would be impossible to understand without also keeping in mind all the activities that he as a patron of the arts was undertaking in the United States at the same time. Both efforts formed part of a parallel process that developed over the course of more than thirty years: while in Spain he tightened the bonds of friendship in his intermittent visits, and in his own country he devoted himself to the philanthropic creation of cultural institutions.

His first journeys to Spain at the end of the nineteenth century had been enough to clarify in his mind the confused ideas he had outlined to his parents in 1890, so that when he had the opportunity to put his plans into practice, he already had a well-elaborated view of them. The "Spanish museum" that Huntington had in mind was to contain a varied body of artistic collections and a library open to the public because his aim was to make it a multipurpose center for the study, research, presentation, and dissemination of Hispanic culture in the United States. The death of his father in 1900 made him the recipient of part of the Huntington fortune, and this inheritance smoothed the way for him to give concrete form to his long-desired project.[1]

1. On his death in 1900, Collis P. Huntington left an inheritance valued at around $50 million, or about $1.4 billion at current values. Bennett, *The Art of Wealth*, 133.

The Hispanic Society of America was formally established in New York on May 18, 1904, and its building was inaugurated on January 20, 1908. Thanks to the quality and scope of its collections, it served as the central point of reference with which Archer, at the age of only thirty-four, made his triumphal appearance on the cultural scene. It was his debut in the field of institutional philanthropy and became the foremost project of his life. Nevertheless, although the Hispanic occupied a privileged and preferential place in the universe of Huntington's cultural interests, it was not the only cultural institution that he created in the United States but rather part of a constellation of complementary institutions in which he also took part as a patron and that laid the basis for his ambitious cultural program.

From a modern perspective, it seems reasonable to consider that Huntington used the Hispanic Society as his model of museum infrastructure because it was with the society's support and patronage that a series of other buildings were erected around it over the next two decades on the area of land in north Manhattan that became known as Audubon Terrace, forming an imposing architectural ensemble in a uniform neoclassical–beaux arts style. The Hispanic Society building, the overall plan for the terrace, and all the other initial buildings were designed by another member of the Huntington clan, Archer's architect cousin, Charles Pratt Huntington. The American Numismatic Society building also opened in 1908 and twenty years later doubled its exhibition space with the construction of an additional section; the American Geographical Society opened its doors in 1911; the Heye Foundation and National Museum of the American Indian was begun in 1916 and completed in 1922; and two later buildings designed by William M. Kendall and Cass Gilbert for the American Academy of Arts and Letters were inaugurated in 1923 and 1930, respectively. All constructed along similar architectural lines, they made up Huntington's particular cultural quartier.

In just a few years at vertiginous speed, he succeeded in creating around him a myth of himself as the "museum builder." This idea connected perfectly in the American collective imagination with the image of pioneer railroad builders and creators of shipyards that had already been formed around the Huntington family, who, of course, had also become

known more recently as generous patrons of culture. With his ceaseless activity, Archer Huntington was recognized as the brilliant new representative of a lineage of builders dedicated to providing the country with the new infrastructure it needed—in this case cultural—to be a great nation. The popularity he gained led his fellow citizens to approve by popular vote the award to him of a special banner of the City of New York in 1923, acknowledging him as one of the individuals who had done most for the city in the previous twenty-five years.[2]

A closer look at the main artifacts of cultural infrastructure that he financed in parallel with the Hispanic Society during these years reveals something more than a diverse and capricious collection of philanthropic projects. If we take as a starting point the observation that the construction of museums, academies, and cultural societies was the activity to which he devoted most of his life and his resources, they become significant elements in providing a framework of reference that gives us a better understanding of the nature of the Hispanic Society.

Why build buildings for cultural institutions? One reply that might seem obvious can be dismissed in advance—that doing so indicates a desire to have one's name inscribed on all of these buildings so that it can be read by posterity. Since 1891, Archer Huntington had made clear in his diaries that he was opposed to gaining public fame through philanthropic actions. When acquaintances or family members questioned his interest in creating a museum, they took as a given an assumption that it was linked to an ambition to put his name on a plaque, which made him furious. "To place one's name on a donation, be it a building or a subscription, is an artificial and flimsy door to fame," he wrote in 1912. "The human race is full of creators, but it is their acts and not the name of some rotting corpse in the cemetery which are interesting."[3]

In effect, none of the museums he founded or the academies he financed bears the name "Archer Huntington." Hence, if what interested him were "acts," specifically in different areas of culture, one can ask the

2. Proske, *Archer Milton Huntington*, 16.
3. Diary entry, June 17, 1912, quoted in Codding, "Archer Milton Huntington, Champion of Spain," 150.

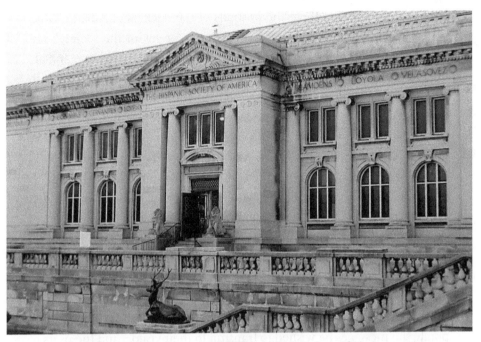

9. Facade of the Hispanic Society of America, New York, c. 2010. *Source*: Asaavedra32, CC BY-SA 3.0, via Wikimedia Commons, at https://commons.wikimedia.org/wiki/File:HispanicSocietyofAmerica.jpg.

question whether for Huntington there was an inherent link among the spaces devoted to aspects of culture, their content and the activities, that could be presented within or emerge from them.

The historian Jacques Le Goff argues in his studies on the Middle Ages that space is the meeting place of the social human and therefore that "any space is orientated and impregnated with ideologies and values."[4] From this perspective, the concept of space, transferred to the buildings in question here, acquires an additional significance as a transmitter of values. There can be no doubt that to enter the Hispanic Society at the top of its stone steps, continue into the Spanish Renaissance–style main

4. Jacques Le Goff, *Lo maravilloso y lo cotidiano en el Occidente medieval*, trans. Alberto Luis Bixio (Barcelona: Gedisa, 2008), 54.

hall, and see hanging there the portraits of the duchess of Alba by Goya and the count-duke of Olivares by Velázquez or any of the society's numerous paintings by El Greco, was for those already initiated into and acquainted with Hispanic culture to be transported into an entirely Spanish artistic and cultural universe.[5] The scenario communicated the glories of a golden era in the history of Spain, while the presence of Roman sculptures, medieval woodcarvings, and cases full of archaeological discoveries in ceramics and bronze made one aware of the prolific artistic productivity of the Iberian peoples through the centuries. The spines of the thousands of books in the library, with their embossed leather bindings and gilded vellum, spoke of a literary tradition both copious and long established over time. In addition, the ensemble presented by the building and its content enabled the visitor to imagine the refined taste and ample knowledge of an exquisite collector.

Because Huntington was the source of inspiration and finance for all these buildings, he was also the central individual with the power to incorporate the messages he wished to transmit to their visitors and the users of their libraries. In the case of the Hispanic Society, he provided the body of Spanish culture inside its walls with all the attributes of an erudite branch of knowledge that went far beyond the folkloric, popular image through which many of his fellow citizens still regarded that culture. Without renouncing the romantic spirit that had accompanied the first American Hispanists in their early examinations of Iberia in the nineteenth century, Huntington proposed a holistic, academic, and refined approach to Hispanic culture, which sought to reevaluate Hispanic studies in the eyes of American society. The Hispanic Society of America might operate independently as a museum and scholarly library, but it also formed an integral part of a series of cultural bodies with similar organizational structures that had the potential to multiply its own effectiveness in extending culture through society or, at the least, among certain social elites.

5. Patrick Lenaghan records that "Huntington assembled in his collection more paintings attributed to El Greco than any other Spanish Old Master." Lenaghan, "El Greco de Toledo en la Nueva York de Archer Huntington," 143.

Similar observations could be made regarding each of the other institutions that surrounded the Hispanic Society on Audubon Terrace. The American Geographical Society—of which Collis Huntington had been a member—was given a new building in 1911 and, with fresh energy and financial support from Archer Huntington, converted into an active center for expert geographers and cartographers. Its impressive building was used to host, among other events, preparatory meetings prior to the peace negotiations at the end of World War I. The dynamic director of the Geographical Society, Isaiah Bowman, a highly respected geographer with whom Huntington developed a warm friendship—revealed, as usual, by their long correspondence—acknowledged the fresh impetus that Archer injected into the institution, not only with his money but also most particularly with his advice that research students be employed and that the society's library be made available for professional purposes. As the Geographical Society's own account of its history recalls regarding Huntington, "He was not only the Society's most outstanding financial benefactor but its most influential leader. By enabling the Society to build its quarters in Upper Manhattan, he provided it with facilities for enlarging its staff, collections, and activities."[6]

In the case of the Heye Foundation, whose neoclassical building he also helped finance, from 1916 it contained the largest collection in the world exclusively dedicated to the culture of Native Americans, the Museum of the American Indian. Since the 1890s, Archer Huntington had shown a tendency to conceive the study of Hispanic culture in anthropological terms. Hence, he was fascinated to see the huge and varied body of Native American artifacts that had been gathered over several years by the collector and banker George Gustav Heye, which thanks to Huntington's support could be displayed in a proper manner in the well-equipped exhibition halls of the new building. This made it possible to increase knowledge of a culture that was one of the roots of American culture and to support further anthropological studies.

6. American Geographical Society, "History," n.d., at https://americangeo.org/about-us/history/, accessed Apr. 7, 2017.

As an adolescent, Archer Huntington had also begun to collect coins. This passion had led him while still very young to make contact with the American Numismatic Society, founded in New York in 1858. By 1904, he had already assembled the major part of his extraordinary collection of thirty thousand coins from every era of Spanish history and had become a leading member of the Numismatic Society. He had a decisive influence in reorganizing the society, instigating the construction of its new building on Audubon Terrace in 1907, and transforming what had been an association of hobbyists into an academic society with a strongly educational character, as the society's website recalls today.[7]

The American Academy of Arts and Letters was the institution to which he allotted the most funds, providing more than $2 million, equivalent to around $25 million today, for the construction of two complementary buildings with exhibition rooms, meeting halls, and even an excellent auditorium and concert hall with an organ of the highest quality. The letters between Huntington and Nicholas Murray Butler, the president of Columbia University, another of his great friends and a member of the academy's board, demonstrate that Archer's dedication to this institution was not just a formal matter; he was consulted on all manner of questions, from the employment of staff to the printing of publications, the organization of events, and, very particularly, the budget, the annual deficits of which he habitually covered.[8]

All these institutions had one thing in common with the Hispanic Society: they were devoted to themes and subjects of personal interest to Archer Huntington. When he first encountered these associations and began to take part in their meetings, he soon realized the limited means they could call upon and the largely amateur nature of their activities. He was young and ambitious, and he possessed sufficient resources to aspire to build something better. It seems likely that in the several journeys he made to Europe by the late 1890s, he observed that the major European

7. American Numismatic Society, "Archer M. Huntington," in "History of the American Numismatic Society," n.d., at http://numismatics.org/archer-m-huntington/, accessed Oct. 3, 2022.

8. Correspondence between Archer Huntington and Nicholas Murray Butler, box 15, AHHP, SCRC.

countries that had already achieved the cultural development Americans wished for also possessed academies and museums, which, supported by governments and leading cultural figures, played a major role in sustaining the cultural life of each country. He also perceived that a structure of prestigious cultural institutions, one that went beyond isolated philanthropic ventures, was necessary to create a breeding ground fertile enough to facilitate the dissemination of "Culture" with a capital C. In the United States, the absence of a European-style aristocracy or monarchy that had dedicated themselves to collecting and cultivating the arts for centuries had marked out a notable difference in cultural development between the young American republic and old Europe.

In Spain, Huntington took part in social gatherings in aristocratic residences that brought together scholars, politicians, writers, and members of the aristocracy, many of whom were at the same time academics, university professors, and directors of museums—gatherings in which questions of literature, art, and archaeology were discussed in a friendly, comradely atmosphere. To what extent his projects in the United States were influenced by a recollection of this model of behavior, which was so attractive to an aesthete such as Huntington, is an open question.

What is clear is that the proposals he put forward, the energetic manner in which he pursued them, and the fortune he made available meant that in a short time he was proposed for membership of the boards and then leading roles in all these preexisting institutions. He combined the role of president of the Hispanic Society of America from 1904 with the roles of president of the American Numismatic Society from 1905 to 1910, president of the American Geographical society from 1907 to 1916, member of the executive committee of the Heye Foundation from 1916, and director of the American Academy of Arts and Letters from 1922. From these positions of leadership, he was able to set in motion many of his plans for these bodies, including his chief priorities: professionalizing their management, providing each institution with a worthy location, publicizing their research, and establishing sets of symbols and awards to be given in recognition of professional merit among their members.

Whereas many wealthy Americans' philanthropic activities centered upon specific financial contributions that were often post mortem in

the form of legacies, Huntington decided to focus on using his wealth to greatest effect in his own lifetime. He encouraged study and research and created cultural infrastructure with an intention of permanence, contributing thereby to entrenching the model of corporate philanthropy that other American millionaires had begun to deploy at the beginning of the century. Major factors in making this form of institutionalized giving common practice in American society were the fiscal norms and practices that began to be widely used after the Revenue Act of 1913 introduced the federal income tax because they had the purpose of reducing the tax obligations of the very wealthy. Donations made as legacies or to suitable causes in one's lifetime could free this class of taxpayers from a significant part of their fiscal obligations and permitted a series of exemptions that also benefited Archer Huntington.[9]

The range of projects that he initiated and the diversity of interests he pursued explain the difficulties his friends and contemporaries found in choosing which of all the facets of his prolific activities best defined him. As another distinguished Hispanist, Henry Grattan Doyle, recalled after Huntington's death, "In Mr. Huntington's case, it is often difficult to determine where the practicing scholar and poet stops and the patron of arts and letters begins, so inextricably do they seem to mingle in this extraordinary man."[10] "Cultural catalyst" would perhaps be the best way to define him because it comprehends the multiple aspects of his public life. However, there still remains the most important question about him: Which kind of culture did he seek to promote?

A serious and profound analysis of the idea of culture and, more specifically, of the difference between high culture and popular culture—which is the underlying debate here—would go beyond the reasonable

9. The fiscal norms established at the federal level in the United States from 1913 with the aim of reducing the pressure of taxation and encouraging charitable donations clearly influenced Huntington's philanthropy, as can be seen from the dates of donations of both land and funds for the construction of particular buildings. See Bennett, *The Art of Wealth*, 227.

10. Henry Grattan Doyle, "Huntington and His Contribution to Hispanic Scholarship," in *Huntington, 1870–1955*, 27.

bounds of this book, but it is a topic that cannot be avoided. Huntington himself did not deliberately avoid this discussion. He always took an interest in the popular expressions of Hispanic and Native American cultures as part of an anthropological study of the cultural products of a people, but his approach to the study of folklore, traditional dress, customs, and so on was always scholarly—from a scientific, all-inclusive perspective. The same could be said regarding his support for the study of geography, numismatics, literature, and American arts.

It seems reasonable to suggest that for Huntington, as for many of his contemporaries, culture had a symbolic role in the system of social categorization. It displayed this role in a special way in the United States, where financial capital had come to occupy a preeminent position ahead of other criteria in the social hierarchies between individuals, so that from the late nineteenth century on cultural capital began to be seen as an additional, extra sign of social distinction or, to put this more clearly, an indicator of elitism and elite status. To have knowledge of culture as well as the time and money to cultivate it in a society that was markedly pragmatic and positivist in nature was a privilege that needed to be carefully managed if one was not to fall into the category "dilettante" or, still worse, "profligate millionaire." Nobody could doubt that Huntington formed part of the country's financial and economic elite. Nevertheless, he did not share in some of the social habits of other millionaires and had rejected entering business to increase his fortune still further because, as his friend Arthur Upham Pope, director of the California Palace of the Legion of Honor in San Francisco and subsequently founder and head of the Asia Institute in New York, wrote after Huntington's death, he chose to follow a different path: "He preferred the scholar's life."[11]

Thanks to the institutions Huntington was involved in and contributed to creating in New York, he gradually formed his own particular network of social relationships that included erudite scholars, American university professors, and European intellectuals, among whom he found common

11. Arthur Upham Pope, *Archer Milton Huntington: Last of the Titans, 1870–1955* (1957; reprint, Palm Beach, CA: Comité Interamericano de Bibliografía, Franklin Classics, 2018), 6.

interests and a similar outlook upon the world around them. The opportunity to find common ground with this group of eminent, cultivated figures and to share common emotions with them gave his life and work meaning.

The Hispanic Society of America was thus an extraordinary enterprise, the result of an aspiration that he had carried with him since his youth. Nevertheless, as an institution and a meeting point for the world of Hispanism, it needs to be examined within the framework represented by the group of institutions Huntington created around it and therefore in the light of the corporate conception of philanthropy that was gaining strength in these first decades of the century. As the first of his institutions and the model for all of them, the Hispanic followed certain guidelines that were carried over into the others, at least in four essential aspects.

In the first place, the buildings that he set out to construct both for the Hispanic Society and his subsequent institutions subscribed to a conservative, classical architectural model characteristic of a particular idea of enlightened culture, representing true "barracks of cultural nobility."[12] Huntington gave great importance to endowing the institutions in which he was involved with meeting rooms and halls that reflected, through the style in which they were built, the importance of the cultural activities taking place within them. Hence, the aesthetic and formal symbolism of these buildings was as important in educating the taste of their visitors as the content offered in each of them.

Second, his ambition for all his institutions was to publish and disseminate the results of the research undertaken within them or in collaboration with experts in the respective field of knowledge. This work of publication had to be approached with a commitment to the highest levels of quality, not just in content but also in form and materials. From the selection of paper to the use of the most advanced typographical techniques, Huntington took care to supervise personally the quality of all these projects and establish a common style for all the resulting publications.

12. Pierre Bourdieu, *La distinción: Criterio y bases sociales del gusto*, trans. María del Carmen Ruiz de Elvira (Madrid: Taurus, 2006), 61.

Third, when he took over a directive position in each institution physically located in more or less the same place, he also established a system for collaboration between them, so that some exhibitions or publications were organized jointly, as in the cases of the International Exhibition of Contemporary Medals, held by the American Numismatic Society and the Hispanic Society in 1910, and the joint publication of a collection of maps of the New World by the Hispanic and Geographical Societies. These collaborative projects had the potential to shape distinctive styles of operation and so create a particular working subculture that could mark out a special community of experts and scholars, an idea that Huntington wished to encourage.

The buildings on Audubon Terrace and the regular presentations of medals and honorary memberships by each society made up a complete assembly of imagery with which Huntington portrayed his conception of cultural capital as representative of a form of meritocracy. The medals and honors with which the work of scholars, artists, and intellectuals was acknowledged and through which some were included in this cultural meritocracy and others excluded gave him an unquestionable position of power and leadership in the field of culture and, most especially, in Hispanic studies in the United States. The patronage he exercised through all these institutions accorded him sufficient cultural and social legitimacy to be able to distance himself from the elements he rejected in the established model of American academic study—that is, the pompous official structures, sterile conventions, and set routines that, in his opinion, obstructed originality and frustrated intellectual activity.[13]

Solemn edifices built to a traditional aesthetic, august publications, outstanding collaborators, professional staff, and the rituals of membership and participation gave the culture created around Huntington an aura of quality and, to some extent, sanctity, an aspect symbolically reinforced by the building of the Our Lady of Esperanza Catholic church in 1912 on Audubon Terrace.

13. Upham Pope, *Archer Milton Huntington*, 5.

The Hispanic Society of America: More Than a Museum

Today the name "Hispanic Society of America" does not give much indication of the activities for which it was intended; it does not contain a single word that identifies it as a museum or a private collection, as in the case of other comparable institutions. It is also true that the society did not seek from the outset to be simply a museum or exhibition hall but a center for the promotion and study of Hispanic culture. How and why this was expected to happen are, in some ways, contained within this very name chosen by Huntington and the meaning its words had for him. Hence, it is worthwhile to begin with a brief examination of this title.

The term *Hispanic* defines the institution's field of interest and refers to the Hispanic culture that originated in the ancient Roman Hispania and took modern form in the nations of Spain and Portugal, which in turn extended it to parts of Asia and the greater part of the American continents. For Huntington, the chief center of interest was always Spain, and so Spain became the primary focus of the society's collections and activities, but at least in his initial conception its radius of action was intended to include not just Spain and Portugal but also the whole of Latin America and even the Philippines.[14] As Federico de Onís pointed out in 1957, the term *Hispanic* was a new one in 1904; Huntington was the first to use it in English, and his insistence on the term had an influence on its subsequent use because the concept of "Hispanic" began to be used to indicate the combining of Spanish and Portuguese departments in many universities.[15]

Although the society's focus was "Hispanic culture" in general, it is interesting to note the international and multidisciplinary character that Huntington sought to impress upon it from its first moments, as seen in the choice of the first nine members of its Advisory Council in 1904, which tells us much of the hopes he harbored for the new institution. Particularly

14. See Hispanic Society of America, "About Us," n.d., at http://hispanicsociety.org/about-us/, accessed Mar. 27, 2018.

15. Onís, "Huntington y la cultura hispánica," 21.

notable were the presidents of major universities: Nicholas Murray Butler of Columbia and Arthur Twining Hadley of Yale. Alongside them were three European Hispanists: the Frenchman Raymond Foulché-Delbosc, who in 1895 had founded the foremost journal of Hispanic studies in French, the *Révue hispanique*; James Fitzmaurice Kelly from Britain, a corresponding member of the Spanish Royal Academy since 1895; and the great Spanish scholar Marcelino Menéndez y Pelayo, then director of Spain's Biblioteca Nacional. Also included were the prestigious Hispanist Hugo Albert Rennert, considered the "dean" of Hispanic studies in the United States at the end of the nineteenth century, and John Milton Hay, the current secretary of state in the Theodore Roosevelt administration, who also had an interest in Hispanic affairs and had taken part in the signing of the Paris Peace Treaty after the Spanish-American War in 1898.[16] Last, also named as members of the committee were President Porfirio Díaz of Mexico and the Argentinian statesman Bartolomé Mitre, president of Argentina from 1862 to 1868 and founder of the leading Buenos Aires newspaper *La Nación*.

More than just an assemblage of eminent men, this council was a symbolic act of foundation in which one could see in clear profile Huntington's ambition to incorporate into the Hispanic a strongly didactic element and a formative social influence as an institution that could call upon the participation of both American and European Hispanists and had the support of a member of the US government and of two distinguished representatives of Latin American governments.

The term *society* also described the nature of the institution. It refers both to its character as a voluntary collective association and to its location as a physical space for interaction between its members. The models for such a "society" were the philosophical and scientific societies that had begun to arise in the late seventeenth century in Europe and had extended their geographical and intellectual scope over the subsequent two centuries. Societies of this kind were associated above all with the

16. John M. Hay had served as a diplomat at the legation in Madrid from 1869 to 1870 and in 1871 published a popular travel book titled *Castilian Days*.

transmission of knowledge and the communication of ideas in a context governed by courtesy and civilized manners. The principal asset of their members was their cultural capital, an indispensable prerequisite for being accepted into such societies.

In accordance with this model, the Hispanic Society established a maximum number for its full membership, from its foundation limited to a hundred, and that the full members had to be elected from among the corresponding members, who could not number more than three hundred. This was to be a small, exclusive community that possessed a magnificent museum and library for its use and enjoyment but nevertheless had a commitment to exhibit its collections to the public and to publicize the society's research.

Last, the term *America* indicated the place of origin of the project, which was not circumscribed to the territory of the United States or even to North America but included the American continents, with at least a nod toward the cultures of Hispanic America. With the name of his new society, Huntington managed to bring together the purely Spanish element and America in an association of lovers of Hispanic culture that in the following three decades developed into an authentic bridge between both cultures.

A brief reflection on the founding values with which the Hispanic Society was conceived indicates that Archer Huntington wished to bring together within it representatives of a diverse and varied range of institutions that shared a genuine appreciation of Hispanic culture. It is symptomatic that the Advisory Council included politicians, intellectuals, and academics from the United States, Spain, other European countries, and Spanish America. Passing over strict academic divisions, which he so disliked, and national boundaries—albeit with the approval of the US secretary of state—his brainchild was to demonstrate a new way of approaching Hispanic culture in the United States, seeking synergies between differing political and cultural actors instead of claiming ownership over this culture as if it were solely an object on display, which thus made the Hispanic something more than simply the museum of a single collector.

If, beyond the question of its name, we also look at the moment when the society was founded and consider this moment in political terms, we

also come upon interesting conclusions. The establishment of the Hispanic Society of America in 1904 came only six years after the war of 1898, in which the United States and Spain had confronted each other. The society was a purely cultural initiative, but one that fit together very well with the political objective of restoring relations with Spain that the US government and Secretary of State Hay had been pursuing since the turn of the century. Reconciliation had begun with the establishment of a framework for bilateral relations through the ratification of a Treaty of Friendship and General Relations in 1903; this was followed by tariff agreements in 1906 and 1909 and the formation of a Spanish Chamber of Commerce in New York, and the process culminated in 1913 with the transformation of the US legation in Madrid into a full embassy, a move that the Spanish government reciprocated with its official representation in Washington.[17]

Added to these demonstrations of goodwill on the part of the US government was the fact that a large number of intellectuals and political figures in Spain, rather than look upon the United States with resentment, regarded the American people with admiration as a model of modernization for Spain to emulate, which helped the wounds of war to heal relatively rapidly.[18]

Within this new context of exchanged glances and then longer looks across the Atlantic, the Hispanic Society of America emerged as a model cultural project, the product of an individual philanthropist's initiative but fully aligned with the US government's desire to turn a page and open up a new phase of relations with Spain—without, equally, undermining the apolitical stance always maintained by the project's founder. Because

17. Antonio Niño, "España y el 98," in *Juan Pablo Fusi: El historiador y su tiempo*, ed. María Jesús González and Javier Ugarte (Madrid: Taurus, 2016), 143.

18. Whereas for Spanish traditionalists and the Catholic Church the republican system of the United States, based on a Protestant majority, represented a danger to their interests, this same system was an object of admiration among Spanish progressives, who saw in it a model of democracy in which respect for public opinion and religious tolerance prevailed. See Antonio Niño, "Las relaciones culturales como punto de reencuentro hispano-estadounidense," in *España y Estados Unidos en el siglo XX*, ed. Delgado Gómez-Escalonilla and Elizalde Pérez-Grueso, 58.

political contacts between Spain and the United States were relatively scarce in the first years of the twentieth century, the Hispanic Society and its president occupied an institutional vacuum and for precisely this reason acquired an importance in Spain that went well beyond that of a collector and his museum.

As well as being an adolescent's dream made reality, the Hispanic Society was one of the institutions that did most to feed the growing fascination among American society for Spanish art, architecture, music, literature, and dance—a tendency that influenced collectors but also managed to flood much of American popular culture with Spanish accents. Three decades of Spanish splendor in the United States were divided by World War I, which formed a spiritual and emotional barrier between the so-called long nineteenth century and the true twentieth century. This immense global event naturally influenced many things, among them the progress of American Hispanism, because it led to a divergence between the exponential growth in interest in learning Spanish and the much lesser attention afforded, in relative terms, to the more erudite aspects of Hispanic culture. In the following decades, these changes gradually altered Huntington's profile as a collector, his aspirations as a Hispanist, the image of his Spanish museum, and the public impact of his society as a center for the dissemination of Hispanic culture.

A Window onto Spain in New York

The Hispanic Society of America was not the residence of a millionaire collector converted into a museum, like Isabella Stewart Gardner's Fenway Court in Boston, which opened its doors to the public in 1903. Instead, from the time of its origin, its objective was to contribute to a better knowledge of the language, art, history, and literature of the countries in which Spanish and Portuguese were spoken. "I only wish to show them what Spain is and what it was. The Hispanic Society should be a window, a showcase for Americans," as, according to Joseph Pijoan, Huntington said to him on several occasions.[19]

19. Josep Pijoan, quoted in García-Mazas, *El poeta y la escultora*, 499.

For this purpose, Huntington gathered together within its walls an exquisite collection, which was already remarkable simply in numerical terms: more than 900 oil paintings and 6,000 watercolors and drawings, which together offer a complete overview of Spanish painting and visual art; 15,000 engravings dating from the seventeenth to the early nineteenth centuries; almost 1,000 pieces of sculpture from the first century BCE to the 1900s; more than 6,000 other items divided between furniture, glassware, jewelry, ceramics, and textiles; an archive of some 175,000 photographs, documenting the life and art of Spain and Latin America; and a splendid library of more than 300,000 volumes, considered to be the finest collection of historic Spanish literature in the world aside form the Biblioteca Nacional in Madrid.[20] Moreover, as well as cultivating his own collections and beyond these overwhelming figures, Huntington also organized independent exhibitions, financed lecture series, and published books—all to disseminate more contemporary aspects of Spanish culture.

The first public events organized by the Hispanic Society set the tone for what Huntington hoped it would become, at least during its first years, when between February and April 1909 it hosted exhibitions by two artists who offered diametrically opposed images of Spain: the sun-washed, joyful, and radiant Spain of Joaquín Sorolla, represented by more than 350 of his works, and a smaller exhibition of the more traditional, darker, and dramatic Spain of Ignacio Zuloaga. Whereas Sorolla's paintings won immediate praise and unprecedented success in the United States—159,831 people visited his exhibition in only one month—Zuloaga attracted less immediate interest, with an attendance of only 28,356, although he would have a much deeper impact in the following years, culminating in the huge success of his exhibition in New York in 1925.[21]

This presentation of the Hispanic Society "in society" was generally applauded in the United States and aroused a growing interest in living

20. Hispanic Society of America, "About Us."

21. Sebastián Cruset, "La exposición de Zuloaga en Nueva York," *La ilustración artística*, no. 1433 (1909): 398; *Catalogue of Paintings by Ignacio Zuloaga*, with an introduction by Christian Brinton (New York: Hispanic Society of America, 1909), 31, exhibition, Mar. 21–Apr. 11, 1909, New York.

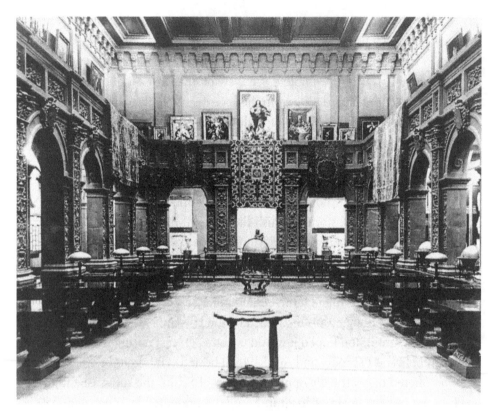

10. Main hall of the Hispanic Society of America, New York, 1911. *Source*: Courtesy of the Hispanic Society of America, New York (NN 57 GRF 2903).

Spanish artists. One of Huntington's most successful decisions was to transfer to New York the complementary nature of these two artists in their contrasting visions of Spain and by this contrast to bring over with them the fervent debate that existed in Spanish society regarding the role of art in social and national regeneration. He thus not only contributed to encouraging the fashion for things Spanish by presenting the American public with attractive images full of picturesque traditional elements but also promoted two great Spanish artists and demonstrated the richness of the current artistic panorama in Spain. As a consequence, the Hispanic Society gained an emblematic status among New Yorkers and in the Spanish collective imagination as the premiere showcase for contemporary Spanish art in the city.

The exhibitions that followed did not achieve the same level of popular or critical acclaim because Huntington chose to present exhibits that drew less media attention, often made up of items from his own collections. Nevertheless, in them he offered superb displays of varied aspects of Spanish and Hispanic American culture: the twenty-three tapestries from the Spanish royal collection in the Palace of El Pardo exhibited for the first time outside Spain in 1917; the more than 2,000 historic documents from the era of Spain's first voyages to America owned by the Peruvian collector Jorge Cabacho; the historic editions of the works of Cervantes exhibited to mark the three hundredth anniversary of his death in 1916; and the exhibitions of drawings and watercolors of Spanish landscapes by the American artists Vernon Howe Bailey and Ernest Clifford Peixotto.

Photographs, a medium in which Huntington showed great interest, were exhibited in a weekly series of exhibitions intended to display life, customs, and traditional dress in rural areas of Spain, Portugal, and different Latin American countries. Most of these images had been taken for the society by women photographers, such as Ruth Matilda Anderson, Anna Christian, Frances Spalding, and Georgiana Goddard King, the Hispanic studies scholar from Bryn Mawr college and a pioneer photographer. Photography was also the principal medium employed to display architectural details of Spanish buildings of the sixteenth and seventeenth centuries in exhibits that attracted the attention of many architects. With such exhibitions, the Hispanic succeeded in maintaining a constant flow of visitors, including the general public, specialists, and scholars.[22] One exceptional occasion was undoubtedly the opening to the public of the Sorolla Room on January 25, 1926, lined by the panels of the artist's *Vision of Spain/Las regiones de España*, which had been long awaited and would become a permanent emblem of the Hispanic Society.

The society took a different approach to the divulgation of Spanish letters and literature, setting out to pursue several lines of activity in parallel to cover every possible aspect of the literature of Spain and, albeit to a

22. For information on all the exhibitions held by the Hispanic Society up to 1954, see *A History of the Hispanic Society of America*, 42–49.

lesser extent, of Portugal and Ibero-America. Huntington was firmly convinced that the society's publications had to be a cornerstone of the institution and to this end set a range of initiatives in motion. On the one hand, he continued with the Huntington Reprints series that he had initiated in 1897, publishing quality facsimile editions of master works of Spanish and Portuguese literature drawn from sources in the Hispanic Society library or from manuscripts held by the British Museum, the Bibliothèque nationale in Paris, the library of El Escorial, and the Biblioteca Colombina, the rare library of books and documents left by Columbus's son in Seville. Publications of this kind, destined above all for libraries, universities, and serious scholars of Hispanic literature, were very well received.

Simultaneously, the Hispanic Society also began to publish new literary texts and the results of original research, seeking contributions from the leading Hispanists in different countries and developing a multinational roster of authors to maintain the debates around Spanish culture the society hoped to inspire at a high level. Among these titles were many works by familiar participants in the leading Spanish institutions of the day, such as the Residencia de Estudiantes, the Centro de Estudios Históricos, and the Instituto Valencia de Don Juan, including Juan Ramón Jiménez, Ramón Menéndez Pidal, Josep Pijoan, José Gestoso y Pérez, Rubén Darío, the German paleontologist and prehistorian Hugo Obermaier, the historian and musicologist J. B. Trend and the Hispanic scholar and translator Aubrey FitzGerald Bell from Britain, the Biblioteca Nacional librarian Julián Paz y Espeso, and the Arabist Julián Ribera y Tarragó and his student and fellow Arabist Miguel Asín Palacios. These authors gained a much wider audience in the United States by being published by the society, and so the Hispanic, without making any express agreements with these Spanish institutions, contributed motu proprio to the common effort to internationalize Spanish culture and publicize contemporary Spanish literature in the United States.[23]

23. Published titles included Ramón Menéndez Pidal, *El Romancero*, 1911; Rubén Darío, *Eleven Poems*, 1916; Juan Ramón Jiménez, *Poesías escogidas*, 1917; Josep Pijoan, *Marbles in the Collection*, 1917; Aubrey FitzGerald Bell, *Baltasar Gracián*, 1921; *Luis de Camões*, 1923; Hugo Obermaier, *Fossil Man in Spain*, 1924; J. B. Trend, *Luis Millán and*

This list of authors, which represents only a portion of all the specialists who published their work through the Hispanic Society, is enough to demonstrate the level of excellence that Huntington sought to imprint upon the society's work of divulgation. It also helps confirm that he pursued an idea of Hispanic studies that was not only international but also interdisciplinary, incorporating a diverse range of fields into his concept of Hispanism in a manner that was little common at the time, with publications that ventured into painting, poetry, archaeology, music, historical documentation, clothing, ceramics, and other topics. In short, "Hispanic studies" included a broad array of Hispanic cultural expression.

From 1919, the society also published Hispanic Notes and Monographs, an occasional series of biographical essays on the most celebrated figures of Hispanic America and studies on different aspects of Spain. On occasion, the Hispanic Society also gave financial support to publications produced by other institutions, such as the *Romanic Review*, a journal on Romance languages from Columbia; the special Hispanic issues of the American Folklore Society magazine; and the prestigious *Art Bulletin*. A similar case was the society's collaboration with one of the foremost women's colleges in the United States, Bryn Mawr. In this instance, the college staff prepared the articles, which were then paid for by Huntington on the sole condition that at least half of the publications had to deal with aspects of Hispanic culture.

In these early exhibitions and publishing ventures, Huntington revealed a virtue that was harder to find in some Hispanists: he did not restrict his outlook to the Spain of the past, the Spain of archaeology, medieval Spain, or the country of the Siglo de Oro that he so admired. He advocated combining past and present and employed the Hispanic Society, alongside its role as a museum, as a meeting point between the United States and a contemporary Spain that hoped to find a form of

the *Vihuelistas*, 1925, and *The Music of Spanish History to 1600*, 1926; Julián Ribera y Tarragó, *La música de la Jota Aragonesa*, 1928; Miguel Asín Palacios, *Compendio de teología dogmática de Algazel*, 1929; and Julián Paz y Espeso, *Catálogos de documentos españoles en los Archivos de París*, 1930. For information on all the publications by the Hispanic Society, see *A History of the Hispanic Society of America*, 550–59.

national regeneration through the internationalization of its culture. He did so, however, in accordance with his own wishes and following his own criteria in the sense that although his work laid a basis for the international promotion of Spanish culture in the United States, it did not at any time, as Javier Moreno Luzón has observed, "go beyond the bounds of an itinerary laid down by the personality of the patron."[24]

This point has to be recognized, but Huntington was nevertheless capable of articulating through the Hispanic Society a historical narrative that linked past and present to offer an overall vision of Hispanic culture. Federico de Onís said of the Hispanic Society in his address on the opening day of the academic year at the University of Salamanca in 1920:

> This Society is not the product solely of a sentiment of worship for the past, or for the picturesque present of Spain, beneath which so many Hispanists conceal their disdain for the Spain of today; that is, for the "eternal Spain." . . . The particular goal of the Hispanic Society is to make known to North Americans the highest forms of the Spanish spirit, in everything that constitutes a legacy for humanity and a contribution to universal culture. The past has to be its natural field of action. Its interest in the present is, therefore, more praiseworthy; and no less praiseworthy, in terms of what they show of Spain, are the criteria of selection and curation with which the Hispanic Society then presents to North Americans the different manifestations of contemporary Spanish life.[25]

The Collector Supplanted by His Museum

Archer Huntington devoted himself with passion to the task of building up his collections throughout the initial years of the century, during which he

24. Javier Moreno Luzón, "Condensar el alma de España: Archer M. Huntington y la internalización de la cultura española," in *Redes internacionales de la cultura española, 1914–1939*, ed. José García Velasco (Madrid: Publicaciones de la Residencia de Estudiantes, 2014), 274.

25. Reproduced in Onís, "Huntington y la cultura hispánica," 23.

traveled frequently to Europe with his then wife, Helen. As the cultural capital of the Western world, the location of the best art dealers, and the temporary place of residence of Archer's mother, Arabella, Paris was one of their preferred destinations.[26] This was an extremely rewarding period for him in which he exercised all his potential as a collector. He combined his interest in making acquisitions in person in collaboration with dealers from Spain, France, and Germany, all of whom offered him items for his collections. A prime example is his visit to Paris in 1906, when Huntington bought from the dealer Charles Seldemeyer five paintings by Goya, three by Francisco de Zurbarán, four by Bartolomé Esteban Murillo, and three by El Greco; a few months later in the same year, he acquired Goya's famous portrait *Duchess of Alba* (1797) at the Paris gallery of E. Gimpel & Wildenstein. Two years later, he bought, this time through Joseph Duveen, the *Retrato de una niña* (Portrait of a Young Girl, 1638–42) by Velázquez for $100,000 (around $2.4 million today), and in 1909 his mother donated to the Hispanic Society the Velázquez portrait *Conde-Duque de Olivares* (1625–26), acquired through Duveen for the astronomical figure of $600,000 (nearly $14 million at current values), the highest amount ever paid for a painting up to that point.

However, the outbreak of World War I in 1914 meant that Huntington had to put a drastic brake on his active search for artworks and historic manuscripts. His arrest in Nuremberg, in early August following Germany's declaration of war on Russia and France, after being found with a suitcase full of historic maps that he had obtained from a German art dealer was, as well as an adventure, an indication of the difficulties that traveling in Europe would involve during the war years.[27] If 1914 was, as Antonio López

26. After Arabella Huntington became a widow in 1900, she acquired a fabulous residence in 1906 at 2 rue de l'Elysée in Paris, which had belonged to Napoleon III's wife, Empress Eugènie, and filled it with objets d'art with the help of her favorite art dealer, Joseph Duveen.

27. This episode was reported in the Spanish press—for example, in *ABC*, Aug. 31, 1914: "Mr. Huntington—Mr. Archer Huntington, who had been arrested in Nuremberg on the day of the declaration of war, has been put at liberty, and has been able to reach Amsterdam."

Vega has put it, "the year that changed history,"[28] by the time the war was nearing its end, Huntington had realized that the golden age of American collecting was also coming to an end. In May 1918, he wrote in his diary: "The question which I find very interesting at this moment is that of the future of American collecting of Art[;] . . . the growing antagonism to the rich will be felt. The great, what may be called transcontinental period is over. And for all we may say, Art collection has been chiefly home decoration and vanity badges. The museum is taking the place of the collector—is the collector in a sense—and the volcanic dealer's fires die down."[29]

Changing times began to subject a figure such as his, one that in many ways represented the image of the old order's conventions, to a corrosion that also affected the art dealers, the "rich" as a social category in themselves, and the idea of visits to Europe as a symbol of cosmopolitanism. Notably revealing in this regard are his reflections on the manner in which the figure of the collector was becoming diluted in a society where it would be the museums as institutions, not their founders, that took the leading role in the changing universe of culture, a phenomenon closely related to the unstoppable movement toward a democratization of culture that was evident around him. He reiterated this idea in a letter to his mother in 1919. "I am about through at last as a collector. Only now and then a book, perhaps. But let the others go for it. I have felt enthusiasm for 'general' collecting—and the [Hispanic Society] shows that. One subject is enough, don't you think?"[30] (Chapter 4 shows, however, that Huntington's lack of enthusiasm for building more museums, expressed here in 1919, did not last long, for he continued to build museums of other types and in other places into the 1930s.)

In the same line of thought, he also decided that the time for presenting exhibitions of work by contemporary artists had ended; in his opinion, this should be the sphere of art galleries. In letters to his mother from this

28. Antonio López Vega, *1914: El año que cambió la historia* (Madrid: Taurus, 2014).
29. Diary entry, May 17, 1918, AMHA, quoted in Codding, "Archer Milton Huntington, Champion of Spain," 163–64.
30. Archer Huntington to Arabella Huntington, Aug. 19, 1919, AMHA, quoted in Codding, "Archer Milton Huntington, Champion of Spain," 165.

period, he indicated that he felt although it had made sense to host exhibitions of this kind at the Hispanic Society during its first years of operation, in future doing so would be a distraction for the staff from the institution's main work. Such comments allow us to discern the change of priorities that had begun to develop in Huntington, relegating his own impulses as a collector to second rank to concentrate on the professionalization of the Hispanic Society, which he had begun to equip with the resources it required to embody the institutionalization of his great Hispanist project.

A Very Feminine Hispanic Society

In the 1920s, a new period opened up in Huntington's professional life in which he dedicated himself to supervising, quite exhaustively, the work of research and cataloging that was being undertaken by the conservators of the various collections in the Hispanic. This was a task he would have liked to carry out in person much earlier, but his many responsibilities had prevented him from doing so. He said as much in a letter to his mother in December 1920. "When I first made the collections," he recalled, "you will remember that the whole field of Hispanics lay before me, and my dream was its classification and presentation by myself, but dreams are dreams, and the administration has taken its toll of my time, and money, of which I had far too much, and to which you have added your share, has been the greatest thief of all. Really, my dear old lady, one cannot carry the burden of wealth and climb mountains."[31]

Acknowledging the limited time he would have to pursue the work of a scholar, Huntington instead involved himself fully in his role as administrator and manager of his museum. With these new plans in mind, he decided to extend the Hispanic Society buildings. A dedicated hall for exhibiting the society's collections of graphics and photography was created, together with a retail space for the sale of its publications, and in 1923 work began on a separate building to house the Hispanic Society library.

31. Archer Huntington to Arabella Huntington, Dec. 6, 1920, AMHA, quoted in Codding, "Archer Milton Huntington, Champion of Spain," 166.

He soon also realized that he needed to have professional staff to take charge of the duties of administration and the proper maintenance of his collections. The moment had come to systematize the society's work, establish practical objectives, and apply efficient methods for the conservation and detailed study of its possessions. In this respect, as in others, nothing was left to improvisation; since 1898, he had been writing notes and references in his diaries and letters on what the personnel of his museum should be like, even when it was no more than a remote project.

The first feature that stands out in his reflections is his conviction that the staff responsible for the tasks of conservation should be women because he considered them most suited to the work required. He intended to find women museum conservators, whom he would expect to acquire, like him, a knowledge of Spanish language and culture, considering the possibility of sending them to travel in Spain. His expectations of his future staff were demanding. "If I ever have a museum," he had written in his diary in 1898, "the staff shall know works and *refranes* [sayings] and shall have met native creatures near to men—from mule to bed-bug. They shall pursue a word and its feathery meanings as an Englishman seeks the brush of a fox; they must block the burrows of escape and ride off with the trophy. Then they may write about their Spain. I think women should do it."[32] He repeated this same idea in a letter to his mother twenty-two years later: "You will be interested to know that the staff is gradually taking shape, and some day I hope that we may issue through them a fine set of monographs. I hope to get each one interested in a single subject, so that they become expert in each case along a definite line. I am more than ever convinced that this is a woman's work."[33]

And so it became. From 1922, a group of women librarians and conservators took charge of the different sections of the society's collections, forming a loyal, professional, and cohesive staff that in the following years

32. Diary of 1898, AMHA, quoted in Codding, "Archer Milton Huntington, Champion of Spain," 154.

33. Archer to Arabella, Dec. 6, 1920, AMHA, quoted in Codding, "Archer Milton Huntington, Champion of Spain," 166.

gradually developed into executive and editorial roles in nearly all the Hispanic Society's research projects and publication programs.

The general social mentality regarding the participation of women in work and public life had undergone major changes during and after World War I. The women's suffrage movement had won the vote for women in Canada in 1917, in the United Kingdom in 1918 (albeit only for women older than thirty), and in the United States in 1920. In addition, many women had been incorporated into new fields of work that had generally been occupied by men prior to the war. Arabella Huntington had made public declarations on the rights of women several years earlier, and her son, perhaps influenced by his mother's opinions, had shown a sensitivity toward these demands, making a contribution of $200 in 1916 to the American suffrage movement's fundraising campaign, for which one of its leaders, Vera Whitehouse, thanked him personally in a letter.[34]

Although Huntington had already thought of women as the most suitable staff for his museum twenty years earlier, it is notable that precisely at the end of the war he began to assemble the core of his female team for the Hispanic Society.[35] The majority of the women newly employed by the Hispanic came from Simmons College, the women's college in Boston, and had degrees in librarianship. Huntington encouraged them to specialize in particular areas of research and to write essays and articles on the subjects assigned to them. He also financed their classes in Spanish and

34. Archer Huntington recorded in his diary on January 12, 1916, that he had met Vera Whitehouse, chairwoman of the New York State Woman Suffrage Party, describing her as a charming person, very active and intelligent, who had both enemies and good friends, and adding that he had given some financial assistance to the suffrage movement. Bennett, *The Art of Wealth*, 178.

35. Prior to 1917, the Hispanic Society's first curators and administrators were men: Mansfield L. Hillhouse, W. R. Martin, and Elijah C. Hills as chief librarians; R. Hayward Keniston as assistant librarian; Francis Lathrop as director of the art collection; William E. B. Starkweather as assistant curator of paintings; Edward L. Stephenson in cartography; Alexander D. Savage and Ralph E. House as curators of printed books; and Edgar S. Buchanan as curator of manuscripts. Only one woman, Mildred Stapley, had been named, jointly with her husband, Arthur Byne, as curator of architecture and allied arts in 1916. See *A History of the Hispanic Society of America*, 544.

visits to Spain and Latin America to get firsthand knowledge of the countries, the language, and their own fields of study—trips that they generally made in small groups.[36] Several women stand out among the faithful conservators of the Hispanic, both for the many decades they dedicated to the institution and because they were awarded medals by the society during Huntington's lifetime.[37]

Elizabeth du Gué Trapier (1893–1974) arrived at the society in 1918 and became the head of its primary art collection as curator of paintings as well as a prolific writer on Spanish art. She compiled its main catalogs of paintings, and the Hispanic published nine monographs by her on artists such as El Greco, Velázquez, Jusepe de Ribera, and Luis de Morales. Alice Wilson Frothingham (1902–1976) joined in 1925 and worked at the Hispanic as curator of ceramics and glass until her retirement in 1968. Several of her meticulous studies on Spanish ceramics and glassware were published in the series Hispanic Notes and Monographs. Anna Pursche (1897–1953) began work at the society as senior librarian in 1923 and remained there until her death, and Clara Louisa Penney (1888–1970) took charge of the monumental task of cataloging some of the Hispanic's rarest possessions as curator of manuscripts and rare books. Among other works, she wrote a major textual study of the early Spanish classic novel *La Celestina* (1499).

One of the central figures at the Hispanic for more than fifty years was Beatrice Gilman Proske (1899–2002), a Simmons graduate who joined the

36. Noemí Espinosa Fernández, "La fotografía en los fondos de la Hispanic Society of America: Ruth Matilda Anderson," PhD diss., Universidad de Castilla–La Mancha, 2011.

37. Of the conservators who worked with Huntington up to his death in 1955, the Hispanic Society awarded its Mitre Medal to Clara Louisa Penney (1937); Alice Wilson Frothingham (1940); and Anna Pursche, Frances Spalding, Adelaide Meyer, and Eleanor S. Font (all 1952). The Sorolla Medal and the Sculpture Medal were also awarded to Beatrice Proske (1937, 1953). The Medal of Arts and Letters was awarded to Ada Marshall Johnson (1945); Ruth Matilda Anderson, Alice Frothingham, and Clara Louisa Penney (all in 1952); and Elizabeth du Gué Trapier (1953). *A History of the Hispanic Society of America*, 546–47.

society staff in 1920 and became curator of sculpture and eventually chief curator of the entire museum. She traveled many times to Spain with Trapier and Frothingham, and in addition to writing many studies and compiling the society's sculpture catalogs, she wrote a brief biography of its founder, *Archer Milton Huntington*, which was published by the society in 1963. Eleanor Sherman Font (1897–1982) was another woman who worked at the Hispanic Society for fifty-four years as conservator first of prints and then of iconography, as did her sister Margaret Sherman Font (life dates not recorded). Both women had graduated in librarianship from Gallaudet College, a college for the deaf, and were completely deaf, but Huntington did not consider this any obstacle to performing their work. Another Gallaudet graduate was Florence Lewis May (1899–1988), who was recruited by Huntington in 1921 and became curator of textiles and a renowned authority on Spanish textiles.

Ada Marshall Johnson (1892–1962) was another of the longest-serving members of the Hispanic Society staff. She joined its women employees in the mid-1920s, working on documentation, and eventually became an eminent expert on Spanish gold- and silverware and a curator of the museum. Similarly, Adelaide Maria Meyer (life dates not recorded) joined as an administrative assistant in the 1920s and rose to become curator of publications.

Women also played leading roles in the creation and study of the Hispanic's photography collections. Ruth Matilda Anderson (1893–1983) won widespread recognition for her excellent work photographing different aspects of Spanish life, beginning with several trips to Spain between 1923 and 1930, commissioned by the Hispanic Society.[38] Alongside her, several other women worked as professional photographers for the society, such as Alice D. Atkinson (1896–1986) and Frances Spalding (1896–1970). Spalding accompanied Ruth Anderson as an assistant on many of her expeditions but later on her own cultivated the photographic study of ornaments and details in *mudéjar* architecture. Back in New York, one of the principal

38. Patrick Lenaghan and Noemí Espinosa Fernández, *Visiones de Latinoamérica en la Hispanic Society of América: Vistas urbanas* (Madrid: El Viso, 2018).

curators of the Hispanic's Photography Department was Margaret Jackson (1902–1986), another graduate of Gallaudet College who was deaf. She became a specialist in microphotography and the use of X-ray photography, which proved a highly useful aid in different areas of research.

The singularly female composition of the Hispanic in these years raises today many questions for analysis that are impossible to answer without more detailed studies.[39] Among them is the unavoidable question of whether the gap in pay between men and women that existed in the museum sector at that time played any part in the choice of a female staff. From what one can see in Huntington's comments in his diaries and in his letters to his mother, and considering his own still-comfortable financial position and the huge investments he had already made in the society, it does not appear that he took this consideration into account in hiring women. In this regard, the comments made by Beatrice Proske in an interview she gave several years after her retirement are particularly relevant. She first accepted a post at the Hispanic Society in 1920, she told the interviewer, because of all the libraries that visited Simmons College to recruit fresh graduates, "the institution that paid the most was the Hispanic Society in New York City. I didn't think I wanted to live in New York City, but since they paid the highest salary, which was I think about $135 a month [around $1,900 today], I decided to accept that offer."[40]

However, Proske's statements are surprising in the feeling of otherness that Hispanic Society employees maintained as a group vis-à-vis other cultural institutions: "In other museums in the country we were known as 'those queer people at the Hispanic Society' because we were not encouraged to join in any other groups that were associated with art in

39. On the relationships between gender and museum studies, see Sally Gregory Kohlstedt, "Innovative Niche Scientists: Women's Role in Reframing North American Museums, 1880–1930," *Centaurus* 55, no. 2 (2013): 153–74.

40. "The Early Years of the Hispanic Society of América: Beatrice Gilman Proske," interview of Proske by Richard Cándida Smith, Internet Archive, Getty Center for the History of Art and the Humanities, 1995, plate, p. 18, Getty Research Institute, Los Angeles, at https://archive.org/details/earlyyearsofhisp00pros. In 1920, Proske earned $135 a month. By 1953, her monthly salary was $353.10 (around $3,800 today). "List of staff members and their work," Nov. 11, 1953, box 35, AHHP, SCRC.

the country."[41] This same attitude of exceptionality, encouraged by Huntington, was maintained in their trips to Spain and Latin America, which could explain the low public visibility of these women's work for decades: "On those first trips we were not allowed to say where we came from. Now, you have to understand that all the European art historians at that time were little old men with beards, and we didn't fit in well with that group. Therefore, it was a protection to us not to say where we were from or what we were supposed to be doing. . . . It's only since Mr. Huntington died in 1955 and everybody else soon after that I have dared talk at all about this early history, you see; it was a dead secret. Express order [from Mr. Huntington]."[42]

By the way, Huntington's lack of prejudices also extended to publicly recognizing the professional merits of outstanding women. His letters reveal that he corresponded with women who were also professionals of prestige in their respective fields. One was the celebrated American portrait painter Cecilia Beaux (1855–1942), the first professional woman teacher of art in the United States and described by Eleanor Roosevelt in 1933 as "the American woman who had made the greatest contribution to the culture of the world."[43] Huntington acknowledged Beaux's unquestionable artistic skill by naming her an honorary member of the Hispanic Society in 1923 and then a member of the Advisory Council and vice president of the society in 1928.[44] Similar examples can be seen in his contacts with Georgiana Goddard King (1871–1939), professor and photographer at Bryn Mawr,[45] and with Concha Espina, who after being awarded the society's Medal of Arts and Literature in 1927 was also made a vice president.

41. "The Early years of the Hispanic Society of América: Beatrice Gilman Proske," plate, p. 20.

42. "The Early Years of the Hispanic Society of América: Beatrice Gilman Proske," plate, p. 22.

43. Quoted in Tara Leigh Tappert, *Cecilia Beaux and the Art of Portraiture* (Washington, DC: Smithsonian Institution, 1995), 5.

44. Correspondence between Archer Huntington and Cecilia Beaux, box 10, AHHP, SCRC.

45. Correspondence between Archer Huntington and Georgiana Goddard King, box 42, AHHP, SCRC.

It was also within the walls of the Hispanic Society that Huntington found a new love, the already much-admired sculptor Anna Hyatt, who would then become his wife and his closest collaborator in giving more sculptural form to his Hispanism. They married in secret in a private ceremony in her studio and workshop on March 10, 1923, when he was fifty-three years old, and she was forty-seven. The date had not been chosen by accident: it was also their mutual birthday, so that in the following years they would celebrate it as their "triple anniversary." They had first met at one of the gatherings the American Sculpture Society held at the Hispanic Society. Archer decided to commission Anna to design a new commemorative medal to be awarded to outstanding specialists on Hispanic culture—the Mitre Medal, so named to mark the centenary of the birth of Bartolomé Mitre in 1921—and it was the first project on which they worked together for the Hispanic Society.

Anna was an entirely different type of woman from his first wife, Helen, who had enjoyed featuring in newspaper society pages, something that Archer Huntington detested. From accounts left by their contemporaries, it does not appear that Helen shared the same interest in Hispanism, although many years later she translated into English several books by Spanish writers.[46] In early 1918, Helen left Archer for the British writer and theater director Harley Granville-Barker, and she and Huntington were divorced in Paris on March 9, 1918. In New York, this divorce led to a considerable scandal, and Huntington sank into a deep depression, which he overcame only after meeting Anna three years later. Josep Pijoan described this difficult moment in Huntington's life in a letter to José García-Mazas. "He was going through a very sad time," Pijoan wrote. "He had had a family difficulty that left him stunned. The house was empty,

46. See, for example, the account of Helen in Ramón Gómez de la Serna, *Some Greguerías*, trans. Helen Granville-Barker (New York: Rudge's Sons, 1941). Helen Gates Huntington used the name "Helen Granville-Barker" after her marriage to Harley Granville-Barker in July 1918. See Granville Barker, *The Unknown Granville Barker: Letters to Helen & Other Texts 1915–1918*, edited by Simon Shepherd (London: Society for Theatre Research, 2021).

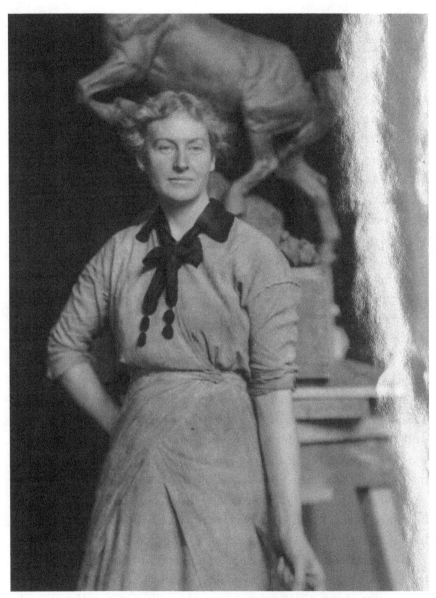

11. Anna Hyatt in her studio, c. 1910. *Source*: Box 95, "Photographs Family Huntington, Anna Hyatt," Anna Hyatt Huntington Papers, Special Collections Research Center, Syracuse University Libraries. By permission of Syracuse University Libraries.

and for company he distracted himself with a parrot that screeched ferociously and climbed on his shoulder pecking at him. I offered to stay there, but better company came, in the shape of the person who later became his wife."[47]

A woman of simple tastes, discreet and independent, Anna, born in 1876, had grown up in Massachusetts. Her father, Alpheus Hyatt, was the professor of paleontology and zoology at Harvard, and her mother, Audella Beebe, was an amateur painter; Anna abandoned her own early plans to become a concert violinist when her interest turned to sculpture.

She was a great lover of animals, especially horses—in her youth she was known among her neighbors for her ability to tame unruly horses, which were often given to her to domesticate—an enthusiasm that had a major influence on her later work.[48] She trained in the Boston workshop of the sculptor H. H. Kitson and at the Art Students' League in New York and began to exhibit her work in 1898. By 1906, she had already established a firm reputation as an animal sculptor. She lived in Europe between 1906 and 1908 and again in 1910, when she won a *mention d'honneur* at the Paris Salon and was awarded a purple rosette by the French government for her sculpture of Joan of Arc on horseback. In 1912, she was identified as one of the twelve women in the United States who earned more than $50,000 a year (more than $1 million at current values) from her own work,[49] and her fame only grew further in subsequent years, during which she also became one of the most active members of the committee of the American Sculpture Society. In 1914, the Plastic Club of Philadelphia awarded her its Rodin Gold Medal and the National Academy of Design its Saltus Award. In 1915, a much larger version in bronze of her equestrian statue of Joan of Arc was erected on Riverside Drive in New York.

Dedicated to her career, Anna Hyatt showed no interest in luxury and the life of high society or in matching the image of a rich, fashionable woman that, thanks to her fame, she could have had in New York. Concha

47. Josep Pijoan to José García-Mazas, undated but written after 1955, in García-Mazas, *El poeta y la escultora*, 499.

48. García-Mazas, *El poeta y la escultora*, 455.

49. Mitchell and Goodrich, *The Remarkable Huntingtons*, 15.

Espina, who met and interviewed Anna in New York in 1930, left a fine portrait of the sculptor. "Tall in height, a slim woman with an elegant figure, simple manners, a rather absorbed expression, sweet and distant. Her hair is whitened with an early scattering of snow; her features, soft, and correct; her eyes clear and thoughtful; a voice that is warm, suggestive, which often drops far away into territory as remote as the expression on her face. And then, a pure, noble smile, opening up over a line of fine, neat teeth."[50]

Anna Hyatt's own diaries provide further insights into the respect that Archer always showed for her work and the importance he gave to ensuring both that she had the ideal conditions in which to develop it and that she won public recognition.[51] In 1925, they moved to a new residence in New York and installed a sculpture studio for Anna so that she could continue to work on her sculptures at home without having to travel to a cold workshop on the other side of the city, which was affecting her delicate health. It was in this new workshop that she sculpted the statue of El Cid Campeador that the Huntingtons donated to Seville in 1929, while another cast of it stands impressively in the center of the plaza in front of the main entrance of the Hispanic Society. Once again Concha Espina's account best describes the atmosphere of the Huntingtons' home. "A spacious, well-ordered residence, richly if severely tasteful. On a mahogany table, lace, gold, and crystal glasses. White-jacketed waiters, exquisite food, fine conversation, in low voices, while a silence extends around us behind screens and drapes. And in every room there is always an original sculpture by Mrs. Huntington: in bronze, in marble, in silver, standing on velvet, damask, and silks."[52]

Espina also wrote, "I admired her as much as a woman as an artist."[53] Marriage to Anna also initiated Archer into a new stage in his life as part of a couple and renewed his ventures in Hispanism with revived energies.

50. *La Esfera*, Apr. 5, 1930, reproduced in Espina, *Singladuras*, 47.
51. Anna Hyatt began to keep a diary in 1925, two years after marrying Archer Huntington. This is now part of the Anna Hyatt Huntington Papers in the Special Collections Research Center at Syracuse University.
52. Espina, *Singladuras*, 50.
53. Espina, *Singladuras*, 50.

This is reflected in the comments made by his friend Ambassador Juan de Riaño in a letter to the marquis of Villalobar in 1924. "As you will know," Riaño observed, "he [Huntington] has married again, to a most distinguished and likeable woman, and has just returned from a cruise by yacht that they have undertaken through the Antilles. Previously I saw him very frequently, because he never left New York, and I customarily called at his home there. But now I see him much less, although I have great affection for him, and am pleased to see the happiness of his present life."[54]

However, this new happiness was darkened by the death in September 1924 of his beloved mother, Arabella, who had given unreserved support to her son's schemes for the Hispanic Society and who for Archer had been "the woman who has been the center of my life-long devotion."[55] Arabella had always been the indispensable "other woman" in enabling Archer Huntington's cultural schemes to take shape and get underway: it was his mother who had given him the land on which to build Audubon Terrace as the site of the Hispanic Society, financed his early travels and many of his purchases, and donated to the Hispanic $250,000 toward the initial building costs (more than $6 million at current values) as well as several major pictures in its collection. In her memory, Archer held a strictly family funeral, which he asked even close friends—including Riaño, who wished to be present in representation of Alfonso XIII—not to attend.[56] The Hispanic Society, embodiment of its founder, also bore the marks of the foremost women in his life.

"Spanish-izing" Europe from America

The Hispanic Society did not limit the scope of its activities strictly to the United States or Spain but also initiated two publishing projects that sought to establish permanent instruments for the dissemination of Hispanic studies and an interest in Hispanic culture in France and Great

54. Juan de Riaño to Marqués de Villalobar, June 12, 1924, (10) 2654/8247, AGA.
55. Archer Huntington to Juan de Riaño, Sept. 20, 1924, (10) 2654/8247, AGA.
56. Juan de Riaño to Marqués de Bendaña, Chief Steward to Alfonso XIII, Sept. 23, 1924, (10) 2654/8247, AGA.

Britain. If Miguel de Unamuno had engaged in a long debate with Ortega y Gasset over whether their objective should be to "Europeanize Spain or Spanish-ize Europe [europeizar España o españolizar Europa],"[57] it appears that Huntington inclined toward the latter option, albeit if a little timidly, by giving his support to two publishing initiatives that sought to bring Spanish culture to the rest of Europe.

Paris had been the location of his first encounter with Spanish painters, but it was also the city in which he first met Raymond Foulché-Delbosc (1864–1929). This French scholar, linguist, and bibliophile shared Huntington's interest in broadening knowledge of Spanish culture from a multidisciplinary viewpoint. Both men also shared a conception of Hispanism that prioritized independent and disinterested research over studies of a more academic variety, dependent on universities. In fact, one could say that Huntington and Foulché-Delbosc represented in their respective countries two sides of the same coin in the way they approached Hispanic studies.

The journal *Révue hispanique* had begun publication in 1894 thanks to the efforts of its founder, Foulché-Delbosc, and despite serious financial difficulties had succeeded in becoming established as a prestigious vehicle for Hispanic studies in France. When, however, a group of university-based Hispanists led by Ernest Merimée and Alfred Morel-Fatio began to publish the *Bulletin hispanique* in 1899 from the University of Bordeaux, Foulché-Delbosc's opposition to the new journal soon turned into a public rivalry.[58] The *Bulletin hispanique* claimed to have an educational focus that the *Révue* lacked, which therefore differentiated the new journal from the older publication, but they effectively came into direct competition in the limited Francophone market they had to share.

57. Miguel de Unamuno, "Sobre la europeización," *La España moderna*, Dec. 1906.
58. Antonio Niño has analyzed this episode in some detail as one that divided Hispanic studies in France in the first thirty years of the twentieth century because it obliged European and American Hispanists to choose between the two journals when publishing their papers and articles. See Antonio Niño, "La rivalidad entre la *Révue Hispanique* and the *Bulletin Hispanique*," in *Cultura y diplomacia: Los hispanistas franceses y España, 1875–1931* (Madrid: Consejo Superior de Investigaciones Científicas, 1988), 154–74.

In 1905, the Hispanic Society of America decided to take charge of meeting the financial needs of the *Révue hispanique*, which freed Foulché-Delbosc from a heavy burden. The society also agreed to publish under his direction *Bibliographie hispanique* and *Manuel de l'hispanisant*, bibliographical guides that Foulché-Delbosc had prepared with the librarian Louis Darrau-Dihigo. Huntington thus demonstrated his intention to keep alive one of the principal publishing channels for independent Hispanism in France.

The growing rivalry between the two French journals and their editors obliged Hispanists to incline toward one or the other, gathering around either title because of personal affinities or perhaps deeper considerations. It is no surprise to find among the Hispanists loyal to the *Révue hispanique* the names of several who were also published by the Hispanic Society, such as James Fitzmaurice-Kelly, Aubrey FitzGerald Bell, Alexander Haggerty Krappe, Miguel Asín Palacios, and even Marcelino Menéndez Pelayo, but nor is it unusual to see in the *Bulletin hispanique* names such as Ramón Menéndez Pidal, Rafael Altamira, Antonio Paz y Meliá, George Bonsor, Arthur Engel, and Pierre Paris (the latter three archaeologists)—all of whom also collaborated with the Hispanic Society. As Antonio Niño has pointed out, beyond the issue of differing levels of friendship, a more profound question underlay this rivalry regarding the model of academic organization that was to be followed in the teaching of the humanities because two approaches coexisted at the time. On one side were the defenders of a Hispanism based on academic institutions, which sought to respond to the evident demand for learning the language; on the other was "the Hispanism that Paul Guinard called 'monastic,' on the margins of the university world, jealous of its independence, devoted to pure erudition, and a defender of the critical spirit against all attempts to subordinate it."[59]

The express support Huntington gave to "monastic" Hispanism in France is entirely in accord with his personal history and preferences. Nevertheless, it was equally not part of his approach to divide; rather, he

59. Niño, "La rivalidad entre la *Révue Hispanique* and the *Bulletin Hispanique*," 160.

always sought to bring together, and so in 1913 he decided to award both Foulché-Delbosc and Morel-Fatio the Hispanic Society Medal of Arts and Literature in a clear gesture of concord between and recognition of the two main expressions of French Hispanism.

Four years after the death of Foulché-Delbosc in 1929, the *Révue hispanique* ceased publication. Leaving behind an archive of eighty volumes of studies of different kinds, it was an excellent index of international Hispanism. As Josep Pijoan recalled years later, referring to Huntington's involvement in the journal, "One could say that the *Révue hispanique* is a monument to the friendship between its editor and the erudite patron, who encouraged him to continue publishing the best works then published in the fields of literary, linguistic, and historical research."[60]

Huntington did not establish any similar type of institutional collaboration with Hispanic specialists in Great Britain until relatively late, primarily because at the beginning of the twentieth century Hispanic studies was almost nonexistent as a distinct field of study in the United Kingdom. Some notable works had already been produced by individual scholars such as James Fitzmaurice-Kelly, who in 1892 had published the first version of his biography of Cervantes and in 1898 his highly regarded *A History of Spanish Literature*. However, it was not until 1916 that the Cervantes Chair of Spanish was established at London University, with Fitzmaurice-Kelly as its first holder and with a financial endowment from the Hispanic Society of America.

It is clear that academic Hispanic studies in Britain, in contrast to its French equivalent, did not gain momentum until the early 1920s, when the Alfonso XIII Professorship of Spanish was established at Oxford, together with a chair in Spanish at Cambridge, the Anglo-Spanish Society in London, and the Gilmour Chair at Liverpool University, occupied from 1922 by E. Allison Peers, founder in 1923 of the *Bulletin of Spanish Studies*. It is not hard to understand, therefore, why it was in 1921 and not any earlier that Huntington initiated a new but ultimately frustrated project to

60. Josep Pijoan to José García-Mazas, undated but written after 1955, in García-Mazas, *El poeta y la escultora*, 439.

open a publishing office for the Hispanic Society in London. This venture sought to answer an evident need among British Hispanists regarding "the notable lack of public or private institutions to finance academic publications, at least in the humanities and social sciences," a shortage that had a direct effect on British historians concerned with the history of Spain.[61]

Huntington initially installed as head of the London office an American editor, William Belmont Parker, the author of several books on the peoples of Latin America that had recently been published by the Hispanic Society.[62] However, two events conspired to prevent the ongoing success of the project. One was the illness and subsequent death in 1923 of James Fitzmaurice-Kelly, who had overseen some of the Hispanic Society's publications in London. The other was the embezzlement of some of its funds by George Wykeham, who had replaced Parker as director and chief editor shortly after the office had opened. Together these two events did away with a project that could have been of great interest for Hispanic studies in Europe, particularly in Spain itself.[63]

Overall, one can see that the Hispanic Society of America had from its origin a dual nature for Archer Huntington. On the one hand, it was the symbol of an ontological conception of Spanish culture, according to which one should be able to find within the broad display of the different artistic creations of a people from across the centuries the essence and characteristics that made this people unique. On the other, it served him as an instrument through which he could articulate his projects in the United States, institutionalize Hispanic studies, and establish permanent channels of communication with the Hispanism and Hispanists of his era—a meeting point not only for the products and vestiges of a culture

61. Sebastian Balfour, "El hispanismo británico y la historiografía contemporánea en España," in *España*, ed. Saz, 166.

62. In 1920 and 1921, the Hispanic Society published the following series of books by William Belmont Parker: *Argentines of Today, Bolivians of Today, Chileans of Today, Cubans of Today, Paraguayans of Today,* and *Uruguayans of Today.*

63. Letters between Huntington and William Belmont Parker from 1921 to 1923 provide further details on the nature of this project and the fraudulent management by George Wykeham at the head of the London office of the Hispanic Society during the office's short life. See box 35, AHHP, SCRC.

but also for the intellectuals, artists, and writers of present-day Spain and the worlds of North America and Europe.

A Pillar of American Hispanism

Despite the singular nature attributed to the Hispanic Society as a living expression of Hispanism in the United States, it needs to be said that the society did not operate alone but rather from its first moments collaborated with other American institutions dedicated to the same disciplines. First among them was Columbia University, particularly through the figure of Nicholas Murray Butler (1862–1947), an educator, diplomat, and politician who held the post of university president for forty-three years, until 1945.

From 1907, by means of a form of mutual entente cordiale, the synergies between the two institutions, aided by the personal relationship between Butler and Huntington, gave a new impetus to American Hispanic studies that was of vital importance for the international appreciation of Spanish culture so desired by the regenerationists of different kinds in Spain. While Butler provided the academic framework and his educational influence over the new generations of students at his prestigious university, Huntington placed his bibliographical resources at the disposition of students and researchers and offered funds to support publications and lecture series, which were generally given at Columbia.

The first lecture organized jointly by the two institutions was given by the British Hispanist James Fitzmaurice-Kelly in 1907 and covered the poem *El Cid*, Cervantes, Lope de Vega, Calderón de la Barca, and contemporary Spanish novelists. This was followed in 1909 by two lectures by Ramón Menéndez Pidal, director of the Centro de Estudios Históricos in Madrid, on the Spanish folk poetry of the *romancero*. In 1910, a lecture was planned by his colleague Rafael Altamira but had to be canceled for reasons of ill health. In 1915, the Nicaraguan poet Rubén Darío was invited to read his poems at Columbia and visit the Hispanic Society, where he was received very affectionately by Huntington.[64]

64. For information on all the lectures given at the Hispanic Society, see *A History of the Hispanic Society of America*, 49–55.

During World War I, in contrast to the decline in interest in the German language and its culture, there was a visible growth in interest in learning Spanish, influenced in part by the increasing importance Latin American markets were acquiring for the United States. It was at this point that Butler turned to Huntington for recommendations on a suitable Spanish academic to be offered a professorship of Hispanic studies at Columbia, a position that Federico de Onís eventually occupied from 1916. Onís had previously enjoyed a brilliant academic career in Spain; though only thirty-one years old, he had already been a professor at the University of Salamanca, a tutor at the Residencia de Estudiantes, and an assistant of Menéndez Pidal.

His arrival in New York was an important step forward for Hispanic studies that served the interests of Spain as much as those of the United States. For the Junta para Ampliación de Estudios e Investigaciones Científicas in Madrid, it represented the establishment of a young intellectual close to the ideas of the Institución Libre de Enseñanza in a major American university, from where he could promote Spanish culture. For many Spanish writers, Onís became the primary intermediary when they sought to get their work published in the United States; he received requests to represent Pío Baroja, Jacinto Benavente, Federico García Lorca, Juan Ramón Jiménez, Vicente Blasco Ibáñez, Pedro Salinas, Dámaso Alonso, Tomás Navarro Tomás, Miguel de Unamuno, Ramón Menéndez Pidal, Ramón del Valle-Inclán, and Azorín (José Martínez Ruiz), among several others.

For the United States, Onís was a specialist who could help develop the field of Hispanic studies at Columbia with the professionalism the university required. In addition, after the United States entered World War I in April 1917, he became a figure who could also contribute to advancing propaganda favorable to the American cause in Spain at a time when pro-German *germanófilos* and the opposing *aliadófilos* were seeking to gain support in Spanish society. Equally, his proximity to Huntington also made him, curiously, a suitable person to win the support of the Hispanic Society's founder for the propaganda work that the Wilson administration was seeking to expand. A letter from Onís to Nicholas Murray Butler on December 10, 1917, records a request that Onís had received indirectly

from the American embassy in Madrid. "They asked my help specially in two things," he informed the university president, "first, in giving information about the persons who might be helpful to them in Spain, . . . and second, in acting as an intermediary between them and the Americans interested in Spain, especially Mr. Huntington, in order that these Americans might cooperate in their work."[65]

World War I was extending its tentacles into nearly every area of American society, and American citizens found themselves impelled to support their country in the war effort at the risk of being considered unpatriotic if they did not. In 1918, it was Huntington's turn, and so at the request of the American ambassador in Spain, Joseph E. Willard, he joined a government delegation headed by August Belmont Jr., a New York financier who had enlisted as an officer in the US Army, to negotiate a trade agreement with Spain in Washington. As a result of this agreement, the Spanish government committed itself to issue export licenses for a range of articles required to cover the needs of the American Expeditionary Force in France during the war and permitted the unrestricted export of iron pyrites, lead, zinc, copper, and other minerals to the United States, while the United States in turn authorized the sale to Spain of cotton and oil, products considered indispensable to sustain Spanish industry.[66] Huntington was already on good terms with the Spanish authorities and regularly in communication with them, so it was in no way strange, particularly in view of customary American practice, that the US government should have turned to him to facilitate such an agreement in time of war.

Once the war was over, Columbia University, in association with the Hispanic Society, resumed its practice of issuing invitations to Spanish cultural figures. In 1919, María de Maeztu, director of the Residencia de Señoritas in Madrid, gave lectures at women's colleges across the United

65. Federico de Onís to Nicholas Murray Butler, Dec. 10, 1917, cover letter to "American Propaganda in Spain," Columbia University Libraries Online Exhibitions, at https://exhibitions.library.columbia.edu/exhibits/show/the_hispanic_institute_between/item/12528, accessed Nov. 13, 2023.

66. For a full account of this agreement, see Montero Jiménez, *El despertar de la gran potencia*, 185–86.

States. Vicente Blasco Ibáñez, a known supporter of Spanish republicanism and already highly successful among the American public, and his fellow writer Ramón Pérez de Ayala also spoke in New York, Blasco Ibáñez on November 3, 1919, and Pérez de Ayala on December 2.

In 1920, Federico de Onís was appointed head of the newly founded Instituto de las Españas at Columbia, and his work of coordinating activities with other educational institutions in the United States and Hispanic America grew significantly. The interest his projects aroused among the Hispanic community of New York was closely followed in the pages of the Spanish-language newspaper *La Prensa*, edited from 1918 by José Camprubí (1879–1942), brother of Zenobia Camprubí and so brother-in-law of the poet Juan Ramón Jiménez. The aim of *La Prensa* was to serve the Spanish and Hispanic American communities in the United States as well as all Americans interested in these communities' culture, and it consequently became one of the pillars of Hispanism in New York, a status it shared with the Instituto de las Españas, the Hispanic Society, and the American Association of Teachers of Spanish (AATS).

This teachers' association was another key institution in the expansion of interest in Hispanic studies and had received Archer Huntington's support since its creation in 1916–17. During the first three years of its existence at least, the New York chapter held its meetings at the Hispanic Society.[67] The AATS became the voice of Spanish and later of Portuguese teaching in the United States and through its journal *Hispania* transmitted to the educational community at large the significant debates in the field of Spanish-language teaching and learning. Federico de Onís also approached the founding president of the AATS, Lawrence A. Wilkins, to propose a collaborative program that would employ visiting teachers from Spain to improve the training of American Spanish-language teachers in summer schools at Columbia. Such a program provided an unsurpassed

67. The first meetings of the New York chapter of the AATS (and in the United States) were held at the Hispanic Society of America on November 25, 1916, and January 6 and October 20, 1917, and the national AATS was founded in New York on December 29, 1917. *A History of the Hispanic Society of America*, 557. The AATS was expanded to become the American Association of Teachers of Spanish and Portuguese (AATSP) in 1944.

opportunity for the Junta para Ampliación de Estudios e Investigaciones Científicas and for its representative in New York, Onís, to make good use of their Spanish teaching staff and capitalize upon the growing teaching of Spanish in the United States.

However, this exponential growth in interest in learning Spanish also tended to highlight, in addition to a shortage of language teachers in the United States, another deficit that American Hispanism had suffered since its early origins: lack of a solid identity. The historian James D. Fernández has examined the causes that underlay this indecisive identity and encapsulates his conclusions in the expression "Longfellow's Law." Taking as a point of departure the personal experiences of the poet Longfellow in his first visit to Spain in the 1820s, Fernández has traced the displacement of an initially practical interest in Spanish as the vehicular language of Hispanic America with a scholarly study of the literature, history, and culture of Spain. "Although the eyes of pragmatism looked south," he observes, "the gaze of students and scholars became fixed towards the east."[68]

This duality, present in American Hispanism since its first steps, generated a series of tensions from the 1920s on to which teachers of Spanish were directly exposed. If one problem was to answer the massive demand for Spanish classes with the scarce number of teachers in the country, another was how to respond to their detractors, who labeled Spanish a language that was easy to learn and useful for doing business in Latin America but did not have a cultural worth comparable to French, German, and Italian.

The rapid popularization of Spanish made it difficult to combine the functional and populist appeal of the language with the prestige associated with the fields of Hispanic study that Archer Huntington and his fellow American Hispanists had been cultivating at a more elitist level. This dilemma between two contrary approaches led many Hispanists to downplay the utilitarian value of the language and maintain the value

68. James D. Fernández, "'Longfellow's Law': The Place of Latin America and Spain in U.S. Hispanism, circa 1915," in *Spain in America*, ed. Kagan, 124. The concept of "Longfellow's Law" as put forward by Fernández is that "U.S. interest in Spain is and always has been largely mediated by U.S. interest in Latin America" (124).

of teaching Spanish purely as a means of gaining entry to the venerable culture of Spain. Given this situation, it is illuminating to consider the exchange of letters that took place in 1926 between Huntington and Henry Grattan Doyle, professor of romance languages at George Washington University, member of the AATS, and future editor of *Hispania*.

In March 1926, Professor Doyle wrote to Huntington to ask for his support in one of the instances where voices from some educational sectors had been heard questioning, with some disdain, the importance of teaching Spanish, comparing it to Choctaw and Hottentot, American Indian and African tribe dialects. For Doyle, this seemed an extremely important matter for all friends of Spain, and he asked Huntington to write to the head of education for the relevant county, confident as he was of the influence that Huntington's name would have in educational circles.[69] However, the recommendation made by Huntington in his reply was the opposite. "It is my impression that any attempt to curb this sort of expression ends in advertising it, and may do more harm than good," he observed. "I base this judgement upon experiences in the past, which have led me to doubt the efficacy of such attempts."[70]

Huntington also added in his letter a possible explanation of what was happening in the United States, relating these attacks on Spanish to the extraordinary surge in the popularity of Spanish art and architecture that could be seen in the Southwest and Florida. Referring to the proliferation of the "Spanish colonial revival" style and the consequent fashion for Hispanic art objects among the country's new magnates, he asked, "Is it not also to be borne in mind that just at this moment the interest in the Hispanic field, particularly in art and architecture through the development in the Southwest and Florida, has been greatly stimulated, and that a reaction may follow?"[71]

69. Henry Grattan Doyle to Archer Huntington, Mar. 4, 1926, box 31, AHHP, SCRC.
70. Archer Huntington to Henry Grattan Doyle, Mar. 6, 1926, box 31, AHHP, SCRC.
71. Huntington to Doyle, Mar. 6, 1926. The "Spanish colonial revival" style, based essentially on colonial-era buildings in Mexico and other parts of Latin America, made Hispanic architecture fashionable through the work of architects such as George Washington Smith, Addison Mizner, and Marion Wyeth. This fashion also led to an increase

Hence, Huntington proposed to Doyle that they should seek only to present a united front in the face of such abuse and continue working to display the benefits of Hispanic culture in America, trusting that those who had an interest in Spain would appreciate work of the kind sustained by the Hispanic Society. However, Huntington also added a final enigmatic request that confirms that some fissures had appeared among the community of American Hispanists: "I trust that those interested feel the Institution [the Hispanic Society of America] is working along sound lines, and if they do not so feel that they will render it and themselves a service by contributing advice from time to time."[72]

With these words, Huntington made it clear that, despite changing circumstances, he remained faithful to the ideas with which he had begun to work years earlier and that the Hispanic Society continued to be above all an institution whose primary aim was to place its collections at the disposal of scholars engaged in historical, literary, and artistic research.[73] Equally, he also made it evident that he took a certain distance from the dispute that had broken out over the teaching of Spanish and the "trivialization" of Hispanic studies. The principal way he demonstrated this distance from such concerns was by undertaking a new project at

in exports of art objects and architectural details and artifacts from Spain to the United States to decorate the new mansions in a "Spanish" style: carved wooden pedestals, entire coffered ceilings, tiles, window grills, tapestries, rugs, furniture, staircases, and even whole cloisters were taken to America piece by piece, generating a traffic of such size that at times the art markets of Madrid were left empty by the huge demand from dealers, as one of the most active exporters, Arthur Byne (see chapter 2) acknowledged in 1923. Factories were also created in the United States to produce copies of the architectural elements most in demand, which led to a further vulgarization of the Hispanic style.

72. Huntington to Doyle, Mar. 6, 1926.

73. In its own history published to mark its fiftieth anniversary in 1954, the Hispanic Society described itself as follows: "While the building of the Hispanic Society actually includes, in the strict sense, a museum, this title as usually and broadly understood is in a measure pretentious. Nor was it the original intention that it should ever be strictly applied. The building is simply the home of the Hispanic Society, and the small collection of objects was included solely for the convenience of the students and members." *A History of the Hispanic Society of America*, 8.

the highest level, a new institution devoted to scholarly Hispanism: the Hispanic Division of the Library of Congress in Washington, DC. After the Hispanic Society, this would be his greatest contribution to Hispanic studies in the United States.

In 1926, Herbert Putnam, librarian of Congress from 1899 to 1939, published a "desiderata list" of the bibliographical "monuments" that he felt should be represented in the Library of the Congress. This list, which among other items included Christopher Columbus's diary of his first voyage to America in 1492, had the effect of placing a spotlight on the need to incorporate a collection of Spanish and Portuguese works, supported by donations.

In 1927, Huntington was the first to make a donation, the generous amount of $50,000 (around $650,000 today), to establish the Huntington Endowment Fund to permit the library to acquire books on Hispanic art, literature, history, and culture in general. The only proviso attached to this donation was that the books in question had to have been published no more than ten years before the date of acquisition; that is, they had to be contemporary titles and editions because the library of the Hispanic Society already had a collection of historic volumes that could not be surpassed. A year later he made another donation of the same amount, part of which would go toward the employment of a consultant to take charge of selecting the books. Alongside this additional fund of $50,000, the interest from which Huntington thought would be sufficient to pay the consultant's salary, he also announced to Putnam his intention to endow a "Chair of the Literature of Spain and Portugal in the Library of Congress."[74] The confidence he had in Juan de Riaño y Gayangos explains the fact that after Riaño had retired as Spain's ambassador to the United States in 1926, Huntington put his name forward to be the first consultant for the Hispanic Division.[75] Riaño had been making plans to travel to South America to look for business opportunities, but he eventually accepted

74. Archer Huntington to Herbert Putnam, Apr. 24, 1928, box 51, AHHP, SCRC.

75. "Hispanic Division Celebrates 65 Years," *Library of Congress Information Bulletin*, Dec. 2004, at https://www.loc.gov/loc/lcib/0412/index.html.

the post, informing Huntington, "My friend Herbert Putnam, of the Library of Congress, wrote to me about ten days ago offering me the post of 'Consultant' in connection with a recent endowment which has been made to the Library for the acquisition of Spanish, Portuguese and South American literature."[76]

Although Riaño said in his letter that it was part of his role to acquire "South American literature," in reality the operational field of the Library of Congress Hispanic collection in its first years was limited to the Iberian Peninsula. This was confirmed by Riaño's successor, Father David Rubio, consultant from 1931 to 1943 and curator of the Spanish and Portuguese collections from 1939 to 1943. Writing of the generous sums that Huntington donated for the purchase of books on the art, literature, history, and culture of the Iberian countries, he noted that "in the initial terms of the donation the other Spanish- and Portuguese-speaking peoples had not been included."[77] In effect, Rubio recalled that after he had been at the Hispanic Division for five years, in 1935 he succeeded in building up a collection of one hundred thousand titles, against only fifteen thousand when he had arrived. Of these fifteen thousand, "from Latin America there had not even been a single volume of Rubén Darío." "Apart from not being very well informed on the publications of Spain and Portugal," Father Rubio recalled, "[Riaño] was already old and unwell, and thought more of living quietly preparing himself for the Great Journey than involving himself in dealing with booksellers, publishers, and authors, all of which required a great deal of activity, patience, and enthusiasm."[78]

In Rubio's opinion, Juan de Riaño had stayed in the post until 1930 more out of friendship for Huntington than out of genuine interest. His observation accords well with the anecdote that in early 1929, not long after Riaño had taken up his position at the library, Huntington entrusted his old friend with another personal task: organizing the presentation of a casting of Anna Huntington's equestrian statue of El Cid Campeador

76. Juan de Riaño to Archer Huntington, July 30, 1928, box 52, AHHP, SCRC.
77. Davíd Rubio, "Mementos," in *Huntington, 1870–1955*, 35.
78. Rubio, "Mementos," 36, 35.

as a gift to the city of Buenos Aires. Riaño undertook this task successfully with the help of Antonio Maura, son of the former Spanish prime minister.[79]

By supporting the establishment of the Hispanic Division in the heart of one of the most respected institutions in the country, Huntington had added a further element of prestige to Hispanic studies. He continued to sustain American Hispanism in the way he knew best—through the scholarly institutionalization of culture.

By 1929 at age fifty-nine, Huntington had reached his mature years with his duty done in his personal and professional life. He had consolidated the Hispanic Society of America as the leading institution of his great cultural project. Through his different initiatives, he had become one of the individuals who had done most to energize the field of Hispanic studies in the United States. Last, in his personal life he had found an essential companion with whom to share his intellectual concerns and form what the American press described as "the heroic couple." While Archer was dubbed a "Titan" of museum building, because of both his height and the extent of his altruistic activities, Anna was referred to as a new Diana thanks to her bronze figure of the goddess, *Diana of the Chase* (1922), which was greatly admired in international exhibitions of sculpture.

A Bridge between Spain and the United States

Sylvia Hilton has written regarding Spain-US relations in the cultural sphere that "a diversity of social actors and institutions operating as a network was able to defy political barriers in order to encourage or take part in cultural interconnections of different kinds."[80] One has to acknowledge the correctness of this assertion in the case of the Hispanic Society, which

79. Juan de Riaño to Archer Huntington, Jan. 4, 1929, box 52, AHHP, SCRC.

80. Sylvia Hilton, "Estudio introductorio. Relaciones históricas hispanoestadounidenses: Visiones del siglo XX en clave cultural," *Revista Complutense de Historia de América*, no. 36 (2010): 26.

from the moment of its foundation up to 1930 showed a strong inclination to collaborate with other bodies and institutions to promote Hispanic studies and encourage their dissemination, pacifically subverting political and cultural barriers to establish cooperative relationships with a broad range of organizations, far from symmetrical and with diverse objectives but all prepared to combine their resources on an occasional or more permanent basis to reinforce the impact of their Hispanist projects.

Graphic 2 presents a single image taken, one might say, from the end of this period. On its left side, one can see the set of institutions in the United States with which the Hispanic Society collaborated to further the cause of Hispanic studies. Until the beginning of World War I, this group was limited to universities and associated institutions with which the society organized lecture series and cofinanced publications, as it did on a continuing basis with Columbia or more occasionally with Bryn Mawr. It was after 1916 and above all during the 1920s that new associations and institutions dedicated to different aspects of Hispanic studies began to emerge in the United States, and so this was when the Hispanic Society established relationships with the AATS and the Instituto de las Españas and even helped create new institutions through Huntington's intervention, such as the Hispanic Division of the Library of Congress. One could also see at this time that Huntington made use of the other academies and associations that he had built around the Hispanic Society on Audubon Terrace to encourage, thanks to their proximity, occasional cooperative projects in specialist areas of Hispanic studies. All these institutional relationships had the same end: to spread the knowledge of and increase the value given to scholarly Hispanic culture in his country.

On the right, the graphic presents the varied collection of Spanish institutions that eventually became linked in one way or another to the activities and donations initiated by Archer Huntington directly by himself or indirectly through the Hispanic Society of America. At times, it is not easy to differentiate one from the other because Huntington personally and very directly took charge of all his contributions of a philanthropic nature, and he donated funds from both the Hispanic Society and his own resources. Something similar could be seen in Spain in the Vega-Inclán

INSTITUTIONAL RELATIONSHIPS OF
THE HISPANIC SOCIETY OF AMERICA,
1898-1930

- Institutional relationships of the HSA in Spain
- Institutional relationships of the HSA in the United States

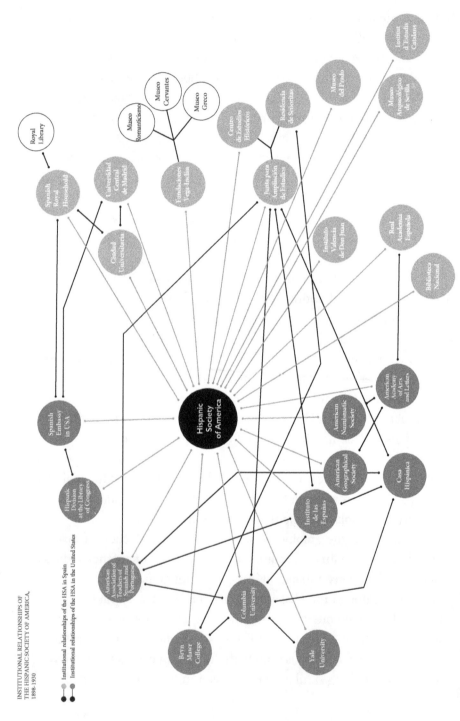

2. Map of institutional relations of the Hispanic Society of America, 1898–1930. Copyright © Patricia Fernández Lorenzo, 2022.

foundations and the Instituto Valencia de Don Juan, both projections and reflections of the personalities of their respective founders. In addition, Huntington tended not to give any publicity to his donations, making it still more difficult to identify them.

In graphic 2, institutions connected to the Hispanic Society are grouped together according to their nature. One can see a preponderance of museums and cultural foundations, such as the Casa-Museo del Greco, the Casa-Museo de Cervantes, and the Museo del Romanticismo in Madrid—the three museums that made up the Fundaciones Vega-Inclán, which had received assistance from the Hispanic Society both for their establishment and their ongoing maintenance. The Instituto Valencia de Don Juan also received funding from the society for a variety of publications; the Prado Museum received a donation of an X-ray machine; and the Institut d'Estudis Catalans obtained financial support for the acquisition of the *Cançoner de Cerverí de Girona* (mid–thirteenth century). In archaeology, the Museo Arqueológico Nacional in Madrid secured Huntington's support in fundraising programs for the acquisition of certain items; the proposed but never established Anglo-American School of Archaeology in Seville obtained a contribution from the Hispanic Society toward its foundation; and George Bonsor's museum in the castle of Mairena del Alcor received a subsidy to photograph and publicize Bonsor's archaeological collections and exhibit them at the Ibero-American Exposition of 1929 in Seville. The aim of all these donations and offers of assistance was, in the first instance, to safeguard, restore, and so permit the study of different aspects of Spain's artistic and historical patrimony in order subsequently to extend knowledge of them in Spain itself.

Libraries were also favored by Huntington's generosity. The Biblioteca Nacional and the Biblioteca Real (Royal Library) were sent complete collections of the Huntington Reprints, and the Residencia de Señoritas and other academic institutions punctually received the other Hispanic Society publications.

In terms of the internationalization of Spanish culture, important informal relationships were established between the Hispanic Society and the Centro de Estudios Históricos to assist the financing of some publications; the Junta para Ampliación de Estudios e Investigaciones Científicas

to support its effective "representative" in New York, Federico de Onís; and the Residencia de Señoritas in Madrid in enabling María de Maeztu to give a series of lectures in the United States. One should also consider the Hispanic Society's publication of works or studies by eminent Spanish intellectuals linked to the Residencia de Estudiantes. The one institution and project in Spain that received the largest amount of funding was without any doubt the Ciudad Universitaria in Madrid, and it has to be recognized that this donation was made because of the special connection between this project and King Alfonso XIII.

If one adds to the Spanish institutions shown on this chart the names of their respective heads or other leading members, there is an evident overlap with graphic 1 of Huntington's social relationships in Spain. The most obvious conclusion to be drawn from this observation is that it highlights the importance personal affinities had both in Huntington's activities as an art patron and in the Hispanic Society's activities as a philanthropic institution. The verification of this point reinforces the opinion that philanthropy and sociability or patronage and friendship—which in him amounted to the same thing—were two intrinsically linked virtues in this stage of Huntington's life.

His friend Arthur Upham Pope noted with admiration that Huntington in his work as a cultural benefactor did not surround himself with committees or advisers to decide the destinations of his donations. He had nothing comparable to a public-relations adviser, for he only followed the dictates of his own conscience and his own personal criteria. He professionalized the administration of the bodies that he founded or in which he participated but did not create a professional structure to coordinate his donations, which he always administered in person and with total autonomy. He maintained a direct relationship between donor and recipient and made his contributions in fields that stimulated him intellectually. In this regard, he operated differently from other American philanthropists, such as John D. Rockefeller and Andrew Carnegie, who created great charitable foundations in accordance with a model described as "scientific giving," through which they established a series of procedures and protocols that systematized the administration of

"wholesale" rather than "retail" philanthropy, according to the terminology originated by Frederick T. Gates, principal adviser on philanthropy to John D. Rockefeller.[81]

Huntington's own cultural schemes followed instead a more independent model of corporate philanthropy, a reflection of his own interests and convictions, and, to a great extent, a romantic ambition. As Upham Pope put it, "He wanted the intrepidity of the pioneer kept alive in American intellectual life."[82]

The Casa Hispánica: A Question of Size

Considering the extensive support Huntington had offered for many years to initiatives and ventures that sought to promote Hispanism in the United States, it can at first sight seem paradoxical that he was notably reluctant to take part in one of the projects of most interest to Spain at the time, the creation of the Casa Hispánica or Casa de las Españas in New York. His position on this matter seems a little unusual given the unquestionable interest that this proposal aroused in 1930 as a potential meeting point for visiting Spanish intellectual figures and students in New York, and so it is worthy of separate consideration. An interesting exchange of letters between Huntington and Nicholas Murray Butler provides us with a closer view and awareness of the former's attitudes to this proposal. In effect, the motivations that lay behind this voluntary abstention from a public project also characterize Huntington's cultural ambitions in his later years.

The origin of the proposal to create a Casa Hispánica as part of Columbia University lay in a desire to respond to a growing interest among students to have an environment in which to study in Spanish and enjoy contact with prominent figures of Spanish culture, in the style of the university's already-established Casa Italiana, Deutsches Haus, and Maison

81. Judith Sealander, "Curing Evils and Their Source: The Arrival of Scientific Giving," in *Charity, Philanthropy and Civility in American History*, ed. Friedman and McGarvie, 223.

82. Upham Pope, *Archer Milton Huntington*, 6.

française.[83] The university president, a friend and collaborator of Huntington in so many other projects and institutions, explained this to him in a letter on January 3, 1930. From the tone of the letter, this does not seem to have been the first time they considered the matter: in the first paragraph Butler indicated slightly regretfully that, owing to changed circumstances, he was obliged to present the case of the Casa Hispánica to Huntington once again and with greater emphasis.[84]

Butler shared with Huntington a concern that the field of Hispanic studies should be properly directed and structured in the face of the new expectations visible in the university. He considered that the growth in demand was owing in part to the success of Federico de Onís at the head of the Instituto de las Españas and in part to the strong interest shown by countries of Central and South America in sending students to Columbia. Spontaneously, too, the students of Spanish at Barnard College, the women's college affiliated with Columbia, had asked for a space under the supervision of the university in which they could use Spanish as an everyday language, a request that could be met under the umbrella of a Casa Hispánica.

Butler continued his letter with a brief description of the type of Casa Hispánica he had in mind and concluded by offering something of

83. In their correspondence, Butler and Huntington customarily referred to this scheme as the "Casa Hispánica," perhaps by analogy with its Italian or French equivalents. However, it subsequently became better known as the "Casa de las Españas," the name that Federico de Onís generally used for it.

84. On March 15, 1927, *La Prensa* of New York had reported the acquisition of two emblematic buildings in the heart of Manhattan, the Grand Central Palace exhibition hall and the Park Lexington office building, to house a Casa Hispánica and Spanish trade center. At the head of the project was Antonio Melián y Pavía, Conde de Peracamps, a Spanish businessman who had made a fortune in the Philippines. However, he had to abandon the scheme because of the bankruptcy of the two buildings' owners, so it went no further. This suggests, nevertheless, that the idea of creating some sort of Casa Hispánica had been under consideration in the Hispanic community in New York for some time. See Emilia Cortés Ibáñez, "José Camprubí y *La Prensa*, pilar del hispanismo en Nueva York," *Océanide*, no. 5 (2013), at https://dialnet.unirioja.es/servlet/articulo?codigo=4218251.

a "sweetener" to Huntington, mentioning that its students would make continual use of the Hispanic Society facilities and library.[85] "The Casa Hispánica which I have in mind should make provision for a small auditorium and for those small libraries, reading and consulting rooms which advanced students would use constantly, singly or in groups, both by day and by night," the Columbia president explained. "Then the upper floor could be fitted up with living rooms for students, . . . these to be occupied by advanced students speaking Spanish and desiring to perfect themselves in that language, and to increase their knowledge of the literature, the art, and the institutions of the Spanish-speaking peoples. The best of these students would of course become constant visitors to the Hispanic Society building, and constant users of the collections that are there."[86]

In Butler's opinion, the university's experience with the Casa Italiana, Maison française, and Deutsches Haus demonstrated the usefulness and positive influence that these study centers could have, and so he appealed to Huntington in the hope of securing his financial support, conscious as he was of the fact that there were very few people in the United States with the same level of knowledge of and interest in all matters related to Spain. "If we had in the United States any other man or woman with one-tenth of your knowledge of things Spanish, or with one-tenth of your interest in them, I should seek that person out. Not knowing where to find such a person, I present the matter once more to you, and leave it on your knees."[87]

However, Huntington, in his reply sent five days later, revealed himself to be peculiarly reluctant to accept this proposal and, unusually for

85. In letters between Huntington and Juan de Riaño, one can see a certain concern over the lower numbers of visitors to the Hispanic Society in the 1920s. In 1922, Riaño wrote that he had read with great interest an article on the Hispanic Society of America in the *Christian Science Monitor*, adding, "I would be very interested in knowing what results the publicity campaign has produced, in the sense of an increase of visitors to the Hispanic" ((10) 2654/8247, AGA). Hence, Butler's highlighting of this aspect in his proposal may have been well received by Huntington.

86. Nicholas Murray Butler to Archer Huntington, Jan. 3, 1930, box 15, AHHP, SCRC.

87. Butler to Huntington, Jan. 3, 1930.

him, revealed doubts regarding his own decisions on the matter. "I feel that I am letting an opportunity to do a fine piece of work slip through my fingers," he wrote, "and there is no sense in stating a number of reasons why."[88]

The project did not attract him, he went on; it did not arouse his interest, and, curiously, "I should not wish to do a small thing for Hispanic culture, and I do not believe that I should care to invest the sum which seems necessary to do a truly efficient one on these lines."[89] In his view, what Columbia was proposing was a project of little substance, which he described as "small," whereas he thought that to be in any way effective it needed to be more ambitious.

Butler expressed his disappointment in his next letter but did not cease his effort because he was well aware of Huntington's generosity and the sums he had recently provided for the building of the American Academy of Arts and Letters. The Casa Hispánica was, in Butler's opinion, not just desirable but also an addition that would be indispensable for keeping interest in Spanish studies and Spanish culture alive and for facilitating contacts with Spanish speakers from every part of the world. He even suggested that it might be more influential than any of the other projects then in progress in the Hispanist field in the United States. With an express allusion to the Hispanic Society of America and the recently created Hispanic Division at the Library of Congress, the Columbia president declared himself convinced that the Casa Hispánica could have a much greater value than the museums and libraries, which ultimately answered only the needs of elites or the curiosity of a few specialists.

"Museums and libraries are all well enough in their way," he argued, "and serve a real purpose for the elite and the intellectually curious, but the power of day-by-day contacts with personalities, with a language and its literature, with its institutions and the revelations of its art, this power reaching not just scores but hundreds, indeed thousands, of alert and eager youth from all over the land, is infinitely of greater significance and

88. Archer Huntington to Nicholas Murray Butler, Jan. 8, 1930, box 15, AHHP, SCRC.

89. Huntington to Butler, Jan. 8, 1930.

greater value."[90] Butler and Columbia had thus chosen to seek to offer new possibilities in learning through the formation of a community of students of Spanish, Spanish-speaking students, teachers, and literary and artistic figures within one of the world's leading universities.

Faced with a range of difficulties in securing financing for the scheme, Butler tried again six months later. In a letter in June 1930, he informed Huntington that the university had already acquired a building to house the future Casa Hispánica at 435 West 117th Street, but further funds were needed to refurbish its rooms and cover operating costs. He estimated at $30,000 (around $500,000 today) the cost of adapting and furnishing the building for its new purpose and considered it necessary to establish a capital fund sufficiently large so that the annual costs of maintenance and personnel, estimated at around $10,000 ($160,000 today), could be covered from its income.[91] Considering that two years earlier Huntington had financed the creation of the Hispanic Division at the Library of Congress with a fund of $50,000, to Butler his request no doubt did not seem outrageous in monetary terms.

Two days later another disappointing reply came from Huntington. This time he was not satisfied with describing the project as "small" but instead, after seeing the budget proposed by Butler, refused to take part in what he called a "microscopic" version of the Casa Hispánica. Nobody could have desired more than he the foundation of a Casa Hispánica in New York, he claimed, but in view of the figures provided by Butler he could see that this was not the type of project in which he could be involved. "The plan for the microscopic version of the Casa Hispánica is not one which I could enter upon, as in my case the obvious line of procedure is toward a more comprehensive undertaking. . . . No one would see with more pleasure the foundation of a Casa Hispánica, but it does not seem to be my job."[92]

90. Nicholas Murray Butler to Archer Huntington, Jan. 11, 1930, box 15, AHHP, SCRC.

91. Nicholas Murray Butler to Archer Huntington, June 3, 1930, box 15, AHHP, SCRC.

92. Archer Huntington to Nicholas Murray Butler, June 5, 1930, box 15, AHHP, SCRC.

Huntington also pointed out that the great difficulties Butler was encountering in securing financing from other sources were not at all encouraging, and he did not hesitate to stress his own incredulity at the fact that not a single Spaniard or Hispanic American living in New York appeared capable of contributing to the establishment of a Casa Hispánica. What kind of future awaited Hispanic studies in North America, he suggested, if at a time when it seemed to arouse the greatest interest and to be expanding rapidly, it met with so little backing? "If there is such slight backing on the North American continent for Hispanic studies," he wrote, "I tremble for their future."[93]

Although disheartened at not being able to find a single friend of Spain with sufficient resources to resolve the question of ongoing finance, President Butler did not abandon the possibility that Huntington would eventually agree to financially support the Casa Hispánica scheme and a short time later wrote again. In his next letter on June 10, he shared with Archer his views regarding the situation faced by the project. He acknowledged that in both the Casa Italiana and the Deutsches Haus the promoters of each project had been able to call upon a generous contribution from a wealthy citizen of Italian or German descent. It had not been the same with the Maison française, but the university had obtained financial support from an American lover of French culture. In the case of the Casa Hispánica, despite the spectacular growth in demand for Hispanic studies and the growing number of Spanish-speaking students at the university, only Huntington appeared as a viable option for resolving the problems involved in getting the project underway. A possible reason why could be found in the statistics of the period, which indicate that the Spanish immigrant community in the United States was substantially numerically smaller than those from other European countries and that most of its members were of the working class, suggesting that the critical mass of potential patrons for a Casa Hispánica was insignificant in size.[94]

93. Huntington to Butler, June 5, 1930.

94. Niño, "Las relaciones culturales como punto de reencuentro hispano-estadounidense," 72.

Butler made this one last attempt to convince Huntington, arguing once again that although the Casa Hispánica might be modest in size, it would have a greater effect in multiplying the range of contacts between the United States and the Spanish-speaking countries than all the museums, lectures, or publications they could ever organize and that, however desirable all such things might be, not all would have the same effect. "It is my measured judgement," he repeated, "that even a modest Casa Hispánica in effective operation in Morningside Heights would do more year by year to strengthen and to spread knowledge of Spanish culture and to multiply effective contacts between the United States and Spanish-speaking countries than all the museums, courses of lectures, publications, and other undertakings, each desirable enough in itself, can do through a series of generations."[95]

For the last time, Butler asked Huntington to consider the possibility of financing the refurbishment of the building with a donation of $30,000 or at the most $35,000, leaving to the university the question of finding the funds for the *casa*'s future upkeep. There is no reply to this final request in the archives. Huntington and Butler often met at the same meetings and other events, where they could have spoken in person, but all we know with certainty is that at the end of 1930 the Casa Hispánica was inaugurated by the university as the Casa de las Españas and that the Instituto de las Españas moved there soon afterward.[96]

95. Nicholas Murray Butler to Archer Huntington, June 10, 1930, box 15, AHHP, SCRC.

96. Until Casa Hispánica moved to its current location in 1966, it was located at 435 West 117th St., a building that no longer exists today. There is no record in either published studies or relevant documents that Archer Huntington or the Hispanic Society ever contributed to the Casa de las Españas. Researchers who have examined this topic indicate that Columbia University was the sole institution that took charge of financing the activities of the Instituto de las Españas, at least until 1934, when Spain's Council for Cultural Relations sent from Spain $2,000 each year for three consecutive years (around $29,000 today). See Consuelo Naranjo, "Compromiso y voluntad: Federico de Onís y la creación del Instituto de las Españas (Nueva York, 1920–1936)," in *Redes internacionales de la cultura española*, ed. García Velasco, 355.

Such a marked difference of opinion between two of the great father figures of American Hispanism is highly symptomatic of the bifurcation between a minority, erudite Hispanism and an academic Hispanism increasingly focused on the teaching of the Spanish language. The letters from Nicholas Murray Butler suggest this as he sought to contest Huntington's excuses by insisting on demonstrating to him that a concern for students' growing demands should take precedence as a means of generating genuine discussion around Hispanic topics—an acceptable argument for the head of a university but one that Huntington did not agree with.

Archer Huntington, meanwhile, chose to continue financing initiatives of a markedly elitist character, with which he made very clear the priority he gave to elevating the prestige of Hispanic studies above attending to the needs of language learning. This appears to be the most plausible explanation for his attitude toward the Casa Hispánica, although it is not the only one. Another factor that may have contributed to his rejection of Butler's proposal was the secondary role to which the Hispanic Society and its founder appeared to have been relegated by comparison with the public prominence that the Instituto de las Españas and its director Federico de Onís had acquired in American Hispanism, which a new Casa Hispánica would make still more evident.[97] Nor should one forget, of course, the economic crisis that had swept across the United States since the Wall Street crash of September 1929 and the enormous losses felt by many businessmen, millionaires included. This does not seem to have been the case for Huntington, but he did mention as one of the

97. According to Juan de Riaño, Huntington had certain reservations about the greater prominence that the Instituto de las Españas had been acquiring in New York. In 1922, the ambassador wrote to Vega-Inclán in Spain: "This could be entrusted to the Instituto de las Españas, which as you know is under the direction of Onís, but this has the inconvenience that (said most confidentially) our friend Huntington has a certain ill-will towards it, since he does not look well upon the tasks that it is carrying out, as he feels—although he does not acknowledge this openly—that they take something away from the work of the Hispanic Society." Juan de Riaño to Marqués de la Vega-Inclán, Dec. 18, 1922, (10) 2654/8247, AGA.

justifications for his refusal to take part in the project the many financial commitments he had to meet for the projects he already had in progress.

Perhaps most curious of all in this episode is the fact that Huntington repeatedly based his rejection on purely structural questions regarding the supposed size of the new institution, describing it as "small" or "microscopic." In contrast to this pragmatic approach, Huntington had always stood out among his countrymen for the special care he took to provide his projects with infrastructure and settings of the highest quality, as was evident in the schemes he promoted during the first thirty years of the century. Hence, he may have felt that the speed and simplicity with which Columbia wished to get the Casa Hispánica into operation to conquer a growing market of Spanish-language students did not suit him. His previous career as a "museum builder" helps us understand the prism through which he judged the new scheme and equally to see the ambivalent relationship he had with anything associated with the democratization of culture. Pushed to choose between cultural proselytism and erudition, Huntington, by his rejection, only reaffirmed his deepest convictions in favor of the latter. His refusal to join in the collective enthusiasm prompted by the new immense market for the consumption of Spanish classes and Hispanic subject matter, themes, and images, which in his view simultaneously trivialized them, was his way of distancing himself from a new era that augured major changes in all aspects of culture.

The fact was that in 1930 the world was changing in ways that departed from Archer Huntington's interests, and it appears that he, by then sixty years old, resisted being carried along by the momentum of the new era and continued to assert the role of culture as a symbol of status. If, as Bourdieu argued, "social subjects comprehend the social world which comprehends them,"[98] the question that presents itself to us today is to what extent the world comprehended Archer Huntington at the dawn of the 1930s.

98. Bourdieu, *La distinción*, 484.

Part Three • Huntington "in Crisis" • 1930-1947

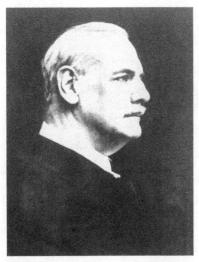

12. Archer M. Huntington, c. 1934. *Source*: Box 95, "Photographs Family Huntington, Archer," Anna Hyatt Huntington Papers, Special Collections Research Center, Syracuse University Libraries. By permission of Syracuse University Libraries.

I will never forget that figure of distinction, nearly six feet in height, immaculately dressed and with aristocratic manners; he seemed to me a *caballero* of the kind Velázquez painted in the seventeenth century. When he entered, you could see from a distance that he was suffering from a heavy cold. Putnam, a good friend of his, said with a great sense of humor and wit, "Archie, let's see how you curse your cold in Spanish." And then Huntington, in a perfect Spanish of Castile, let forth a litany of curses for his cold, which I still remember, but I do not consider suitable to repeat here.

—David Rubio, "Mementos," in *Huntington, 1870–1955*

4

A Humanist in a World in Crisis

Gain Some Distance to See Better

The first years of the 1930s saw the beginning of a new era for Europe and the United States, one marked by economic crisis, political instability, social unrest, and war. The United States suffered a shattering financial crisis following the crash of the New York stock market on October 29, 1929, which led to the Great Depression, the longest and deepest economic crisis in US history. Overcoming it involved an ambitious program of progressive legislative reforms that from 1933 modified the model of American capitalism. Meanwhile, in the unstable arena of Europe the economic crisis and resulting social malaise were combined with the expansionist ambitions of Adolf Hitler's Germany and Benito Mussolini's Italy, which in 1939 dragged the continent into World War II.

For its part, Spain was immersed in the exhilarating but convulsive period that opened up following the victory of Republican parties in the local elections of April 12, 1931. The results of these elections provoked the fall of the monarchy and the establishment of Spain's Second Republic. In the scarcely five years between 1931 and 1936, a wide-ranging series of progressive policies was introduced by the governments of the left, but their alternation in power with opposing political forces resulted in a dysfunctional revanchism that impeded real government action and an intensifying political radicalization that divided Spain to the point of leading it by 1936 into a fratricidal conflict, the Spanish Civil War.

In only ten years, the world witnessed radical economic, social, political, and cultural change. It was a time of crisis, change, breaks with the past, and abrupt and often violent transformations.

At the beginning of this decade, Huntington celebrated his sixtieth birthday. The world that he had known was disappearing before the astonished eyes of the multimillionaire; as he looked on, initially with concern and later with nostalgia, pillars of the once-buoyant American financial system were knocked away, the monarchy fell in Spain, and culture and the arts were harnessed and pummeled without any compunction in Europe by political regimes determined to achieve power and the destruction of their opponents. The question naturally arises regarding the extent to which these new circumstances influenced his devotion to Hispanism and philanthropy and what role he continued to play as a patron in this new arena.

Very little information has come through to us on Huntington's life during these years because he chose to limit his appearances in American public life and ceased to participate actively in the cultural life of Spain, not visiting the country again after the summer of 1929. This decision to remain offstage in the new *theatrum mundi* reduced his visibility in the customary social and cultural circles and, consequently, his influence as a public figure.

"Gain some distance to see better" is a phrase that could summarize the attitude Huntington adopted during the 1930s. This distancing may have helped him to look objectively upon events at a time characterized by increasing confusion but that also enabled him to escape from an environment that had begun to endanger many of the achievements of Hispanism and other branches of culture he had sought to establish.

This distancing was not just a matter of attitude. The many months that his wife, Anna, who was suffering from tuberculosis, spent in various sanatoriums in Switzerland and the United States between 1931 and 1934 and their search for homes where they could enjoy tranquility outside a city stricken by the crisis were important motivations that led Archer to spend long periods away from New York. The most immediate consequences of this change in his life were the gradual delegation of part of his work in Hispanism to his associates at the Hispanic Society and a greater availability of free time, which he decided to devote to writing poetry, an interest he had not been able to follow for many years because of his multiple responsibilities.

From a financial point of view, Huntington's wealth was not directly affected by the crisis sweeping over his country. Between 1929 and 1932, more than five thousand financial entities in the United States collapsed in bankruptcies, which then extended in a cascade effect to every sector of the economy, and the country entered into a recessionary spiral during which more than thirty thousand companies ceased business and twelve million people were unemployed.[1] By remarkable good fortune, after his return from Spain in August 1929, Huntington had sold most of his holdings on the stock market, except his shares in Huntington family businesses, because the rise in his holdings' value at the time had seemed excessively strange to him.[2] Thanks to this decision, his personal finances did not undergo the disintegration suffered by so many other American investors, who found themselves ruined from one day to the next. Nevertheless, the country's economic situation led him to rethink his role as a cultural patron and modify the nature of some of the philanthropic initiatives he undertook at this time by comparison with those he had engaged in over the previous thirty years.

Huntington's attitude toward Spain also changed, and he maintained an increasing distance from the institutions of the new Spanish Republic "of the intellectuals."[3] Like other American Hispanists, he read with concern the news reports of incidents of violence against Spain's cultural, religious, and historic heritage, and a growing wariness intruded into his hispanophilia. In truth, the Spain of the Second Republic was equally unable to count on the blessing of the State Department in Washington. During the presidency of Herbert Hoover from 1929 to 1932, US diplomatic

1. U.S. History.org, "The Great Depression: Sinking Deeper and Deeper, 1929–1933," U.S. History: Pre-Columbian to the New Millennium, n.d., at https://www.ushistory.org/us/48b.asp, accessed June 6, 2022.

2. "He [Huntington] explained that he had called the meeting of top bankers to coordinate his instructions to sell every share of common stock that he owned, with minimal effect on the stock market." Mitchell and Goodrich, *The Remarkable Huntingtons*, 49.

3. This was the term that Juan Pablo Fusi Aizpurúa used to refer to the years of the Second Republic; see Juan Pablo Fusi Aizpurúa, "La república de los intelectuales," in *La España del siglo XX*, ed. Santos Juliá et al. (Madrid: Marcial Pons, 2007), 589–613.

authorities looked on the establishment of the new regime with suspicion because, as Gabriel Jackson argues, ever since 1917 both the United Kingdom and the United States "considered any progressive outbreak in the politics, not just of Spain, but also of Portugal and the countries of Latin America, to be a direct consequence of the Soviet revolution."[4] A different stance was taken from 1933 by President Franklin D. Roosevelt, a Democrat, and his ambassador in Spain, Claude Bowers, as both men showed themselves favorably inclined toward the republic in principle, although circumstances deriving from the global situation led to an increase in tension in bilateral relations prior to the outbreak of the Spanish Civil War.

Despite the disturbances, the new leaders of the Second Republic stamped a change of direction on cultural policies in Spain, which came under the leadership of the Ministry of Public Instruction and Fine Arts, with the objectives, inspired by regenerationism, of protecting the Spanish artistic heritage, making it better known, and encouraging its appreciation among the country's nonelite. Culture ceased to be left to the whims and initiatives of philanthropists and aristocrats and began to be seen as an area of public interest to be managed by government institutions and the intellectuals at their head.

The close relationship and friendship that Huntington had maintained with King Alfonso XIII and his circle of aristocrats conditioned his own public image in Spanish affairs, which would remain irredeemably linked to monarchist Spain—that is, a Spain that had failed. In addition, while the Hispanic Society had been able to act during the preceding decades as a facilitator for the international promotion of Spanish culture, in the United States by 1930 the leading role in such promotional tasks was being taken by Columbia University's Instituto de las Españas and Casa Hispánica, at the head of which was Federico de Onís, who was fully in agreement with the new directives set out by the Junta para Ampliación de Estudios and the Junta de Relaciones Culturales (Council on Cultural Relations) of the republic's Ministerio de Asuntos Exteriores (Ministry of

4. Gabriel Jackson, "II República, New Deal y Guerra Civil," in *España y Estados Unidos en el siglo XX*, ed. Delgado Gómez-Escalonilla and Elizalde Pérez-Grueso, 115.

Foreign Affairs) in Madrid. Huntington had been a center of attention and a point of reference for anyone concerned with Hispanic culture in New York, but in 1930 with his reluctance to take part in Columbia University's Casa Hispánica project he had already made evident a distance between himself and the new forms of leadership of Hispanism in the United States as well as the secondary role the Hispanic Society would take in the new circumstances. The question arises regarding what Huntington did next in this new scenario.

In broad terms, one can say that he adopted an attitude of withdrawal with regard to Spain, focusing his attention on his own country, his family, and his internal world. He promoted cultural projects directed at the ordinary American public, very different from the ventures he had dedicated himself to setting up in the three previous decades, and traveled with Anna to help her recover her health. He organized his daily life away from New York City and dedicated himself assiduously to his poetry, publishing fourteen books of poems between 1930 and 1936, most inspired by Hispanic themes.[5] This behavior does not seem entirely anomalous for a cultivated cosmopolitan and patron of the arts in the context of a decade dominated by economic crisis, political antagonisms, and war.

It is sometimes said that silence separates more than distance, and this aphorism is particularly applicable in the case of Huntington, who, despite there being an ocean between them, continued to maintain a dialogue with Spanish realities through the correspondence he exchanged with his Spanish friends. These letters, in which Archer could detect the manner in which artists and intellectuals were gradually taking sides in an ever more fragmented country, provided him with a mosaic-like image of the years of the Second Republic that enabled him to remain informed on what was happening in Spain.

5. The books of poetry by Archer Huntington published from 1930 to 1936 were *The Ladies of Vallbona*, 1931; *Rebuznos*, 1932; *America, The Lady of Elche, Moraima's Tower, Polvo, Quatre Poèmes, The Sea, Torn Sails of Faith,* and *Youth*, 1933; *Alfonso the Eighth Rides By* and *The Silver Gardens*, 1934; *Rimas* and *Vela Venanosa*, 1936. Despite the occasional Spanish and French titles, all his poetry was in English.

Republican Spain in Letters

On April 14, 1931, the Second Spanish Republic was proclaimed, and King Alfonso XIII left Spain, never to return. Huntington wrote a heartfelt letter of farewell to the deposed king, with which he marked the end of a relationship that he had appreciated highly and brought an end to a fruitful stage in his life.

> For many years, thanks to your intervention, your Majesty, I have been cordially received and helped enormously in the task to which I have dedicated my life; when I turn to look at those years, I find myself obliged to give you my thanks for your generosity, kindness, and unwavering consideration, which have contributed so much to the success of this task. Whatever the future may bring us, I hope that you know that I do not forget all that you have done, Your Majesty, and I also hope that you and your loved ones may be profoundly happy.[6]

One cannot say that Huntington was, strictly speaking, a monarchist, but he had enjoyed the years in which there had been a degree of understanding and harmony among the king, the aristocratic circle around him, and the leading intellectuals in Spain. This had been a prolific period in which Huntington had participated intensely as a privileged "outsider" in the system, with the king's approval. However, a Spain without a king felt a need for change. Many artists and intellectuals who had been critical of the last governments of the monarchy gave their support to the new regime that emerged from the elections. At the beginning of 1931, three influential figures—Gregorio Marañón, Ramón Pérez de Ayala, and José Ortega y Gasset—had created the Agrupación al Servicio de la República (Grouping at the Service of the Republic), a movement through which they sought to articulate the support of intellectuals for the new republic and committed themselves to its reforming policies. With the additional

6. Archer M. Huntington to Alfonso XIII, Apr. 14, 1931, reproduced in "Retratos de hombres ilustres. 83, Alfonso XIII, rey de España," in *Sorolla y la Hispanic Society*, 342.

involvement of such figures as the poet Antonio Machado and significant popular support, the Agrupación won thirteen seats in the elections to the republic's new Constituent Cortes, or Parliament, on June 28, 1931. Miguel de Unamuno also took part in the Constituent Cortes, elected for the Coalición Republicano-Socialista (Republican-Socialist Coalition) in Salamanca, and several other leading intellectual figures aligned themselves with the new regime. The Republican government, despite this widespread support, encountered serious difficulties in getting its promised reforms underway but nevertheless from the beginning showed itself determined to change the country's institutional structures and the manner in which authority was administered.

In the cultural field, the new government sought to pursue a national cultural policy, placed in the hands of the Ministry of Public Instruction and Fine Arts and its principal officials—reforming intellectuals, many drawn from the circles around the Institución Libre de Enseñanza, who introduced a dynamism into public institutions that they had previously lacked. Under Marcelino Domingo and later Fernando de los Ríos as education ministers and Ricardo de Orueta at the head of the Dirección General de Bellas Artes (Department of Fine Arts) of the Ministry of Public Instruction, between April 1931 and December 1933 a tremendous amount of legislative work and administrative reform was carried out, all directed toward the central goal of giving tangible form to the long-desired regeneration of culture for the Spanish people.[7]

In these first years of the republic, individuals were as important as policies, and the Ministry of Public Instruction initiated a practice of making honorary appointments based on a desire to attract great names from the world of art and letters to join the new trusts formed to administer the country's museums, libraries, and other cultural institutions. Many of these figures, who by accepting these appointments indicated their support for the republic, were part of Huntington's circle of contacts in Spain.

Ramón Pérez de Ayala was appointed director of the Prado Museum, although for practical purposes this position was occupied on an interim

7. Cabañas Bravo, "Ricardo de Orueta, guardián del arte español."

basis by the far more qualified art historian Francisco Sánchez Cantón because Pérez de Ayala had also been named as the new Spanish ambassador in London. Gregorio Marañón was appointed to the Prado's governing board. In the trust, or *patronato*, that administered the Museo de Arte Moderno (Museum of Modern Art) in Madrid (whose holdings were later divided between the Prado and the Centro de Arte Reina Sofía), Mariano Benlliure was named honorary director, and Ignacio Zuloaga, José López Mezquita, and the writer Ramón del Valle-Inclán were appointed members of the trust. José Ramón Mélida was appointed president of the governing *patronato* of the Museo Arqueológico Nacional—of which he was already the director—while Ricardo de Orueta, Sánchez Cantón, and the archaeologist Manuel Gómez Moreno, a friend of Sánchez Cantón from the Centro de Estudios Históricos, were appointed to its board. Gómez Moreno was in turn appointed director of the Instituto Valencia de Don Juan, and Manuel Bartolomé Cossío was reappointed to the committee of the Fundaciones Vega-Inclán and subsequently, in April 1933, named as director of the Museo Nacional de Escultura (National Museum of Sculpture) in Valladolid.[8] Valle-Inclán was also given the post of conservator of Spain's Patrimonio Artístico Nacional (National Artistic Heritage), although he resigned after only a few months because of disagreements with the ministry, and in 1933 was appointed director of the Spanish School of Fine Arts in Rome. These are just some examples of an appointment policy that set out to reinforce these intellectuals' commitment to the republic but was not free of controversies and criticisms, such as the arguments expressed by the artist Ricardo Baroja when he confessed his disenchantment with the republic to Ricardo de Orueta,[9] and

8. Under the previous government, shortly before the fall of the monarchy, the three museums set up by the marquis of Vega-Inclán (the Casa-Museo del Greco, the Casa de Cervantes in Valladolid, and the Museo del Romanticismo in Madrid, which together made up the Fundaciones Vega-Inclán) and the Instituto Valencia de Don Juan, which had initially been private foundations, were taken under the aegis of the state and the Education Ministry because by this time these institutions were receiving public funds. Hence, their administrators were publicly appointed.

9. Ricardo Baroja's comment was, "The republic that places Pérez de Ayala at the head of the Prado and has indicated Valle-Inclán as a possible director of the Museum of

by Ignacio Zuloaga, who, after being named president of the *patronato* of Madrid's Museum of Modern Art, refused the appointment.[10]

Taking as a guide the map of Huntington's social networks in Spain from 1898 to 1930 (graphic 1), one can see the changes in position that many individuals experienced with the Second Republic. The aristocrats who had played prominent roles in a great many of the cultural initiatives during the monarchy, such as the marquis of Vega-Inclán, would be displaced to the periphery of cultural life, while intellectuals who had been far from the center of cultural activities on an institutional level prior to 1929, such as Ramón Pérez de Ayala and Ricardo de Orueta, would fill the most important posts in the network of cultural institutions set up in Republican Spain.

Although Archer Huntington was at least acquainted with most of the individuals who now occupied significant positions in Spain's museums and cultural institutions, by late 1931 his main circle of friends had been seriously weakened. Vega-Inclán had lost status and power with the disappearance of the king; Joaquín Sorolla, Menéndez Pelayo, Guillermo de Osma, and, most recently, George Bonsor had died; Juan de Riaño had retired; and the new political circumstances had broken some of the connections in Huntington's network of contacts. Although he remained in contact by letter with his closest friends, in the new institutional framework his actions related to Spain were restricted to a few largely testimonial contributions, such as the publication in 1935, in collaboration with the duke of Alba and the Royal Spanish Academy of History, of a book by Hugo Obermaier and Henri Breuil on the prehistoric wall paintings

Modern Art already has to be regarded with reservations, because neither of them knows a word about art, and they have unmistakably demonstrated their lack of ability." Quoted in María Bolaños Atienza, "Una edad de plata para los museos," in *En el frente del arte*, ed. Bolaños Atienza and Cabañas Bravo, 106.

10. Zuloaga resisted accepting the appointment made by the republic's government when in 1931, without consulting him, it named him as new head of the *patronato* of the Museum of Modern Art. Only the intervention of Marañón, who asked him not to reject the post publicly, persuaded Zuloaga to accept the appointment and then resign a few weeks later, without making any public statement. See Suárez-Zuloaga, "Antonio Zuloaga Dethomas," 127.

of Altamira, *Las cuevas de Altamira en Santillana del Mar*; the financial support of $5,000 (around $80,000 today) to the Instituto Valencia de Don Juan in 1936; and the translation into Spanish by Ernesto Giménez Caballero of Huntington's book of poetry *The Ladies of Vallbona*, presented to Huntington by Alba and some of his Spanish academic friends.[11] The question again arises, therefore, regarding what place Huntington found for himself amid this accumulation of changing circumstances.

On February 22, 1931, he received by letter the news of his honorary appointment as president of the *patronato* of the Fundaciones Vega-Inclán, but this appointment had been made in the last months before the proclamation of the republic, while Elías Tormo y Monzó, the art historian and a Huntington associate, was education minister in the interim government of General Dámaso Berenguer, formed after the fall of the Primo de Rivera dictatorship in early 1930.[12] Minister Tormo had introduced a new set of regulations for the museums set up by Vega-Inclán to bring them under the control of the Ministry of Public Instruction and thus end the state of uncertainty in which they had existed up to that point because of their increasing reliance on public funding.[13] In February 1931, an appointment as president of a *patronato* still signified an institutional recognition of Huntington as a Hispanist and art collector by the teetering regime of Alfonso XIII. He wrote proudly to Vega-Inclán, in the jocular tone habitual in his letters to the marquis, "As to my presidency, I presume

11. Duque de Alba to Archer Huntington, Jan. 5, 1935, box 7, AHHP, SCRC; Duque de Alba to Archer Huntington, Apr. 20, 1936, box 7, AHHP, SCRC ("I have been sent from Madrid your affectionate letter of March 17, and together with it they inform me that they have received the cheque for $5,000 that you so generously as always are donating to the Instituto Valencia de Don Juan for the continuation of its work"); Duque de Alba to Archer Huntington, Jan. 5, 1935, box 7, AHHP, SCRC.

12. Marqués de la Vega-Inclán to Archer Huntington, Feb. 22, 1931, box 56, AHHP, SCRC.

13. Under Royal Decree 583/1931 of February 6, 1931, all the foundations and donations of the marqués de la Vega-Inclán were declared to be incorporated into the Ministry of Public Instruction and Fine Arts, and a single joint trust, or *patronato*, was appointed to administer all of them.

you will not ask me to do much work, as I cannot be of much assistance at this distance."[14]

Two months later, however, the question was not just one of the physical distance between New York and Spain but of an emotional distance, a weakening of the linkages between Huntington and the new regime in a Spain that had broken with the king and where intellectuals and aristocrats appeared to be moving in opposite directions. Huntington was left in an uncomfortable position, faced with two unavoidable issues: the growing divisions among his own network of friends and the growing controversial image of American art collectors in Spain.

For all the political divisions that would gradually fracture Spanish society, in 1931 there was a general concern on all sides of public opinion regarding the insatiable plundering of Spain's cultural heritage that had taken place in the preceding decades. Art dealers had set about exporting all kinds of art objects and architectural details to satisfy avid collectors, especially Americans, including entire monasteries dismantled stone by stone. This was not a new problem, for the legal protection provided by different governments for the country's artistic heritage had been deficient since at least 1900. In the first two decades of the century, governments had introduced only generic legal measures that placed scarcely any limitations on an individual's ability to dispose freely of works of art, so during the 1920s the existing legislation had been complemented by new regulations, which did indicate a serious concern in the governments of Alfonso XIII for the care of the national heritage but were still insufficient to deal with the problem.[15]

14. Archer Huntington to Marqués de la Vega-Inclán, Mar. 19, 1931, box 56, AHHP, SCRC.

15. The Royal Decrees of February 16, 1922, on the artistic artifacts that could be exported from Spain and the procedures to do so, and of January 9, 1923, on the prior authorization needed for any items to be disposed of by the Catholic Church, were scarcely effective and did not prevent a continuation of fraudulent sales. Under the Primo de Rivera regime, the Royal Decree-Law of August 9, 1926, defined the nature of the *tesoro artístico nacional*, the country's artistic treasures, simplified much earlier legislation, extended protected status to official national monuments, and was rather more effective.

Cries of alarm about the pillaging of Spain's heritage had considerable public impact, and reports of the departure of major artistic artifacts from the country featured on the front pages of the Spanish press throughout 1929 and 1930. Cases of illegal sales by the Catholic Church, such as the sales of the great iron choir screen of the Cathedral of Valladolid, acquired by agents for William Randolph Hearst, and of the tapestries from Palencia Cathedral, which also found their way to the United States, drove the new Republican government to introduce a series of measures that finally succeeded in putting an end to the destruction of Spain's heritage.[16] The legal concept of a *tesoro artístico nacional*, or national artistic treasure, was introduced into the new Constitution of 1931, and the far-reaching Ley del Patrimonio Artístico Nacional (Law on the National Artistic Heritage) was passed in 1933.[17] These two measures together represented a real legislative revolution in terms of the protection extended to the artistic and cultural heritage of Spain.

Huntington was aware of the climate that existed in Spain regarding foreign collectors, which he had been able to discern during his last visit to the country in 1929. His concern at the possible rejection he might encounter as a collector of Spanish art among some sectors of society—in spite of the prestige he still possessed among those who knew his record the best—was not without foundation. For this reason, he wrote to Vega-Inclán to ask him to thank Francisco Sánchez Cantón for his statement published in the Madrid newspaper *ABC* on March 1, 1931, describing the Hispanic Society as a "spiritual province" of Spain. "Many thanks for

Last, the Royal Decree of July 26, 1929, organized the administrative services associated with the *tesoro artístico*.

16. María José Martínez Ruiz, *La enajenación del patrimonio en Castilla y León, 1900–1936*, vol. 2 (Valladolid: Consejería de Cultura y Turismo de la Junta de Castilla y León, 2008), 40. Since 1957, the choir screen from Valladolid has been in the Metropolitan Museum of Art in New York.

17. Article 45 of the Constitution approved on December 9, 1931, stated: "Every [item of the] historical or artistic wealth of the country, whoever may be its owner, forms part of the cultural treasures of the nation [tesoro cultural de la nación] and will be under the safeguard of the state, which will have the capacity to prohibit its export and removal and decree the legal expropriations it considers suitable for its defense."

the articles from *ABC*, two of which reached me in due time," Huntington wrote. "Please, thank Mr. Luca de Tena [the newspaper's owner] for his courtesy in this matter, and express to Sánchez Cantón my feeling of gratitude for the delicate manner in which he has handled these articles."[18]

In his article, Sánchez Cantón had described the actions Huntington had taken outside Spain to prevent certain works of art and collections from being lost or dispersed, "rescuing [the things that] we did not know how to keep or were not able to; a happy outcome, since within its [the Hispanic Society's] walls our artifacts are not in the house of a stranger [en casa ajena]."[19] Sánchez Cantón was, along with Elías Tormo and Ricardo de Orueta, one of the members of the San Fernando Academy of Fine Arts who had done most to denounce the plundering of Spain's artistic and historical heritage. Hence, when he made these and similar statements in defense of Huntington, he provided fresh arguments against those who sought to label the American collector a depredator of Spanish art and reasserted the value of Huntington's work and his commitment to Spain.

In addition to providing legal protection for Spain's artistic heritage, the new government also set to work on improving its conservation and extending knowledge of the country's artistic traditions among the public, increasing the relevant section of the Public Instruction Ministry's budget by 50 percent. New museums were created, and existing ones were reorganized because most of them lacked any form of educational presentation and the conditions required to offer adequate service for visitors.

Of particular interest among the new museums was the inauguration on June 11, 1932, of the Museo Sorolla in the painter's former home in Madrid, which his widow, Clotilde, had donated to the Spanish state in 1925. In the hands of the Ministry of Public Instruction and Fine Arts, it became a model cultural initiative of the Republican administration, a new paradigm of public intervention. The origin of this museum lay in Joaquín Sorolla's own declared desire to place his personal collections

18. Archer Huntington to Marqués de la Vega-Inclán, Mar. 10, 1931, box 56, AHHP, SCRC.
19. *ABC*, Mar. 1, 1931.

at the public's disposition. Sorolla wished to emulate the American art patrons who opened their collections for public enjoyment and appreciation, a practice that also connected with the liberal, Krausist convictions with which he had shown himself to have some sympathy. It appears that Huntington and the Hispanic Society had also been in Sorolla's mind when he made these decisions, and Huntington, one of Sorolla's foremost clients, "had to appear as a possible model, embodied in an institution as singular and ambiguous as the Hispanic Society of America, [which was] a fine example of a private initiative at the service of the public [good]."[20] Huntington was not just a spiritual presence in the Museo Sorolla, for in 1932 he also sent a bust of Sorolla by Mariano Benlliure from the Hispanic Society collection to form part of the new museum.

The opening of the Sorolla Museum was followed by further inaugurations of the Museum of Sculpture in Valladolid; the Cau Ferrat museum in the former home of the artist Santiago Rusiñol in Sitges, Catalonia; a museum dedicated to the painter Julio Romero de Torres in Córdoba; and the Museo del Traje (Museum of Textiles and Costume) in Madrid, among several others. These projects provided tangible proof of the worth of the new official policies on museums, which sought to give priority to visual culture and facilitate direct public access to artistic collections. At the same time and with the same aim of bringing Spanish culture closer to the people, other projects more clearly oriented to popular audiences were initiated, most notably the Museo Ambulante (Traveling Museum), formed as part of the Misiones Pedagógicas (Educational Missions) set up in 1931 by Manuel Bartolomé Cossío, the originality of which still surprises today.[21] These "missions" were groups made up mostly of young volunteers that toured the country, especially rural areas that were often near completely lacking in conventional educational facilities and completely unexposed to conventional culture. They presented theater shows, concerts, film screenings, talks, and a "museum" of copies of great works

20. Bolaños Atienza, "Una edad de plata para los museos," 101.
21. Carmen Rodríguez Fernández-Salguero, "Cossío y el Museo Ambulante de las Misiones Pedagógicas: Memoria de un idilio," in El arte de saber ver, ed. Guerrero, 273–83.

of art and left behind, when they moved on to another town, small libraries, gramophones, and selections of records. Another similar project was the traveling theater group La Barraca, set up by the poet Federico García Lorca.

Alongside these domestic policies, the republic also planned to implement an international cultural policy in which the Foreign Ministry's Junta de Relaciones Culturales, set up under the monarchy in 1926 but given a broader role by the republic, would become notably prominent in cooperation with the long-established Junta para Ampliación de Estudios. Their objectives included encouraging Hispanic studies and stimulating interest in studying the Spanish language and its civilization in other countries. The number of lecturers in Spanish in foreign universities was increased to around thirty; fresh endowments were given for the existing chairs of Spanish language and literature at the universities of Utrecht, Amsterdam, Poitiers, and the Sorbonne, and financial support was extended to the Instituto de las Españas at Columbia in New York, the Seminar on Romance Studies of the University of Berlin, the Spanish-German Institute of Cologne, Brussels University, the Department of Hispanic Studies at London University, and a series of smaller institutions dedicated to Spanish culture. The Spanish Academy of Fine Arts in Rome and the new Colegio de España in Paris were placed under the authority of the Junta de Relaciones Culturales, and several other initiatives were launched to promote Spanish culture abroad.[22] These measures were accompanied by others of a more political nature, with the appointment of cultural attachés to the Spanish diplomatic delegations in the United States, Argentina, and France; these political positions, however, were occupied by academics, such as Federico de Onís in the United States.

Huntington did not play any notable role in Spanish cultural or museum policies during this decade, in contrast to previous decades, although his influence was present in the minds of many of the leading

22. On Spain's cultural relations with other nations during the Second Republic, see Lorenzo Delgado Gómez-Escalonilla, "Las relaciones culturales de España en tiempos de crisis: De la II República a la Guerra Mundial," *Espacio, tiempo y forma, Serie V: Historia contemporánea*, no. 7 (1994): 259–94.

figures involved in developing them. One demonstration of the distance he had taken from current cultural developments in Spain can be seen in a letter that José López Mezquita wrote to him in August 1932. López Mezquita brought Archer up-to-date on two of the leading young poets of the time, Federico García Lorca and Rafael Alberti, with whose work Huntington appeared to be completely unacquainted. It seems strange that Huntington, a lover of poetry, was not at least aware of the work of García Lorca, considering that the poet had been in New York from the summer of 1929 to the spring of 1930 and had been notably active in the cultural life of Columbia at Federico de Onís's invitation.

> Stamped and packaged as printed matter I have sent you from the publishers Calpe in Madrid some books by the two young avant-garde poets that enjoy the greatest prestige in Spain. Their names are García Lorca and R. Alberti. You will remember a conversation between us regarding the young people who are distinguishing themselves in [the world of] letters, and I promised to send you these books. In addition, I have sent you a short anthology, in which, as well as the poets already known to you such as Unamuno, Machado, and Juan Ramón Jiménez, there are those of the new generation. The most important book by García Lorca seems to have sold out its first edition so I have not been able to send it, but I hope to find a copy secondhand, and then I will send it on to you.[23]

Another sign of Huntington's growing remoteness from Spanish cultural life was the fact that in 1936 he was still not personally acquainted with Alberto Jiménez Fraud, a much-loved and admired figure in Spain for his invaluable work as director of the Residencia de Estudiantes. When Jiménez Fraud visited the United States in February 1936, three of Huntington's old friends in Spain wrote letters of introduction asking him to meet this distinguished scholar: Vega-Inclán, Francisco Sánchez Cantón, and the duke of Alba, in Alba's case because of the relationship

23. José López Mezquita to Archer Huntington, Aug. 21, 1932, box 46, AHHP, SCRC.

he had established with Jiménez Fraud on the Spanish-English Committee founded by Jiménez Fraud in 1922.[24] "I have the greatest pleasure in presenting to you through this letter my excellent friend Don Alberto Jiménez," wrote the duke on February 1, "with whom I have been collaborating for many years in the English Committee that exists here, and who is the director of the Residencia de Estudiantes in this city, where he has carried out most admirable work, and is a person who has always shown the greatest attention and warm friendship toward me, feelings that I return most sincerely."[25]

Jiménez Fraud had been invited to New York by the Spanish-born philanthropist Gregorio del Amo to give a series of lectures on the history of universities in Spain. Huntington never got to see him because he was away from New York at the time, as he wrote in a letter of apology to Sánchez Cantón on February 27: "It is with great regret that I was unable to see your friends A. Jiménez Fraud and the daughter of Cossío, but when the cold weather comes I have to take my wife away from New York to a warmer climate."[26]

Anecdotes like this demonstrate that by the mid-1930s Huntington was not familiar with and had not met many of the most respected intellectuals from the Spain of the Second Republic who visited New York, so that by then his relationship with Spain was more or less limited to the letters he still exchanged with his long-established friends and acquaintances. One can see also a divergence between Huntington's maintenance of personal relationships by letter with his network of friends and the disappearance of the institutional relationships between Spanish official and cultural bodies and the Hispanic Society. This confirms the gradual distancing of Archer Huntington and his Hispanic Society from contemporary Spanish reality.

24. For example, see Marqués de la Vega-Inclán to Archer Huntington, Jan. 31, 1936, box 56, AHHP, SCRC.

25. Duque de Alba to Archer Huntington, Feb. 1, 1936, box 7, AHHP, SCRC.

26. Archer Huntington to Francisco Sánchez Cantón, Feb. 27, 1936, box 53, AHHP, SCRC.

The letters Huntington received from Spain between 1931 and 1936 can be divided into two main groups according to theme: those that dealt with the political situation, among which the duke of Alba and José López Mezquita were indisputably the leading voices from contrary positions, and those that offered more personal views of the Spanish cultural world, with Concha Espina, Ignacio Zuloaga, Francisco Sánchez Cantón, Vega-Inclán, and, again, José López Mezquita all offering their own points of view.

In the former group, López Mezquita was the first to send Huntington his favorable opinion of the political changes that had taken place in Spain and in December 1931 wrote optimistically, "Soon we are going to have a President of the Republic, Sr. Alcalá Zamora. We all think he is a man who will do very well in undertaking a difficult role, and then . . . we hope things will get on track, little by little."[27] However, problems soon began to intensify with the failed coup d'état organized by General José Sanjurjo on August 10, 1932, which threatened the republic's democratic system and revealed the level of opposition among sections of the army and conservative groups to the progressive reforms introduced by the government of Prime Minister Manuel Azaña. López Mezquita referred to these events in another letter in late August 1932. "You will already have had news of the very disagreeable events we have seen due to the military uprising that took place on the 10th of this month," he wrote. "The government has much to think about with all these tales, and Sr. Azaña is ever more firm, and is demonstrating himself to be a politician and ruler of a kind that there has not been in Spain for a long time. General Sanjurjo will surely be condemned to death, but I think the Republic will not wish to stain itself with blood, and he will probably be pardoned."[28]

27. José López Mezquita to Archer Huntington, Dec. 8, 1931, box 46, AHHP, SCRC, ellipses in original.

28. José López Mezquita to Archer Huntington, Aug. 21, 1932, box 46, AHHP, SCRC. Sanjurjo was indeed condemned to death, but his sentence was commuted to life imprisonment, and he was later given amnesty and allowed to go into exile in Portugal, from where he continued to conspire against the republic.

Life in Spain was disrupted by growing political radicalization, particularly after a general election in December 1933 and the effective victory of the right, much of which was grouped together in a coalition of conservative and Catholic parties known as the Confederación Española de Derechas Autónomas (Spanish Confederation of Autonomous Right-Wing Groups). A new administration—made up of center parties but reliant on right-wing support—then modified or reversed many of the progressive policies introduced by the Second Republic's first government. On this occasion, it was the duke of Alba who passed on to Huntington his impressions of the growing tension. A comparison of the letters Alba had sent Huntington over the previous decades, in which cultural matters had occupied most space, with those he wrote after the fall of the monarchy reveals the growing centrality of political observations and confidences in his correspondence. Because of Alba's own political commitments and his ardent defense of the monarchist cause, his vision of the situation was completely different from that of his former protégé López Mezquita, the painter Alba himself had recommended to Huntington after the death of Sorolla. Alba wrote to Huntington in January 1934:

> Much could be said of political matters, the situation is now one of apparent tranquility, but a dark cloud is hanging over us that is not without danger. . . . I fear there may perhaps be an outburst; I hope too that the combative spirit hereditary in [our] race may rise up in the face of these impositions, and will also see how to impose by force what we have conquered at the ballot-box. . . . The spectacle in the Cortes is lamentable: yesterday they almost came to blows because someone cried out ¡Viva España! [Long live Spain!]. And this in a session in memoriam, dedicated to Sr. Macià, the principal cause of the dismemberment of the Catalan region, who, even though he had died a Catholic, his henchmen did not allow to be buried with the insignia of his religion.[29]

29. Duque de Alba to Archer Huntington, Jan. 5, 1934, box 7, AHHP, SCRC. Francesc Macià, the foremost leader of left-wing Catalan nationalism and first president of the restored Catalan autonomous government, the Generalitat, in 1931, had died at age seventy-four on December 25, 1933.

Vega-Inclán, for his part, wrote Huntington in January 1934 to confirm the dispatch to New York of Sorolla's painting of the members of the Casa-Museo del Greco *patronato*. Begun in 1910–12, this large work had been left unfinished at the artist's death. Following the announcement of the election results, the revolutionary general strike launched by anarchist workers' groups on December 8, 1933, which had begun in Zaragoza and then spread to some other provinces, may have been the reason why Vega-Inclán decided to send this painting out of the country: it portrayed King Alfonso XIII, Huntington, the marquis himself, and the other trustees of the museum (see this painting in chapter 2). This image was the clearest demonstration of the important role Huntington had played in the creation of the El Greco Museum in Toledo. Vega-Inclán decided to send it to New York, he wrote, because Huntington had officially been appointed president of the Fundaciones Vega-Inclán, which was the legal owner of the painting, three years earlier. "I received your cables informing me of the arrival . . . of our painting of the *patronato*," he wrote. "All this and the painting itself are sent in the nature of a gift, in as much as I personally can do so, and offered [as such] to the Hispanic Society and its President."[30]

With this letter, Huntington perhaps for the first time began to understand the depth of politicization affecting all aspects of culture in Spain and that artistic creations associated with the deposed monarchy could not escape. Of special concern to American Hispanists were the dangers that threatened Spain's historic monuments; several churches had already been the target of attacks by uncontrolled anticlerical demonstrators. Huntington understood the turn that popular unrest was taking, and his anxiety only grew when he heard of the severe escalation in political and social violence represented by the briefly successful revolutionary general strike in October 1934 in Asturias, where workers' militias took control of the region's mining districts and cities such as Oviedo and Avilés. This time it was López Mezquita who gave him an account of these events in a letter dated November 6. "I could not come back to Spain until October

30. Marqués de la Vega-Inclán to Archer Huntington, Jan. 12, 1934, box 56, AHHP, SCRC.

19," he explained, "because communications with France were almost completely interrupted due to the revolutionary movement that had broken out by the time I arrived in Paris. It has been a very grave business, and terribly tragic in Asturias, where there are still people in armed groups in the mountains. In the rest of Spain everything seems calm, but there is something strange in the atmosphere."[31]

Political and social disturbances had a direct effect on the cultural world, and writers and artists equally and directly suffered the consequences of a Spain in crisis. Concha Espina, the writer and a long-standing friend of Huntington, was one of those who communicated to him the difficulties writers were encountering in carrying on their work in Spain by late 1935. "Our beloved Spain is living through a very insecure situation," she wrote, "and for writers with no more source of income than our work the present state of affairs could not be bleaker."[32]

Concha Espina had made public statements in favor of the Azaña government's progressive policies during the first two years of the Second Republic, "a period in which the writer distinguished herself for her campaigns for women's equality."[33] Like many other writers, she joined the Asociación de Amigos de la Unión Soviética (Association of Friends of the Soviet Union) and supported the Republican ideals of education and cultivation of the arts. She also maintained progressive ideas in her personal life; her divorce from her husband, Ramón de la Serna, in 1934 was one of the most widely publicized court cases of the era in Spain not only because it was one of the first such cases after the legalization of divorce in 1932 but also because Espina was represented by the lawyer and women's rights activist Clara Campoamor. However, as political radicalization and antireligion demonstrations came to dominate the political scene, Espina's opinions changed, and her position shifted to one of increasing support for frankly reactionary tendencies.

31. José López Mezquita to Archer Huntington, Nov. 6, 1934, box 46, AHHP, SCRC.
32. Concha Espina to Archer Huntington, Dec. 15, 1935, box 31, AHHP, SCRC.
33. Cristina Narbona, "Prólogo," in Espina, *Singladuras*, 9.

Ignacio Zuloaga, whose correspondence with Archer was characterized by a rustic, coarse tone in Spanish that delighted Huntington, also wrote him in early 1935, one of a few letters in which he spoke of the solitude and sadness he felt because of the climate he saw around him in the years preceding the Civil War. "Here I live surrounded by solitude, and fully at work. Humanity is getting ever more rotten, so one has to live far away from them because envy has taken on horrifying proportions."[34] Even López Mezquita sent similar comments regarding the work of artists in Spain in February 1936, writing that "the repercussions of this state of things are catastrophic for artists. For me at least it's terrible because some minor commissions I had in prospect have been postponed.... I am very dispirited and wasting time pitifully."[35]

Other intellectuals continued their work in this discordant Spain, with greater or lesser success. Ramón Menéndez Pidal sent Huntington a copy of the second volume of his major historical study *La España del Cid* in 1935, for which Archer thanked him in an affectionate letter.[36] Francisco Sánchez Cantón, then deputy director of the Prado, informed Huntington in early 1936 of his work in restoring Lope de Vega's house in Madrid, for which Huntington congratulated him in turn a few days later. "In the last few months," wrote Sánchez Cantón, "I have been enormously busy with the restoration and reconstruction of the house of Lope de Vega, where he lived for the last twenty-five years of his life, and in which he died. I am sending you with this letter a copy of the little book we have produced; the illustrations will give you an idea of what we have done, and the text of how scrupulous the evocation has been."[37]

When another general election in February 1936 gave victory to the coalition of the left known as the Frente Popular (Popular Front), a first attempt at some sort of resort to force was prepared by the rightist parties

34. Ignacio Zuloaga to Archer Huntington, Mar. 6, 1935, box 58, AHHP, SCRC.

35. José López Mezquita to Archer Huntington, Feb. 3, 1936, box 46, AHHP, SCRC.

36. Archer Huntington to Ramón Menéndez Pidal, undated, Correspondencia Archer Huntington 1935, FMP.

37. Francisco Sánchez Cantón to Archer Huntington, Feb. 4, 1936, box 53, AHHP, SCRC.

to prevent the handover of power to the victors. The Right had been mistaken in their predictions: they had expected to win a comfortable election victory, as the duke of Alba had written to Huntington at the beginning of February. "We are very busy here working for our Cause at the forthcoming elections, only a fortnight off now," Alba announced. "Things are shaping well, and we expect to have about 300 members of the Right returned, which will give us the majority in the Cortes, and perhaps we can then impeach the President, with all the far-reaching consequences that may have. The Royalist Cause is gaining ground rapidly, and, as most of the Right are really Monarchists, we look forward confidently to the future."[38]

The new left-wing government implemented a series of urgent measures and sought to resume and extend the reforming policies of the first Republican government, essentially by reinstituting measures that had been rescinded by the rightist governments of 1933–36. However, strikes and the strategy of tension generated by fascist violence resulted in still more disorder. In mid-April, López Mezquita informed Huntington of fresh acts of violence. "I suppose you will have heard of our political upheavals since the February election," he wrote with a mix of despondency and optimism.

> There have been some [incidents of] violence but not as many as the foreign press will surely have suggested. In Elche they burned some churches, clubs, and private houses but at my studio fortunately nothing happened. The President of the Republic was removed from office in a few hours (I think deservedly), and there is a very great amount of nervousness due to the passionate feelings on left and right. I have great faith in don Manuel Azaña and I still harbor the hope that he will know how to free our country from the tyranny that would be imposed by a dictatorship of the right or the left.[39]

38. Duque de Alba to Archer Huntington, Feb. 3, 1936, box 7, AHHP, SCRC.
39. José López Mezquita to Archer Huntington, Apr. 19, 1936, box 46, AHHP, SCRC. President Niceto Alcalá Zamora had lost the trust of both the Right and the Left by his efforts to intervene in political decisions since 1933 and was rapidly removed

Right-wing army officers were preparing a military uprising, but in July the assassination by leftists of the monarchist leader José Calvo Sotelo precipitated events and so accelerated the level of commitment among the Right to the revolt, which began in Spain's Moroccan Protectorate on July 17, 1936. After two confused days during which Azaña's first prime minister, Casares Quiroga, and then another leading Republican failed to form viable governments and resigned, a new prime minister, José Giral, took the decision, in order to oppose the attempted coup, to release arms to the workers' organizations, whose members took to the streets to carry out a longed-for social revolution.

Huntington was able to follow the course of events through the letters he received, and the news of this fatal outcome could only result in converting his growing distance from Spain into a complete break. With no alternative in sight, Archer Huntington accepted with resignation the outbreak of the Spanish Civil War.

Rethinking Philanthropy in the 1930s

If Huntington was keeping a distance from Spain, in the United States he was engaged in a parallel process regarding the cultural life of New York, albeit in a different manner. One could argue that Huntington was moving away from one particular model of art patronage, adapting his work as a philanthropist and allowing it to evolve to meet the needs of a country that had sunk into the greatest economic crisis in its history.

The Great Depression begun by the crash in 1929 had brought an unprecedented social crisis, and President Herbert Hoover and his Republican administration, reluctant to take interventionist measures, lost popularity at the same rate as Americans lost their jobs. With the rate of joblessness at more than 25 percent—and still higher among African Americans, Hispanic immigrants, and other minorities—unemployment

from office on April 7 on accusations of exceeding his powers. Manuel Azaña, who in February had returned to the post of prime minister, which he had occupied in 1931–33, was formally chosen by the Cortes as the new president in May, with Santiago Casares Quiroga as his prime minister.

became the country's greatest problem. A wave of social indignation grew in strength and eventually ended Hoover's hopes of reelection when the presidential election of November 8, 1932, was won by the Democrat Franklin Delano Roosevelt with his promise of a "New Deal" for the American people. Roosevelt launched a dynamic program of public investment and progressive reform, increased the level of public intervention in social and economic affairs, avoided social unrest, and helped the United States recover its confidence.

Huntington was aware of the degree to which the crisis was affecting many of his fellow American millionaires, commenting on January 1, 1933, with some surprise that of the six hundred millionaires there had been in New York before the crash, there were no more than sixty-five left.[40] In such circumstances, it is reasonable to think that Huntington had difficulty in finding his place in the changed American scene. The building projects he had helped initiate for various cultural institutions in New York remained underway, and he maintained his financial commitment to them, but the plans he had conceived for their future research, exhibitions, and publishing programs had to be relegated to the background in the face of the country's urgent needs and a fiscal policy less inclined to encourage this type of investment. This was the case with an exhibition of paintings by José López Mezquita to be held at the Hispanic Society in 1935, which Huntington found himself obliged to cancel because of concerns over tax issues related to the temporary import of works of art, as is shown in an exchange of letters between the two men in November 1934.[41]

Yet not everything had changed for Huntington. The economic crisis left many cultural projects orphaned of support, and within Archer Huntington the spirit of a museum builder remained alive. In contrast to the type of institutions that he had helped create in New York during his

40. "Out of the so-called millionaires in New York City, only sixty-five are left. Nearly all are bankrupt." Huntington quoted in Mitchell and Goodrich, *The Remarkable Huntingtons*, 60.

41. Archer Huntington to José López Mezquita, Nov. 10, 1934, and López Mezquita to Huntington, Nov. 26, 1934, box 46, AHHP, SCRC.

early years, in the early 1930s he set about promoting museums in areas away from the city and with themes that had a broader popular appeal and were more accessible to the average American citizen. The first of these projects was a maritime museum built next to the shipyards that his family owned in Newport News, Virginia.

The Mariners' Museum and Park in Newport News was to be devoted to shipbuilding, the culture of the sea, and the sea's influence on different civilizations. His decision to create a maritime museum, like all the projects he undertook in his life, was linked to a personal passion, in this case his love of travel, exploration, and the great exploits of history as well as his own technical knowledge of the construction of ships and boats.[42] In his youth, before he told his father of his decision to devote his time to collecting Spanish art, he had worked in the Newport News yards learning the business of building and selling ships. In addition, he liked to sail and had a yacht built in the same yard, which he named the *Rocinante*, after Don Quijote's horse.

His new project, begun in 1930, consisted of a museum linked to the work and business activity that went on in the shipyards, which would also have a strong educational element based on engineering and technological progress. This scheme coincided in some ways with the project that Henry Ford had initiated in 1929 next to the headquarters of his motor company in Dearborn, Michigan. The centerpiece of the new Henry Ford Museum of American Innovation, Greenfield Village, was an outdoor museum made up of a series of small buildings in the style of American farms, within which were exhibited the inventions, early creativity, craftsmanship, and industrial products of celebrated Americans such as Thomas Edison, the Wright brothers, and Ford himself. It opened to the public in 1933 and in its first year received some 234,000 visitors, a number that would triple by 1940. Greenfield Village, with a markedly popular style, set out to celebrate traditional American values and evoke the spirit of the independent, self-sufficient worker.

42. On the Mariners' Museum and Park, see its website at https://www.marinersmuseum.org/about-the-mariners/, accessed July 3, 2018.

In 1927, John D. Rockefeller Jr. had begun to finance the restoration of Colonial Williamsburg, also in Virginia, as another open-air museum and by the mid-1930s had invested more than $60 million in the scheme (nearly $1 billion at modern values). An idealized restoration and reconstruction of an eighteenth-century, colonial-era Virginia town, the museum was a sanctuary of faith in America, in which typical American values such as individual freedom, self-government, integrity, and responsible leadership were once again emphasized—although it omitted certain aspects of America, such as slavery and the poverty that many farmers had suffered during the period the museum evoked.[43]

Archer Huntington, without abandoning his scholarly preferences, formed part of this new wave of cultural philanthropy, which sought to reaffirm the value of the spirit of the industrial entrepreneurs and businessmen of America at a time when the United States was undergoing a period of confusion and crisis. This particular form of philanthropy highlighted the industrial, business, and technological successes of the recent past in a country that needed to overcome a crisis of confidence. The Henry Ford Museum, Williamsburg, and the Mariner's Museum were three initiatives that have proved very popular in American society; they still receive visitors in large numbers today and continue to reflect their patrons' intentions to present philanthropic schemes with a strongly educational component that would serve to reinspire and reanimate the audacious, dynamic, hard-working spirit that had characterized society in the United States in its era of greatest economic expansion.

The Mariners' Museum would be a very different museum from the Hispanic Society, one that, in some ways, would be more attractive to

43. During this same period, another set of institutions of a different kind in being dedicated to contemporary art was also set in motion in New York, notably the Museum of Modern Art, established in 1929 by the philanthropists Abby Aldrich Rockefeller (wife of John D. Rockefeller Jr. and so also involved in Williamsburg), Lillie P. Bliss, and Mary Quinn Sullivan. For her part, Gertrude Vanderbilt Whitney created the Whitney Museum of American Art in 1930 out of her own collection, and Hilla Rebay began to organize the modern art collection of Solomon R. Guggenheim, which first opened as a museum in 1939.

Americans. Two features of the museum are especially significant in helping us comprehend the extent of the transformation visible in Huntington in the 1930s. First, the architecture of the museum building was purely functional at the request of the cofounder and first president of the museum, Homer L. Ferguson, a naval engineer who was also president of the Newport News shipyard. In a letter to Huntington in April 1931, Ferguson clearly explained that the new building needed to be a piece of infrastructure built by engineers, not architects, because it would not be used to exhibit works of art but works of science as applied in the construction of ships. In his opinion, a Greek- or Roman-style neoclassical building would be completely unsuitable for the type of objects that would be exhibited within it because these objects were based purely on science and mathematics, and so he urged Huntington to hold back from imposing a style on the museum of the kind that the philanthropist was accustomed to favoring in New York. "The moment you attempt to produce an art building on the usual Greek or Roman lines," Ferguson asserted, "you have made something which will clash entirely with the exhibits, which are purely scientific and mathematical."[44] Second, part of the original idea for the museum had been to exhibit the scale models made in the Newport News yard as part of the shipbuilding process, in accordance with historical criteria, and that only in certain exceptional cases could other models be added that had not been made in the United States. Hence, the Mariners' Museum had a patriotic focus from the outset.[45]

However, Huntington could not resist giving his new museum a broader historical and international focus as well, and from 1932 he sent Ferguson and members of his staff on journeys around the United States, Asia, and Europe in search of pieces for its collection. He donated a great number of works of art, books, and maps to the Mariners' Museum, among them a painting by Sorolla, *Christopher Columbus Leaving Palos* (1910).

Excited by his new project, Huntington also made his Spanish friends part of the scheme, asking their help in locating items of interest in Spain

44. Homer L. Ferguson to Archer Huntington, Apr. 4, 1931, box 43, AHHP, SCRC.
45. Archer Huntington to Homer L. Ferguson, Aug. 3, 1931, box 43, AHHP, SCRC.

for his museum. López Mezquita set about seeking out typically Iberian small boats and canoes around Spain and Portugal. In November 1934, he sent Huntington a quite detailed explanation of his acquisition of one boat for the Mariners' Museum: "On November 22 the inshore fishing boat [*barca de jábega*] will leave Málaga, sent to the address that you gave me. . . . I also acquired the oars and other pieces of equipment necessary so that it may be exhibited just as if it were about to be launched into the sea to fish. . . . I of course bought the smallest one I found, and it has a length of eight meters. Its name is *Isabel*, and is in great condition for the sea, from what her owner assured me."[46]

Benigno de la Vega-Inclán was also drawn into the project and took charge of ensuring that some materials sent from Spain arrived in Virginia, writing back to Huntington in January 1934, "I have received your cables informing me of the arrival of the boats."[47]

Within only a few years, the Mariners' Museum gained a prestigious reputation and attracted large numbers of visitors. Huntington, as he acknowledged in his letters to Homer Ferguson, did not need to concern himself with all the details of its management, which was left in the hands of Ferguson and other executives from the shipyards. This led him to reflect on the skills of businessmen in managing any kind of project, including cultural ventures. As he put it, "After all, it is the trained businessman who runs this country, not the professors, and I am continually reminded of the words of the founder of this shipyard, 'commerce is king,'"[48] a phrase very typical of the Gilded Age that his father, Collis, often repeated and that Archer remembered in 1942.

A related interest also led Huntington to create the Golf Museum at the James River Country Club near Newport News, a scheme he decided to take up in 1931–32 not because of his love for the sport but because in his visits to the shipyards, of which he was still the largest shareholder, he

46. José López Mezquita to Archer Huntington, Nov. 6, 1934, box 46, AHHP, SCRC.

47. Marqués de la Vega-Inclán to Archer Huntington, Jan. 12, 1934, box 56, AHHP, SCRC.

48. Archer Huntington to Homer L. Ferguson, June 27, 1942, box 43, AHHP, SCRC.

had noticed many executives' devotion to golf. "The golfers have been golfing for ages," he explained, "yet no one had thought of a museum. Then and there I brought one into existence, the first Golf Museum, I believe, founded by the most execrable of golfers."[49]

To ensure that it had a collection worthy of a museum, he sent some of the company's staff to Europe to acquire golf-related antiques. Also, his Spanish friends once again came to his aid, and in November 1933 the duke of Alba wrote to tell him that he had requested golf clubs from the exiled King Alfonso XIII and the prince of Wales so they could be sent to the United States to form part of the new museum and that he was already sending a club that had belonged to a mutual friend, the late Guillermo de Osma, and another from the duke's own collection, both of them engraved with their owners' initials. "I am sending you two golf clubs for your museum," Alba wrote in English, "one belonged to our old friend Osma, and I have written his name on it; the other is my own, also initialed. During my stay in England, I asked the Prince of Wales for one of his clubs, and in Paris I asked my King."[50]

These initiatives demonstrate that Huntington's desire to create museums remained active, albeit in fields distant from his original concerns. These were not museums or cultural institutions of the kind he had habitually dealt with, but rather the type his country demanded, museums that reflected the interests of the American middle class, had a distinct regional emphasis, and were placed in settings that in themselves provided an extra attraction for visitors. The Mariner's Museum and the Golf Museum were projects intended to give a fresh value to the American cultural heritage with collections that, though of limited artistic importance or historical depth, had the virtue of not being alien to this same heritage. In this regard, Huntington adapted himself to the new social context and collaborated with his ideas and money in the promotion of a connection between culture and leisure that was very suited to the tastes and new lifestyles of the American middle class.

49. Quoted in Proske, *Archer Milton Huntington*, 25.
50. Duque de Alba to Archer Huntington, Nov. 15, 1933, box 7, AHHP, SCRC.

His third great project in these years was very much related to the changes of residence that Huntington and Anna had begun in 1930, which, in a parallel movement to their creation of new museums, led them away from New York. The fall in prices in the real estate market, the changing atmosphere of the city, and Anna's fragile health led Huntington to buy a property in South Carolina called Brookgreen Gardens, on what had been four rice plantations, surrounded by swamp and forest, originally just to spend the winters. The warm climate was good for Anna, who found the cold of New York winters increasingly harmful. Moreover, the remoteness of Brookgreen from major cities allowed them to carry on a more relaxed style of life without the social and professional obligations of their lives in New York.

Throughout 1931, Huntington threw himself into the organization and transformation of his new property in the South, originally 6,000 acres (more than 2,500 hectares) but eventually expanded to 9,100 acres (3,600 hectares), including an extensive beachfront along the South Carolina coast. The Depression was having a devastating impact on the African American population of the area, with many farm laborers completely unable to find work. Aware of their precarious conditions, Huntington contracted an initial group of a hundred men to work on his land. At the same time as offering them work, he also ensured they were taught different trades and financed the building of decent housing as well as a school, a medical clinic, and a church to serve the needs of their families. Notes in Anna Hyatt Huntington's diaries record Huntington's commitment to these deprived communities and the extent to which he was personally involved in these aspects of the Brookgreen project, a concern that connected spiritually with the legacy of his father's concern to aid African Americans.[51]

Huntington also had a house built to his own design, which he called "Atalaya" (Spanish for "watchtower"), a large, single-story complex in the form of a U around a wide courtyard and constructed entirely of brick, the typical material used by Arab builders in medieval Spain. The house

51. Mitchell and Goodrich, *The Remarkable Huntingtons*, 55.

was markedly Spanish or Moorish revival in style, with iron grills on the windows, long colonnades, patio courtyards, and on one side a tower, which—as well as serving to conceal a large water tank—recalled the real watchtowers the Huntingtons had seen along the coast of Morocco. Included in the house was a large studio for Anna Huntington to work, and nearby she designed spectacularly lush gardens in the form of a giant butterfly. Very soon they began to spend every winter there, enjoying the benign climate, the beach, and the natural environment.

Several of Anna's sculptures were placed around the gardens. Noting how well they could be seen there, in 1932 the Huntingtons decided to expand the scope of Brookgreen and make it an open-air museum of American figurative sculpture. Influenced by ideas of uniting art and nature, they decided to introduce the work of other artists and began to acquire pieces by other sculptors who in this time of crisis had few chances of selling their work. This new venture signified a real "boom" for young American sculptors as the Huntingtons bought a large number of pieces for Brookgreen Gardens, including some by artists who were beginning their careers and for whom such an opportunity represented a very important first recognition in the American art market.[52] In the open-air museum's first six years, from 1932 to 1938, more than 190 pieces of sculpture were added to it.[53]

This new creation by Archer and Anna was not far removed in spirit from the ideas that inspired the cultural policies of the New Deal, launched by President Roosevelt beginning in 1933 as part of his program for economic recovery. With the aim of stimulating employment in all the various fields associated with culture, at the end of 1933 the first public-work program for artists was launched, the Public Works of Art Project, which gave painters, sculptors, designers, musicians, dancers, and actors the status of professional workers and so made them potential beneficiaries of the Roosevelt administration's employment programs. The Public

52. Proske, *Archer Milton Huntington*, 23.
53. Jane McCarthy and Laurily Keir Epstein, *A Guide to the Sculpture Parks and Gardens of America* (New York: Michael Kesend, 1996).

Works of Art Project was succeeded in 1935 by the Federal Arts Project as part of the Works Progress Administration, and through these programs around ten thousand artists from every part of the United States produced more than fifteen thousand works of art, which served to embellish public buildings, schools, libraries, cultural centers, parks, and other settings with sculpture, mural paintings, films, photography exhibits, and many other forms of artistic expression. The only guideline set by the government was that the most suitable source of subject matter would be the "American scene,"[54] so that landscapes and cityscapes, scenes from everyday life, baseball games, and other images of the "American Way of Life" multiplied in a wave of artistic production that has sometimes been given little value by critics—with a few exceptions—but that in those years represented a new discovery. "At the time it was a revelation to many people in America," as the writer Francis O'Connor put it, "that the country even had artists in it."[55] These policies and programs encouraged American society to identify with artistic creations of its own, which succeeded in connecting with the American people.[56]

If these new cultural policies were inspired in part by the Mexican muralists and their attempts to create a new form of public art that was not constrained by the strict conventionalism of European art, then an open-air museum of American sculpture from the late nineteenth and twentieth centuries in a beautiful natural setting could similarly be more easily appreciated by the average American citizen than could a museum of scholarly culture.[57] In this sense, the dynamic that Anna and Archer Huntington impressed upon Brookgreen in the 1930s can be associated with the public policies that supported the work produced by American

54. Jerry Adler, "1934: The Art of New Deal," *Smithsonian Magazine*, June 2009, at https://www.smithsonianmag.com/arts-culture/1934-the-art-of-the-new-deal-132242698/.

55. Quoted in Adler, "1934."

56. Jonathan Harris, *Federal Art and National Culture: The Politics of Identity in New Deal America* (New York: Cambridge Univ. Press, 1995).

57. Brookgreen Gardens continues to be a highly popular sculpture park today, attracting large numbers of tourists to the area.

artists.[58] In addition, up to that point the great metropolitan centers had been the great hubs of the country's cultural life, concentrating within them the greatest wealth, the most important museums, and the best-equipped libraries. A sculpture museum in South Carolina, far from any major city, contributed to cultural and regional decentralization, so that art would not remain circumscribed solely to the nation's great urban centers.[59]

In a little more than three years, Archer and his wife had created three new museums in the United States. However, Anna continued to suffer from tuberculosis, and as Huntington's friend and doctor in Spain, Gregorio Marañón, had proposed in 1929, it was again recommended that she undergo extended treatment in a sanatorium in Switzerland. Between August 1932 and September 1933, the Huntingtons took up residence in Leysin, to the east of Lake Geneva, so that Anna could receive the medical attention she needed.

From central Europe, Huntington could follow events across the continent more easily. The economic crisis had fully taken effect; by 1932, output worldwide had fallen by 60 percent compared to 1929; world prices had dropped by 40 percent; and unemployment had reached figures close to six million in Germany and three million in Britain.[60] In politics, a nationalist fascist regime headed by Benito Mussolini had been in power in Italy since 1922, while in Germany the largest group to emerge from elections in 1932 was the Nazi Party of Adolf Hitler, who would be named

58. In 1933, the artist George Biddle, who had worked with the Mexican artist Diego Rivera and been inspired by the Mexican muralist movement, told President Roosevelt—a former school friend—of his ideas for a socially committed American art and proposed that the public buildings and parks of Washington, DC, could be enhanced by a federal program to contract a group of artists to decorate and improve them. See Marcia M. Mathews, "George Biddle's Contribution to Federal Art," *Records of the Columbia Historical Society* 49 (1973–74): 493–520.

59. Don Adams and Arlene Goldbard, "New Deal Cultural Programs: Experiments in Cultural Democracy," [1986] 1995, Webster's World of Cultural Democracy, at http://www.wwcd.org/policy/US/newdeal.htm.

60. Julio Aróstegui, *La Europa de las Grandes Guerras (1914–1945)* (Madrid: Anaya, 1994), 54.

head of the government in January 1933. The effects of the economic crisis, along with corruption scandals, also had a major influence on French politics, provoking the fall of Prime Minister Édouard Daladier after only one month in office in 1934. In the United Kingdom, the formation of national unity governments made it possible to maintain greater political stability, despite the dynastic crisis caused by the abdication of King Edward VIII in 1936. However, the foreign policy maintained by Britain's Conservative prime ministers did not avert the bleak prospects foreshadowed by Germany's expansionist ambitions.

Conscious of the new circumstances that were approaching, Archer and Anna, on their return to the United States, decided to move away definitively from New York City, donating their Fifth Avenue townhouse to the National Academy of Design, and in October 1933 Archer acquired a new property to be called "Rocas" near Haverstraw, New York, around forty miles northwest of the city. He wanted to be close enough to New York so that he could still visit the Hispanic Society every week but far enough away to be able to disconnect from new commitments and discourage unwelcome visitors.

With the two residences they had recently acquired—Rocas outside New York and Atalaya in South Carolina, for alternate use in summer and winter, respectively—the Huntingtons escaped from New York City life. Their distance from the city also limited their accessibility to the numerous people who asked to visit them. This was evidently the case when in October 1934 Benigno de la Vega-Inclán wrote Huntington to tell him that he would shortly be in New York and wished to pay Archer a visit.[61] Huntington had to explain the difficulties that would be involved for Vega-Inclán in traveling from New York to Huntington's new winter home at Atalaya because of the limitations on the use of automobiles imposed by the government to save consumption of gasoline. If Vega-Inclán chose to travel by train, he would have to consider all the discomforts of a journey that, with two changes of train, would take almost twenty-four

61. Marqués de la Vega-Inclán to Archer Huntington, Oct. 23, 1934, box 56, AHHP, SCRC.

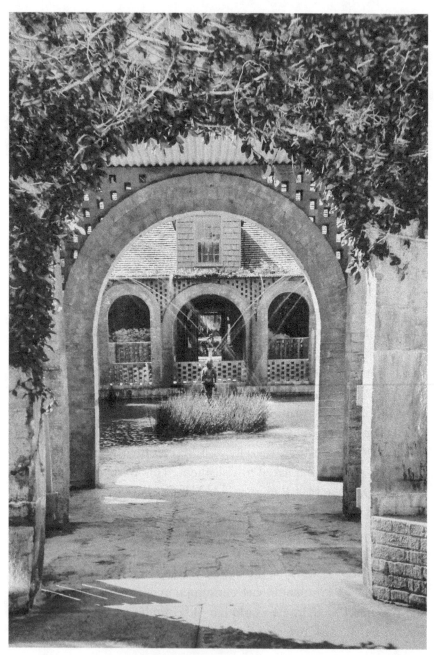

13. Atalaya (Watchtower), the Huntington residence in South Carolina, 1935. *Source*: Box 97, "Photographs Family Property, Atalaya," Anna Hyatt Huntington Papers, Special Collections Research Center, Syracuse University Libraries. By permission of Syracuse University Libraries.

hours before he arrived at the Huntingtons' South Carolina estate. Hence, while on the one hand he encouraged Vega-Inclán to make the journey, he asked that he should attempt it only if Dr. Marañón, given the state of health of the seventy-six-year-old marquis, permitted it.[62]

His peaceful life in the countryside also encouraged the growth of a new concern in Archer Huntington, one for the protection of the natural environment and wilderness areas. President Roosevelt was a convinced conservationist, and environmental protection—then referred to generally just as "conservation"—was one of his administration's priorities. Several elements of the New Deal reflected this concern. Most famous was the Civilian Conservation Corps, which over nine years enlisted around three million young men to work in rural areas planting trees, fighting forest fires, building roads, improving access to national parks, and carrying out other valuable tasks. Believing that natural areas would be better cared for in the hands of government, Roosevelt also oversaw a major reorganization and expansion of the system of national parks, incorporating many new areas and acquiring 18 million acres (more than 72,000 square kilometers or 27,800 square miles) of formerly private land to add to the parks. These policies were widely supported across American society, by both Republicans and Democrats and by the wealthy as well as those with much lower incomes.[63]

Huntington, a good patriot, shared this conservationist sensibility as one of the central values in the collective mentality of the United States. Life in the open air was giving him great pleasure, and so, convinced of the need to contribute to the protection of natural resources, he also created a large park around the Mariners' Museum in Newport News. This lush natural woodland extends more than 550 acres (225 hectares) around the broad Lake Maury, specially protected to encourage stopovers by migrating water birds and with several statues by Anna Huntington standing

62. Archer Huntington to Marqués de la Vega-Inclán, Nov. 7, 1934, box 56, AHHP, SCRC.
63. Neil M. Maher, *Nature's New Deal: The Civilian Conservation Corps and the Roots of the American Environmental Movement* (New York: Oxford Univ. Press, 2007), 151–80.

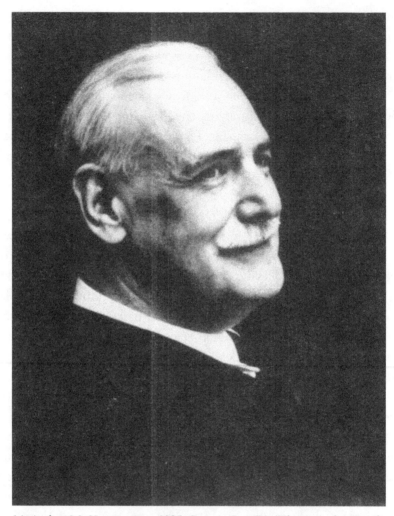

14. Archer M. Huntington, 1935. *Source*: Box 96, "Photographs Family Huntington, Archer," Anna Hyatt Huntington Papers, Special Collections Research Center, Syracuse University Libraries. By permission of Syracuse University Libraries.

out among the trees. In 1934, he also gave his former country home at Arbutus Great Camp in the Adirondacks in New York State to Syracuse University, together with 12,000 acres (5,000 hectares) of land to serve as a wildlife refuge and research center. Much later, in 1947, he effectively donated—selling it for just one dollar—another Adirondack property that he

had inherited from his father, Camp Pine Knot on Raquette Lake, to the State University of New York at Cortland to be another outdoor education center. Another idea that Huntington had in mind at this time was the creation of a chain of wildlife refuges along the eastern seaboard between New York State and South Carolina.

When one looks at his activities during these years, Huntington appears as a quite different type of cultural patron from the Hispanist of the 1920s. His actions indicate that he was able to understand the new relationship between philanthropy and American society and that he sought to channel his activities into fields not yet contaminated by the political interests that had infiltrated other areas of culture. However, these schemes also reveal a man who in the face of adverse external circumstances tended to escape into himself and occupy his mind in new projects, relegating to secondary importance his earlier involvement in Hispanism and, especially, in the life of a Spain that was descending into civil war.

Huntington in the Crossfire

The outbreak of the Spanish Civil War in July 1936 inaugurated the darkest period in Spain's twentieth-century history. The immediate internationalization of the conflict was reflected in the unacknowledged support given by Germany and Italy to the military uprising and by the Soviet Union to the Republican government in the face of Great Britain and France's passivity. The United States, with an isolationist foreign policy and still beleaguered by its own economic problems, looked on the turbulent waters of 1930s Europe merely as a spectator.

If supporters of the Second Republic felt they were defending democratic legality and freedom against fascism, the idea that the military uprising led by General Francisco Franco "was a struggle to the death between the true Spain, a fatherland in danger, and a foreign enemy, Russia, the Soviets, the Communists, who desired its ruin" was proclaimed by uprising's supporters from the very beginning.[64] Given this belief, the

64. Santos Juliá, "Memoria, historia y política de un pasado en guerra y dictadura" in *Memoria de la guerra y del franquismo*, ed. Santos Juliá (Madrid: Taurus, 2006), 28.

military revolt against the established government was rapidly transformed into a crusade, an idea supported and encouraged by most of the church hierarchy, who by granting the uprising a sacred character made its continuation inevitable.

The inevitability of war as an honorable means of dealing with political and ideological conflict had been gaining ground in Europe and was not exclusive to the Spain of the Second Republic. The "aestheticization" of political life to seduce the masses with ideas of a complete break with the established order had been popularized in a continent marked by antagonisms between fascism and communism, democracy and totalitarianism, and nationalism and internationalism, to the point where an extreme level of polarization and social tension had been reached that demanded radical solutions. The war in Spain was the first violent explosion of this tension in Europe and an aperitif to the confrontation that would soon arrive on a global scale.

The Spanish war also erupted in US society and politics, becoming a phenomenon with a magnetic effect on intellectuals, many politicians, and much of the population at large. On few occasions had so many Americans been so moved by an event abroad in which their country was not directly involved. As one historian has observed, "Liberals and radicals in particular embraced the Republican cause with unheard-of fervor. On the opposite side, the support for Franco from the Catholic establishment was absolute."[65] The US government maintained a policy of nonintervention and refused to sell arms to the government of the Spanish Republic. Roosevelt's reasons for this stance were his desire not to lose the support of Catholic and anti-Communist voters as well as a wish to avoid increasing tension with Germany and Italy, the same position taken by Britain and France.

Two opposing visions of the meaning of the war and the motives for it confronted each other not only on the battlefields but also in the American press, arts, and media. Reports from Spain telling of famous writers sympathetic to the republic who had involved themselves in the conflict,

65. Marta Rey García, "Fernando de los Ríos y Juan Francisco de Cárdenas: Dos embajadores para la guerra de España (1936–1939)," *Revista española de estudios norteamericanos*, no. 11 (1996): 133.

such as Ernest Hemingway—whose later novel *For Whom the Bell Tolls* (1940) expressed that sympathy—had a major impact, as did films and documentaries made in favor of one side or the other to win the support of the American public. The major Hollywood studio heads and Catholic opinion supported Franco, while actors, scriptwriters, directors (with a few exceptions, such as John Ford), and independent producers were more inclined to be pro-Republican.[66] Added to these polemics was the commitment of the American volunteers who, evading the prohibitions imposed by the US government, made their way to Spain to fight for the republic with the International Brigades, such as the Lincoln Brigade. By January 1939, "more than seventy percent of the American public was in favor of revoking the embargo [on arms sales to the Spanish Republic], and this was neither a subversive nor a radical minority."[67]

Archer Huntington did not escape the dilemmas raised by the war and the barrage of propaganda. He was the direct target of diplomatic efforts by Franco's Nationalist authorities in Burgos to win the support of the Hispanic Society for their cause, but at the same time he was also receiving accounts from different acquaintances of their own very personal experiences of the war and its dramas. Their words, their concerns, their hopes, and above all their eventual reasons for disillusion formed a written corpus that enriches our narrative of the Spanish Civil War and illuminates from different viewpoints the events of the war as an experience shared by the generation of intellectuals and politicians who made up Huntington's social world in Spain. A reconstruction of the panorama communicated in this correspondence serves to highlight the very complicated situation Huntington faced in these years, as both a renowned Hispanist and a hispanophile—that is, a friend of Spain and a friend to his Spanish friends.

66. Sonia García López, "Estados Unidos y la Guerra Civil Española," in *España en armas: El cine de la Guerra Civil Española*, ed. Vicente Sánchez Biosca (Valencia: Diputación Provincial de Valencia, 2007), 45–52.

67. Soledad Fox Maura, "Miradas opuestas: La Casa Blanca y la opinión pública estadounidense ante la guerra de España," *Circunstancia*, no. 19 (2009): 5, at https://ortegaygasset.edu/wp-content/uploads/2019/05/Circunstancia_Numero_19_Mayo_2009.pdf.

A deeper examination of this stage in his life is indispensable for bringing to light fresh aspects of Huntington's role as a Hispanist because, thanks to this correspondence, we can say, on the one hand, that he always maintained bidirectional lines of communication with a country that was falling apart before his eyes and that he was powerless to assist and, on the other, that if one thing united all those who wrote to him from Spain, it was that Huntington himself and the Hispanic Society continued to represent in the midst of war a bulwark of Hispanism in the United States.

Epistles among Pistols

Those friends of Huntington who had remained in Spain or had taken sides with one of the two warring factions sent him disparate fragments of the country's drama in their letters. Some wrote to ask for his help, others to tell him their version of events, and others to inform him of their imminent departure from Spain on their way to exile. Writing in very different circumstances and sometimes from opposing sides, his correspondents provided him with information much more valuable than he could have obtained from other sources, relating their personal experiences of the conflict. Through their letters, they consciously or unconsciously led Huntington to relive with them, in locations he knew well, all the anguish and adversities of a country immersed in a war between compatriots.

Although the Nationalist administration in Burgos was not officially recognized as a legitimate government by the democratic nations, the duke of Alba and Juan Francisco de Cárdenas, a right-wing diplomat, acted as its diplomatic "agents" in Britain and the United States, respectively. In the information they sent to Huntington, both men sought to influence his feelings to win his support for their cause. In Alba's case, his letters were a prolongation of the correspondence he had maintained with Archer for many years, which more recently had been taken over almost entirely by political commentary. From the first weeks of the war, the duke saw Huntington as an ally for his cause in part because of their mutual friendship and in part because of Huntington's conservatism and privileged financial position and their shared cultural affinities. Hence, Alba sought to justify the unavoidable evils that came with the military

rising before asking for Huntington's assistance, as in his letter of October 6, 1936, where he points out, "Under the circumstances, all help is most welcome."[68]

In early January 1937, he also passed on news of the seizure by Republican militias of the historic residence of the House of Alba in Madrid, the Palacio de Liria, and its subsequent damage by fire in the fighting, repeating the account broadcast by the Francoists that this destruction had been directly caused by the Republicans. Modern historical research discounts this version of events, though, indicating that the fire had been started by bombing by Italian aircraft serving with the Nationalists, the palace was not subsequently "ransacked," there was no separate burning of the building after the bombing, and its paintings and artworks were removed only to prevent further damage. Nevertheless, the duke's letter is still of interest for the impact it had on Huntington's sentiments. Alba wrote in English before reverting into Spanish:

> Yes! Unfortunately the news is quite true. My house was destroyed, and although I have not yet received any direct news, what probably happened is the following: In the month of July, just after the Civil War started, the house was confiscated and occupied by the Communist Party. The Government, being then as usual with no power, did not intervene. For some time, the Communists looked after the place with care, and lived on the premises with my servants. In November some incendiary bombs set fire to the roof. Some say that they were dropped by Red planes, others by ours. The fire was put out. Then, for two days the Palace was ransacked. Most of the things taken out, and transported in lorries to an unknown destination, probably Valencia [by then capital of the republic because of the fighting in Madrid]. . . .
>
> After this, the Palace was burned by the Reds, as also were the Archives and the Stables, and I am told nobody saw the planes, who are supposed by the Reds to have been the cause of this final and total destruction. . . . All the other works of art, books, etc., which are said to

68. Duque de Alba to Archer Huntington, Oct. 6, 1936, box 7, AHHP, SCRC.

be in Valencia, I am afraid I shall never see again, because I hear que se ha montado allí un negocio de antiguedades, medio de enriquecer a canallas. Temo que mis cuadros salgan por allí, y se hayan vendido sin que yo pueda evitarlo [that an antiques business has been set up there, a means of enriching scoundrels. I fear that my paintings will leave through there, and that they have been sold without myself being able to avoid it].[69]

Huntington received this news with stupefaction and was deeply affected. He replied with consternation a few weeks later. "My own sorrow at the thought is so great that I can only faintly imagine what it must mean to you. The madness of this war, with all it means, will be a sad memory for Spain and all of us. . . . Talleyrand said, *Il faut avoir vécu en France avant la Révolution pour savoir ce que c'ést le plaisir de vivre.* He might be speaking of Spain."[70]

With this famous phrase by the French statesman Talleyrand on the effects of the French Revolution—"one has to have lived in France before the Revolution to know what the pleasure of living is"—and his own very personal comparison with the Spanish situation, Huntington encapsulated his feelings of loss on hearing of the destruction caused by the war in Spain. The Spain that he had admired so much was disappearing before his eyes as he looked on, powerless. The worst predictions were being fulfilled, and the destructive violence of war dominated the destinies of a country that abandoned the romantic image of the Spain of the early 1900s that had welcomed the new century amid a flourishing cultural life.

Huntington added in this same letter to Alba, "*Le monde est dans l'attente, ou personne ne sait encore du juste s'il faut regretter ou espérer!* [The world is in a state of expectation, in which no one still knows whether to lament or have faith!]."[71] The question arose whether one could expect anything positive from this situation or simply mourn the catastrophe of a

69. Duque de Alba to Archer Huntington, Jan. 9, 1937, box 7, AHHP, SCRC.
70. Archer Huntington to Duque de Alba, Feb. 26, 1937, box 7, AHHP, SCRC, emphasis in original.
71. Huntington to Duque de Alba, Feb. 26, 1937, emphasis in original.

fratricidal war. The fact was that many Spanish politicians and intellectuals came to see the Civil War as a valid means of achieving the regeneration of the nation in a Europe where democratic principles were faltering. An appeal to violence as a solution and its justification for the sake of a greater good became part of many Europeans' unconscious assumptions at the time; Huntington, however, revealed in this letter his own doubts on the validity of such ideas.

In May 1937, Alba was formally appointed head of the official delegation of Franco's "national government" in London. His primary objective was to ensure that the British Conservative government maintained the policy of nonintervention in the Spanish Civil War that it had been promoting in Europe.[72] The optimistic vision that he passed on in his letters to Huntington of an imminent Nationalist victory and a swift end to the war was not incompatible with the observation that resistance might be stronger than expected, but he made it clear he believed that "our victory is certain, though not immediate. A new Spain will arise full of enthusiasm, but so many things that we loved will have disappeared forever."[73]

Such statements revealed a conformity with devastation that was incomprehensible to Huntington because they combined a euphoria at the emergence of a postwar "New Spain" with regret for the Spain that was about to disappear. For years, Huntington's work, centered on the Hispanic Society of America, had consisted of safeguarding through an array of cultural projects the Spain that he had come to know since his first visit in 1892: a country that in his eyes had managed to keep intact many of its historic traditions and ways of life and where one could still see in the present the roots of its ancestral past, a Spain that was different from any other European country, the last redoubt to resist an industrialization and technification that had swept away the last vestiges of premodern societies in other parts of the continent. The question lay open regarding just how one could aspire to the future emergence of a "New Spain" after a cruel war

72. On the duke of Alba's work in London, see Juan Avilés Farré, "La misión del duque de Alba en Londres (1937–1945)," in *Propagandistas y diplomáticos al servicio de Franco*, ed. Moreno Cantano, 55–80.

73. Duque de Alba to Huntington, Jan. 9, 1937.

that would cast aside so many things that Archer Huntington so admired and with it the associated and equally painful question how one could accept the destruction and disappearance of half of this same, admired Spain. Many Spaniards, by this time absorbed in the spiral of antagonism and conflict, desired a violent break with the past that would finish with one or other of the "two Spains," but Huntington, like many Spaniards who rejected such absolutist solutions, could not accept such a view.

At the same time, Huntington was also receiving contrasting reports from another good friend and collaborator, José López Mezquita. In Valencia, the new seat of the Republican government after it was forced to leave Madrid with the advance of Franco's forces in November 1936, a large number of intellectuals and other figures aligned with the Republican cause continued their work, López Mezquita among them. The artist once again became a counterpoint to Alba and in his letters gave Huntington a very different image of the war than the view sent by the duke of Alba from London. The account he gave was that of the other half of Spain, that of those who remained loyal to the republic. "As you will see I am still here in Valencia," López Mezquita wrote in May 1937, "in the Casa de la Cultura, a refuge for those of us who could not carry on in Madrid. . . . This terrible war as you know is still going on, but every day that goes by makes the victory of the government of the Republic more assured. Here we are far away from the front, but nevertheless we have received a criminal visit from the fascist aircraft the other day that caused innocent victims (women and children who died without [being] any kind of military target)."[74]

López Mezquita sent these rather triumphalist comments a month after the bombing of the Basque town of Guernica, which had had an enormous impact on international opinion. In addition, his letter provides evidence of one action taken by Huntington that is very important for understanding the manner in which, at a time when taking sides seemed

74. José López Mezquita to Archer Huntington, May 24, 1937, box 46, AHHP, SCRC. The Casa de la Cultura was a center specially created by the Republican government on its arrival in Valencia to provide a location for exhibitions and cultural events and a place for intellectuals and artists evacuated from Madrid and other cities to work.

unavoidable, he continued to display his independence as the characteristic feature of his position. From the artist's words, it seems that Huntington had commissioned López Mezquita to make a copy for the Hispanic Society of a portrait of President Manuel Azaña that he had painted earlier. After all, the society had to continue to be a home for the whole of Spain and the treasure chest of its living history. "As you will have supposed and as I informed you in my previous letter," López Mezquita informed Huntington, "President Azaña was delighted that I should make a replica of his portrait for the Hispanic Society. I am now taking advantage of my stay here to see him and add the last touches, and at the first opportunity I will send it to New York."[75]

From a very different direction and with an entirely different objective, the letters Huntington received from Franco's official representative in the United States, Juan Francisco de Cárdenas, reveal another side of the war, the propaganda campaign to win over American opinion. Cárdenas had arrived in the United States at the end of August 1936 and made his base at the Ritz-Carlton Hotel in New York. A career diplomat, he had abandoned his post as the republic's ambassador in Paris after the military uprising and placed himself at the service of the Nationalist insurgents. In the United States, though still not officially recognized by the government, he sought to resume the activities he had previously undertaken as the Spanish Republic's ambassador in Washington, a post he had occupied from 1932 to 1934.[76]

The cordial language Cárdenas used in his letters to Huntington indicate that he and Huntington had already come to know each other during Cárdenas's earlier term at the Washington embassy, but one can also see the clear intent within them to gain Huntington's support for Francoism in the United States. From the moment of his arrival in New York, Cárdenas set out to establish a direct line of communication with Huntington and began by asking for financial support for his cause. "I have come [here] to

75. López Mezquita to Huntington, May 24, 1937.
76. Misael Arturo López Zapico, "Against All Odds: El diplomático Juan Francisco de Cárdenas durante la Guerra Civil Española y el primer franquismo," in *Propagandistas y diplomáticos al servicio de Franco*, ed. Moreno Cantano, 303–30.

seek to obtain subscriptions in favor of those who, in Spain, are fighting against communism, barbarism, and the destruction of civilization with such heroism," he wrote in September 1936.[77] However, it appears that, despite Cárdenas's evident tenacity, Huntington, for his part, while maintaining the relationship on amicable terms, avoided meeting the diplomat on several occasions on the grounds that he was away from New York or Washington—which at the same time was no less than the truth.

Franco's representative did not start off on a good foot in his work in the United States, for his credibility and his behavior were questioned by the American authorities, to the point that Senator Gerald P. Nye, the strongly isolationist proponent of the Neutrality Acts, which attempted to mandate the avoidance of all US involvement in foreign wars, requested that Cárdenas's activities be investigated by Congress. This meant that Cárdenas, from his first contacts with Huntington in the fall of 1936, had no alternative but to defend himself against the rumors that were circulating about him. In October, he sought to exonerate himself by anticipating one set of allegations. "Yesterday it came to my knowledge that certain rumors that affect me are circulating in New York, and that they are complete calumnies," he declared to Huntington. "As I have faith in the truth and believe that ultimately this will prevail, I trust that they will be dispelled very soon, but I believe I ought to warn you so that they do not take you by surprise. Riaño knows the story."[78]

Cárdenas sought to gain Huntington's attention by raising one of the subjects that would be of most concern to a Hispanist, the protection of Spain's historical and artistic heritage. On April 22, 1937, he requested Huntington's help in organizing a committee of art collectors in

77. Juan Francisco de Cárdenas to Archer Huntington, Sept. 17, 1936, box 16, AHHP, SCRC.

78. Juan Francisco de Cárdenas to Archer Huntington, Oct. 14, 1936, box 16, AHHP, SCRC. The "rumors" eventually raised by Senator Nye were that Cárdenas during his earlier period as Spanish ambassador in 1932–34 had established links with a Spanish trading company in New York, García & Díaz, which since the outbreak of the Civil War had been "part of a Spanish espionage network serving Franco," and that Cárdenas thus was acting in a manner that was "a flagrant violation of the Neutrality Act." See Xabier Irujo, *Gernika: The Market Day Massacre* (Reno: Univ. of Nevada Press, 2015), 60.

the United States to prevent the alleged dispersal and sale in the United States of items cataloged as the possessions of Spanish national museums, a proposal intended to sow suspicion regarding the actions taken by the Republican government to protect artistic treasures by transferring works from the major museums of Madrid and other cities to Valencia.[79] He also informed Huntington of a proposal made by an old acquaintance of the collector, the painter José María Sert, to present a text to the League of Nations for its approval and subsequent ratification by all national parliaments that would declare null and void all sales or transfers abroad of works of art classified as the property of national museums in time of war.[80] Cárdenas asked Huntington to sign this petition and help him to obtain more American signatories—a distinctly obscure maneuver because the document had already been presented to the league a month earlier, on March 22, with signatures from more than 350 distinguished individuals from different countries.[81]

 79. The idea that the great works of the Prado and other artistic treasures had been removed to Valencia by the Republican authorities as an act of vandalism and to sell them through an artistic "black market" to enrich the individuals involved, as repeated by the duke of Alba in the letter to Huntington on January 9, 1937, quoted earlier, was a constant theme of Francoist propaganda throughout the Civil War. This account was effectively challenged by the Republican authorities at the time because no proof of such black-market sales appeared, and it has also been disproved by subsequent historiography. In general, although some criticisms are made of details of the program, the work undertaken by the Second Republic to protect Spain's cultural heritage during the Civil War, led by Timoteo Pérez Rubio and Ricardo de Orueta, is widely regarded as a major achievement. See *Arte salvado: 70 aniversario del salvamento del patrimonio artístico español y de la intervención internacional* (Madrid: Sociedad Estatal de Conmemoraciones Culturales, 2010), and Arturo Colorado Castellary, *Arte y caja de reparaciones: La incautación republicana, la evacuación a México y Ginebra y la gestión franquista* (Madrid: Cátedra, 2023).

 80. Cárdenas sent to Huntington in French the full text of Sert's proposed petition to the League of Nations. Juan Francisco de Cárdenas to Archer Huntington, Apr. 22, 1937, box 16, AHHP, SCRC.

 81. "With the date of March 22, 1937, a petition was presented at the League of Nations endorsed by more than 350 signatures of artists and personalities from the intellectual field from a variety of countries." José María Sert to José Félix de Lequerica

A letter sent by Sert around this time to the president of the Royal Academy of Fine Arts of San Fernando, which had left Madrid to take up temporary residence in the Nationalist zone in San Sebastián, suggests that one origin of these rumors and allegations was a conversation Sert had with the international art dealer Joseph Duveen in which Duveen told him that he had just been offered Goya's portrait *Condesa de Chinchón*, part of the collection of the dukes of Sueca, but had not bought it because he was not sure of the reliability of the individuals proposing the sale. Duveen also said he had heard that some American museums were intending to acquire works from the Spanish national collections if the Valencia government suggested it and that the American press had reported that the Art Institute of Chicago had been offered five paintings from El Escorial.[82] This was an extremely important issue that had to concern any sincere Hispanist. The fact that the League of Nations might become involved showed that this matter was not trivial and that such an intervention might be justified by a situation of real danger for the great treasures of Spanish art.

Amid serious doubts on the future of Spain's historical and artistic heritage, Huntington continued to receive new accounts of the war and its catastrophes and could see through their letters the extent to which his Spanish friends had become aligned on one side or the other, some through deep political or religious conviction and others for circumstantial reasons. Ignacio Zuloaga, despite having maintained with his family a position of political independence since 1931, became a passionate supporter of the Nationalists from early 1937. It appears that his commitment was given extra impetus by the destruction, apparently initiated by a unit of leftist militia, of the house where he and his brothers had been born in Eibar in the Basque Country.[83] In his letters to Huntington, Zuloaga

(Franco's ambassador in France), Jan. 12, 1940, quoted in Arturo Colorado Castellary, "Arte salvado: Los antecedentes de una deuda histórica," in *Arte salvado*, 19.

82. José María Sert to President of the Real Academia de Bellas Artes de San Fernando, 1937, (10) 82/07821, AGA. Goya's *Condesa de Chinchón* was never actually offered for sale and after the war was incorporated into the Prado.

83. Suárez-Zuloaga, "Antonio Zuloaga Dethomas," 129.

vehemently declared his support for the Nationalist cause, writing in October 1937, "Here we are still at war, but wishing that it all ends soon. I believe that Franco is one of the greatest men in the world."[84] His commitment to Franco's forces was total, and some of his subsequent artistic work helped reinforce some of the primary myths and imagery built up by Francoism.[85]

Concha Espina found herself in a more dramatic situation. From her country home in a village in the province of Santander, where she had taken refuge to escape the bombing in Madrid, she described very starkly her worst experiences of the war after she was detained by Republican militias.[86] "One of my first letters after months of a nightmare in the hands of the Communist hordes is for you," she wrote to Huntington in September 1937. "God has chosen to return me to civilization and the culture of the West, by the hands of my own children, when a death sentence against me had already been signed. . . . My house in Madrid has been sacked, my library and my archive torn apart. A whole record of work as heroic and worthwhile as mine, over more than forty years, has been torn apart in an afternoon by an enraged, dirty rabble, under the direction of men who call themselves—I don't know if they don't burn their own lips when they do so—with inconceivable cynicism, intellectuals."[87]

One has to ask how Huntington must have received news of this kind and how such reports influenced his spirits and the opinions he formed of the war. They undoubtedly had a powerful impact on him. This explains his immediate reaction, which was to attempt to help his friends as much as he could, still more so in a case like that of Espina, who even in such terrible times seemed so affected by the loss of her Silver Medal and diplomas from the Hispanic Society, awarded in recognition of her writing in 1927.[88] When

84. Ignacio Zuloaga to Archer Huntington, Oct. 7, 1937, box 58, AHHP, SCRC.

85. Zuloaga's painting *El Alcázar en llamas* (1938), showing the defense of the Alcázar of Toledo by Francoist troops against surrounding Republicans, is one of the few representations of the Civil War painted by a significant artist.

86. After this episode, Espina wrote a book on her experiences, *Esclavitud y libertad: Diario de una prisionera* (Valladolid: Reconquista, 1938).

87. Concha Espina to Archer Huntington, Sept. 26, 1937, box 31, AHHP, SCRC.

88. Espina to Huntington, Sept. 26, 1937.

asked for help, Huntington did everything possible to restore to her some of the precious items she had lost, for three months later she showed her gratitude in a rapid reply. "It is for me both significant and greatly consoling," she wrote, "that the first and perhaps the only thing that I am going to recover of my literary possessions comes from that Hispanic Society, by the hand of Mr. Huntington, illuminator of Spanish art, in these tragic days for our artistic heritage, decimated by fire or plundered by the rapacity of Marxism."[89]

Mariano Benlliure, who had formed part of the circle closest to Huntington in Spain, wrote to him in September 1937 to describe the precariousness of his financial situation and to offer to sell him several busts he had unsold in his workshop. Unlike many, he had remained in Republican Madrid at the beginning of the war, though ill health would later oblige him to move to Paris. However, feeling, like so many others, that he needed to clarify his political position, Benlliure explained his ambiguous situation, wherein because of his work he was respected by both sides, and he made it clear that his only interest was in continuing to work as honorably as he always had done. As the elderly sculptor commented to Huntington, "I made, as a commission from the [Republican] army staff, a bust of the General [José Miaja, commander of the Republican defense of Madrid], giving up the fee for the war orphans." He went on, "Everyone has been respectful toward me, they gave us all kinds of facilities with no more political inclination or slant than [would be suggested by] the respect due to the conduct I have always shown, the love of work and the struggle to go further along the pathway of art that has no end, and to do good by helping inasmuch as my strength allows all those who are working for the good of culture. . . . Everyone has respected whatever is contained in my workshop."[90]

Huntington responded to Benlliure's inquiry by saying that he might be interested in buying the artist's bronze bust of Vicente Blasco Ibáñez.

89. Concha Espina to Archer Huntington, Dec. 30, 1937, box 31, AHHP, SCRC.

90. Mariano Benlliure to Archer Huntington, Sept. 10, 1937, box 10, AHHP, SCRC. I am grateful to Lucrecia Enseñat, director of the Fundación Benlliure and great-granddaughter of the artist, for confirming that the bust in question was of General José Miaja, the leading Republican military commander.

The Hispanic Society already had a portrait of the writer by Sorolla, but this was an opportunity to help his friend and acquire another of his portrait busts at the same time.

However, at that time the bronze head of Blasco Ibáñez by Benlliure was being exhibited in the official pavilion of the Spanish Republic in the International Exposition of 1937 in Paris, the same pavilion that contained Picasso's *Guernica*. To acquire it, as Benlliure explained to Huntington, the American would need to contact the pavilion's director and request the bust from him, but Huntington decided not to do so. It was one thing to help a friend, another to deal with the authorities of the Republican government to ask for a work that had been presented in Paris in a pavilion that in Europe had become a primary symbol of the republic in its struggle against Franco.

Incidents like this illustrate the kind of situation that many Spanish artists and intellectuals had to confront as their artistic abilities were respected only at the cost of being capitalized upon by one side or the other. It should equally not surprise us, therefore, that during these months as part of his customary network of friendships Huntington was, on the one hand, exchanging letters with the sculptor of a bust of General Miaja and the painter of a portrait of President Azaña of the republic, while on the other continuing to share—together with these same artists—a close friendship with the marquis of Vega-Inclán, who from the Nationalist zone was continuing his efforts to protect Spain's monuments and national heritage.[91] Huntington was not prepared to break off his personal relationships because of the abnormal circumstances of a war between compatriots and kept all his contacts open as long as he could, against the grain of the political prejudices that dominated Spain at war.

However, this was not the only unusual situation in which he found himself. Another of a different nature stemmed from the proposal to recreate the Centro de Estudios Históricos of Madrid at Johns Hopkins University in Baltimore. The geographer Isaiah Bowman, his good friend and previously director of the American Geographical Society in New York for

91. José María de Campos Setién, *La aventura del marqués de la Vega-Inclán* (Valladolid: Ámbito, 2007), 52–54.

twenty years, had since 1935 been the president of Johns Hopkins.[92] In a letter to Huntington in March 1937, Bowman explained his proposal to provide support through the Department of Romance Languages at Johns Hopkins for the Spanish intellectuals who had been associated with the Centro de Estudios Históricos. This would be done by means of a cooperation agreement initially valid for five years, and he invited Huntington to use the university as an intermediary if he wished to provide assistance for these Spanish scholars. "My object in writing you is to say that if you have any purpose or desire to help these men, I would be happy to have you make this University the instrument of such assistance."[93]

Bowman also wrote that Johns Hopkins hoped to be able to work with Ramón Menéndez Pidal, the illustrious former director of the Centro de Estudios Históricos, who had left Spain after the war broke out and whom Bowman hoped to bring to the United States. "I have also been told that Pidal sailed for Havana in January," wrote the university president. "We have been hoping to find support to bring him to this country. You may have plans in this direction."[94] Bowman, who knew Huntington well, did not doubt that he would be interested both in helping Menéndez Pidal and in the proposal to create an "American Center of Spanish Studies" as a means of keeping alive, at least temporarily, the values of the Madrid *centro* in the United States. At the same time, as Bowman also indicated, the plan also had a complementary objective: "As you see, the plan proposes the use of the scholars in question for the cultivation of closer relations with the countries of Hispanic America."[95]

In its official memorandum on the Project for an American Center of Spanish Studies, Johns Hopkins University acknowledged the difficult situation in which Hispanic studies had been left because of the outbreak

92. Isaiah Bowman had also been a member of the Council on Foreign Relations since 1921 and during World War II acted as an adviser to the US State Department and President Roosevelt.

93. Isaiah Bowman to Archer Huntington, Mar. 3, 1937, box 11, AHHP, SCRC.

94. Bowman to Huntington, Mar. 3, 1937. Menéndez Pidal was still in France at that time and did not leave for Cuba until some time later.

95. Bowman to Huntington, Mar. 3, 1937.

of civil war in Spain and that the admirable work of the Centro de Estudios Históricos faculty and associates in Madrid had been interrupted. It proposed that, until suitable conditions were reestablished in Spain, a Center of Spanish Studies should be established for an initial period of five years, with a commitment to provide it with all the necessary facilities and resources, such as offices, lecture halls, access to libraries, funding to cover its costs, and the necessary academic measures to give the doctorates and masters degrees granted by the center equivalent status with those awarded by other university faculties.[96]

The university also wanted Menéndez Pidal to be the center's director. "It will be desirable to have Menéndez Pidal appointed director," Bowman wrote, "even if he can come for only a year, but it is doubtful if he will be allowed to leave Madrid."[97] Despite these doubts, he also proposed several other names to complete the future teaching staff: the philologist and cultural historian Américo Castro, who was at that time in France, to take charge of everyday administration and serve as professor of medieval and Renaissance civilization; the poet Dámaso Alonso, then in Valencia, as teacher of Spanish Golden Age literature; another poet, Pedro Salinas, who had already taken up exile in the United States and was teaching at Wellesley College, to cover nineteenth- and twentieth-century Spanish and Latin American literature; the Austrian Hispanist Leo Spitzer, already a faculty member at Johns Hopkins, for philology; the poet and translator José Robles Pazos, who had been teaching at Johns Hopkins before the war, as lecturer in theater; and another Johns Hopkins professor, H. Carrington Lancaster, to teach a course on Franco–Spanish relations in the seventeenth century. It was also suggested that, if possible, courses on Portuguese and Catalan should be added.

The memorandum also proposed an annual budget of $32,000 ($450,000 at current values), which over five years would amount to $160,000 (around $2.25 million today). This was expected to cover costs

96. Isaiah Bowman to Archer Huntington, June 19, 1937, box 11, AHHP, SCRC.

97. Bowman to Huntington, June 19, 1937. Menéndez Pidal had in fact already left Spain.

and salaries, books, eight research grants for students from the United States, and five grants for Latin American students. Something was also to be set aside for publications, something like the *Revista de filología española* founded by Menéndez Pidal in 1914.[98]

There is no formal reply from Huntington to Bowman's proposal in the archives, but Archer did insert in the envelope with the original letter a brief handwritten note in which he acknowledged the merits of the project but added, "The plan is a fine one as everything you do, but it is not for me."[99] However, the idea of reestablishing the Centro de Estudios Históricos in some form outside Spain had been on the minds of several figures in the intellectual community. Américo Castro, who had served as the republic's consul in Hendaye on the Franco-Basque border in the first months of the Civil War, told Menéndez Pidal in a letter on March 18, 1937, of the possibilities being discussed in the United States of creating a Hispanic institute in America to give him, Menéndez Pidal, some professional prospects outside Spain. "[Leo] Spitzer told me," Castro wrote, "that they had asked for money from Huntington to create a Hispanic Institute in the United States and place yourself at its head, together with Dámaso and Salinas. I have no idea how these things work."[100]

Federico de Onís, from his base at Columbia in New York, had also been looking into alternative possibilities, and in April 1937 he suggested to Castro that they should use the infrastructure of Spanish cultural institutions in different Latin American countries to re-create a version of the Centro de Estudios Históricos, with offices and administrative headquarters in New York or Havana or Buenos Aires.[101] Moreover, by July 1937 Menéndez Pidal was in New York, having been invited as a visiting professor to Columbia. Huntington wrote to congratulate him for

98. Bowman to Huntington, June 19, 1937.

99. Note by Huntington in Bowman to Huntington, June 19, 1937.

100. Quoted in Catalán, *El archivo del Romancero*, 1:190.

101. Federico de Onís to Américo Castro, Apr. 13, 1937, quoted in Consuelo Naranjo and Miguel Ángel Puig-Samper, "Los lazos de la cultura se convierten en lazos de solidaridad: Los inicios del exilio español," in *Los lazos de la cultura*, ed. Naranjo, Luque, and Puig-Samper, 314.

having been able to travel from Spain and for his new relationship with the university.[102]

However, although many people were seeking a way out in the United States for the leading figures of the Centro de Estudios, generally in the belief that within a short time it would be possible to rebuild the institution in Spain, these proposals did not prosper, and after teaching at Columbia through the academic year of 1937–38, Menéndez Pidal preferred to return to Europe, taking up residence in Paris until after the end of the Civil War.

Such situations, like many others, demonstrate that Huntington remained in the minds of many Spanish intellectuals when they sought to rebuild outside a Spain at war the many cultural connections of Hispanism through the organizations and universities with which they had established collaborative relationships during the previous decades. The Hispanic Society of America and its president continued to be one of the pillars of Hispanism in New York, and Huntington was still sought out by those who hoped to find means of ensuring a continuity for Spanish culture beyond the terrible circumstances of the war.

In February 1938, it was the Cervantes expert Francisco Rodríguez Marín, then age eighty-three and one of the first men Huntington had met during his stay in Seville in 1898, who wrote Huntington to tell him that he was continuing to work on a new book after escaping from Madrid to the village of Piedrabuena in the province of Ciudad Real, south of the city, where he was living with his daughter. "I don't know if a card of mine will have come into your hands that I sent you on March 31 of last year from this little corner of La Mancha," he wrote, "where I came fourteen months ago, fleeing from the projectiles that the foreign aircraft and howitzers were discharging on Madrid."[103]

The painter Miquel Viladrich, who had stayed in Republican Barcelona, was another who told Huntington of the hardships he was suffering.

102. Archer Huntington to Ramón Menéndez Pidal, July 5, 1937, Archer Huntington Correspondence of 1937, FMP.

103. Francisco Rodríguez Marín to Archer Huntington, Feb. 20, 1938, in García-Mazas, *El poeta y la escultora*, 516.

In October 1938, he wrote a long letter in which, as well as thanking Huntington for the distinction conferred upon him by the Hispanic Society in awarding Viladrich its Medal of Arts and Literature in 1937, he described the difficulties he was experiencing because he could not sell any of his work in Spain. Huntington had bought some forty paintings by Viladrich in 1926, a large part of his existing work at the time. "In these two years I have seen my studio in Madrid broken up," Viladrich recounted, "various paintings of mine destroyed in Barcelona, and my workshop and possessions in Aragon made useless by the foreign bombing. My financial possibilities, which thanks to yourself had been assured since the year 1926 when I sold you my paintings, have now been reduced to nothing . . . because I do not sell anything even though I work with the same belief, I can only rely on a very modest salary that my wife obtains as an art teacher."[104]

In view of his desperate situation, Viladrich proposed to Huntington an agreement through which in exchange for a monthly pension, the artist would send work to the Hispanic Society. "Could you," he asked, "by means of the Consulate or Embassy of the United States in Barcelona send me some amount, and I in turn could deliver my work there?"[105] However, at the end of the war a few months later Viladrich had to leave Spain for exile in Argentina.

Huntington read such letters and responded with encouraging words, always trying not to express any political opinions that could compromise him. However, during these three fateful years, he also awarded through the Hispanic Society some significant distinctions to figures in Spanish life whose cultural contributions he admired irrespective of any political position. As well as to Viladrich, the society awarded its Medal of Arts and Literature in 1937 to the duke of Alba and Mariano Benlliure. Huntington also wished to acknowledge the immense work of Miguel de Unamuno by appointing him a member of the society's Advisory Council in 1936, shortly before the great philosopher's death in December that year, three months after his famous confrontation with the Francoist general Millán

104. Miquel Viladrich to Archer Huntington, Oct. 1, 1938, box 56, AHHP, SCRC.
105. Viladrich to Huntington, Oct. 1, 1938.

Astray on the brutality of the war. A year later, Huntington awarded the same distinction to Ignacio Zuloaga.[106]

The prestige that Huntington had gained in Spain during the three previous decades led a range of personalities from the Spanish cultural world to approach him during the Civil War. A crucial factor at this time was the fact that Huntington placed his relationships of friendship and his commitment to Spanish culture above any kind of ideology.

Remaining Neutral in a Battle of Propaganda

The public ambiguity exhibited by Huntington during the three years of the Spanish Civil War was not very different from that of many other American Hispanists, who similarly chose to remain on the margins of the conflict. In his case, he did not conceal his wish to continue in a position of official neutrality and communicated this to his friend Alba in April 1938: "As you know, I am forced to be entirely neutral as to Spain—which I am not. But the Society is representative of both sides."[107] Huntington wished to maintain the complete neutrality of the Hispanic Society of America, and so he, as its president, was obliged always to appear impartial, although he also revealed in glimpses that his own personal position was not entirely equidistant.

He was equally clear to Juan Francisco de Cárdenas in expressing his desire to remain officially neutral when the latter sought in early October 1938 to persuade Huntington to be listed as an "adviser" to the bimonthly magazine *Spain,* one of the most substantial ventures produced by the Francoist propaganda services in the United States.[108] The Nationalists'

106. *A History of the Hispanic Society of America,* 542–48.
107. Archer Huntington to Duque de Alba, Apr. 18, 1938, box 7, AHHP, SCRC.
108. The journal *Spain,* the first issue of which had appeared in October 1937 under the editorship of Miguel Echegaray, formerly agricultural attaché in the Spanish Republic's embassy in Washington, DC, was published from February 1938 by the "Peninsular News Service," an American front company officially headed by the pro-Franco journalist Russell Palmer but effectively managed by Cárdenas and Echegaray. See Antonio César

agent in New York had written, "*Spain* will be a year old on the 15th of this month, and we would like to publish in this issue, which coincides with the Fiesta de la Raza [October 12, Columbus Day], some maps or other documents related to the discovery of America. . . . Would you be so kind as to put us in contact with the Director or other person that you believe would be best suited to help us? Would you equally be so kind as to give us your advice, so that whatever we do may be supported by the guarantee that your authority and knowledge represent for all of us?"[109]

In an immediate reply, Huntington referred him to one of the conservators at the society and suggested that any of the paintings by Sorolla in the Hispanic Society collection would be suitable for his purposes. However, he also stressed once again that the Hispanic Society of America could not display a position on the war in Spain and gave his final answer on the matter. "Of course, you understand it is impossible for the Hispanic Society to occupy anything but a neutral position, but I trust that will not prevent you from using the art to which you refer."[110]

The same fragmentation between the supporters of one half of Spain or the other was reproduced in the Spanish community in New York as in American society. This division was conditioned above all by the socioeconomic status of the Spanish residents, for while support for Franco was drawn essentially from the business community and the professions, most Republican supporters were Spanish migrants from working-class or rural backgrounds, who formed a majority of the city's Spanish community in the 1930s. Representing these two groups, two envoys coexisted in the United States, the republic's official ambassador, Fernando de los Ríos, and Franco's "diplomatic agent," Juan Francisco de Cárdenas.

Fernando de los Ríos, a distinguished socialist intellectual, centered his efforts on setting up the Spanish Information Bureau and gathering

Moreno Cantano, "Proyección propagandística de la España franquista en Norteamérica (1936–1945)," *Hispania Nova: Revista de historia contemporánea*, no. 9 (2009): 1–26.

109. Juan Francisco de Cárdenas to Archer Huntington, Oct. 7, 1938, box 16, AHHP, SCRC.

110. Archer Huntington to Juan Francisco de Cárdenas, Oct. 7, 1938, box 16, AHHP, SCRC.

funds for the Spanish Republic through a range of support organizations, the most important of which were the North American Committee to Aid Spanish Democracy and its offshoot, the American Medical Bureau. The latter, headed by the surgeon Edward K. Barsky, organized the dispatch of ambulances and medical supplies and equipment to the Republican zone and in January 1937 sent a full field ambulance and medical team. De los Ríos was very successful in fundraising for the republic and in attracting prominent intellectuals and public figures to its cause, among them First Lady Eleanor Roosevelt, who, however, does not seem to have succeeded in influencing the president's opinion regarding the arms embargo on Republican Spain. Despite his successes among the public, in the official sphere the republic's ambassador was seeking to achieve something that ultimately proved impossible: to change the US government's nonintervention policy. Although de los Ríos had numerous meetings with Secretary of State Cordell Hull, he did not secure any concessions in the prohibition of arms sales to the republic.

The Republican ambassador also met Archer and Anna Huntington at the home they still kept in New York. A handwritten note with the letterhead of the Spanish embassy sent to Huntington records this encounter, albeit without a date. In the note, Ríos thanked the Huntingtons effusively for the welcome they had given him and his daughter at their home, "one of the homes of the greatest cultural refinement and most noble and simple manners I have found in my life." He added, "To the gratitude that I have always felt to you as a Spaniard, because of your work for Spain, I can now add my great personal esteem."[111]

Cárdenas, for his part, focused his attention on convincing the wealthy classes and the American business community of the importance of the Nationalist cause. From his press and propaganda office, he publicized the ideas of Francoism and succeeded in gathering together a group of sympathizers from the New York Spanish community in a social center,

111. Fernando de los Ríos to Archer Huntington, undated, box 31, AHHP, SCRC. Although the letter is undated, this meeting must have taken place toward the end of 1936 because the ambassador mentioned in a postscript that he had received Huntington's book of poetry *Rimas*, which was published in New York in 1936.

the Casa de España.[112] In his work, he enjoyed the unconditional support of Catholic organizations and their press and media outlets, all of which joined in transmitting the idea that the war in Spain was a crusade against communism, an argument that was well received in the Catholic community and among broader conservative groups.

The fierce disputes generated in the United States by the Spanish war reached into all the mass-communications media and all the main intellectual circles of the country. Further questions arise, therefore, on how Huntington, as a Hispanist, dealt with this situation and equally how other representative figures of American Hispanism reacted to the news coming from Spain.

Archer Huntington and his Hispanic Society formed one of the three main pillars of Hispanism and Spanish culture in New York, alongside the Instituto de las Españas and the Casa Hispánica at Columbia, headed by Federico de Onís, and the newspaper *La Prensa*, edited by José Camprubí. When the Civil War began, Camprubí "wished to be impartial, which placed him in the sights of both the right and the left; hence the Republicans labeled the newspaper right-wing, and the Francoists said completely the opposite."[113]

The Instituto de las Españas at Columbia was no exception. It feared that taking a political position would damage the academic prestige it had achieved and did everything possible to keep politics out of the classroom.[114] Nevertheless, a different stance was taken by Federico de Onís, who had publicly declared his loyalty to the republic and subsequently

112. The Casa de España (which had no connection with the Casa de las Españas at Columbia University) was created in May 1937 by Cárdenas and some former members of the Spanish Chamber of Commerce in New York and became the main center for pro-Franco activities in the city. It held events, initially almost in secret, to raise funds for the National Spanish Relief Association to carry out relief work in the Nationalist zone. When its meetings became more public in 1938, they were heavily picketed by antifascist groups.

113. Cortés Ibáñez, "José Camprubí y *La Prensa*," 5.

114. "Politics: The Hispanic Institute in Spanish Civil War and WWII," Columbia University Libraries online, at https://exhibitions.library.columbia.edu/exhibits/show/the_hispanic_institute_between/politics, accessed July 25, 2023.

devoted much of his time to attending to any request for assistance he received from Republican exiles. The poets Pedro Salinas and Jorge Guillén, the historian Claudio Sánchez Albornoz, and the former ambassador Fernando de los Ríos were only some of the figures who later thanked Onís for his help.[115]

In April 1938, anguished by the situation of many of his friends and colleagues inside and outside Spain, Onís published a letter in a Montevideo newspaper prominently reaffirming his solidarity with the republic. "In this critical moment," he wrote, "in which a government that, in the most difficult circumstances, has succeeded in organizing a heroic people finds itself in danger, [a people] who are dying for the ideas in which I believe, I declare my total solidarity with this people and its government."[116] His commitment was absolute, and thanks to his contacts at universities in the United States, Puerto Rico, Mexico, and Argentina, he was able to help many exiled Spanish intellectuals to find posts that allowed them to continue their creative and teaching work outside their homeland.

Archer Huntington, the other great focal point for the study of Spanish art and culture in New York, occupied a position very different from that of Camprubí and Onís because he was, of course, entirely American. His reactions can perhaps be seen in the context of those expressed by other American Hispanists during the Spanish Civil War.

The Hispanic experts in the United States and other countries were, as we have seen, a direct target of wartime propaganda.[117] From the Francoist side, in June 1937 the former director of the Biblioteca Nacional in Madrid, Miguel Artigas, issued a public appeal to the "Hispanists of the World" from the pages of the *Heraldo de Aragón*, published in the Nationalist zone. He exhorted them to show their support for the insurgent

115. Albert Robatto, "Federico de Onís entre España y Estados Unidos," 264.

116. "Letter Federico de Onís to Antonio Machado and Tomás Navarro Tomás, April 15, 1938, Page 1," Columbia University Libraries Online Exhibitions, at https://exhibitions.library.columbia.edu/exhibits/show/the_hispanic_institute_between/item/12625, accessed Nov. 13, 2023.

117. Delgado Gómez-Escalonilla, "Las relaciones culturales de España en tiempos de crisis," 268.

cause in the face of the destruction the Republican forces were inflicting upon Spain's historical, artistic, and cultural heritage. In the list of names of illustrious Hispanists he cited in his article, Huntington came first. "What an impression of horror you are going to suffer if you visit those cities that have been or still are red," the article proclaimed, "you, you who form the family of Hispanists—Huntington, Croce, Farinelli, Fitzgerald, Costler, Espinosa, Schevill, Martinanche, Thomas—the Thomas in London, and the one in Brussels—, Vossler, Pfandl and so many others—when you come to visit us, to continue your studies in your second homeland!"[118]

In making the community of Hispanists and Hispanic scholars a priority target of their propaganda, Francoist spokesmen were seeking to appeal to ideas and images of an "eternal Spain" and its unchanging essence as the expression of particular ideological assumptions sustaining the Francoists' political position. The cultural representatives of the Republican government, for their part, responded to these accusations through Tomás Navarro Tomás, the current acting director of the Biblioteca Nacional, who published his own letter to the Hispanists of the world, which added further fuel to the controversy. Huntington, like his compatriots in the field of Hispanic studies, found himself in a difficult dilemma, whether to avoid making any declarations on the conflict and so fall in line with US government policy or to make a public show of commitment.

Sebastiaan Faber concludes in his study of the attitudes of American and English-speaking Hispanists during the Spanish Civil War that American academic Hispanism showed itself "extremely reluctant to express itself in public on the war, maintaining a silence that, in retrospect, appears surprising and almost immoral." He adds that a range of factors could explain this strictly apolitical posture of the world of Hispanic studies: first, the American academic tradition, little given to producing public intellectuals; second, the fear that any adoption of political positions could

118. Miguel Artigas, "Clamor de infortunio: A los hispanistas del mundo," *Heraldo de Aragón*, June 5, 1937, quoted in Sebastiaan Faber, *Anglo-American Hispanists and the Spanish Civil War: Hispanophilia, Commitment, and Discipline* (New York: Palgrave Macmillan, 2005), 10.

divide the scholarly community and damage the prestige of the profession; and last, the fact that many American Hispanists were by then more interested in Latin America than in Spain.[119]

In effect, a majority of American Hispanists chose, like Huntington, to avoid making any statements on the ideological conflict and confrontation between the two Spains. This attitude came to be such a matter of near consensus that Alfred Coester, the editor of the most influential journal of Hispanic studies in the United States, *Hispania*, declared in 1936 that he would refuse to publish any article on the war that was not entirely neutral.[120] Coester was an academic and writer admired by Huntington, and in 1935 the Hispanic Society had awarded him the Mitre Medal for his studies on Hispanic America. Thus, in this context and in the United States, Huntington's attitude does not appear entirely strange, even though it might seem paradoxical that those Americans who knew Spain, its idiosyncrasies, its history, and its language best were those who said least about the conflict.[121]

The dilemma faced by Huntington in these years was shared by many others, but with a significant difference of degree. He was not simply a Hispanist, for his public profile in the United States as a multimillionaire, the possessor of an exceptional collection of Spanish art, and president of the Hispanic Society of America was very much greater than that of other Hispanists who worked in the universities. Huntington had played an intermediary role representing the US government in the diplomatic negotiations leading to the commercial agreement between Spain and the United States in 1918, and he held various honorary posts in Spain, such as the presidency of the Fundaciones Vega-Inclán. He was not just a

119. Sebastiaan Faber, "El hispanismo anglosajón y la Guerra Civil Española," *Revista de erudición y crítica*, no. 4 (2007): 104.

120. Faber, "El hispanismo anglosajón y la Guerra Civil Española," 104.

121. This was not the case with Hispanists and students of Hispanic studies in Britain, for whom the Spanish Civil War was a matter of the greatest concern for both scholars and the country. British Hispanists aligned themselves with one side or the other, and so whereas J. B. Trend and Gerald Brenan supported the republic through their writing, E. Allison Peers gave his loyalty to the Right.

Hispanic scholar but a person of public interest. His case in this situation, as throughout his life, was an exceptional one.

Art in Wartime

Isolated incidents can, on occasion, be the best means of documenting the climate of a particular period. This is so for an incident involving Ignacio Zuloaga, which is added here as an end note to this chapter because it serves to illustrate the manipulation to which Archer Huntington and many other American intellectuals—together with, it is fair to say, a great many other men and women who were similarly concerned about developments in the war in Spain—were subjected. This incident and the reactions to it demonstrate the tensions between action and inaction Huntington underwent behind the curtain of public silence he maintained during the Spanish Civil War.

On March 8, 1937, the propaganda outlets of the Nationalist regime issued a news report that Ignacio Zuloaga had been tried and sentenced to death in Republican-held Bilbao and that the sentence would be carried out the following week. The report "portrayed Zuloaga as a victim of the Republican camp, which, from the very moment when they murdered the painter, would be seen before the eyes of the whole world as pitiless executioners of culture and the arts."[122] The story was false, but this was not the first time such a story had been circulated regarding Zuloaga; in August 1936, only a few weeks after the war began, Nationalist-controlled Radio Seville had already announced that the artist had been shot by Republicans. The purpose of this lie had been to counteract the impact of the disappearance and subsequent murder by Nationalist sympathizers—although this was never officially acknowledged—of Federico García Lorca, who had been taken from his home in Granada on August 18. To deny these reports, at the request of the Republican authorities, Zuloaga, who was then at his country home in Zumaia in

122. Javier Novo González, "Ignacio Zuloaga y su utilización por el franquismo," *Ondare: Cuadernos de artes plásticas y documentales*, no. 25 (2006): 235.

the Republican-controlled Basque Country, had appeared personally on radio to confirm that he was alive.[123]

When the new allegation of a death sentence against Zuloaga appeared in March 1937, the news reached Huntington not directly through the press but from American artists. As well as being one of the modern Spanish painters most admired by Huntington, Zuloaga had been a very well-known and influential figure in artistic circles in the United States, and the news of his apparently imminent death provoked an immediate reaction in Huntington and others, as can be seen in a sudden burst of cables sent on March 9.

At four o'clock that afternoon, Huntington received a telegram from Thornton Oakley, a prominent American artist and book and magazine illustrator. Oakley asked for information urgently from Huntington on the veracity of the reports, picked up by the Associated Press and repeated in various American newspapers, that Zuloaga had been condemned to death. He also asked for his advice and assistance as a personal friend of Zuloaga in preparing a joint statement of protest to be presented to the Republican government.[124]

The news caused great concern, and Huntington felt impelled to act. He immediately sent a cable to his secretary in New York instructing her to take the necessary measures to organize a formal protest to be presented jointly by the Hispanic Society, the other academies and institutions on Audubon Terrace, and other artistic associations. At the same time, he also asked her to make the necessary inquiries with the Spanish Republic's ambassador to the United States, Fernando de los Ríos, and with *La Prensa* editor José Camprubí, urging them to use their influence to forestall and halt the execution and so avoid the disastrous effect it could have on Spain's reputation.[125]

123. Suárez-Zuloaga, "Antonio Zuloaga Dethomas," 128.
124. Thornton Oakley to Archer Huntington, telegram, Mar. 9, 1937, box 35, AHHP, SCRC.
125. Archer Huntington to his personal secretary, Miss Perkins, telegram, Mar. 9, 1937, box 35, AHHP, SCRC.

A few hours later Huntington received a note from his secretary indicating that reliable sources had confirmed that the reports were untrue and that Zuloaga was safe in France. There can be no doubt that Huntington had been greatly alarmed by the earlier reports both because of his personal regard for Zuloaga and because of his awareness of the repercussions such an execution could have for Spain in the United States. An official rebuttal came from the head of the autonomous Basque government, Juan José Aguirre, who informed Ambassador Ríos by cable, "This news is totally incorrect, I have already said that this gentleman is not now in the territory under the jurisdiction of the Basque Government. The report in question comes from the rebels, with the sole purpose of discrediting us."[126]

This anecdote is not only an illustration of the unrestricted use of deceit and misinformation to create confusion in the conflict and distort the image of the enemy but also of interest in view of the immediate reaction shown by Huntington, who in these circumstances demonstrated the capacity he had to mobilize opinion in the artistic and Hispanist circles of the United States. Had the allegations been true, and had the reports of Zuloaga's execution proved correct, would Huntington have broken his ambiguous silence? From his exchange of telegrams, it appears he would have taken the lead in making an "official" joint protest by various American institutions to the Republican government. Perhaps, however, the fact that he became aware that the information he and many others were being fed was manipulated did no more than reinforce his decision to remain silent. Huntington knew that Spanish art had become one of the weapons thrown into the interplay of political propaganda, and he consciously and voluntarily chose not to play the same game.

126. Quoted in Novo González, "Ignacio Zuloaga y su utilización por el franquismo," 236.

5

The Tribulations of Mr. Huntington

The Reflections of a Resigned Hispanist

That the best portrait we can have of a person is the one they themselves write is a maxim that numerous thinkers have turned to throughout history, suggesting that, as they see it, while the body can be portrayed with a paintbrush, the soul is revealed with a pen. Ever since Greek and Roman times, this idea has contributed to the belief that a letter has a curious capacity to evoke the personality of the writer and so trace an image of their spirit.[1] As well as transmit information, a letter can project the character, ideas, and state of mind of the writer and consequently become a kind of "autobiography in miniature."[2] To a certain extent, a letter always transmits an idea of a "self in history," a personal interpretation of a particular historical moment as seen through the writer's own experiences, which makes such letters an individual but simultaneously very reliable source for historical research.

Archer Huntington was, like most of his contemporaries, a person who made intensive use of letter writing. His cosmopolitan nature, his visits to Europe, his broad range of social contacts, his international ventures, and his responsibilities in the family businesses made letters his principal

1. Carmen Serrano Sánchez, "Espejos del alma: La evocación del ausente en la escritura epistolar áurea," in *Culturas del escrito en el mundo occidental: De Renacimiento a la contemporaneidad*, ed. Antonio Castillo Gómez (Madrid: Casa de Velázquez, 2015), 67.

2. Verónica Sierra Blas, "Cartas para todos: Discursos, prácticas y representaciones de la literature epistolar en la época contemporánea," in *Culturas del escrito en el mundo occidental*, ed. Castillo Gómez, 114.

means of communication. Despite this, however, after reading a large part of his correspondence, one cannot say that Huntington was an "epistolary animal." Apart from those he sent his mother, most of his letters contain few personal references and are written in an austere, eminently functional style that provides us with few leads to an insight into his inner life.

However, some of his letters dealing with the years of the Spanish Civil War and the immediate postwar period surprise the modern reader by the frankness of his opinions and the wealth of comments contained in them. Far from the plain, prosaic man revealed by the style he customarily used, a Huntington emerges who was emotionally involved, who suffered, who became disillusioned, who lamented the losses he saw, and eventually became resigned to them. Thanks to these letters, we can examine not only what he did but how he experienced these dramatic events that moved the whole of the Western world.

An approach of this kind helps complete our profile of Huntington during the most violent years of the twentieth century and gives us an opportunity to observe from a complementary, more emotional perspective the personal conflicts he lived through during and after the Spanish Civil War. He had been dedicated to Hispanism and Hispanic culture for more than thirty years, and so the war between Spaniards marked a before and after in his mature years, a decisive moment in his life after which many of his projects were left truncated. Ideas related to absence or loss arose in his letters and led to feelings of impotence and nostalgia for a lost world. Disappointment at seeing how easy it was to destroy what Spain had built up and treasured over so many years filled him with a sense of disappointment. These feelings formed part of the emotional burden Huntington carried with him from the late 1930s.

An examination of the correspondence between Huntington and Josep Pijoan between 1936 and 1939 is our principal source for his most pessimistic reflections. These letters reveal a man overwhelmed by the destruction in Spain. A feeling of disillusion runs through them, and they became an exercise in introspection of great documentary value. If one compares the letters to Pijoan with those written to others around the same time, one can see that in them Huntington poured out his despondency much more openly. This makes these letters stand out among

his correspondence because in general he tended to reply with words of comfort and condolence but without revealing his own sense of dejection to friends who wrote to him and were enduring terrible circumstances. Pijoan—to whom Huntington customarily wrote in English—was a different case because he had been living and working in the United States for many years, which enabled him to understand and share in certain typically American forms of communication and of showing emotion. From his teaching position at the University of Chicago, he was able to follow the events of the war, not without sadness but nevertheless with something of the view of an "outsider" who, like Huntington, was sufficiently far from the battlefields to form a dispassionate analysis of the conflict. This made it easier for Huntington in his own letters back to Pijoan to express his emotions more openly.

It was also the case that at this time Pijoan was still insisting repeatedly on his wish to collaborate professionally with the Hispanic Society, which may have played a part in making Huntington extend himself rather more than usual in his replies because there was no shortage of letters in which his response to his friend had to be a negative one. Hence, from our point of view, we have to thank Pijoan for his insistence because it obliged Huntington to provide the reasons why it was not possible to consider new collaborative projects with a Hispanic Society that he expected to close its doors temporarily to the public.

In a letter to Pijoan on September 17, 1936, Huntington summarized his plans for the new situation for the first time. The events in Spain since the military uprising of July 18 and the outbreak of civil war had obliged him to take drastic measures: a halt to all sales of the Hispanic Society's publications, a freeze on all new activities beyond the continuation of those already in progress, and a reduction in the funds assigned to the society's exhibitions, which were suspended. Huntington painted a panorama of a crisis with consequences that Pijoan was aware of—the disappearance of cultural publications and the concentration of available funding solely on scientific research. "Of course," he wrote, "you are aware of the inevitable results for scholarship that must come from the Spanish conditions of today. The publication of scholarly books in a period of financial depression always ceases to a great extent, and whatever funds

there are available must go into utilitarian and scientific investigation, or that kind of research which seems to be most popular in America."[3]

With a certain sense of resignation and impotence, Huntington lamented aloud, "What can I do?" As he pointed out, he could do little in the face of a devastating situation that had repeated itself in a cyclical manner throughout history under different names but that ultimately brought only destruction. "I greatly regret all this," he explained to Pijoan, "but what can I do? I did not create the conditions which are not new in the world, but recurrent in one form or another or under one name or another. . . . I fear we shall hear little of scholarship for a long while."[4] Pijoan in turn complained with some bitterness of the situation in Spain, writing, "You will have already seen in the newspapers that a campaign along the coast is about to begin. It looks like these red and black gentlemen have proposed to themselves to crucify Spain with another Carlist war disguised as communists and fascists. Poor country!"[5]

Huntington took advantage of these words from Pijoan to offer in his reply one of his most negative but visionary reflections on the future of Spain after the war. Very aware of the cultural divergences within the country, he also foresaw the difficult future coexistence of the different national sensibilities that existed in Spain. In effect, he had commissioned Sorolla in 1911 to paint the large series of wall paintings *Las regiones de España* or *Vision of Spain* for the reading room of the Hispanic Society because he so admired the cultural richness of Spain and delighted in recognizing the differences of character that had arisen between its provinces and regions in habits and customs that had survived for hundreds of years. It was for this same reason that what he feared most from the war were the problems that could emerge between regions. "Catalonia and Castile will never make good bedfellows, I fear," he suggested to Pijoan. "The whole thing is lamentable in the last degree, but, as you well know, unavoidable."[6]

3. Archer Huntington to Josep Pijoan, Sept. 17, 1936, box 51, AHHP, SCRC.
4. Huntington to Pijoan, Sept. 17, 1936.
5. Josep Pijoan to Archer Huntington, Nov. 8, 1936, box 51, AHHP, SCRC.
6. Archer Huntington to Josep Pijoan, Nov. 11, 1936, box 51, AHHP, SCRC.

Institutional relationships with a Spain at war had been broken off, and of all the projects previously fostered by the Hispanic Society there remained only the work of cataloging and studying its collections, which the staff continued silently behind its doors. To explain the new situation to Pijoan, Huntington used a highly visual metaphor. "I am no longer *en activo* [on active service], and I am cleaning house rather than adding new stones to the walls."[7] He thus forcefully indicated his lack of enthusiasm in response to recent events. He was not even remotely engaged by the prospect of any new projects, and the fact that Spain was still at war had made him reconsider earlier decisions. It was neither prudent nor recommendable to initiate studies or exhibitions on Spanish culture, he believed, because Spain was a fragmented country, and its culture was being utilized in a partisan manner by both sides. Hence, in another letter from July 1938 he reiterated that he had no enthusiasm at all for fresh projects and concluded with a bitter reflection on the destruction unleashed by the war: "Spain has succeeded in demolishing more in a few months than can ever be restored."[8]

What, however, could be done with an institution like the Hispanic Society, the product of a romantic dream born in 1904 in a climate very different from that of 1938? Huntington was not a naive dreamer, and he preferred to set his dreams aside and take practical measures. The Hispanic Society ceased its public activities, and its collections were stored away in view of the uncertainty of recent circumstances. With its doors closed, Huntington decided to await the arrival of better times, although inwardly he knew that he might not live to see them.

At the age of nearly seventy, Huntington could see that current attitudes to art were entirely different and that the new generations gave no attention to the type of art and works of art that had interested him in former decades. This was not merely a circumstantial question as a consequence of the war in Spain but reflected a change in collective sensibilities, in the concern for art as something transcendental beyond its purely

7. Archer Huntington to Josep Pijoan, July 11, 1938, box 51, AHHP, SCRC.
8. Archer Huntington to Josep Pijoan, July 25, 1938, box 51, AHHP, SCRC.

aesthetic or monetary value. Mass culture had begun to make its appearance and would explode fully on center stage following World War II. The programs of the cultural New Deal implemented by the Roosevelt administration and the promotion of an American popular culture more distant from a European-based high culture had formed mass culture's breeding ground. These circumstances had resulted in a change in the cultural programming of American art institutions and in the tastes of the population, who asked for a culture they could understand.

Huntington had shared in this new approach in some ways and even contributed to it in the early 1930s with cultural projects that were more popular in tone. In 1938, however, conscious of his age and with a degree of stoicism, he declared that this situation no longer distressed him because he believed that in the end it was only a question of time before the world recovered its sanity and good sense, although he also thought that neither he nor Pijoan might live to see it. As he wrote to Pijoan in July 1938, "As I draw near seventy years of age, I find the attitude toward art in this country entirely changed—Spain in an insane condition—and all of the lines of work concerning which I have been interested entirely forgotten by the recent generation. This does not in the least distress me because these things are temporary, and it is only a question of time when they will all swing back to an attitude of sanity—but that will not be while you and I are alive."[9]

From his letters and despite the confusion of these years, one can say that Huntington had arrived at a clear understanding of the moment he was living through and the historical circumstances that were distancing him from what he had previously regarded as his destiny. The war in Spain laid waste to the work he had undertaken for years as part of the extensive cultural community of international Hispanism. Huntington accepted this, and his initial incomprehension was converted into resignation. As Miguel de Unamuno had written years earlier, "Culture, high culture, disinterested, artistic, literary, scientific, philosophical, is a very delicate plant, and demands heroic sacrifices from those who cultivate

9. Huntington to Pijoan, July 25, 1938.

it."[10] Huntington undoubtedly knew that this was not the right moment to insist on its cultivation. Anna Huntington was also conscious of her husband's plans and wrote in her diary in 1939, "Archer might be anticipating retirement."[11]

The political climate in Europe appeared to foreshadow more conflicts on the continent, and visual imagery had become a powerful weapon in the hands of those in power. The end of Spain's devastating civil war in April 1939 was followed only a few months later by the outbreak of World War II and in 1940 by the German occupation of Paris, the cultural center of the Western world. As the world Huntington knew fell apart, he looked on with ill humor and with feelings that, from his written reflections, gradually developed into nostalgia.

A long letter Huntington wrote to the duke of Alba in English in January 1941 was an exercise in introspection in which he, effectively in a kind of monologue, explained what he had found in Spain and what Spain had meant for him. He was then seventy-one years old. A year earlier he had resigned from all the posts he still held in the various institutions of which he was also a patron, such as the American Academy of Arts and Letters and the National Institute of Arts and Letters. He had already sold all the stock he had retained in the family businesses, such as the Newport News Shipbuilding and Drydock Company, when he had liquidated all his other stocks in 1929 and had gradually transferred much of his properties in land and real estate to public and charitable bodies to be managed in the public interest. Freed of many of his responsibilities, he was able to reflect upon the past in view of the uncertainty of the future.

This letter merits close examination because it acquires its full meaning if one traces the combination of thoughts and observations that Huntington connects within it. He engaged in something of a regression in time, for his ideas in this letter were the same as those he had expressed

10. Miguel de Unamuno, *Andanzas y visiones españolas* (1922; reprint, Madrid: Alianza Editorial, 1988), 127.
11. Quoted in Mitchell and Goodrich, *The Remarkable Huntingtons*, 67.

in his letters to his mother or in his diaries from his first visits to Spain more than forty years earlier. In a kind of living testament, Huntington poured out his memories both of the emotions he felt when he first arrived in Spain and of the feelings he came to hold after years dedicated to understanding the country, in each case with an optimism that comes as a surprise after the experience of the Civil War—an optimism that always made him stand apart from the pessimism that had taken root in Spain after 1898.

Three ideas underlie this letter. First, for Huntington, Spain was a cause of pain, as it had been for Unamuno. When he wrote that he felt great sorrow for Spain but had always loved Spain and its people, he meant that he loved them despite their imperfections. In effect, he repeated this sentiment when he asked, as a rhetorical question, whether one has to be perfect to be loved. "At a time like this one does not know what to write," he pondered. "The plan to level humanity from a high seat is, I fear, a poor plan, and must end badly. The face of the carved world is not made to level humanity upon. But I grieve greatly about Spain. I have always loved Spain and her people. Need one be perfect to be loved?"[12]

Second, he took pride in having come to know the Spanish soul hidden beneath the surface, at having been able to lift the veil and see inside and discover a heart that, even in 1941 and despite the long journey they had experienced together, continued beating intensely. He went on:

> I sought out what was hidden within those dark eyes, the sons of mingled races. I found a heart. And now, after an adventure of many years, I still hear the beating of that splendid heart, and I still love Spain and her people. They welcomed me with dignity, a dignity I learnt to respect and cherish. We came to trust each other, and through the long years that trust has not faltered. I speak out of the old and real Spain, into which I came quietly before the motor had devastated its traditions, though it never did more than affect the surface of things. I

12. Archer Huntington to Duque de Alba, Jan. 14, 1941, box 7, AHHP, SCRC. The quotations that follow in the chapter text are from this letter.

came to know their bullfighters, their painters, their government leaders, their rulers.

It was always the same men and women of an older grace, of a more simple tradition, of a more fiery conception of life. I came to know their bravery, their considerations, their hospitality, and the faithfulness of their friendship. I have been greatly honored by their truth and love and it has never failed. Having nothing to ask from them, they gave me all.

Third, there was a vocal lament for the imminent future and the probable arrival of a moment when tourists would come to Spain in an organized manner. Huntington was saddened by this prospect, convinced as he was that these new tourists would not attempt to get to know the authentic Spain but only tour its monuments, criticizing anything they could not understand. When he had arrived in Spain, he had done exactly the opposite: in addition to learning Spanish, he had made an effort to meet representatives of every one of the different typologies of people and characters who inhabited the country's geography. In contrast, he complained,

> the travelers of today should not waste their time trying to penetrate these silent, wistful hearts. Let them go on with their march from cathedral to bullring, continue their foolish criticism of what they cannot see, but I do not venture to believe that they have raised the secret curtain which hides the inner soul-room of a noble race.
>
> I went to Spain when I was twenty-two, filled with enthusiasm, tradition and the matter of books. I tried to speak in the language of *Don Quijote*, of Lope, of Calderón. To my astonishment I found that a new Spanish was spoken, but a new Spanish filled with the echoes and richness of the old. At once I began laboriously to acquire some of this, and, as far as most do perhaps, I acquired it. Among the people the old still lasted. The dialects were more serious. Catalan was about to have a rebirth, in a last-moment effort to preserve through pride one more of the barriers to comprehension between peoples against the subconscious realization of the need of a universal tongue. If I found religion still frozen over by the ice of formalism, pure waters lay beneath. As a heretic I have been pitied, but not shunned.

He concluded with a statement on the different Spains that coexisted with passion in the one, same Spain: "There are many Spains, from Biscay to Málaga, from Valencia to Castile, each has a variant of the same race, each bears the high flag of independence dyed into a heart full of emotions. May all be well."

This letter stands out among all the others from Huntington quoted in this book and gives an impression that the recipient was a matter of secondary importance for him, so that the letter became rather more of a soliloquy, a series of reflections addressed to himself. The frankness he had come to share with the duke of Alba in their earlier letters had created a degree of confidence sufficient to allow Huntington to open his heart. Because of the feeling of nostalgia he poured into this letter and how well the letter reflects the romanticism that still survived in his fascination with Spain and Spanish studies in the 1940s, this document deserves a special place among the tribulations of the man who was known as Mr. Huntington.

Culture in Arms

In only a very few years, the world had changed very rapidly, and Huntington had to reconsider how to adapt the aims and activities of the central project of his life to the new circumstances. From its first foundation, the Hispanic Society had presented an image of the Spain that Huntington had known personally and that he wished to perpetuate in the United States. This explains why it did not admit into its exhibitions any of the artistic creations that had been produced since the beginning of the century by the great Spanish artists who were at the forefront of avant-garde movements in Europe. This was a valid choice, and Huntington always justified it by saying that contemporary art should be the concern of art galleries, not of an institution like the Hispanic Society, which, although it had promoted the contemporary artists of the time in its early years, gave space in its rooms only to works that shared a particular vision of romantic Spain. The Hispanic Society was a great institution, but from its origins it had been restricted to reflecting the tastes and ideas of its founder, who

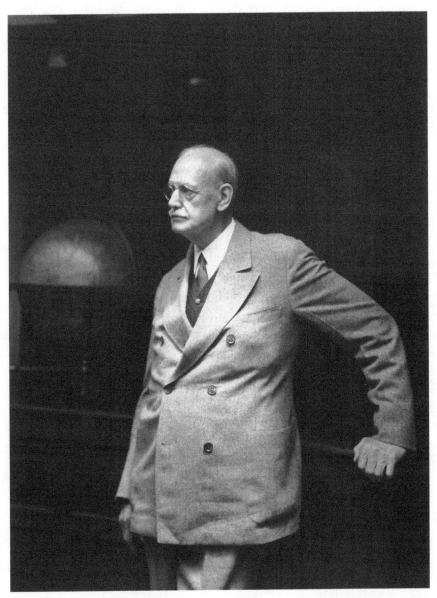

15. Archer M. Huntington at the Hispanic Society of America, New York, c. 1940. *Source*: Box 95, "Photographs Family Huntington, Archer," Anna Hyatt Huntington Papers, Special Collections Research Center, Syracuse University Libraries. By permission of Syracuse University Libraries.

was not prepared to renounce his original objectives. Huntington did not want to board the train of the avant-garde and so distanced himself from a contemporary Spain that in the 1930s was evolving in new and very diverse directions.

This very personal perspective had acted in his favor during the first decades of the century, when he had left a distinctive imprint in the United States. The Spain of traditional customs, romantic Spain, the Spain of the sixteenth-century Golden Age had all become a focus of interest among the wealthy classes of America, but by the late 1920s these images had also crossed over the border that separated elitist from popular culture. Both the *España negra* of Zuloaga and the white, sun-soaked, optimistic Spain of Sorolla had conquered America in the early 1900s and 1910s, and it had been Huntington who had introduced them into the country. Later, however, this very personal approach became more damaging to him, particularly from the 1930s on, when art and artists often became agents for political messages. Artistic images became part of a code of symbols and indicators that, caught in a spiral of partisan emotion, accelerated the process of politicization of art and culture in general. This tendency led to the proliferation of a language of artistic confrontation through which the modernity of certain artists was acclaimed in some countries but condemned in others, especially those where dictatorial regimes had won power. This condemnation reached its peak in the doctrine of "degenerate art" proclaimed by the Nazi regime, which spread to other European countries after 1937.[13]

In the case of Spanish art, the arrival of the Second Republic had brought with it the politicization of the intellectual community and of art in general, a phenomenon that only grew in intensity with the outbreak of the Civil War because, as Juan Pablo Fusi Aizpurúa has observed, "the

13. *Degenerate Art* was the title of an exhibition organized by the Nazi regime in Munich in 1937 with the aim of ridiculing the works by modern artists that had been acquired by German public museums under the Weimar Republic prior to 1933. In opposition to the work of expressionists, Cubists, Dadaists, and surrealists, the regime presented works by its own favored artists in a classical style with pure, heroic forms that, in the Nazi view, exalted values of race, land, and blood.

war made culture part of the psychological and propaganda war fought by both sides."[14] The Spanish Republic's pavilion at the International Exposition in Paris in 1937, planned by the government of the Popular Front when Spain was already engulfed in conflict, exhibited the work of the avant-garde Spanish artists who by then were hugely successful in the international art market, such as Julio González with his sculpture *Montserrat*, Joan Miró with his giant mural *El segador* (*The Reaper*, also known as *Catalan Peasant in Revolt*), and of course Picasso with *Guernica*, which became an international symbol of the barbarism of war. The pavilion was a showcase in the heart of Europe, displaying a type of Spanish art very different from the images that had formerly been so successful in the United States. The question remained as to how well a Spanish art that was so far removed from the work of a Zuloaga or Sorolla would be received in New York.

The Museum of Modern Art, or MoMA, in New York, founded in 1929, had been the first important American institution to exhibit the work of Picasso, contributing decisively to his acclaim as the founder of Cubism. Alfred H. Barr, MoMA's first director, interpreted Picasso's Cubist radicalism as an expression of the highest value of modernity: freedom. It was a freedom that interestingly connected with the stylistic liberty attributed to a much earlier great artist hugely admired in the United States, Velázquez, which made both men points of reference in both aesthetic and ethical terms for young American painters.[15] Picasso personified the artist who chose to pursue individual experimentation, without regard for painterly rules, and was taken as a model by the artists of the New York School. He also appeared as a champion of resistance to fascist barbarism through art, regarding painting as a weapon of war against the enemy. With his declared intention of "making war on war," Picasso took on a symbolic status for the entire artistic world. Joan Miró, for his part, presented a form of painting that, inspired initially by the ideas of surrealism, had broken with all established norms but appeared to have a similar sense

14. Fusi Aizpurúa, *Un siglo de España*, 94.
15. María Dolores Jiménez Blanco, "Spanish Art and American Collections," in *When Spain Fascinated America*, ed. Suárez-Zuloaga, 61.

of social commitment. The active political stance taken by both men against Francoism gave their work a moral significance that won them the pro–Spanish Republican sympathies of most American artists and of a large part of American society.

In this adverse environment, Archer Huntington and his Hispanic Society met with a degree of ostracism. Their commitment to an art based on a traditional Spanish aesthetic, associated with the romantic image of Spain, distanced them from many aspects of the contemporary country, from the tragic Spain that was fighting a war regarding which everyone needed to make their position clear. Aesthetically speaking, Huntington had established his own position thirty years earlier, but now, much to his regret, this choice had political connotations. The *costumbrista* art he so enjoyed, with its images of traditional life and customs, was a gentle, affable style of art with little sense of social commitment in comparison with the combative art that now filled the cultural arenas of the Western world. Moreover, by distancing itself from current events in Spain, the Hispanic Society had ceased to be a benchmark for lovers of Spanish art and other Americans who were attracted by the new cultural trends associated with Cubism, surrealism, and other *-isms* but did not find within the rooms of the Hispanic any of the things that interested them in the new cultural life of Spain. In addition, the Civil War had destroyed the cultural connections the society had established over the preceding three decades, while Franco's insurgent forces had already shown signs during the war of a growing anti-Americanism, brandishing the banners of traditionalism, opposition to all forms of liberalism, and even the version of anticapitalism preached by the Spanish fascist movement, the Falange.[16] Faced with this situation, the Hispanic Society had to reconsider how to focus its activities. As an institution, it had functioned for more than thirty years as a living center for Hispanic studies, not just as a museum of historic art and culture; it now needed to decide how to react in a new context.

16. Lorenzo Delgado Gómez-Escalonilla, "Las relaciones culturales entre España y Estados Unidos: De la [Segundo] Guerra Mundial a los pactos de 1953," *Cuadernos de historia contemporánea*, no. 25 (2003): 38.

An intense moral debate must have gone on in Huntington's mind as he confronted an uncomfortable situation in which his actions in the Hispanic Society could take on a symbolic import that went beyond his control. The museum in Upper Manhattan in which he had sought to condense the soul of Spain could have been broken in two to reflect the realities of a divided Spain in which each half fought for the destruction of its adversary, an outcome he was not prepared to contemplate. He wished to keep the institution safely above such conflicts, but this mission was difficult to sustain when culture and art had become additional instruments at the service of social and political confrontation.

Huntington's public silence went together with his increasing isolation from the life of New York in a slow peregrination that culminated around the time of the end of the Spanish Civil War in 1939, when he moved from Rocas in New York State to establish his main residence definitively in Connecticut, around sixty miles from the city, not far from the area where his father, Collis P. Huntington, had spent his boyhood. Anna and Archer decided to buy land in a tranquil rural area between the small towns of Bethel and Redding, where they commissioned the building of a large but relatively austere farm, to be called Stanerigg. The decision to move farther away from New York was ideal in enabling Huntington to continue his work with fewer interruptions, as Anna wrote: "I hope Archer will get more uninterrupted work on the farm, as it's too far away for frequent trips to town, or many visitors to come."[17]

Moving to Connecticut was, as Anna also recorded in her diary, a means of finding rural tranquility and of avoiding "money-seekers." Huntington was a generous man and known for his large fortune, so it was a habitual occurrence for him to be visited by a wide range of people seeking financial assistance for different projects or just to survive at a time when the United States had become the shared refuge for many exiled European intellectuals. Anna recalled with a degree of discomfort the

17. Quoted in Mitchell and Goodrich, *The Remarkable Huntingtons*, 84. The name "Stanerigg" is Scottish dialect for "Stone Ridge" and evokes Anna Hyatt Huntington's much-loved Scottish deerhounds, which she bred in kennels at the farm.

continual visits Archer received with requests for financial help, which he found difficult to refuse. "The number of indigent old friends unable to get by in Florida on a meager income," she wrote, "and middle-aged scholars who couldn't find a job, who visited him with their hands out and departed with a check or a promise of support, was legion."[18]

The new house in Connecticut was simple, plain, and even had something of a prisonlike aspect, with no concessions to any architectural style. Huntington himself decided on the design, the materials to be used, and the distribution of buildings around the farm and did not allow the architect he employed to pursue any ideas of his own. It had a luminously well-lit studio where Anna could work on her imposing sculptures and an office with library for Archer, where he often shut himself away to write poetry. They spent most of the years of World War II there, adapting to the rationing of a range of goods and gasoline, which restricted both their own visits to New York and the arrival of visitors at Stanerigg. These were years in which Huntington's health gradually became weaker and in which his letters and his poetry were his principal entertainment. Stanerigg Farm became his "Monastery of Yuste."[19] Initially, he and Anna continued to divide their time between summers in Connecticut and winters at Brookgreen Gardens, but by the late 1940s they spent more and more of each year at Stanerigg. It was there that Huntington decided to spend his last years, ever more distant from a civilization that seemed to him to have gone mad and in which culture, as he understood it, had become an object of consumption or, still worse, a weapon of political propaganda.

During these years, the once-intense dialogue that he had maintained with the community of Hispanists through his own travels and his work at the Hispanic Society became a one-sided conversation in which his

18. Quoted in Mitchell and Goodrich, *The Remarkable Huntingtons*, 95.

19. Yuste is a small remote monastery in the Sierra de Gredos mountains west of Madrid to which Emperor Charles V (or Carlos I of Spain) retired after he abdicated all his titles in 1556 and where he spent the last two years of his life. José García-Mazas, who visited Stanerigg Farm many times to talk with Huntington and then write his book *El poeta y la escultora*, originated the metaphorical comparison between Yuste and the last residence of Archer Huntington.

poetry was the sole witness to his memories and yearnings. The kind of life chosen by Huntington at this time unavoidably recalls the beautiful poem by Unamuno, "I exile myself into memory, / I am going to live on remembrance."[20]

However, his writing and contemplations were not limited to Spain and Hispanic studies. Huntington visualized with considerable lucidity a wholesale change in the accepted models of culture and understood that it was difficult to imagine, at least in the short term, any return to the moments of splendor that culture, or rather high culture, had enjoyed in the preceding decades. This observation led him in his letters to think again of the future that awaited the different tendencies in art, culture, literature, and the work of publishing and museum curation in a world where by the 1940s even the museums and cultural institutions of the United States were finding it difficult to survive because of shortages in funding. Could one imagine a society without museums or cultural institutions? Once again Josep Pijoan was the recipient of Huntington's most pessimistic ruminations. In a letter in January 1943, Huntington reexamined the most pressing problems affecting museums. "If this war continues for an abnormally long period, it is obvious that no museum or institution of the kind in the United States will have any funds to maintain itself along former lines. As you know, the great institutions are already in difficulty, and minor ones are suffering greatly."[21]

In the circumstances of the war, when a shortage of funds was endangering the actual survival of some of the most important institutions in the country, philanthropic appeals to Americans' patriotism and sense of public duty that had been made continually since the 1890s acquired a very different meaning. The campaigns undertaken from 1942 by the US Office of War Information aroused the patriotism of many Americans through advertising, songs, films, and other media, which to some extent made the changes experienced by Americans in their everyday lives less

20. "Me destierro a la memoria, / voy a vivir del recuerdo." Miguel de Unamuno, "Me destierro a la memoria," in *Cancionero, diario poético* (Buenos Aires: Losada, 1953), online version at https://poemario.com/pdf/destierro-memoria.pdf.

21. Archer Huntington to Josep Pijoan, Jan. 9, 1943, box 51, AHHP, SCRC.

onerous. Ration cards for gasoline, food, canned goods, and even shoes were part of daily routine; larger items such as refrigerators and automobiles were no longer produced for ordinary consumers; and taxes rose to the extent that some individuals paid up to 90 percent of their income.[22] There was no margin for cultural philanthropy in a society at war. An individual's personal commitment needed to be directed toward other priorities, and Huntington, as a good citizen, was aware of this. In acknowledging a drastic reduction in his own finances because of the war, he also acknowledged the difficulties this implied for continuing with the plans he had intended for his cultural institutions. "The reduction in income will be so drastic," he informed Pijoan in early 1943, "that it will no longer be possible for me to carry out any of the plans for which for many years I have been preparing, and I do not expect to see the time when anything like the old situation for publishing, and some of the publishing institutions, will be returned."[23]

Influenced by the climate of patriotism that was coursing through the United States, Huntington argued that Americans had two enemies to overcome in the 1940s, the Axis powers and the Great Depression. He emphatically asserted that there was no alternative but to win the war because, while achieving peace might be something desirable, it would not be sufficient. He rejected any suggestion that the Germans could by force do away with the idea of freedom in the world and accepted that it was the responsibility of Americans to demonstrate that this was indeed an impossibility. If they did not, there would be no place for institutions like the Hispanic Society of America, which would have "to be closed or abandoned." Looking back at history, as Huntington did frequently to interpret events in his immediate present, he suggested that there had never been a situation like the current one and declared, resorting to warlike rhetoric, that ultimately despotism would be crushed by those who believed in justice.

22. U.S. History.org, "The American Home Front," US History: Pre-Columbian to the New Millennium, n.d., at https://www.ushistory.org/us/51b.asp, accessed June 18, 2022.

23. Huntington to Pijoan, Jan. 9, 1943.

There is but one question now before the American people, and that is the winning of the war. The consideration of "winning the peace," as it is called, is quite beyond my power of prediction, but certainly life in America must for a long period be greatly changed. The Germans have seen fit to believe that force can drive freedom from the world. It is now our business to see that this is not true. If it is true, then our institutions had better prepare at once to be closed or abandoned. Such a condition has never existed in the world before, even under the murderous acceleration of wickedness which we have seen at the hands of previous conquerors, but as they were all defeated in the end, we may anticipate the crushing of this outrageous despotism by those who believe in justice.[24]

Such feelings were shared by the American people at a time when public appeals to support the war effort reached every home via radio, films, and the press. World War II had taken on dimensions that had previously been inconceivable. Huntington himself had to turn over his house Rocas outside New York to be used as a temporary military facility. At Stanerigg Farm in Connecticut, Anna Hyatt Huntington set up a Red Cross group, where from ten to fifteen women worked every day. In Europe, the war, with its bombing and the movement of the battlefronts, was destroying in its wake the historical and artistic heritage of whole areas, and Huntington observed with resignation that he thought it would be a vain effort to restore monuments and create fresh institutions. He wrote Pijoan in early 1944: "If this monstrous war ever comes to an end, I shall look forward to the pleasure of seeing you again—but I think you can now see how hopeless it is to restore destroyed monuments or to found new institutions in a world which disregards them so recklessly."[25]

Huntington shared with Pijoan his fears, his disappointments, and his feelings of impotence during the years that extended from the beginning of the war in Spain to the end of World War II. The changes taking place in the world had powerful effects on art and culture. The development of a consumer society and the arrival of mass politics also opened the

24. Huntington to Pijoan, Jan. 9, 1943.
25. Archer Huntington to Josep Pijoan, Jan. 7, 1944, box 51, AHHP, SCRC.

doors to a new society that, among many other things, had a new way of comprehending reality and, above all, had a new concept of culture.[26] Huntington perceived this change and meditated on the world that had been lost, the world that the wars had swept away but that, in his deepest convictions, he trusted would reemerge to shine again in the future.

Commitments to Hispanism after the Spanish Civil War

The panorama left behind by the Civil War in Spain was desolate: three hundred thousand dead in the fighting, a devastated country, and a fragmented society, which the installation of a monolithic authoritarian regime under Franco would do nothing to overcome. Moreover, added to the feelings the war had already aroused in Huntington, there was soon an increasing concern over the deteriorating state of bilateral relationships between Spain and his own country. Formal diplomatic relations had already been broken off during the Civil War, and with the first steps of the new regime this split developed into hostility. The Francoist authorities exhibited a certain aversion to the United States because by ideological affinity they preferred to promote cultural relations with Nazi Germany and Fascist Italy. The new Spanish leaders saw in the United States a rival in influence over the Hispanic American countries and sought to establish a position as privileged interlocutor with all the Spanish-speaking republics. American representatives and diplomats, for their part, having initially given no great attention to their relations with Francoist Spain, soon became aware of the potential danger it could represent as a possible spearhead for Axis influence in Latin America. Hence, they focused their efforts on building closer cultural and economic relationships with the Latin American republics with the aim of deactivating any influence fascist ideology might be able to gain within them. With this scenario in the background, Huntington observed the new circumstances shaping cultural developments in Spain.

26. Eric Hobsbawm, *Fractured Times: Culture and Society in the Twentieth Century* (London: Little, Brown, 2013), 9–20.

One of the first measures taken by the victors in the Civil War was to refuse to acknowledge the role played by the International Committee for the Safeguarding of Spanish Art Treasures in protecting and ensuring the survival of Spain's artistic heritage. This committee had been set up in January 1939 under the auspices of the secretary-general of the League of Nations, Joseph Avenol, following a proposal by José María Sert and under the presidency of David David-Weill, a banker, collector, art patron, and president of the National Museums of France. It was made up of representatives of major European and American museums, including the Louvre in Paris, the Tate and Wallace Collection in London, and the Metropolitan in New York. Another member was Joseph Duveen, by then Lord Duveen, the art dealer who for years had sold works of art to both Archer and his mother, Arabella.[27]

As the war neared its end and the defeat of the republic seemed certain, the Republican government of Juan Negrín had communicated its willingness to transfer into the safekeeping of the League of Nations the artistic treasures that had been evacuated from Madrid and other cities and then moved from Valencia to castles and disused mines in Catalonia. The International Committee was formed in response. An agreement was signed between the committee and the Negrín government in Figueres—by then, one of the republic's last redoubts—on February 3, and the transfer of the artworks began almost immediately by truck to the French border and then by train to the league buildings in Geneva. Duveen and other committee members met the costs of the journey to Switzerland. During the first part of this odyssey in Spanish territory, the convoys were bombed by Francoist aircraft despite the insistent telegrams that the duke of Alba, at Sert's request, sent asking for the bombing to be halted.[28]

27. Duveen was one of the British representatives on the committee as a trustee of both the Tate Gallery and the Wallace Collection. His activities as a dealer and, later, an art patron had won him enormous prestige in the art world, and in 1933 he had been given the title "Baron Duveen of Millbank" for his work with the Tate. He died in May 1939, however, only a short time after taking a seat on the International Committee.

28. Colorado Castellary, "Arte salvado," 14.

When the war was over, the League of Nations secretary-general proceeded to return the Spanish art collections to Franco's ambassador in Switzerland, the marquis of Aycinena, in a ceremony at the end of March 1939.[29] However, the new custodians of these rescued masterpieces did not acknowledge the credit due to either the Republican politicians and officials who had taken part in the evacuation—as was only expected—or the members of the International Committee, who were even sometimes described as collaborators of the "Reds." Of no effect were the continuous appeals made to the Francoist authorities by José María Sert for some recognition to be given for the immense services given by the International Committee. His insistence even won him some unpopularity among the Francoist hierarchy, who went so far as to refuse to renew his passport.[30]

Given these antecedents, Archer Huntington was greatly relieved to hear the news from his Spanish friends of the return of their great paintings to the Prado and other Spanish museums. Vega-Inclán was the first to notify him in a letter in July 1939. "Nothing has been lost from our museums," he wrote excitedly. "Of the Prado everything has been recovered, with relatively little damage. I am pleased that the enormous propaganda that has been deployed against Spain has not blinded [all of] you."[31] However, barely two weeks later Huntington also received a letter from Francisco Sánchez Cantón with worrying news of the condition in which some of the paintings evacuated from the Prado had returned. "As to the absurd and prejudicial exodus to which a government without direction submitted the paintings of the Prado, I have no desire to speak of it either," wrote the museum's deputy director. "I attempted to convince [them] with as many arguments as I could find; later, seeing the uselessness of

29. Clause 9 of the Figueres Agreement had set down the terms for the return of the artworks that formed part of the Spanish national heritage, stressing that they could be returned only to a government in Spain "so that they remain a common treasure of the Spanish nation."
30. Colorado Castellary, "Arte salvado," 14.
31. Marqués de la Vega-Inclán to Archer Huntington, July 15, 1939, box 56, AHHP, SCRC.

reasoning, I made difficulties and tried to ensure that this misguided journey was delayed; I achieved little. In January 1938 they threw me out of the museum."[32]

After the Prado had closed its doors to the public on August 30, 1936, and its official director, Ramón Pérez de Ayala, had left Spain, Sánchez Cantón, until then officially only deputy director, had taken over its administration as acting director. As he recounted to Huntington, on January 11, 1938, he had been dismissed from his post for opposing the evacuation of the Prado's collections and delaying the dispatch of artworks to Valencia, a position that ran contrary to the policy of the republic's Junta Central del Tesoro Artístico (Central Council of Artistic Treasure), headed by the artist Timoteo Pérez Rubio, with whom Sánchez Cantón had often clashed. Sánchez Cantón went on in his letter in July 1939:

> By immense fortune since the victory it has been possible to recover everything; but how much have so many paintings suffered with this criminal peregrination: Goya's *Los Fusilamientos* [Third of May] in tatters; *The Charge of the Mamelukes* missing a head and part of the sky; the *Philip IV on Horseback* by Velázquez with a scratch 30 centimeters long; *Las Lanzas* [The Surrender of Breda] with a chip in it . . . and nearly all of them yellowed, and shocking. They try to make people believe that the transfer was done to keep them safe, when they themselves were the first to be convinced that there was no danger at all in the Prado, since they filled it with more than 20,000 paintings, the entire collections from the Royal Armory and Palace Library, the display cases from the Museum of Natural Sciences, etc., etc. No regime has ever established itself on the basis of such lies.[33]

These explanations and details repeated the official account maintained by the Franco regime, under which Sánchez Cantón had resumed his post and which denied that the purpose of the evacuation had been

32. Francisco Sánchez Cantón to Archer Huntington, July 27, 1939, box 53, AHHP, SCRC.

33. Sánchez Cantón to Huntington, July 27, 1939, ellipses in original.

the protection of the artworks. Huntington's reply expressed his concern at Sánchez Cantón's description of the state of the paintings, together with his joy at their return to their proper place because he had harbored serious doubts as to whether Spain's artistic treasures could ever be fully recovered. "I am delighted to know that you are again at the Museum," he wrote back in English two weeks later, "and that things have not been more destroyed than was anticipated. At one time I felt that the pictures would never again see their proper place.... What you tell me with regard to *Los Fusilamientos de Goya hechos girones* [in tatters] is certainly a great shock. Who could have supposed a few years ago that such devastating influences could be turned loose in any country?"[34]

In view of the new regime's first actions, it was easy to foresee that the Spain of "national Catholicism" would dedicate itself to purging social and cultural life and eliminating any sign of diversity and independence. In such a bleak panorama, cultural life would be confined within strict limits set by intolerance, Catholicism, and Falangism, as Huntington himself could see when he received news later in 1939 of the order to abolish the Junta para Ampliación de Estudios e Investigaciones Científicas. This institution had taken the leading role in opening cultural relations between Spain and the United States, and the Hispanic Society had been in productive contact with many of its principal figures, such as Ramón Menéndez Pidal, men whom the new Spain now labeled antipatriotic for having "opened up the country to foreign influences that had been the seed of the fratricidal conflict."[35]

In such an unfavorable context, traditional Hispanism was destined to lose prominence as a current in cultural life in the United States by comparison with the growing focus on "Pan-Americanism," which responded more directly to the political concerns of the moment. Although this divergence was not new, the political impetus now given to Pan-Americanism certainly was, for the authorities in the United States had since 1938

34. Archer Huntington to Francisco Sánchez Cantón, Aug. 14, 1939, box 53, AHHP, SCRC.

35. Delgado Gómez-Escalonilla, "Las relaciones culturales entre España y Estados Unidos," 36.

created a series of bodies to coordinate inter-American collaboration and further the overall aim of bolstering US influence among the republics of Latin America, beginning with the Bureau of Educational and Cultural Affairs at the State Department.

Breaking with the traditional separation between public and private bodies, several private philanthropic foundations collaborated with government agencies in improving US commercial and cultural relations with other countries on the American continents. The Rockefeller, Carnegie, and Guggenheim Foundations as well as museums such as the MoMA and other public cultural institutions contributed to the creation of scholarships, scientific exchanges, libraries, art exhibits, and leadership-training programs directed at Latin America. This extensive Pan-Americanist network began to take shape in the years just prior to the US entry into World War II and secured the involvement of influential figures drawn from diverse fields, from politicians to artists, filmmakers, and intellectuals. The agency most responsible for pursuing this mission was the Office of the Coordinator of Inter-American Affairs, created by President Roosevelt in 1940 and assigned to Nelson Rockefeller, a businessman and philanthropist who, thanks to his business contacts, already had extensive knowledge of Latin America.

The first Conference on Inter-American Relations in the Field of Art organized by Rockefeller's office in 1940 was attended by 125 representatives of different cultural institutions from around the United States, with the objective of developing proposals for cultural exchanges with Latin American countries. It is interesting to note that among these representatives was Robert C. Smith, executive secretary of the Hispanic Division of the Library of Congress, an entity that had been created in 1927 with support from Archer Huntington.[36] Up to that point, the division had focused most of its attention on Spain and Portugal, but from 1939 it would undergo a significant reorientation toward the cultures of Latin America.

36. Fabiana Serviddio, "Los murales de Portinari en la Sala Hispánica de la Biblioteca del Congreso de Estados Unidos: Construcción plástica de una identidad panamericana," *Cuadernos del CILHA: Centro Interdisciplinario de Literatura Hispanoamericana* 12, no. 14 (2011): 124–52.

For his part, Huntington did not always remain on the sidelines in this new era. Independence had always been one of the principal characteristics of his model of philanthropy. Amid the surrounding turbulence, Huntington decided to make a fresh contribution to the field of Hispanic studies with the creation of a special setting to facilitate access to all of Hispanic culture in the heart of the Library of Congress: the Hispanic Reading Room, the chief legacy of his work on behalf of American Hispanism to be inaugurated after the Spanish Civil War.

The origins of his relationship with the Library of Congress date back to a decade earlier, when in 1927 and 1928 he had constituted the Huntington Endowment Fund to permit the establishment of the library's Hispanic Division and fund the creation of a new post of consultant on Spanish and Portuguese literature, initially occupied by Juan de Riaño, his friend and former Spanish ambassador to the United States. In the mid-1930s, with the Hispanic Society inactive, the world of American Hispanism largely silent, and the cultural life of Spain in pieces, Huntington demonstrated his commitment to Hispanic culture once again by providing a large financial donation to enable the architect Paul-Philippe Cret to design and build a reading room within the library that would re-create the style of Spanish colonial architecture of the sixteenth century, with airy, vaulted ceilings, Puebla tiles from Mexico, wooden paneling, and wrought-iron chandeliers. He also provided a secondary fund to cover ongoing running and maintenance costs.

Father David Rubio, the Hispanic Division's consultant at the time and a very well-known figure in Spanish circles in the United States, later recalled how Huntington's donation for the Hispanic Reading Room developed. "After five years of work and several journeys to Spain and Portugal we now had some one hundred thousand volumes in the Hispanic Section, whereas there were no more than fifteen thousand when I had begun," he wrote in 1957. "Dr. Putnam, the Librarian of Congress, very pleased with my labor, informed Mr. Huntington of the state and progress of his foundation and invited him to pay a visit.... After lunch, we walked around Deck A, where the Semitic Division was then located. On seeing it, Huntington asked, 'Where is the Hispanic Division?' I replied, 'We are waiting for some *mecenas* [patron of the arts] to help us found it.' Mr. Huntington said

goodbye to us, and some months later the director of the Library called me to his office and said, 'We have here a new gift from Mr. Huntington, to create a special room dedicated to Hispanic culture.'"[37]

The Hispanic Reading Room was officially opened on October 12, Columbus Day, in 1939, and the first full head of the Hispanic Division was Lewis U. Hanke, a Harvard scholar and distinguished Hispanist who had also taught at Columbia. He was also the founder and editor of *Handbook of Latin American Studies*, created at Harvard in 1935 and since 1939 published by the Hispanic Division of the Library of Congress. Huntington and Hanke also commissioned a mural with Christopher Columbus's coat of arms to decorate the south wall of the reading room.

However, the more Hispanic American emphasis that the State Department wished to impress upon the Hispanic Reading Room was evident from the beginning. In his speech at the inaugural ceremony, the new librarian of Congress, Archibald MacLeish, who had just taken up the post on the retirement after forty years of Huntington's old friend Herbert Putnam, insistently stressed the unity of the Americas, north and south, and urged North Americans to familiarize themselves with the Hispanic past of Central and South America as a means of creating brotherhood among all Americans. The new Hispanic Reading Room, in his opinion, represented a perfect meeting point for Americans from the United States and Latin Americans, who shared the same past of a struggle for liberty.[38]

Conscious of the importance of visual imagery as a means of propaganda, MacLeish and Nelson Rockefeller commissioned the Brazilian artist Candido Portinari to paint four large murals for the vestibule of the Hispanic Reading Room, which were completed between October 1941 and January 1942. The original idea for the subject matter of these murals was suggested by the executive secretary of the Hispanic Division, Robert C. Smith, a specialist in Brazilian art, who proposed that they should evoke themes related to the colonial history and culture of Latin America and, more specifically, Brazil. *Discovery of the Land, Entry into*

37. Rubio, "Mementos," 36.
38. John R. Hébert, *The Hispanic and Portuguese Collections: An Illustrated Guide* (Washington, DC: Library of Congress, 1996).

the Forest, Teaching of the Indians, and *Mining of Gold,* with a modernist, symbolic aesthetic, portray the three races—Black, white, and Indigenous—that lived alongside each other in the Americas in harmony. In this regard, the murals of the Hispanic Reading Room vestibule reflected the Pan-Americanist spirit then being promoted by the US administration to bring Latin American culture closer to ordinary American citizens and vice versa. In effect, the Portinari murals at the Library of Congress constituted the most ambitious art project of Rockefeller's Office of the Coordinator of Inter-American Affairs because they represented the rather artificial construction of a cultural past common to all the peoples of the Americas, a multicultural hemispheric identity based on values of respect for all races and tolerance of cultural diversity. In accordance with the guidelines for this official commission, Portinari distanced himself from the critiques of North American imperialism that had, for example, characterized the works created in the United States by Mexican muralists and had provoked widespread public rejection in the 1930s.[39]

There is no document in the available archives to indicate that Huntington had any influence on any decision regarding these murals. It seems, nevertheless, that he accepted the more Latin American focus that it had been decided to give to the Reading Room. A letter he sent to MacLeish in June 1940 indicates his conformity with this reorientation because at the same time he clearly expressed his support for the idea, proposed by the Library of Congress, that all material on fields related to the cultures of Latin America should be centralized equally in the Hispanic Reading Room. Moreover, he also offered to donate to the Reading Room various books and historic documents in the Hispanic Society collections related to the history or culture of Latin American countries after their independence from Spain. As Huntington said in this letter, Spain was really the specific area of study for the Hispanic Society of America, albeit that in its beginnings all aspects of Hispanic studies were to be taken in. "Spain, Spanish literature, art, and history, is our field," he wrote, "although in the early years of the Hispanic Society we had planned to include the whole

39. Serviddio, "Los murales de Portinari," 149.

[Hispanic] field." He went on, "However, as the Room in the Library of Congress completes, in some measure, part of the Hispanic plan, it is natural that that should be the center."[40]

One can see in Huntington's actions and comments regarding the Reading Room a dual purpose: on the one hand to demonstrate to the academic community in the United States his continuing commitment to Hispanism, despite all that had happened, while on the other to disassociate the Hispanic Society from political temptations by separating into two different areas the culture of Spain—in which there was less interest by 1939—and the culture of Hispanic America so that the society could remain distant from all politically committed movements and politicized discourse.

After the inauguration of the Hispanic Reading Room, Father David Rubio was charged with traveling to Spain to acquire more books and documents. As a report in the Madrid newspaper *Pueblo* noted in April 1941, "Within a short time Doctor Rubio will arrive in Madrid. He will be acquiring Spanish books for the Library of Congress of the United States. . . . Since 1932 Doctor Rubio, who was born in our province of León, has been Consultant on Hispanic Literature at the Library of Congress. He is in charge of the Huntington Foundation, which provides funds for the purchase of books related to Hispano-America, Spain and Portugal. Due to his efforts, the Library of Congress has become one of the most important in the world."[41]

This was not Rubio's first visit to Spain as consultant or curator for the Hispanic Division, for in 1933 he had met the republic's education minister at the time, Fernando de los Ríos, the future Spanish ambassador in Washington, and reached an agreement with him for an exchange of official publications between Spain and the Library of Congress, which was interrupted by the Civil War.[42]

40. Archer Huntington to Archibald MacLeish, June 10, 1940, box 43, AHHP, SCRC.

41. *Pueblo*, Apr. 8, 1941.

42. "El padre David Rubio, O.S.A., y la Fundación Hispánica de la Biblioteca del Congreso de Washington," *Revista nacional de educación*, no. 70 (1947): 79.

In his visit to Spain in 1941, Father Rubio made contact with some of Huntington's old friends and took part in one of the meetings of the Instituto Valencia de Don Juan's governing trust, where he met the duke of Alba. He also met Ramón Menéndez Pidal, who had returned to Madrid after spending the latter part of the war in France and who gave him, to pass on to Huntington, the accounts relating to the financial contribution Archer had made in 1929 toward the publication of Menéndez Pidal's great work on Spanish folklore, *El romancero*, which had been halted by the Civil War. In his accompanying letter, Menéndez Pidal wrote,

> I am taking advantage of the kindness of Father Rubio to send to the Hispanic Society the account for the tasks carried out as a result of the donation of 1929, which were making such good progress when the war interrupted them. Father Rubio will be able to tell you himself all the details that are not included in the attached papers. I am sending with this letter a copy of what has been printed [so far]. Although an incomplete work, it merits being preserved in the Library. Of interest above all is the edition of the poem of Fernán González.[43]

The head of the Hispanic Division, Lewis Hanke, also visited Spain a few years later, in 1946, representing the Library of Congress. Other American Hispanists severely criticized this visit because in the same year the United Nations had imposed diplomatic sanctions on the Franco regime.[44] Despite the cordial nature of his visit, the Francoist authorities later censured the publication in Spain of Hanke's major work on Bartolomé de las Casas, *The Spanish Struggle for Justice in the Conquest of America*, which was published in Spanish in Argentina shortly after it appeared in English in 1949. Ten years had to go by before a notably "sanitized" version could appear in Spain in 1959 and nearly forty before a complete edition was published in Madrid. As Lewis Hanke recalled

43. Ramón Menéndez Pidal to Archer Huntington, May 8, 1941, Correspondencia Archer Huntington 8/5/1941, FMP.
44. Josep Barnadas, "Lewis U. Hanke, 1905–1993: Algunos rasgos de su obra historiográfica," *Boletín del Instituto Riva-Agüero*, número especial 23 (1996): 383–95.

in 1988, however, he did not regret visiting Spain in such a conflictive period. "I consulted other colleagues," he explained, "and I decided to make the trip because this was one more aspect of [our] relations with the whole world, and we could not stand on the margins of the Spain of the 1940s."[45] This anecdote also serves to indicate that Huntington had helped set up the Hispanic Reading Room at the ideal time; a few years later a project of this kind would not have been possible on the same basis because of the antagonism in the United States toward the new Spanish regime.

With the Hispanic Reading Room in the hands of its administrators, Huntington was able to continue working with autonomy and freedom in encouraging the work of research and cataloging at the Hispanic Society. He never gave up his determination to go further in the study of his rich repertory of Iberian culture. He had made long journeys to gather together collections that were worthy of the best museums and libraries in the world, and he had a responsibility to study and manage them correctly, still more so when so much had been destroyed in the war in Spain. Despite the growing difficulties that affected the lives of ordinary Americans after the United States entered World War II, Huntington still wished to follow closely the work of his faithful team of conservators. These women were, in the words of Anna Huntington, "the joy of his declining years."[46]

Every week he was driven from his farm in Connecticut to New York City to be brought up to date on the advances made in research and the creation of publications. However, in addition to the increasing restrictions on transport because of the war, he had also begun to suffer from arthritis in his legs and hips, which little by little prevented him from maintaining the same schedule of visits to the Hispanic Society. However, the fact that he could no longer be present with the assiduity he would have wished and so had to communicate with his conservators by letter has left us written records that today constitute an important source for our knowledge of his projects during these years.

45. Statements by Hanke in "Lewis Hanke: La defensa a ultranza de Bartolomé de las Casas," *El País*, Oct. 17, 1988.
46. Quoted in Mitchell and Goodrich, *The Remarkable Huntingtons*, 110.

From his letters, Huntington enjoyed supervising the work at the society and the fact that most of it was done by women, as he indicated in a letter in March 1943 to Alice Wilson Frothingham, the specialist conservator of ceramics and glass. "You are perhaps not unaware of the pleasure I find in the work of the staff," he wrote. "And one chief reason is because they are women, and so prove to my keen satisfaction the assertion I have so often made, that museum work is a woman's work. If I have repeated it *ad nauseam* one more repetition will do no harm."[47]

Although Huntington was by then almost seventy-three years old, he did not tire of proposing new studies and research projects based on his collections, which tells us much about the great energy he could still display in his immediate circle. In his role as guide and supervisor, he not only proposed projects but also made suggestions on how the work should be organized and subsequently published. Publishing the results of research into its collections was virtually the only activity carried on by the Hispanic Society in these years, a focus that, equally, fitted well within Huntington's central ideas on museum management. He had long ago set out a theory regarding the administration of any museum collection in his diary in 1898, and that theory had scarcely changed: he was convinced that the first priority was to gather together a group of well-qualified professionals to devote themselves to the work of conservation so that these collections could be properly studied and then exhibited to an informed public. Hence, for Huntington, catalogs had to be the foundation of any museum's work. In the same letter to Alice Frothingham, he went on: "Of course you are entirely aware of my theory of museum direction, which consists primarily in the building of a staff competent for preserving the collections for those who wish to know, but always through the medium of publications and case exhibitions. Our catalogues, as far as they can be made, must be the essence of the latest conclusions."[48]

47. Archer Huntington to Alice Wilson Frothingham, Mar. 6, 1943, box 35, AHHP, SCRC.
48. Huntington to Wilson Frothingham, Mar. 6, 1943.

The closeness he maintained with his staff continued into the following years. This was no doubt one of his principal sources of pleasure—the quality of the work his conservators devotedly performed under his direction. Through his own personal dedication, Huntington succeeded in transmitting to them his love for Hispanic culture, and his team of conservators were the best living legacy he could have created to ensure the continuity of his great Hispanist project in the United States.

Despite difficult circumstances, Huntington did not forget his old friends during these years, and his friends did not forget him. During the 1940s, he continued to exchange letters with his closest associates in Spain, such as Vega-Inclán, Alba, Zuloaga, and Benlliure. Thanks more to a private initiative by his friends than to any official intervention in 1941, the Spanish government appointed him a member of the *patronato* of the Museo Sorolla and then in 1942 of the *patronato* of the Fundaciones Vega-Inclán.[49] In January 1944, the Spanish Ministerio de Educación (Ministry of Education) examined the possibility of awarding Archer Huntington the Franco regime's highest civil award, the Grand Cross of Alfonso X, a proposal that would, however, remain in limbo for two years. It was another old friend, Concha Espina, who intervened to ensure that the insignia was eventually awarded to him by a decree in July 1946, and the associated certificate was sent to him a year later, in August 1947.[50]

49. Decree on the Patronato de la Fundación Museo Sorolla, June 26, 1941, and Archer Huntington to Miguel Espinós, Spanish consul in New York, Sept. 4, 1941, R.2494, exp. 114, Archivo del Ministerio de Asuntos Exteriores y Cooperación (AMAEC), Madrid; Undersecretary of the Ministerio de Educación Nacional to Undersecretary of the Ministerio de Asuntos Exteriores, Oct. 8, 1942, R.2488, exp. 136, AMAEC. Huntington had already been made honorary president of the Fundaciones Vega-Inclán under the monarchy in 1931, but this new appointment followed a reorganization of these and similar foundations under the Franco regime.

50. Germán Baraibar, chargé d'affaires at the Spanish embassy in Washington, to Archer Huntington, Aug. 14, 1947, box 54, AHHP, SCRC. The Grand Cross of Alfonso X was the Franco regime equivalent of the Grand Cross of Alfonso XII, which Huntington had already been awarded in 1906.

The Spanish community in New York, however, "could not understand" the Franco regime's demonstrations of esteem toward Huntington.[51] Huntington himself appeared to harbor some doubts as to the reasons why he was being decorated with this new Grand Cross, as he expressed in a letter on August 14, 1946, to his friend Nicholas Murray Butler, the former president of Columbia University: "Just why it should be given me I do not quite understand, but no doubt it will do no harm."[52]

Huntington replied courteously to these appointments and acknowledgements, but he did not go looking for them. In fact, as he reminded his friend Pijoan in December 1944, "I have always hesitated to receive dedications as well as degrees from universities and medals. When I was younger, I received a number, as you know, but later I have always declined them."[53] He remained determined to maintain financial support for the fifteen museums and institutions that he had created over the course of his life and to which he had devoted so much of his wealth, but by 1947 he did not think of venturing into new projects. Nevertheless, even though he had intended to make his retirement definitive after the Spanish Civil War and World War II, tired as he was of public life and his responsibilities, history still had in store for him one last surprise in the Spain of the 1950s, which would be difficult to understand without keeping in mind the turbulent experiences of the 1930s and 1940s.

51. Carmen de la Guardia Herrero, "Las relaciones entre Estados Unidos y España en la época de Huntington," in *El tesoro arqueológico de la Hispanic Society of America*, ed. Bendala et al., 61.

52. Archer Huntington to Nicholas Murray Butler, Aug. 14, 1946, box 15, AHHP, SCRC.

53. Archer Huntington to Josep Pijoan, Dec. 15, 1944, box 51, AHHP, SCRC.

Part Four ◆ Huntington "in Memory" ◆ 1947-1955

16. Archer M. Huntington, c. 1953. *Source*: Box 95, "Photographs Family Huntington, Archer," Anna Hyatt Huntington Papers, Special Collections Research Center, Syracuse University Libraries. By permission of Syracuse University Libraries.

The weight of years had already weakened him to such an extent that even his poetic inspiration had abandoned him. He could not concentrate as before, and the ungrateful muses left him. He felt dull-witted, in pain, part-paralyzed, losing his sight, and the hallucinations he suffered in the evenings made him fear for his mental faculties. The poet lost the desire to live, since he no longer had the inducement of inspiration from his muses. That existence could not be called life. . . . The present writer went to visit him every week. The last time, five days before he died, I went into his bedroom. He was in bed. He was wearing blue pyjamas, mended in some places. The big, bony hands, so powerful in other times, lay immobile on the white sheet. A light shone in his cloudy eyes when he saw me. He smiled, squeezed my hand, and, without letting go, said, "I know that this time I'm dying."

—José García-Mazas, *El poeta y la escultora*

6
The Ageing Hispanist and Franco's Spain

Huntington "Revisited"

In late 1953, Archer Huntington and the Hispanic Society of America once again became news in the Spanish press. Years after the establishment of the Franco regime, and when the great art patron and Hispanist had visibly kept his distance from Spain since 1936, he and his work suddenly attracted the interest of government authorities, public bodies, and the media. Honorary awards for him and his wife, declarations of esteem from a variety of institutions, and a previously unseen desire to establish a spiritual bond with Huntington's prolific contributions to the world of Hispanic studies formed part of a new policy of rapprochement with "Spain's American friend," which was promoted by the Ministries of Foreign Affairs and Education and articulated through the regime's Instituto de Cultura Hispánica (Institute of Hispanic Culture).

This new interest in Huntington on the part of the Spanish authorities cannot be ignored in any comprehensive examination of his public profile in Spain, essentially for three reasons. First, these approaches would mark in an unusual way the final stages of a life that had been dedicated to furthering an approach to Hispanism very different from the ideas associated with the "Hispanist" policies of the Francoist authorities. Second, there can be no question that this attitude was heavily influenced by the state of bilateral relations between the United States and Spain in a period dominated by the early stages of the Cold War. Third, one can see behind this initiative the influence of the relatively liberal Catholic sectors within the Franco regime led by Education Minister Joaquín Ruiz Giménez, who were seeking to advance a moderate

cultural "opening," at least until they were demoted from their positions of power in 1956.

One has to ask what had changed in Spain for the figure of an octogenarian American Hispanist who had scarcely been heard of in the Spanish press for more than a decade, a friend of the late King Alfonso XIII and of several exiled intellectuals, abruptly to merit so much gratitude from Spain in the 1950s. Answering this question requires a parallel examination of Huntington's life in the United States and Francoist Spain in the same years.

Archer Huntington had been living on his farm in Connecticut for several years, far from the noise and bustle of the modern world. Tormented by arthritis and sometimes obliged to use a wheelchair, he continued to spend his time writing poetry—in 1953 he published his *Collected Verse*, incorporating most of his poetic output from the preceding years—and overseeing the work of the Hispanic Society and the Mariners' Museum. His network of friends in Spain had shrunk severely because of the deaths of many old associates and the exile of others. Benigno de la Vega-Inclán had died in 1942, Ignacio Zuloaga in 1945, Juan de Riaño in 1939, Francisco Rodríguez Marín in 1943, Mariano Benlliure in 1947. Concha Espina and the duke of Alba were virtually the only friends left in Spain with whom he still corresponded regularly, and the duke died in Switzerland on September 24, 1953. Hence, Huntington's contacts with Spain were reduced to a minimum. He still had some other Spanish friends living outside the country, such as Josep Pijoan, who had moved to Switzerland, from where he continued to write to Huntington in late 1954, and José María López Mezquita, who wrote from his exile in Cuba that he wished to return to Spain; he was granted his wish in 1952 and died there on December 6, 1954.

Huntington's social circle had effectively disappeared, and the only friend who at the beginning of 1954 still wished to obtain an explicit official acknowledgment of the Huntingtons in Spain was Concha Espina, who was eighty-four and had suffered from severely deteriorating eyesight for many years, to the point of being virtually blind. "The enormous debt that Spain has toward you both," she wrote in March of that year, "I wish to mitigate as much as possible with the support of my pen; but

I am going to be eighty-five years old the next April 15, and for fourteen years, since the war, I live and work within an inclement night; I can now do very little, even though I still have more than enough will and enthusiasm."[1]

The testimonies of some Spanish friends who visited the Huntingtons during these years are our best resource for forming an idea of the atmosphere in which Archer and Anna lived at this time. Francisco Sánchez Cantón was one of them, and in a eulogy he read to the San Fernando Academy of Fine Arts in Madrid in 1956 he gave this portrait of the Huntingtons and their home:

> On a low, sparsely wooded hill, with scarcely any sign of a garden, a house, largely of wood, painted white or whitewashed. Lacking in any external decoration. With no luxury inside: the furniture, which had never been sumptuous, was very well-used. The rooms were small in size; the dining room did not go beyond, in its dimensions nor its furnishings, those of any similar room of the Madrid middle class. The hallway, with hunting trophies, and the living room, looking out onto the fields, retained a certain style, but nothing imposing. In one small room, rather like a cell, there was a worktable, with a leather-backed chair, hemmed in by shelves loaded with books; its owner and myself scarcely fitted into it standing up. He showed me the proofs of the book that appeared a few months later with the history of the fifty years of the Hispanic Society of America. Locks and bolts, which he himself opened and closed, revealed that this cramped room was his favorite corner. . . . For servants, I saw no more than a gatekeeper, who was also elderly, and a housekeeper, who was not young either; and, naturally, our lunch, carefully prepared, revealed the existence of a cook, perhaps a woman, in the traditional flavors of the dishes. The only evidence of luxury was the pair of Scottish deerhounds, very large, almost violet in color, which looked on, with dignity and restraint, at our lunch and conversation. This ambience did seem to me bizarre, but I do not know if I might

1. Concha Espina to Archer Huntington, Mar. 3, 1954, box 31, AHHP, SCRC.

describe it as exemplary, even saintly, from a man who was a millionaire so many times over.[2]

In 1953, Huntington had little desire to initiate any new projects or embark on new ventures because he no longer had the energy that his powerful physical presence had always proclaimed. In addition, the visitors who did arrive at Stanerigg passed on to him the image of an American society in a state of paranoia after the sudden emergence of the threats embodied by the Cold War and the fear of possible Communist infiltration. The campaign launched by Senator Joseph McCarthy to seek out potential Communists in the public administration and the military and the climate of distrust this campaign generated led to a witch hunt that also extended into the different fields of culture. Organizations such as the House Committee on Un-American Activities pursued actors and intellectuals accused of being or having been members of the Communist Party. Even in areas such as sculpture and poetry—the two art forms cultivated by Anna and Archer Huntington—the idea began to spread of an identification between modernist aesthetics and Communist ideology.

With the aim of maximizing their impact, anti-Communists in the literary and artistic spheres had made approaches to a broad range of American conservatives who shared their rejection of modernist aesthetics, Archer Huntington among them. As Alan Filreis has indicated in his study of the "counter-revolutionary" movement that attempted to discredit the literary avant-garde in the United States in the 1950s, what united the anti-Communists in their fight against experimental poetry was not politics, but aesthetics.[3]

2. Sánchez Cantón, "Necrológica," 19, eulogy read at the session of the Real Academia de Bellas Artes de San Fernando, January 13, 1956.

3. From the information gathered by Filreis, it seems Huntington made a contribution of $2,000 to the antimodernist League for Sanity in Poetry to pay for publications, a minimal sum by comparison with the donations he customarily made, which makes this an anecdote of little significance in the sum of his philanthropic activities. Hence, this donation lacked the political implications that Filreis appears to attribute to it. See Alan Filreis, *Counter-Revolution of the Word: The Conservative Attack on Modern Poetry, 1945–1960* (Chapel Hill: Univ. of North Carolina Press, 2008), 222.

Worrying reports also reached Archer Huntington from De Witt McClellan Lockman, president of the National Academy of Design, to which the Huntingtons had donated their New York residence at 1083 Fifth Avenue in 1940, regarding the existence of Communist activity within the academy.[4] There was a generalized atmosphere of mistrust, which only intensified with the outbreak of war in Korea in 1950.

American society had looked with suspicion at the authoritarian and antidemocratic nature of the Franco regime in Spain since the end of the Civil War, but the fervently anti-Communist stance of the regime was now seen with new eyes by a fearful society that prioritized issues of national defense over other political considerations. This led to a change in attitudes toward the Spanish regime, which could also be seen in Huntington.

On the other side of the Atlantic, Spain itself was also experiencing a moment of change in its international status in relation to the democratic nations of the Western world. After the end of World War II and the Allied victory, Franco's Spain had been ostracized. Excluded from the United Nations and without the possibility of joining the Marshall Plan for European reconstruction, the country had been left politically in a corner. However, the rapid intensification of the Cold War in 1947 meant that the political debate was no longer centered on a dispute between democrats and antidemocrats but on the conflicts that could flow from the confrontation between Communists and anti-Communists, a change that was very beneficial for the Franco regime. Because of its geographical location, Spain was a country of strategic interest for the deployment of US military forces in Europe in the face of any threat from the Soviet Union, a factor that American defense planners had been highly conscious of since the late 1940s.[5]

Spain was presented with an opportunity to reposition itself on the international stage. Aware of the antipathy the regime still aroused in many

4. Mitchell and Goodrich, *The Remarkable Huntingtons*, 126.

5. William Chislett, "El antiamericanismo en España: El peso de la historia," working document 47/2005, Real Instituto Elcano de Estudios Internacionales y Estratégicos, Madrid, Nov. 15, 2005, 3.

Western foreign ministries, Franco's governments of the 1950s decided to practice a parallel diplomacy that would serve their new aims by, in many cases, operating outside conventional official channels. With the Ministry of Foreign Affairs at its hub, an effort was initiated to project a new image of Spain abroad based on three main principles: first, to make the most of the country's anticommunism; second, to expand Spain's presence in the international organizations and movements set up to sustain the worldwide fellowship of Catholics, such as Pax Romana and Catholic Action; and, finally, to present to the world a cultural policy of apparent normality that would make life in Spain appear comparable with life in other European countries.

In developing this kind of cultural diplomacy, the regime was able to call upon an extensive group of politicians and officials in Catholic associations, who took charge of the Ministries of Foreign Affairs and Education. Alberto Martín-Artajo had been at the head of the former since 1945, and in 1951 Franco appointed as education minister Joaquín Ruiz-Giménez, former president of Pax Romana in Spain, a former ambassador to the Vatican, and a figure with more open-minded and liberal ideas than many other leading Francoists. These two men initiated a change in the image the regime presented abroad, replacing Falangist fascist symbols with the traditional symbols of Catholicism and associating them with an official "Pan-Hispanism" that could potentially be exported to the Spanish-speaking countries of America.[6]

Alongside Ministers Martín-Artajo and Ruiz-Giménez, Alfredo Sánchez Bella, head of the regime's Instituto de Cultura Hispánica since 1948, set in motion a series of cultural initiatives to spread the ideals of "Christian renovation" in Spanish America and soften the image of the regime in Western countries' eyes. Their mission, as expressed in publications such as the journal *Cuadernos hispanoamericanos* and the format and programming of conferences and art exhibits, was to build bridges,

6. Antonio Moreno Juste, "Los católicos españoles y la política europea en los años cuarenta y cincuenta," in *La internacional Católica: Pax Romana en la política europea*, ed. Glicerio Sánchez Recio (Alicante: Biblioteca Nueva, 2005), 169–206.

which in the medium term could be converted into political collaboration and so help overcome Spain's international isolation. To achieve this goal, Sánchez Bella needed to win the support of leading figures in the countries of Latin America, which were united to Spain by language but which in many cases also hosted significant communities of exiled Spanish intellectuals. In this context, the word *Hispanismo* took on a new identity to suggest a Christian-inspired, traditionalist, political, and cultural current presented to the Hispanic world as an alternative to liberal or Communist models. With these objectives in mind, the Instituto de Cultura Hispánica, in accordance with the guidelines laid down by Ruiz-Giménez from the Education Ministry, set out to assimilate into this Christian-traditionalist outlook certain sectors that had previously been more associated with liberal culture with the hope of achieving a renovated image for the Franco regime.

To those in charge of this program of cultural diplomacy, the visual arts appeared the ideal medium for projecting an image of modernity to the world. Consequently, art in Spain was given a dual set of objectives. National exhibitions within the country were the place to exhibit the works of artists with a traditional style, while international exhibitions became a suitable stage upon which to win artistic prestige and display cultural openness by giving international prominence to the more avant-garde works of young artists who broke away from traditional styles of painting and sculpture.[7]

7. The Bienales Hispanoamericanas de Arte, or Hispano-American Biennials, were the main instrument used by the Instituto de Cultura Hispánica to promote Spanish art that was modernist in style and quite different from the regime's official tastes. Their declared purpose was to strengthen and re-create cultural bonds between Spain and the Americas, Hispanic America in particular, and three were held: in Madrid in 1951–52, in Havana in 1954, and in Barcelona in 1955–56. The fact that the United States also took part demonstrates that the biennials' purpose was not solely to defend and promote Hispanidad and that they also reflected Spain's ongoing effort to draw closer culturally and politically to the United States by diverse means. See Valeriano Bozal, *Arte del siglo XX en España* (Madrid: Espasa Calpe, 1995), 32.

In 1950, after maintaining sanctions for four years, the United Nations authorized its members to resume permanent diplomatic relations with Spain, and Stanton Griffis was appointed US ambassador in Madrid. In 1952, Spain was admitted into the United Nations Educational, Scientific, and Cultural Organization, and in 1953 the efforts of Spanish diplomats culminated in two major successes, the signing of a concordat with the Vatican on August 27 and only a short time later the conclusion of the Pact of Madrid with the United States on September 23. The United States needed allies in the West to assist in its policy of containing communism, and the arrival of the Republican Dwight D. Eisenhower in the White House in January 1953 had accelerated talks to secure an agreement with Spain. The three separate agreements that made up the pact established a basis for mutual defense, provided Spain with US military and economic assistance, and in return gave a green light to the construction of four US air and naval bases on Spanish territory, initially for ten years but open to renewal. Spain was thus conclusively incorporated into the area of US influence, gaining international respectability without having to make internal political concessions.

This new bilateral relationship linked Spain and the United States together militarily, but this was not the end of the new contacts between the two countries. The accords facilitated the approval of a further series of agreements for educational and scientific cooperation, all of which helped generate a climate that encouraged the regime's timid approaches to Huntington at the end of 1953. For many Spaniards, the endearing image of the venerable Hispanist and his wife working away steadily to promote Spanish culture recalled the splendor of an earlier era. Added to this was the positive response that Huntington had given to the good news of a Spain that had now become an ally of his country after years in which they had turned their backs on each other.

The press was the main medium used to proclaim the need to rediscover and restore the image of this historic Hispanist. Within the framework of the reestablishment of diplomatic relations and the Madrid Pact, in December 1953 the American Friends of Spain Foundation was constituted in New York under the presidency of Stanton Griffis, who had recently relinquished his post as first postwar US ambassador in Madrid. Its

principal aim was to encourage closer and friendlier relations between the two countries through cultural collaboration. The Spanish press reported the creation of the new association but also gave space to articles that criticized the absence of Archer Huntington from its membership, lamenting that, given that he had been a precursor of the new closeness between Spain and the United States since the beginning of the century, it was sad to see he was not even included in the foundation's executive committee.[8]

In January 1954, the Madrid newspaper *ABC* carried an article with the title "Huntington ausente" (Huntington Absent), which urged: "This omission must be rectified. . . . A society of Friends of Spain in North America cannot be without Mr. Huntington, at least as an honorary member. His name should figure by right in any enterprise [created] to work toward cultural compenetration between Spain, the colonizer of the New World, and the United States, which is today the firmest buttress of western civilization."[9] Ten days later, another piece appeared in *ABC* by Concha Espina, at the time an honorary vice president of the Hispanic Society of America, with the laconic title "Deudas de honor y de amor" (Debts of Honor and of Love). She gave a flattering portrait of Archer and Anna, to whom, she asserted, Spain had owed a great debt for many years.[10]

There can be little doubt that these articles in the press played their part in influencing the actions undertaken immediately afterward by the Spanish Ministry of Foreign Affairs. In effect, it does not seem coincidental that ten days after the publication of the first article the ministry's director general of foreign policy, Juan de Bárcenas, asked the Spanish consul in New York, Román de la Presilla, to supply detailed reports on Archer Huntington. His message of January 19, 1954, said:

8. To remedy this situation, on October 26, 1954, the American Friends of Spain Foundation sent a letter inviting Anna Huntington to join its Council of Trustees. However, she refused the invitation three weeks later, pointing out that she had already refused to take part in another two committees and that she did not think it would be correct to act differently in this case. Anna Hyatt Huntington to Angier Biddle Duke, Nov. 17, 1954, box 8, AHHP, SCRC.

9. "Huntington Ausente," *ABC*, Jan. 9, 1954.

10. Concha Espina, "Deudas de honor y de amor," *ABC*, Jan. 19, 1954.

Subject: Attitude of Huntington

By order communicated from the Minister of Foreign Affairs, I request that you kindly inform me in as much detail as possible of the attitude toward Spain maintained by the noted Hispanophile Mr. Archer Huntington, both during the National Movement and in subsequent years, of international isolation for Spain.[11]

A few weeks later, he added in a longer letter, "Indirectly, we know the antecedents, that is, his continued distance from us since 1936. However, it has come to our knowledge that it appears he may have a desire to correct this attitude, and that, if we took some kind of step toward him, he would do the same much more so toward us."[12]

The ministry's interest in Huntington had prompted a response from the consul in New York at the beginning of February 1954, with an extensive report titled "Attitude of Mr. Archer Milton Huntington." This report made reference to José García-Mazas, a journalist and professor of Spanish in New York who comes into view at this point and who evidently was the source of much of the information passed on to Madrid by Román de la Presilla.

> Sr. García-Mazas, an employee of the company García & Díaz, agents for the Transátlantica Española shipping company in New York, who for some time has been publishing articles, both in the Spanish press, *ABC* and *La Vanguardia*, and in the newspapers of New York, devoted to the personality and work of Mr. Archer M. Huntington, indicates to me that Mr. Huntington has not been engaged in political activity of any kind.
>
> According to the same informant, Mr. Huntington knew H.M. Alfonso XIII personally, and it seems that, since the advent of the Republic in Spain, he has not had any connections nor relations with the

11. Director General of Foreign Policy Juan de Bárcenas to Spanish Consul in New York Román de la Presilla, Jan. 19, 1954, R. 3538, exp. 28, AMAEC.

12. Juan de Bárcenas to Román de la Presilla, Feb. 8, 1954, R. 3585, exp. 28, AMAEC.

successive governments, [and that] he has expressed regret that he does not have contact with any of the Ministers of the current government.

In some of the interviews given to Sr. García-Mazas, it appears the latter allowed himself to probe the feelings [of Huntington] as to whether he would welcome with pleasure being made the recipient of some kind of honorary distinction, or recompense, for his brilliant and tenacious work as a Hispanist, to which he replied by suggesting that he did not deserve anything, but letting it be seen [at the same time] that it would be a source of legitimate pride for him if the Government were so to remember him.[13]

It is hard to imagine what the ageing Huntington would have thought had he known that José García-Mazas, to whom he had opened the doors of his home, was passing on part of the information he gathered in their long conversations to representatives of the Spanish government.

Very little information exists on José García-Mazas (1912–2001). What we know of his life comes from his own statements and much of it from a long letter he wrote to the Huntingtons in October 1955 as well as from a recent publication on his career written and edited by his daughter.[14] He

13. Román de la Presilla to Juan de Bárcenas, Feb. 2, 1954, R. 3585, exp. 28, AMAEC.

14. José García-Mazas to Archer and Anna Huntington, Oct. 10, 1955, box 31, AHHP, SCRC; M. Isabel Torres-Ullauri, *El Quijote Gladiador / The Quijote Gladiator* (N.p.: Privately published, 2022). In this letter to the Huntingtons, García-Mazas wrote, "I became a schoolmaster, with the ambition of teaching classes by day and carrying on studying philosophy by night. But the Civil War came to Spain. . . . The Communists offered 1,000 pesetas for the head of García-Mazas on Radio Valencia. My crime? Having been in charge of a Catholic school. God helped me to get out of Spain. . . . The Reds took their anger out on my pupils; they shot two of them . . . , they put my father-in-law in prison and tortured him, and didn't kill him only because he was an old republican. I returned to Spain after the Civil War. I finally graduated in Philosophy in 1942. I obtained a professorship in Valencia and was preparing my doctorate. . . . But another misfortune got in my way. The Falangists gave me castor oil to drink, they took away my teaching post and locked me up for two weeks in the Civil Government in Valencia . . . until my family in Cuba, in contact with the Cuban Ambassador in Madrid, were able to get us out of Spain. This is how I was paid for having created a soup kitchen for poor students. I

was born in Cuba to parents from Galicia, but while he was still a child, they moved back to Spain, where he completed his education. He worked as a schoolteacher in Valencia, where he married. After the outbreak of the Civil War, he and his family fled to Cuba and then New York, where he began to work as a Spanish teacher in several universities.[15] He wrote five books, of which the most important is his book on the Huntingtons, *El poeta y la escultora: La España que Huntington conoció* (The Poet and the Sculptress: The Spain That Huntington Knew), published in Spain by the Revista de Occidente in 1963.[16]

García-Mazas entered the lives of the Huntingtons on October 26, 1953, when, as Anna Huntington recorded in her diary, he arrived at Stanerigg Farm to interview Archer for an article on Archer's work that he said he intended to publish in the Spanish press.[17] From that point, he won their confidence and friendship and became an interlocutor between them and the Spanish government. In fact, because of the interest shown by the Spanish Foreign Ministry in knowing more of Huntington's attitudes toward Spain, only a few weeks after the first exchange of messages with Madrid, Consul Román de la Presilla paid a visit to Stanerigg with

had dared to expose a big thief who was trafficking with the food of the poor children. . . . And the big thief had powerful friends. Poor Quijote-Mazas!"

15. García-Mazas taught at the following colleges: New York University (Spanish teacher 1946–49; associate professor 1958–64); Columbia University (Spanish teacher 1946–49; assistant professor 1954–48); City College of New York (assistant professor 1964–72; full professor 1972–81, and finally emeritus professor). He also took part in educational activities directed toward Spaniards and Hispanic Americans in the United States, such as Hispanics for Higher Education.

16. Other books by García-Mazas include *Spain, Enigma and Reality* (Buenos Aires: Sur Americana, 1954); *Primera antología sonora de autores españoles contemporáneos*, co-edited with Hipólito Escolar (New York: Chilton Books Educational Division, 1965), and *Vida y cultura hispánica*, vol. 4: *De la ilustración al 98* (New York: Eliseo Torres & Sons, 1976).

17. "A Cuban journalist named José García-Mazas came to see Archer to interview him for an article to appear in a chain of Spanish newspapers." Anna Huntington, diary entry, Oct. 26, 1953, reproduced in Mitchell and Goodrich, *The Remarkable Huntingtons*, 127.

García-Mazas, who introduced him to the Huntingtons. A report on this visit, dated February 23, 1954, was sent to Juan de Bárcenas in Spain, with these comments:

> They live in a spacious, old, colonial-style country house, isolated, in part due to the infirmity suffered by Mr. Huntington, severe arthritis, and [also] voluntarily, so that each of them can dedicate their time to their preferred activities and interests, the wife to sculpture and the husband to poetry and reading.
>
> ... I could summarize my impressions by noting that these are highly admirable people who from a sense of vocation have dedicated their lives to the study of our language and history. That they have made our country known in their country in such a generous manner and without any self-interest other than the logical concern that must be felt by the creator of a great work such as the Hispanic Society, and the Catholic church that he built and gifted to the city of New York, even though he is a Protestant, and that in my opinion they do not desire anything more than an official expression of gratitude, that is, a recognition of their work.
>
> Hence my impression is an excellent one, and I believe that whatever is done in their honor will be very well deserved, [whether] letters or honorary distinctions, and will give them the greatest satisfaction, and that in contrast, if this is not done, this will necessarily be a cause of disappointment. I sincerely believe that any initiative should begin in this manner, with awards to his wife, and a reaction will surely come after that.[18]

This document demonstrates that Huntington himself never initiated any approaches to the Spanish authorities during the 1950s and that the advances came instead from the opposite direction, different agencies of the Spanish government that had developed an all-new interest in

18. Román de la Presilla to Juan de Bárcenas, Feb. 23, 1954, R. 3585, exp. 28, AMAEC.

reestablishing contact with Archer Huntington and presenting him as the American friend that Spain needed. Anna Huntington, who had always taken a secondary role in Archer's Hispanist activities, now became the object of fulsome expressions of gratitude from Spanish officials in accordance with the recommendations made by Consul de la Presilla in his report. The positively intensive campaign of public recognition of both Huntingtons initiated by the Spanish authorities in 1954 should be considered in the light of this diplomatic correspondence because it significantly modifies the appearance of complicity with the regime that might initially be attributed to Huntington and his wife.

The city of Barcelona took the next step, and on March 23, 1954, during a Week of North American Culture, a monument sculpted by Enrique Monjó was unveiled in the Jardines de Pedralbes (Gardens of Pedralbes), which showed the profiles of both Huntingtons on a bronze medallion mounted on a massive block of granite, with the inscription "Barcelona, a Ana y A. Milton Huntington, egregios hispanistas" (Barcelona, to Anna and A. Milton Huntington, eminent Hispanists). Newspapers in Spain published photographs and extensive reports of the ceremony, and the *Diario de Barcelona* recounted that the idea of honoring the Huntingtons in Barcelona had arisen from the artist Monjó and a Catalan industrialist, Manuel Claparols, who as well as Monjó's friend "was a fervent follower of the work of Archer Huntington, which prompted his decision to finance, anonymously, the bronze."[19] This same industrialist also commissioned a bust of Huntington from Monjó that was presented to the US embassy in Madrid. After glowing speeches in praise of Huntington from Mayor Antonio Simarro of Barcelona and Miguel Mateu, the president of the Real Academia de Bellas Artes de San Jorge (Royal Academy of Fine Arts of San Jorge), before an audience made up of all the local authorities

19. Immaculada Socias, "El memorial de Barcelona a Archer Milton Huntington, el fundador de la Hispanic Society of America, y a su esposa, la escultora Anna Hyatt Huntington," in *Conflictes bèl.lics, espoliacions, col.leccions*, ed. Immaculada Socias (Barcelona: Publicacions i Edicions de la Universitat de Barcelona, 2009), online version at https://diposit.ub.edu/dspace/bitstream/2445/8764/3/MemorialHuntington2003esp.pdf, quote on 8.

and leading figures from local political and cultural life, the current US ambassador to Spain, James C. Dunn, returned the compliments with a speech declaring that he saw in this tribute a symbol of the genuine understanding between Spain and the United States. Subsequently, the City of Barcelona also commissioned from the writer José María Millás Vallicrosa a short biography, eventually to be titled *Breve semblanza de Mr. Archer M. Huntington* (A Brief Sketch of Mr. Archer M. Huntington).

This event in Barcelona was followed by further tributes to the Huntingtons. On March 25, Archer was offered a doctorate honoris causa by the University of Salamanca,[20] and two months later the San Jorge Academy of Fine Arts in Barcelona named Anna Hyatt Huntington as its corresponding member in New York. She was honored again on July 18 with the award of the Grand Cross of the Order of Isabella the Catholic, one of Spain's highest civil awards, presented by the Foreign Ministry "in recognition of the great merit you have gained through your magnificent work in Hispanism at the side of your husband, the illustrious Mr. Archer Milton Huntington."[21] The Spanish press again reported these awards to the Huntingtons and provided extensive information on the importance of the Hispanic Society of America and its collections and all the activities that Huntington had undertaken in Spain so many years earlier.

However, the most important acts in tribute to the Huntingtons were still to come and would take place in the setting of an institution that was of key importance to the Franco regime in the mid-1950s, the Ciudad Universitaria in Madrid. Archer Huntington had not been able to see it built because his last visit to Spain had been in 1929 during the Ibero-American Exposition in Seville, and at that time work on the site had scarcely begun. Nevertheless, he had been aware of the project since its

20. The director general of universities of the Ministry of National Education informed the director general of cultural relations of the Foreign Ministry that authorization had been given to a request from the University of Salamanca to make this award on the same day, March 25, 1954 (R. 3684, exp. 13, AMAEC).

21. Pedro Benavent de Barberá, general secretary of the Real Academia Catalana de Bellas Artes de San Jorge, to Anna Hyatt Huntington, July 19, 1954, box 52, AHHP, SCRC.

first inception because it had been championed with such great enthusiasm by King Alfonso XIII in 1927, and Huntington had been one of its first patrons.

Huntington had had no contact of any kind since that time with the Ciudad Universitaria or with the Central University of Madrid, which had awarded him a doctorate honoris causa in 1920 at the suggestion of the Faculty of Philosophy and Letters. All that he knew in 1954 was that the campus had been devastated in the war and that reconstruction work was in progress. In these circumstances, Archer Huntington and Anna Hyatt Huntington decided to make a gift to Madrid's Ciudad Universitaria in the form of a sculpture.

The Torch of Friendship

On February 9, 1954, Director Alfredo Sánchez Bella of the Instituto de Cultura Hispánica received news of the gift the Huntingtons proposed to offer to the Ciudad Universitaria, a large group of figures sculpted by Anna titled *The Torch Bearers*, or *Los portadores de la antorcha*. This was a gesture of friendship in the form of a work of art that, in terms of its source, could not have served better the institute's publicity campaigns only a few months after the signing of the Madrid Pact. No one could fail to be aware of Archer Huntington's relationship with the late King Alfonso XIII, and the fact that he had lent his support from New York to the first work done on the Ciudad Universitaria twenty-five years earlier offered the Franco regime an image of continuity that was very beneficial among sectors of society that still kept alive the desire for a restoration of the monarchy.

The origin of the proposal to present *The Torch Bearers* to the university campus in Madrid is not clear. According to the version given by the intermediary between the Huntingtons and the Spanish authorities, José García-Mazas, the idea was his. He said as much publicly in the speech he gave at the inaugural ceremony for the statue on May 15, 1955, where he appeared as representative of and in the name of the Huntingtons. "When accident or destiny led me to the workshop of Anna Hyatt Huntington," he declared, "to write about her work as a sculptor, when I saw such work, I did not doubt to ask for an example of it for Spain. And my request could

not have been better received, by the sculptor and by her husband, the great Hispanist of our century, Archer Milton Huntington. . . . Hence, they authorized me to offer this gift to the Ciudad Universitaria, which we now see so worthily emplaced here."[22]

This account of the donation was repeated in a letter that Alfredo Sánchez Bella sent to the Spanish Ministry of Foreign Affairs on May 10, 1955, asking that García-Mazas be made a commander of the Order of Isabella the Catholic. In his letter, Sánchez Bella wrote that *The Torch Bearers* had previously been intended for Buenos Aires after the statue had first been offered to an institution in Spain that had not responded to the proposal. "Hearing of this," he went on,

> the collaborator of the Institute of Hispanic Culture in New York, José García-Mazas, did everything possible to modify the disposition of Mr. and Mrs. Huntington. He managed to do so, and not only in the specific case of this monument—the cost of casting of which has been seven million pesetas, and transportation to the value of 400,000 pesetas has also been paid for by them [the Huntingtons], and even a further 120,000 pesetas for packing costs (in total 7,520,000 pesetas or $3,046,557 today)—but also, independently of this, Sr. García-Mazas exerted an additional influence, by winning the friendship of Mr. and Mrs. Huntington, in [ensuring] that the latter entirely modified the rather distant attitude they had shown toward Spain in recent years, despite being sincere Hispanists.[23]

García-Mazas's influence had ostensibly been the determining factor in securing a gift of such significance for the Spanish authorities, although what really seems to have appeared extraordinary to Sánchez Bella was that García-Mazas had also succeeded in changing the Huntingtons' inclinations toward Spain, an achievement that, in the view of the head of the Institute of Hispanic Culture, was sufficiently important

22. Report of the event by José García-Mazas, May 16, 1955, box 31, AHHP, SCRC.
23. Alfredo Sánchez Bella to Minister of Foreign Affairs, Madrid, May 10, 1955, R. 6630, exp. 51, AMAEC.

to merit García-Mazas's being made a member of the Order of Isabella the Catholic.

However, this version of events requires qualification if we are to take into account the recollections of the rector of the Central University of Madrid at the time, Pedro Laín Entralgo, included in the memoir he published many years later, *Descargo de conciencia* (Disclaimer of Conscience, 1976). In the chapter headed "Rector ma non troppo," within a survey of the most important projects he planned during his time as rector, he recalled as one of them "the revival of the Huntington Chair, a visible consequence of which soon came in the donation of the statue *The Torch Bearers*, [seen] today in the campus of the Faculty of Medicine and on the postcards of modern Madrid."[24]

The former rector evidently believed that the presentation of *The Torch Bearers* had been a direct consequence of the reactivation of the proposal for a Cátedra Huntington, or Huntington Chair, at the Central University of Madrid. In 1929, Huntington had made a large, semianonymous donation for the endowment of a "chair of American literature" at the university, but it had never been established. Francisco Sánchez Cantón, the dean of the Faculty of Philosophy and Letters in 1954 and Huntington's old friend from the Prado Museum, also mentioned this chair in his eulogy of 1956, when in recounting all the areas in which Huntington had acted as a patron in Spain he referred to "a substantial donation to found a Chair of Hispanic Literature at the University of Madrid, which, after many years had gone by without this being instituted, I had the opportunity to inaugurate in 1954."[25] This statement and Laín Entralgo's description appear to suggest that the university authorities had taken the initiative to revive the idea of a Huntington Chair and provide it with new and more substantial content as part of a reestablishment of the earlier relationship between Huntington and Spain.

The General Archives of the Universidad Complutense (the name taken by the main faculties of the former Universidad Central de Madrid

24. Pedro Laín Entralgo, *Descargo de conciencia, 1930–1960* (Barcelona: Seix Barral, 1976), 402.

25. Sánchez Cantón, "Necrológica," 17.

in 1970) retain records of the lectures given under the auspices of the Huntington Chair between 1954 and 1957. Rather than a full professorship, the Cátedra Huntington functioned as an annual series of lectures given by distinguished international scholars, and although in 1929 the chair had been described as one of American literature, the lectures of the 1950s had a more Hispanic focus, dealing with subjects and themes in Spanish literature from an international perspective.[26] These records also show that after a little more than three years of activity, the chair once again became inactive, precisely a year after the education minister and university rector who had encouraged its creation, Ruiz-Giménez and Laín Entralgo, had left their posts because of divergences from other sectors of the regime.

Leaving to one side these evident discrepancies regarding the inspiration for the donation of *The Torch Bearers*, once the proposal had been made, Alfredo Sánchez Bella replied to Anna Huntington with his grateful thanks a week later, on February 17, 1954, in a letter where he also informed her that a meeting would be held immediately under the chairmanship of the minister of education to decide on a location for the sculpture in the Ciudad Universitaria. He went on, "It is likely that the Ciudad Universitaria will agree to give the name of yourself and your husband to one of its large avenues, as a sign of [our] gratitude."[27] Sánchez Bella also included some photographs of possible sites for the statue and promised to award Anna with an honorary membership in the Institute of Hispanic Culture.

Instances of official recognition of the Huntingtons continued to multiply, which was not surprising, given that they proposed not only to donate the sculpture to the Ciudad Universitaria but also to take charge

26. The Huntington Chair presented a series of lectures: in 1954 by the Portuguese scholar Álvaro Júlio da Costa Pimpão; in 1955 by Professor Arnald Steiger of the University of Zurich; in May 1956 by the eminent Cuban philologist José María Chacón y Calvo; and in 1957 by Joseph Piel of the University of Cologne (108/09-49, Archivo General de la Universidad Complutense de Madrid).

27. Alfredo Sánchez Bella to Anna Hyatt Huntington, Feb. 17, 1954, box 41, AHHP, SCRC.

of all the expenses involved in its journey to Madrid. "Their kindness is such that, García-Mazas tells me, they do not wish Spain to suffer any expense of any kind," Sánchez Bella informed his colleagues, "and have a determined intention to pay for the transportation, assembly, and other costs that may be incurred due to the journey and the time spent in Spain by the technical personnel who will eventually install the sculpture. One has to agree that the gesture is generous."[28]

Sánchez Bella visited the Huntingtons with García-Mazas during June 1954 to consider the logistical aspects of the dispatch of *The Torch Bearers* to Spain because the arrival of the monument was an event that the Spanish government intended to have great media impact.[29] The comments made by Minister of Foreign Affairs Alberto Martín-Artajo in a letter to Concha Espina in January 1955 leave no room for doubt as to the importance the regime wished to give to the inaugural ceremony. "You can inform them [the Huntingtons]," wrote the minister, "that the sculpture they are going to send within a few weeks will be placed in the best location in the Ciudad Universitaria: in the grand campus that is now formed by the Faculties of Pharmacology, Medicine, and Oral Medicine. The splendid sculpture will be raised at the axis of this U, and in line with the Avenue. The inaugural ceremony will be given maximum prominence and the greatest importance."[30]

The Torch Bearers was a sculpture much loved by both Huntingtons. It consists of an allegorical group in which a young naked man on a rearing horse bends down to take up a flaming torch from an older man who is lying prostrate upon a rock. With this monument, Anna wished to represent the passing-on of knowledge from one generation to the next. She recorded in her diaries that while she was working on it, she had in mind the heroism of the Spaniards who for centuries had fought for their ideals

28. Report by Alfredo Sánchez Bella of Feb. 23, 1954, R. 3585, exp. 28, AMAEC.

29. Archer Huntington to José García-Mazas, May 25, 1954, box 31, AHHP, SCRC.

30. Alberto Martín-Artajo to Concha Espina, Jan. 18, 1955, box 31, AHHP, SCRC. The "U" referred to is the main square of the Ciudad Universitaria, surrounded by the medical faculties.

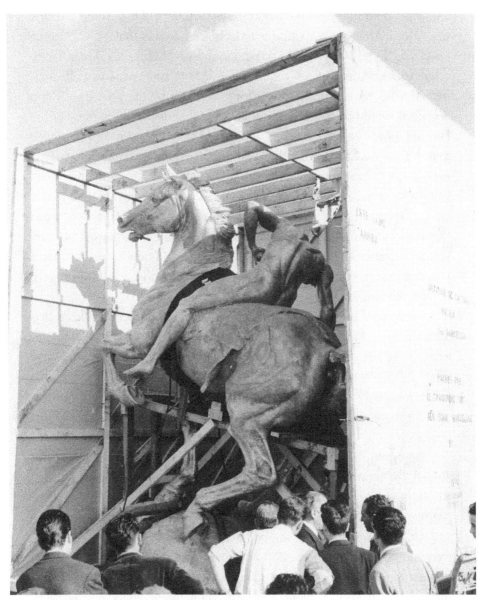

17. Unpacking of Anna Hyatt Huntington's sculpture *The Torch Bearers* at the University City of Madrid, 1955. *Source*: Box 68, envelope 47 (MH-68/47), Archivo Mundo Hispánico, Agencia Española de Cooperación Internacional para el Desarrollo, Madrid. By permission of Agencia Española de Cooperación Internacional para el Desarrollo.

and who could now lead the world from the Ciudad Universitaria. At the same time, Archer was writing a collection of poems that would also be titled *The Torch Bearers*, his last work published before his death. Dedicated, as something of a farewell statement, to his wife, this collection includes the verses that, translated into Spanish by the poet José María Souvirón, would be inscribed on the pedestal beneath the statue. For the Huntingtons, *The Torch Bearers* was a symbol of a transfer of knowledge that in their declining years they had a responsibility to make to younger generations to preserve the values of the society and world in which they had lived. Spain, after the agreements of 1953, was also part of their world, having become one of their country's allies. *The Torch Bearers* was a gift that could illuminate Spain's way forward in this new framework of international relations, which Archer Huntington could only celebrate. Spain was once again part of the circle of Western nations, and Huntington, though old and weary, could again take part in its life.

For the public at large in Spain, this sign of appreciation from two distinguished Americans represented good news that validated the actions of the Spanish authorities because it demonstrated a restoration of relations that were not just political ties but also bonds of friendship. This constituted very favorable propaganda for a regime that sought both to win international acceptance and to perpetuate its hold on power within Spain.

Moreover, for Spanish intellectuals within the country and in exile abroad, the figure of Archer Huntington evoked a moment in history and a cultural context in which Spanish culture had attained a high level of prestige among the international community in literature, art, music, and science. The names "Huntington" and "Hispanic Society of America" were directly linked to the effort to make Spanish culture more international and increase its international presence that had been instigated by the various currents of regenerationism. Many intellectuals were aware of the support Huntington had given to the advancement of Hispanic culture in the United States in the first thirty years of the century.

However, perhaps the most interesting aspect of this episode is the fact that for some Spanish intellectuals in the early 1950s the name "Huntington" actually represented not just a memory but also a living example

of commitment to Hispanism. To explain this assertion, we need to look back five years earlier, to 1948, when Huntington had begun to give public acknowledgment to the work of several figures who by then were living in exile and therefore a source of discomfort for the Franco regime. He did so in the manner he best knew how, by awarding them medals and recognition for professional merit from the Hispanic Society of America.

In 1948, the society distinguished an old friend, Rafael Altamira, who had been living in exile in Mexico since 1944, by making him a member of its Advisory Council, an honorary post he retained until his death in 1951. A year later, in 1949, the society awarded its Medal of Arts and Literature to three more exceptional figures: the poet Juan Ramón Jiménez, who remained in exile in the United States and Puerto Rico; the writer Ramón Pérez de Ayala, then in Argentina; and the philosopher José Ortega y Gasset, who had returned to Spain in 1945 but was prevented from resuming his professorship at the university in Madrid. The same medal was also presented to Francisco Sánchez Cantón, who two years later would be appointed dean of the Faculty of Philosophy and Letters in Madrid, and to J. B. Trend, the Cambridge Hispanist and musicologist who in the following year would publish books on both Juan Ramón Jiménez and Federico García Lorca. In 1950, the entire career of Manuel Gómez-Moreno, the former director of archaeology at the pre–Civil War Centro de Estudios Históricos, was rewarded with the society's Cervantes Medal, and in 1952 Dr. Gregorio Marañón, the Huntingtons' personal friend and once their doctor in Spain, was awarded the same medal, while the Catalan cellist Pau (or Pablo) Casals, in exile in France, received the Mitre Medal for his services to the arts.

In 1950, apparently in response to these gestures of recognition for professional and artistic merit by Huntington, a ceremony in tribute to him was organized to mark his eightieth birthday at Wellesley, a women's liberal arts college founded in 1870. Many prominent Hispanists took part in this event, and one of its principal organizers was the exiled poet Jorge Guillén, who was then professor of Spanish at Wellesley.[31]

31. Guardia Herrero, "Las relaciones entre Estados Unidos y España," 61.

Huntington was a discreet patron of Wellesley College, keeping his contributions to the college anonymous. The letters he exchanged with its president, Margaret Clapp, in 1950 indicate that in 1948 he had made a donation of $10,000, followed now by one of $50,000, equivalent in total to around $700,000 today. He was interested, as he explicitly stated, in providing financial support for the activities of the Spanish Department. He effectively insisted on this as a condition to Clapp when she suggested distributing the funds among the general activities of the College, writing to her, "I have given my life, as you know, to Spanish work chiefly, and therefore I am forced to consider this the only means of doing anything for college work."[32]

The Department of Spanish at Wellesley subsequently decided to publish an anthology of articles in Huntington's honor, some in Spanish and some in English. The college's motivation was made clear in the introduction to the volume, which was to increase public knowledge of the interest Huntington had shown over many years in supporting educational and working opportunities for women. "Not just for the reasons already expressed, but for something more," the introduction stated, referring to the inspiration for the collection, "for the faith and interest Mr. Huntington has had in the education of women, a notable feature that is worthy of appreciation in the life of this great friend of Spain."[33]

In the summer of 1952, President Clapp visited Huntington to present him personally with a copy of this collection, *Estudios hispánicos*, which had been published in Mexico City. The list of contributors is highly interesting, beginning with Ramón Menéndez Pidal, who in a singular annex to the main collection included an article titled "Un recuerdo de juventud" (A Memory of Youth). There were also contributions by the late exiled poet Pedro Salinas, who until his death in 1951 had taught at Johns Hopkins; Homero Serís, the Cervantes expert and long-standing collaborator with the Hispanic Society who was by then head of the Center for

32. Archer Huntington to Margaret Clapp, Oct. 18, 1950, box 57, AHHP, SCRC.

33. Spanish Department, Wellesley College, introduction to *Estudios Hispánicos: Homenaje a Archer M. Huntington* (Mexico City: Wellesley College, 1952), n.p.

Hispanic Studies at Syracuse; the philologists José Manuel Blecua and Ramón Lapesa; the Austrian Hispanist and Johns Hopkins professor Leo Spitzer; the historian Agustín González de Amezúa; the poet Narciso Alonso Cortés, who had been first director of the Casa-Museo de Cervantes in Valladolid; J. B. Trend; the eminent French Hispanist Marcel Bataillon; Tomás Navarro Tomás, professor of Spanish philology at Columbia; Joaquín Casalduero, another Cervantes scholar; the literature professor Carlos Clavería; and several more international scholars, all of whom had wished to be part of the collection.

This collective tribute bore witness to the influence of the many collaborative projects that Huntington had established and maintained through transnational cultural networks during the most buoyant decades of twentieth-century Spanish culture, networks he had helped sustain with his philanthropic efforts. These same networks had, much to his regret, been torn apart almost entirely by the Spanish Civil War, but a significant number of intellectuals were now timidly attempting to reanimate them around a figure of acknowledged international importance in the field of Hispanism and Hispanic studies. Huntington gratefully received the acknowledgment of those who, for him, were above all professional colleagues, Hispanists equally dedicated to the study of Spanish culture.

For the authorities in Spain, Huntington emerged as a figure capable of combining the conservative profile of a distinguished and wealthy American Hispanist with extensive connections to the moderate sectors of Spanish exiles. The one figure in the regime most interested in pursuing this idea was without doubt Education Minister Ruiz-Giménez, and the most suitable instrument at his disposal for giving some immediate shape to an approach to Huntington was the Instituto de Cultura Hispánica, which had already presented Archer with an honorary membership as early as June 1951 through the then Spanish consul in New York, Pelayo García Olay.[34] With such initiatives, the authorities of the Franco regime hoped to display the high esteem they had for Huntington's work

34. Pelayo García Olay to Alfredo Sánchez Bella, June 25, 1951, R. 3022, exp. 185, AMAEC.

while avoiding situations in which the community of Spanish exiles could capitalize on his image.

The signing of the Madrid Pact in 1953 subsequently tipped the balance in favor of the regime in the symbolic struggle for recognition from the neutral figure of Huntington, and as a result of the new circumstances *The Torch Bearers* arrived in Spain on April 18, 1955, amid great expectation. Eleven days later, Sánchez Bella informed the Huntingtons in ample detail of the statue's journey from the port of Barcelona, where it was mounted onto a large platform, to Madrid.

> In the tiny old villages of Aragon and Castile the passage [of the statue] caused serious difficulties because the classic balconies and tiled awnings above the streets made it inevitable that some detours had to be made to avoid the centers of towns. Some bridges also had to be bypassed, so the route was quite long. Since they also could not travel at night, the group's peregrination lasted a week.
>
> It went by the main road as far as Calatayud—the old Aragonese town—and from there crossed Castile, through Soria and Aranda de Duero, and then, crossing the Somosierra pass, it arrived in Madrid. We members of the Executive Committee of this Institute went to meet it in the village of Fuencarral, and then accompanied it along the extension of the Castellana, escorted by motorcycles of the Armed Police, through part of Madrid, amid the astonishment of the public who asked themselves what that enormous wooden box could contain.
>
> The next day the work of unpacking began and, in the evening, in the presence of the Minister of National Education, the Rector of the University of Madrid, and the Director Generals and Executive Committee of the Ciudad Universitaria, the side panels of the case were removed, leaving the group of figures open to be seen.[35]

This detailed account by Sánchez Bella, which must have delighted the Huntingtons, also recorded some of the comments made by onlookers.

35. Alfredo Sánchez Bella to Archer and Anna Huntington, Apr. 29, 1955, box 41, AHHP, SCRC.

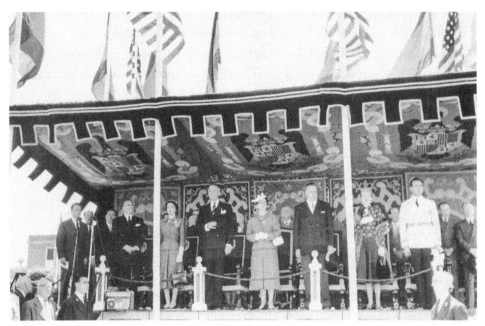

18. Inauguration of the sculpture *The Torch Bearers* in the University City of Madrid, May 15, 1955, with the wife of Francisco Franco, Carmen Polo (*center*); Minister of Foreign Affairs Alberto Martín-Artajo (*right of Polo*); and Ambassador John Davis Lodge (*left of Polo*). *Source*: Box 68, envelope 47 (MH-68/47), Archivo Mundo Hispánico, Agencia Española de Cooperación Internacional para el Desarrollo, Madrid. By permission of Agencia Española de Cooperación Internacional para el Desarrollo.

"The group is frankly *soberbio*, superb, as we say," he went on, "and the location where it will stand will be greatly enhanced by this marvelous work of art. . . . Work will also begin on sculpting the emotive and beautiful words of Mr. Huntington."

The inaugural ceremony was held on May 15, 1955. It was attended by many prominent figures and a large crowd, who heard speeches by the university rector, the US ambassador, and José García-Mazas as representative of Mr. and Mrs. Huntington. Center stage on the dais were the wife of General Franco, Carmen Polo de Franco, Foreign Minister Alberto Martín-Artajo, and Education Minister Joaquín Ruiz-Giménez, behind whom were members of the university faculty and representatives

of university bodies. The speeches were full of references to the cultural values that endured in Spain and the defense of the threatened ideals of Western civilization, with a rhetoric that called upon its listeners, especially the university's young students, to preserve the integrity of the Spanish character.

The inauguration was considered a significant success, and Franco himself expressed his gratitude to the Huntingtons in a letter sent the same day. "For half a century," wrote the *generalísimo*,

> the [element that is] most genuine and universal in Spain, its culture, has found in you not only an ever-warm welcome, but also the most generous patronage. In a gesture without precedent in the history of artistic patronage, both of you, together, have understood how to unite cultural conservation with artistic creation, for while on the one hand we must remember the foundation of the Hispanic Society as an exemplar of a worthy institution, on the other there is the statue of *El Cid* in Seville, another in Los Angeles, and this statue in the Ciudad Universitaria of Madrid, as the serene embodiment of the highest ideal. You can be sure that in future the illustrious name of the Huntington family will be closely linked to the greatest cultural enterprises in Spain.[36]

Huntington replied courteously to this letter from Franco, although by then his health had deteriorated a great deal.[37] Anna Huntington recorded in her diary a visit García-Mazas made to Stanerigg after his return from Spain to play them a tape he had recorded of the ceremony.[38] In a letter sent just after the event, he had already told them that the inauguration "was broadcast on radio, by a network, to the whole of Spain" and that "the Spanish government wanted to try to name you Dukes of Huntington,"

36. Generalísimo Franco to Mr. and Mrs. Huntington, May 15, 1955, box 32, AHHP, SCRC.
37. Archer Huntington to Generalísimo Franco, May 25, 1955, box 32, AHHP, SCRC.
38. Anna Hyatt Huntington, diary entry, June 3, 1955, AHHP, SCRC.

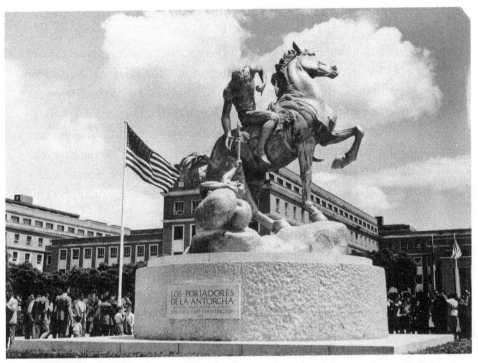

19. Anna Hyatt Huntington, *The Torch Bearers*, University City of Madrid, 1955. Source: Box 68, envelope 47 (MH-68/47), Archivo Mundo Hispánico, Agencia Española de Cooperación Internacional para el Desarrollo, Madrid. By permission of Agencia Española de Cooperación Internacional para el Desarrollo.

but he had already explained to Sánchez Bella that as American citizens they could not accept titles of nobility.[39]

Nevertheless, as John Davis Lodge, the US ambassador to Spain, had celebrated in his speech, *The Torch Bearers* was a symbol of friendship between Spain and the United States that would give visible form to the ever-closer links that spiritually united the two nations. A gift suited to the new era.

39. José García-Mazas to Archer and Anna Huntington, May 16, 1955, box 33, AHHP, SCRC.

The Huntington Foundation: Plans and More Plans

For all the public impact of *The Torch Bearers*, the most ambitious project to connect the names of Archer Huntington and the Hispanic Society of America with the Ciudad Universitaria in Madrid was the proposal to create a North American institute in the city to be called the Fundación Huntington (Huntington Foundation). This proposition was certainly original and attractive for the Spanish government. It had the potential to develop into more than just a gesture of friendship in the manner of the donation of a statue and could be interpreted as a real example of cooperation and cultural exchange in an arena as important as university teaching and research.

The first written reference to this idea is found in a letter of May 1954, in which Huntington, replying to García-Mazas, pointed out to him that, despite the interest there might be in the establishment of a North American institute in Madrid, he foresaw that the project could encounter problems in the future. Faithful to his own ideas of common sense, Huntington considered that it would be very difficult to involve Americans in such a project in the current political circumstances. His lack of confidence in the prospects for the scheme led him to write that he hoped that the plan then being put forward by García-Mazas and the Institute of Hispanic Culture would not be set in motion in too hurried a manner and in unsuitable conditions. "I think it would be very difficult to enlist many Americans in an affair of this kind," Huntington observed, "owing to the conditions under which we are living at the present moment, and which no doubt you understand. I sincerely hope that the plans of which you are speaking may not be undertaken too hurriedly at such a moment as this."[40]

Once again, what is clear from this letter is that the Huntington Foundation, though it might have been an attractive prospect in the medium term, was not a project that was initiated or particularly supported by Archer Huntington in 1954. He also gave signs, as he had done previously, that he was fully aware of the still precarious state of relations between Spain and the United States. In 1952, an initial program of educational

40. Archer Huntington to José García-Mazas, May 31, 1954, box 33, AHHP, SCRC.

exchanges had been created to permit the training of Spanish professionals in US colleges and centers, and in 1954 Spain was incorporated into the US government's Technical Exchange Program. However, these schemes dealt only with technical areas, directed as they were toward modernizing aspects of Spain's economic infrastructure.[41] It was not until 1958, four years later, that the Fulbright Agreement for academic exchanges with American universities was extended to Spain. Hence, one can easily see that in 1954 the idea of creating a North American foundation in Madrid to permit student exchanges—inside the Ciudad Universitaria and with the possibility of operating under the umbrella of such a prestigious institution as the Hispanic Society of America—would be a very attractive project for the officials of the Institute of Hispanic Culture and even more attractive if the burden of financing such a scheme would indeed be carried by Huntington and the Hispanic Society.

Despite Huntington's reservations, the Instituto de Cultura Hispánica continued working on the idea, as is once again recorded in a document preserved in the archives of the Ministry of Foreign Affairs. In a letter sent to Foreign Minister Martín-Artajo on May 10, 1955, only a few days before the inauguration of *The Torch Bearers*, Alfredo Sánchez Bella indicated that Archer Huntington had been sent via García-Mazas the plans for a future Fundación Huntington, with the additional comment that Sánchez Bella hoped to obtain a significant donation from the millionaire for other work at the Ciudad Universitaria. Clearly, García-Mazas had consolidated his position as a privileged intermediary with the Huntingtons and had gained the confidence of Sánchez Bella, who went on to point out, "Sr. García-Mazas, in every area of activity in which he has intervened as a collaborator of this Institute, has always done so without financial interest of any kind."[42]

41. Lorenzo Delgado Gómez-Escalonilla, "Cooperación cultural y científica en clave política: Crear un clima de opinión favorable para las bases USA en España," in *España y Estados Unidos en el siglo XX*, ed. Delgado Gómez-Escalonilla and Elizalde Pérez-Grueso, 209.

42. Alfredo Sánchez Bella to Alberto Martín-Artajo, May 10, 1955, R. 6630, exp. 51, AMAEC.

During this same period, the intervention of a very different personality, the novelist Concha Espina, also played a part in this new state of relations. Determined at the age of eighty-five to obtain official recognition in Spain for her American friends, she, too, set out to mediate between the Huntingtons and the Ministry of Foreign Affairs. In a letter in November 1954, she had informed Archer Huntington that she had proposed to the Spanish government that he be awarded a title of nobility. To further her goal, she included a suggestion: "If you were to indicate, delicately and officially, to this government, some desire to contribute to the cost of the Paraninfo [a proposed university auditorium, the plans for which had also been sent to Huntington], as a supreme kindness after you have done us so many favors, my proposal to win for you the most well-deserved title of nobility would gain in speed and efficacy."[43]

Offering the award of an aristocratic title, something that seemed a recurring theme among the Spanish authorities at different times, did nothing to encourage Huntington to change his plans. In fact, he expressly asked Espina not to waste her time and with great delicacy pointed out to her that in the United States a noble title would not mean the same as in Spain. He and Anna did not desire any honors of this sort. "A title in America, as you know, does not express the splendor and importance of one in Spain, and the simplicity of our own personal style of living has been marked for many years."[44]

A month later, however, in January 1955, Huntington was again obliged to refuse a proposal from Espina to request a noble title for Anna and himself, adding that he had even found amusing the title she had suggested, "Conde de Bivar [sic] del Cid"—after Rodrigo Díaz de Vivar or Bivar, the medieval warrior El Cid—but still considered it impossible to accept because he had always deliberately refused all honors and distinctions of this kind.[45] Nevertheless, Espina persisted with her idea and shortly afterward forwarded to Huntington a letter from Foreign Minister

43. Concha Espina to Archer Huntington, Nov. 17, 1954, box 31, AHHP, SCRC.
44. Archer Huntington to Concha Espina, Dec. 2, 1954, box 31, AHHP, SCRC.
45. Archer Huntington to Concha Espina, Jan. 5, 1955, box 31, AHHP, SCRC.

Alberto Martín-Artajo that gave a detailed summary of the projects associated with the Huntingtons that the Spanish authorities had in mind.

> Precisely in front of the U [the central square of the Ciudad Universitaria] there are vacant sites where one could build the Spanish–North American Institute of Culture, the "Huntington Foundation," for which the architects have already sent the corresponding project drawings so that they may be examined by them [the Huntingtons] and so that they may decide, definitively, what is to be done. If it were built there, the Foundation could give the name "Campus Huntington" to the whole of the enormous quadrilateral that would be created, with the statue located at its center, and in the background the buildings of the institution, as I have mentioned.... From what I have been told, Mr. Huntington saw the models and was very excited by this project. This would truly be a proper manner of ensuring that the illustrious name of these two great Hispanists will be definitively linked to the history of Spanish and Hispano-American culture. All our efforts should be directed toward this end, for which I request your cooperation. Naturally, you can also rely on mine in turn in the concession of this title of Count, which I consider could very well bear the magnificent name of Vivar del Cid, as you suggest.[46]

Concha Espina died a few months later, on May 19, 1955, and Archer Huntington died at Stanerigg Farm on a cold winter's afternoon on December 11. Nevertheless, the idea of the Huntington Foundation did not disappear with them. It is hard to know with any certainty how it could be possible that a project that had never been endorsed by Huntington himself could continue after his death. Beyond any desire Anna Huntington may have had to honor the memory of her late husband, all evidence suggests that the concerns of the Institute of Hispanic Culture and the university authorities in Madrid, together with García-Mazas, were the determining factors in giving a new stimulus to the scheme in the first months of 1956.

46. Alberto Martín-Artajo to Concha Espina, Jan. 18, 1955, box 31, AHHP, SCRC.

The surviving documentation on the matter, which essentially consists of the letters passed among Sánchez Bella, Anna Huntington, and García-Mazas, seems to show that there were two quite different phases in the formulation of the project. After beginning discussions with considerable impetus, from February 1956 Sánchez Bella adopted a more distrustful attitude. His intransigence regarding the control he wished to maintain over the future Fundación Huntington led him to obstruct any kind of agreement.

To understand the reasons why these tortuous negotiations developed as they did, it is necessary to recall the agitated atmosphere of Spain's universities in the first half of 1956. Joaquín Ruiz-Giménez and his team at the Education Ministry had introduced a series of reforms that, without seeking to change the established model of education under the Franco regime, were meant to offer some degree of cultural renewal in the universities. They had no intention of initiating any program of liberalization but did encourage changes in the style of language and the scope granted for cultural initiatives with the aim of moving Spanish universities out of the state of immobility in which they had remained since the Civil War. However, the calls for dialogue, coexistence, and the reconciliation of all sides in Spain being made from magazines such as the *Semanario de actualidades* and *Arte y letras*, in Minister Ruiz-Giménez's speeches, and in recent exhibitions of less conventional art were all seen as provocations by the most intransigent sectors of the regime.[47]

Tensions had begun to grow in October 1955, after the death of José Ortega y Gasset and the criticisms made by student groups of the way the news of his death had been reported.[48] This episode led to the prohibition of a University Congress of Young Writers, which in turn was followed in February 1956 by a call for a Congreso Nacional de Estudiantes (National Students' Congress) in open opposition to the official Falangist students' union, the Sindicato Español Universitario (Spanish University

47. Jordi Gracia, "Proceso evolutivo o crisis y conversiones: Los años cincuenta y el viejo falangismo," in *Memoria de la guerra y del franquismo*, ed. Juliá, 325.

48. Mercedes Cabrera, ed., *José Ortega Spottorno (1916–2016): Un editor puente entre generaciones* (Madrid: Alianza Editorial, 2016).

Union). This unrest, inspired in part by clandestine Communist groups, demonstrated the growing strength of opposition within the universities. Official attempts to halt the protests led to street demonstrations, which were repressed with great severity by the police and led the regime to decree the closure of Central Madrid University. The consequences were immediate: the university rector, Pedro Laín Entralgo, had to resign, and Minister Ruiz-Giménez was dismissed. With these dismissals, "the [men of] understanding were removed from the levers of power in the Ministry of Education."[49] They were replaced by loyal Falangists, Segismundo Royo Villanova at the university and Jesús Rubio in the ministry.

Franco considered the experiment in greater openness inspired by the liberal Catholic groups led by Ruiz-Giménez to be concluded. The men who had been displaced, however, were also those who had been most involved in trying to create the Huntington Foundation in the Ciudad Universitaria. The question therefore arises regarding how much these changes affected the development of the project and to what extent they altered the attitude of the head of the Institute of Hispanic Culture, Sánchez Bella.

In March 1956, a month after the disturbances in Madrid and the subsequent dismissals at the Education Ministry and the University of Madrid, José García-Mazas arrived back in Spain with the intention of finalizing the main outlines of the proposed Huntington Foundation. It is not easy to identify who could have been the source of the instructions García-Mazas brought with him to these negotiations, given the vacuum left by Archer's death. It is hard to believe that Anna Huntington had made note of the technical observations. Another possibility is that they had been made by Archer Huntington's successor as president of the Hispanic Society, Anna's nephew Alpheus Hyatt Mayor, a man of liberal views and a senior curator at the Metropolitan Museum of Art in New York.

García-Mazas provided an account of the ensuing meetings held in Madrid between March 22 and 26 in a detailed report he sent back to the United States on March 31. He engaged in an intensive series of visits and

49. López Vega, *Gregorio Marañón*, 439.

meetings between different ministerial offices and the US embassy over four days, attempting to reconcile conflicting interests and divert suspicions. He presented a proposal for the projected collaboration among the Hispanic Society of America, the Institute of Hispanic Culture, and the Ciudad Universitaria that became problematic, particularly for Alfredo Sánchez Bella.

Disagreements were already visible in their first meeting because Sánchez Bella demanded as an indispensable condition that the Spanish authorities should retain total control over the operation of the foundation. García-Mazas argued for the opposite, as he reported back to Anna Huntington and Alpheus Hyatt Mayor:

> I brought Dr. Bella's attention to the fact that the center for the Huntington Foundation in Madrid must be governed by an American director and American staff. Furthermore, I explained to Dr. Bella that the "Spanish Chapter of the Huntington Foundation will only advise the Executive Director in regard to studies, courses, lectures, books, and publications needed for the Spanish section of the "Center." I also pointed out that the "Spanish Chapter" will be the basis of the Center within the Spanish environment, and will provide funds to help the Center in the important task of building and promoting international understanding. Dr. Sánchez Bella did not agree with me on these points but explained that he wanted to control the Foundation.[50]

For his part, Sánchez Bella had proposed that a Spanish *patronato*, or public trust, should have ultimate control over the institution and its activities, with the American partners left only with some representation on the board and responsibility for funding. García-Mazas saw this structure to be incompatible with American business models. "Dr. Bella suggested that a *patronato* or Spanish corporation be formed to control the Center

50. "Trip of José García-Mazas to Spain," report, Mar. 31, 1956, box 33, AHHP, SCRC, 1.

and all its activities," he reported. "The American corporation should provide funds only, and perhaps 'some' representation."[51]

The US embassy in Madrid shared García-Mazas's view, and its cultural attaché, John F. Reid, agreed with him in stating that the Huntington Foundation "must be kept out of politics or sectarian organizations, and that it should be directed by American professors to be appointed by a Board of Directors in New York."[52] Reid promised to cooperate with the Huntington Foundation by donating books and furniture for its planned American library as well as films and equipment for its film theater. Ambassador John Davis Lodge also had a meeting with García-Mazas on March 23. He confirmed the same ideas as his attaché, and so García-Mazas added in his report, "We discussed the Foundation's aims, and Mr. Lodge recognized the fact [that] there would be certain subjects which should not be taught."[53]

During the same few days, another meeting between García-Mazas and the Architecture Department of the Central University is testimony to the advanced state that had been reached in preparations for the project in that he was shown several models of the proposed building and how it would be situated in the surrounding site. The university's secretary-general gave a commitment to prepare the documents necessary to donate the land required to the Huntington Foundation.

The university's new rector, Segismundo Royo Villanova, featured in another of García-Mazas's meetings on March 23. Aware of the argument that had arisen with Sánchez Bella regarding the foundation's governing structure, the rector wished to mediate and sent García-Mazas to speak to Rodrigo García-Conde, head of the Department for Foundations at the Ministry of Education, who explained to him the two legal options available for establishing a foundation that would operate on Spanish territory: an entirely foreign foundation, legally based abroad and with its own staff to represent it in Spain, or a Spanish foundation, whose funding, held in

51. "Trip of José García-Mazas to Spain," 1.
52. Quoted in "Trip of José García-Mazas to Spain," 1.
53. "Trip of José García-Mazas to Spain," 2.

trust, had to be based and registered in Spain and whose activities had to be dedicated entirely to altruistic purposes.

The new education minister, Jesús Rubio, discussed the thorny issue of the foundation with García-Mazas on March 24. He agreed that the Huntington Foundation should be administered by American staff, but only so long as the students did not actually live and have rooms in its buildings. His fears were less to do with whoever might have control of the foundation than with its students' activities within the Ciudad Universitaria. "He suggested that the aim of the Huntington Foundation be to encourage and direct high-level research on Spanish and American civilization, without going into the 'hotel business,' as he strongly recommended that students reside outside the University area at all times."[54]

Curiously, the architectural plans for the foundation presented up to this point and sent to Anna Huntington included a sizeable number of bedrooms, each with its own bathroom. These plans had been initiated when Ruiz-Giménez was education minister, but the new minister clearly saw this feature as unacceptable.

Amid this situation, on March 26 García-Mazas, as he recounted, was received by Franco himself. The purpose of the meeting was to present to the *caudillo* and head of the Spanish state some details of the Huntington Foundation and request his support for the project. García-Mazas explained to the general that the foundation was intended to be a center for postgraduate studies specializing in Spanish and American culture, that it would welcome students not only from the United States and Latin America but also from Portugal and Spain, "and that many, if not all, the students will come to Spain in the spirit in which the late Mr. Huntington did, many years ago." He then asked expressly for Franco's assistance in constituting the Spanish section of the foundation so that it might be made up of outstanding Spanish writers, scientists, and business figures. At the same time, he reported, he also made clear that this Spanish section would play only a consultative and advisory role and at no time would have executive authority over the foundation because this authority would

54. "Trip of José García-Mazas to Spain," 3.

be held by the American board of directors. He also added that the project would require financial support from Spanish business interests, to which Franco replied, according to García-Mazas, that this would indeed be highly desirable. In the conclusion to his report, García-Mazas assured Anna Huntington of Franco's complete support for the project, claiming that "the foundation will receive the Generalísimo's fullest cooperation at all times."[55]

The next day the director general of cultural relations at the Foreign Ministry, Antonio Villacieros, met García-Mazas and asked to be informed of the proposals and their progress. Villacieros made evident his interest in taking charge of the project, for he asked that any fresh negotiations on the matter should be initiated through his office and not that of Sánchez Bella; he, Villacieros, was more correctly the person responsible for Spain's international cultural relations.

It seemed that García-Mazas had only to mention the Huntington Foundation to find every door in Madrid opened to him. The attraction of the project for the Spain of 1956 and the possibilities it seemed to offer were undeniable, although it also had its risks, and Sánchez Bella, who appears to have foreseen them, was, according to García-Mazas, inflexible on certain issues. "Dr. Bella, informed as to the outcome of my conversation with Generalísimo Franco and our mutual understanding as to the procedure for setting up the Foundation," wrote García-Mazas in the same report, "no longer argued but seemed to have resigned himself to the Generalísimo's will. It was obvious that he was not too pleased with the result of my visit and that he was in agreement not because of any change of heart, but merely because he felt it was the diplomatic thing to do."[56]

Nevertheless, eight months later Sánchez Bella's attitude appeared to have changed entirely, and he expressed a much greater willingness to negotiate. Convinced that he needed to try other options, he traveled to New York once again in November 1956 and had a meeting with Alpheus Hyatt Mayor, president of the Hispanic Society since Archer's death. Sánchez

55. "Trip of José García-Mazas to Spain," 5.
56. "Trip of José García-Mazas to Spain," 5.

Bella also wrote promptly in English to Anna Huntington, informing her, "I spoke to Mr. Hyatt about the possible plans in which we might cooperate in the future, particularly about the interest we have, [and] this interest is already well known to you, in perpetuating your husband's memory."[57]

It seems, however, that this conversation with Alpheus Hyatt did not have the desired effect, for ten days later Anna Huntington wrote back to Sánchez Bella to say that it would be difficult to secure funding for the project. "Just at present we have to contain our ambitions for the future," she explained, "to fit what small resources we can find to start in a smaller way here in New York. Also the very precarious international situation is against the building up of funds just now, an unfortunate combination of circumstances that adds difficulties in getting public interest in private plans."[58]

Even though the foundation did not get much further, the details of the project as presented by Sánchez Bella are nevertheless of interest in helping us to understand the nature of the Spanish regime's concern to perpetuate the memory of Huntington in the climate of the 1950s.

The planned design for the Huntington Foundation, as described in detail in the extensive letter Sánchez Bella sent to Anna Huntington on November 16, 1956, consisted of a main building in the form of a V, centered on a large main assembly hall. In front of the building, a work by the Spanish Uruguayan sculptor Pablo Serrano, who had won the grand prize for sculpture at the Bienal Hispanomericana in Barcelona in 1955, would be placed. The whole complex would bear the name "Campus Huntington" as soon as the members of the Huntington Foundation confirmed their acceptance of the site, which had been offered by the Ciudad Universitaria of Madrid through the Spanish consul general in New York on January 26, 1956.

The objective of the project, according to the Spanish authorities, was clear: to realize Archer Huntington's dream of making Spain a bridge for

57. Alfredo Sánchez Bella to Anna Hyatt Huntington, Nov. 16, 1956, box 41, AHHP, SCRC.

58. Anna Hyatt Huntington to Alfredo Sánchez Bella, Nov. 26, 1956, box 41, AHHP, SCRC.

uniting the two Americas. Hence, the Huntington Foundation in Spain should act as a meeting point between the United States and Hispanic America in all areas of culture. Sánchez Bella went on, "We believe that the understanding between the USA and Hispano-America in the cultural field will be more easily attainable through Spain than from any other point. . . . This understanding could be reached through an Institution which might be a kind of 'super–Faculty of Sciences of the Mind,' to study the present-day problems of the Americas and Spain."[59]

An American foundation with a base in Madrid that carried the name of a prestigious Hispanist would find it easier to attract Latin American students to be educated in Spain, he argued. Moreover, the Huntington Foundation, according to Sánchez Bella, would not limit its activities to the Spanish capital; in addition to providing a residence (which had been restored in the project plans, despite or perhaps ignoring earlier opposition) with a well-stocked library and other facilities in Madrid, it could also create a similar institution in the United States and later, perhaps, in the main cities of Latin America. This prospect echoed the schemes the Spanish authorities had attempted, unsuccessfully, to promote some time earlier in Latin America through the failed Instituto de Cooperación Intelectual (Institute of Intellectual Cooperation).[60]

The creation of the Huntington Foundation in the manner thus laid out by the Institute of Hispanic Culture, claimed Sánchez Bella, required only a commitment from the Hispanic Society of America to cooperate fully with the Central University of Madrid to guarantee that the scheme would prosper. As he put it, "It would be a guarantee for the Foundation if it cooperated directly with the University of Madrid. This institution cannot be separated from the Madrid University authorities, because otherwise, the Governing Body of the University City would not authorize it. This is a necessary condition for all the foreign colleges."

59. Sánchez Bella to Hyatt Huntington, Nov. 16, 1956; subsequent quotations from Sánchez Bella to Hyatt Huntington come from this letter.

60. Antonio Cañellas Mas, "Las políticas del Instituto de Cultura Hispánica, 1947–1953," *Historia Actual Online*, no. 33 (2014): 77–91, at https://doi.org/10.36132/hao.v0i33.970.

Although Sánchez Bella had given up his demand that Spanish representatives should retain exclusive control of the foundation, he now proposed a system to coordinate Spanish and American involvement through an administration in which an American director and an American executive committee, along with a group of private patrons, would take charge primarily of overseeing the institution's finances.

The Institute of Hispanic Culture also put forward proposals for the foundation's educational program, which, it suggested, should be structured in three different areas: one would attend to students from the United States interested in Hispanic culture; the second would cater to Hispanic American students pursuing higher-level studies in similar subjects in Spain; and the third would provide opportunities for Spanish students to study in the United States. On this last point, Sánchez Bella proposed the Hispanic Society of America as a suitable center for such studies. "From the educational point of view," he enthused to Anna Huntington on November 16, "the Institution could be composed of three sections: North Americans interested in the problems of Hispanic culture, Hispano-Americans interested in the same problems, and Spaniards interested in carrying out studies in the United States on common subjects, especially, in their contemporary aspect, economy, social and technical problems, etc., which they would be able to do in the Hispanic Society of America, once they have sufficient knowledge for it, attained in this Center in Madrid."

The idea that the Hispanic Society was expected to bear financial responsibility for the greater part of the investment required for the Huntington Foundation became still clearer in the following paragraph, in which Sánchez Bella nevertheless made an offer to look for at least some financial support in Spain, if this were ever necessary. He suggested casually, "Should the Institution need financial help for the maintenance of all or one of its parts, there would not be any difficulty in procuring the means here in Spain."

Sánchez Bella also included, presumably to avoid any reservations on the part of the Hispanic Society, a declaration of principles, which stated that the foundation would focus on cultural subjects, excluding any political activities. He declared emphatically, "Naturally, the Institution should

be exclusively dedicated to cultural work. Under no circumstances, as with the House of France, should it get involved in any activity of a political nature. Hispano-American culture cannot be linked with any regime."

It is no surprise that in view of the student unrest that had been seen at the beginning of the year, Sánchez Bella wished to take precautions of this kind regarding any future Huntington Foundation. Far more surprising was his assertion on the historic freedom of Spanish university professors, given that a policy of purging university teachers for any sign of public disaffection with the regime had been in place since 1939.

At the end of his letter, Sánchez Bella expressed his doubts regarding the possibility of any rapid initiation of work on the foundation but still emphasized his continuing interest in securing a positive outcome and so the urgent need he saw for definitive decisions to be taken on what the foundation should be.

This project never came to fruition for a variety of reasons: first, because of the lack of commitment and sufficient funding from the Hispanic Society of America and, second, because of the absence of any structure that would have been acceptable to the Spanish authorities. The project was left in the hands of Alfredo Sánchez Bella, who resumed the leading role in the negotiations with José García-Mazas in a climate quite different from the one that existed when conversations on such an ambitious project had begun. Nevertheless, the simple fact that so much work had been done in Spain on defining the scope and functions of the Huntington Foundation and that this work had involved the highest levels of the regime provides us with a valuable insight into the forms of university education the Franco regime wished to set in place in Spain in the mid-1950s.

Huntington after Huntington

This book should perhaps conclude with the failure of the plans for the Huntington Foundation, negotiations around which went on through the months that followed the death of the man who would have given it his name. Eighty-five years of intense living, from 1870 to 1955, most of them dedicated to fostering love and admiration for Hispanic culture, are more than sufficient. Nevertheless, it would not be right to ignore the fact that

the name "Huntington" remained in the minds of Spanish diplomats and politicians for another decade as they saw with concern that he received regular tributes on the anniversary of his death in the United States but not in Spain. A range of voices in official Spanish circles—most of all Spanish diplomats in the United States—recommended the organization of some kind of ceremony in Spain in memory of the late Hispanist and in tribute to his wife. The idea that it was important not to allow other sectors appropriate his memory was a central factor in inspiring these proposals.

The first major event in tribute to Archer Huntington took place in Washington, DC, on December 11, 1956, the first anniversary of his death. The Hispanic Division of the Library of Congress, to whose creation he had contributed so much, organized a ceremony in his honor under the chairmanship of the secretary-general of the Organization of American States, José Antonio Mora. The chargé d'affaires at the Spanish embassy, José María Garay, among the guests at the main table, described the event in great detail in a report sent to the Spanish Foreign Ministry's Cultural Relations Department in Madrid. He summarized the eulogies given by the Cuban professor José Juan Arrom of Yale; Henry Grattan Doyle, the professor of romance languages at George Washington University and old friend of Huntington; and Howard F. Cline, the current director of the Hispanic Division. At the end of his report, Garay also informed Madrid that "Professor Federico de Onís was also announced as one of the participants, but did not appear at the event, nor did he send his article to be read."[61] However, the collection of papers read at this tribute that was published shortly afterward with the simple title *Huntington, 1870–1955* did include an article by Onís, "Huntington y la cultura hispánica," in which he affectionately recalled the role of tutor that Huntington had played for him when he first arrived at Columbia in 1916 and the great significance the Hispanic Society had acquired in the advancement of Hispanic culture in the United States since the century began.[62]

61. Report from José María Garay to Dirección General de Relaciones Culturales, Madrid, Dec. 13, 1956, R. 5602, exp. 52, AMAEC.
62. Onís, "Huntington y la cultura hispánica," 19–23.

A year later, the Spanish ambassador in Washington, José María de Areilza, informed Madrid of a commemoration to be held in New York on December 14, 1957, to mark the second anniversary of Huntington's death. Areilza proposed that Spain should organize some kind of similar but separate event in his memory, after noting, "The characteristics of the persons who have organized this event make it advisable to abstain from collaborating with it. However, it seems to me that, so that it may not only be Puerto Ricans and South Americans who remember the work of Mr. Huntington in New York, something analogous should be organized, on the part of Spain and in Spain, to remember his personality in the press, or through the Institute of Hispanic Culture."[63]

The director of the Institute of Hispanic Culture at the time, the hardline Franco loyalist Blas Piñar, agreed with the proposal from Ambassador Areilza and suggested that an academic ceremony in memory of Archer Huntington should be held at the institute.[64] José Miguel Ruiz Morales, the current director general of cultural relations at the Foreign Ministry, decided on a date, replying to Piñar, "It is considered more appropriate to hold back the event in tribute to him for the next anniversary of his death, December 11, 1958."[65] This proposal was duly passed on to Ramón Bela y Armada, head of the Department of Exhibitions and Conferences, and Antonio Serrano, head of cultural policy for the Americas and the Philippines at the Foreign Ministry, to coordinate any potential events. However, nothing concrete seems to have been done by the end of 1958.

Despite all these proposals, the final spark for an eventual official initiative from the highest levels of the Spanish state to pay tribute to the work of the Huntingtons did not come until five years later. On July 11, 1963, the director general of information at the Ministerio de Información

63. José María de Areilza to Dirección General de Relaciones Culturales, Madrid, Dec. 12, 1957, R. 5602, exp. 52, AMAEC.

64. Blas Piñar to Director General de Relaciones Culturales, Jan. 31, 1958, R. 5602, exp. 52, AMAEC.

65. Director General de Relaciones Culturales to Blas Piñar, Feb. 13, 1958, R. 5602, exp. 52, AMAEC.

y Turismo (Ministry of Information and Tourism), Carlos Robles Piquer, wrote to the current director of the Institute of Hispanic Culture, Gregorio Marañón Moya—the son of Huntington's friend and former doctor—to set the still pending matter in motion once again. Robles Piquer noted:

> During my recent visit to the United States I had the opportunity to prove for myself what I already knew from numerous accounts, that is, the importance of the work undertaken by the Hispanic Society of America, created and maintained by Mr. Archer Milton Huntington. You yourself know this work well, because your distinguished father was very closely associated with it and was a vice president of the Society.
>
> I think that the public act of recognition for this labor that Spain owes to the memory of Huntington and his work, which is today continued by the Society and especially by his widow, has been delayed longer than is right. This lady . . . is the object of numerous tributes in the United States, and it does not seem to me that Spain should lag behind in these initiatives.[66]

Four months later, on November 5, the Spanish ambassador in Washington, Antonio Garrigues Díaz-Cañabate, held a meeting with José García-Mazas, who by then was attempting to raise support for the erection of a monument to the Huntingtons in Madrid. Since the collapse of discussions over the Huntington Foundation in 1956, García-Mazas had continued to act as a link between Anna Huntington and Spain, carrying out minor business for her and working on his book on the Huntingtons, *El poeta y la escultora*, which also appeared in 1963. He also continued to press upon various Spanish institutions the need for a truly substantial monument to Archer Huntington in Spain. Some of his projects were minor—such as offering examples of Anna Huntington's work to different Spanish cities—but in 1958 he had organized the formal donation of

66. Carlos Robles Piquer to Gregorio Marañón Moya, July 11, 1963, box 54, file 3811, Agencia Española de Cooperación Internacional para el Desarrollo (AECID), Archivo Central, Instituto de Cultura Hispánica.

two busts of Archer by Anna to the Casa-Museo del Greco in Toledo and the Casa-Museo de Cervantes in Valladolid by contacting Francisco Sánchez Cantón, then president of the Fundaciones Vega-Inclán.[67] Later he worked with Juan de Ávalos, a traditionalist sculptor much favored by the Franco regime, on creating new castings of Anna Huntington's statues *El Cid Campeador* and *The Torch Bearers*, which were presented to the city of Valencia in 1964.

During the same period, García-Mazas had also encouraged Ávalos to begin work on a full-scale Huntington monument, the initial design of which was presented to the Spanish press in October 1962.[68]

In a letter sent to Ambassador Garrigues the very day after their November 1963 meeting, García-Mazas informed him that Juan de Ávalos was prepared to create the monument he had already designed without payment, needing only the materials to do so, and asked Garrigues to intervene to ensure that the project could proceed. "I beg you to obtain a decision from Don Gregorio Marañón Moya and Don Carlos Robles on this matter," he insisted, "I can obtain the $30,000 in New York, but it seems to me that this should be a tribute from Spain." He urged the ambassador to accelerate the process so that the central figures of the monument could be exhibited in the future Spanish Pavilion at the New York World's Fair in 1964, "to show the whole world, and North Americans in particular, the manner in which Spain knows how to thank its sincere and unconditional friends." As an added incentive García-Mazas also informed Garrigues of the contacts he had been making in New York to seek options for a possible permanent site for the Spanish Pavilion. "The idea of the Spanish Consul, Sr. Bañón, is that the Spanish Pavilion, after the Fair has ended, since it can be disassembled, could be brought into the city and made into a Spanish Institute [that would be a] worthy home for Spanish cultural activities in this metropolis, and I see that this is of interest to Your Excellency." García-Mazas claimed that he had already

67. José García-Mazas to Francisco Sánchez Cantón, Oct. 7, 1958, box 31, AHHP, SCRC. The two busts were eventually presented and unveiled in 1962.

68. *El Alcázar*, Oct. 3, 1962, newspaper clipping, box 54, file 3811, AECID.

begun conversations with New York University through its vice chancellor, General Frank Howley, with the intention of getting the university to cede some land as a site for the pavilion in Manhattan.[69]

It appears that García-Mazas's meeting with the ambassador had some effect; after another two months, formal steps were taken in Spain to constitute an interministerial commission to coordinate efforts by all the relevant bodies in preparing the expected tribute to the Huntingtons.[70] The "Note to the Minister" of January 30, 1964, from the secretary of the Institute of Hispanic Culture, Enrique Suárez de Puga, to Foreign Minister Fernando Castiella is an indispensable source for understanding the Spanish regime's intentions and ambitions in pursuing this initiative and for identifying the continuing role of José García-Mazas. According to this same note, the idea had also been mentioned of obtaining financial support from Anna Hyatt Huntington for the purchase of a site in Manhattan to be a permanent location for the Spanish Pavilion of the World's Fair. Designed by Javier Carvajal, this pavilion was already widely admired and had been described in *Life* magazine as "the Jewel of the Fair." As Suárez de Puga pointed out, "One does not need great imagination to realize the great interest there would be in the establishment of a Spanish Institute of this quality in the City of New York."[71]

69. José García-Mazas to Antonio Garrigues Díaz-Cañabate, Nov. 6, 1963, box 33, AHHP, SCRC.

70. A "preparatory meeting" on the question of a Huntington monument had also been held in July 1963 but apparently without any practical result. Instituto de Cultura Hispánica to Head of the United States Section, Foreign Ministry, Madrid, July 23, 1963, box 54, file 3811, AECID.

71. "Note to the Minister" from Secretary-General of the Institute of Hispanic Culture Enrique Suárez de Puga, Jan. 30, 1964, box 54, file 3811, AECID. It is highly probable that the idea of linking a Huntington monument to the World's Fair pavilion and of seeking money from Anna Huntington to acquire land in Manhattan had come from García-Mazas, who, as we have seen, had been trying for years to get a monument erected in honor of the Huntingtons in Spain and perhaps saw in the recent accumulation of circumstances an ideal opportunity to exert pressure to obtain a favorable decision. In 1958, he had met the elder Gregorio Marañón (who died in 1960) in Toledo, and it appears the eminent doctor had welcomed the idea of a Huntington monument with enthusiasm.

The Interministerial Commission set up to organize the tribute to the Huntingtons met on seven occasions between April 1964 and December 1966. The first meeting on April 28, 1964, brought together representatives of a wide range of institutions: the director of the Institute of Hispanic Culture, Gregorio Marañón Moya; the US ambassador to Spain, Robert F. Woodward; the head of the Instituto de España, the marquis of Lozoya; the rector of Madrid Central University (the university's highest authority), Segismundo Royo Villanova, and its dean of the Faculty of Philosophy, José Camón Aznar; the mayor of Madrid, José Finat Escrivá de Romaní; and several directors general at the Foreign Ministry, including Alfonso de la Serna of cultural relations, Gratiniano Nieto of fine arts, Miguel García Lomas of architecture, Carlos Robles Piquer of information, and Suárez de Puga himself.[72]

In the course of this and subsequent meetings, the overall appearance of a future tribute to the Huntingtons and its associated program were decided. An avenue in a residential area would be renamed "Calle de los Huntington," special medals would be minted in their honor, and there would be academic ceremonies, an exhibition at the Biblioteca Nacional, and, finally, the definitive commissioning of a sculpture from Juan de Ávalos to be placed in the Ciudad Universitaria of Madrid. Dates were

In a letter García-Mazas sent to Dr. Marañón on October 7, 1958, he wrote, "As one can see that you are very busy, I ask that you pass this business on to your son Gregorio [Marañón Moya], who, as Secretary of the 'Spanish Friends of the United States,' will take charge of bringing it to a conclusion." In this same letter, García-Mazas also insisted on forming a committee to administer the creation of a Huntington monument, in which he proposed to include old friends or acquaintances of Huntington, such as Francisco Sánchez Cantón, Ramón Menéndez Pidal, and Juan Francisco de Cárdenas. When he saw, therefore, that the Institute of Hispanic Culture and the Spanish authorities were once again showing interest in a tribute to the Huntingtons in 1963–64, he was able to take advantage of this new attitude and repeat his proposal with a ready-made design for a monument, created by Juan de Ávalos the previous year. José García-Mazas to Gregorio Marañón, Oct. 7, 1958, box 31, AHHP, SCRC.

72. Interministerial Commission, minutes of meeting, Apr. 28, 1964, box 54, file 3811, AECID.

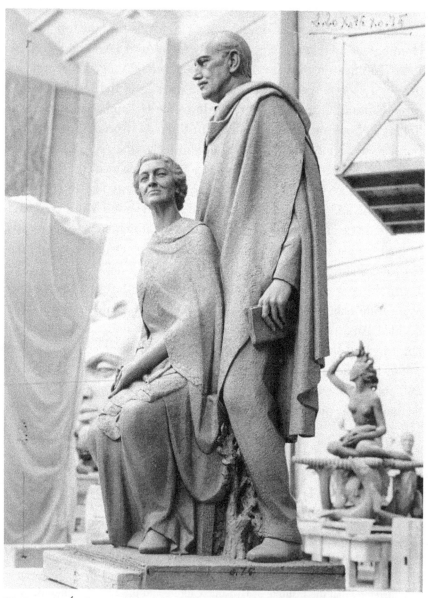

20. Juan de Ávalos, sculpture of Archer M. Huntington and Anna Hyatt for the proposed Huntington Monument, Madrid, 1964. *Source*: Box 54, folder 3811, Central Archive, Instituto de Cultura Hispánica, Agencia Española de Cooperación Internacional para el Desarrollo, Madrid. By permission of Agencia Española de Cooperación Internacional para el Desarrollo.

21. Juan de Ávalos, scale model of the Huntington Monument, 1964. *Source*: Box 54, folder 3811, Central Archive, Instituto de Cultura Hispánica, Agencia Española de Cooperación Internacional para el Desarrollo, Madrid. By permission of Agencia Española de Cooperación Internacional para el Desarrollo.

agreed for the main events of the commemoration, which were initially to be held toward the end of October 1964.[73]

The monument proposed by Ávalos would consist of a large, triangular granite plinth, surrounded by steps, with at its center a large obelisk that would be quite plain except for a ring of six female figures sculpted in relief at about a height of six meters and in front of this obelisk a bronze sculpture almost two and a half meters tall with figures of the Huntingtons. Archer would be standing, wearing a Spanish cape, while Anna would be seated in front of him, with a Spanish mantilla around her shoulders and sculptors' tools in her hands. In total, the monument would be more than fourteen meters (forty-six feet) high.

It was agreed that its location should be an area of gardens within the Ciudad Universitaria between the Museum of America and the Aeronautical Engineering Faculty, which would be renamed the Jardín de los Huntington.

The first disagreements from members of the Interministerial Commission came from Dean of Philosophy José Camón Aznar, who in July 1964, after seeing photos of models of the monument supplied by Ávalos, raised serious doubts regarding the suitability of a monument to the Huntingtons of such size and permanence in the Ciudad Universitaria. "We lack monuments to Cardinal Cisneros [the great cardinal and statesman of the era of Ferdinand and Isabella, who founded what is now the university in Madrid], to all the great geniuses of Spain, and to the very King who initiated this Ciudad Universitaria," he wrote to Marañón Moya. "We may find ourselves in the situation that, between San Martín [the general and leader of Argentinian independence] and the Huntingtons, the only people with statues are foreigners. In the case of Huntington, however much of a benefactor he may have been for our culture, he is not a personality of weight in universal science. For this reason, I believe we should reconsider before erecting this monument to perpetuate his memory because this is the highest form of consecration that Spanish science can provide." Camón Aznar went on to add that "with the award of honors, with the

73. Interministerial Commission, minutes of meeting, June 10, 1964, box 54, file 3811, AECID.

celebration of some sort of official ceremony, with the placing of a plaque on an official building, our gratitude would be [suitably] demonstrated."[74]

In some ways he was right, for a monument of this size did not make sense in the Ciudad Universitaria if one did not also take into account, alongside the Huntingtons' merits, considerations of a more political nature, as Suárez de Puga felt obliged to explain in a later meeting. As the minutes record, "[Suárez de Puga] allowed himself to explain that this tribute did not only have the nature of a demonstration of gratitude for the work of Mr. and Mrs. Huntington, but also looked to the future, in that it was hoped that the Huntington Foundation [sic] would resume its collaboration with Spain, which had been so fruitful in the past, especially in view of the possibilities offered by the eventual [permanent] installation of the Spanish Pavilion from the New York World's Fair."[75]

The commission decided to continue with its plans for a memorial but asked for a new design for a monument from the architect Pascual Bravo, who had already designed several buildings in the Ciudad Universitaria. He proposed a very different monument: a large pool surrounded by a low stone wall, with at one end a vertical slab, also in stone, bearing a bronze medallion with the Huntingtons' profiles. This would not be built in the Ciudad Universitaria as such but in the Parque del Oeste just to its west. This change provoked further delays and a conflict with Juan de Ávalos.

As Enrique Suárez de Puga subsequently described in a report to the Institute of Hispanic Culture, at the beginning of 1965 he traveled to the United States and on January 23 went with García-Mazas to see Anna Huntington, then age eighty-eight, in Connecticut. His purposes were, first, to show her the draft design for the monument prepared by Pascual Bravo and, second, to reach some decisions on the options put forward by the Institute of Hispanic Culture regarding the future of the Spanish Pavilion. To his disappointment, as Suárez de Puga explained, the effect of

74. José Camón Aznar to Gregorio Marañón Moya, July 17, 1964, box 54, file 3811, AECID.

75. Interministerial Commission, minutes of meeting, Sept. 28, 1964, box 54, file 3811, AECID.

this meeting at Stanerigg Farm was to make him abandon the latter project definitively. "I had occasion during a lunch with Mrs. Huntington," he reported, "to outline the possibility that the Hispanic Society of America could be one of the patrons of this institution." However, "I think I can inform you that the Foundation of Mr. and Mrs. Huntington [sic] is not in a suitable condition to take charge of the financial support for our idea."[76] The prospect of being able to tap into financial backing by the Hispanic Society of America for a Spanish cultural center in New York faded rapidly away and with it a good part of the Institute of Hispanic Culture's interest in the Huntington question in general.

García-Mazas, however, still hoped to prevent the Huntington monument being delayed yet again sine die, and so that some use could be made of the work that had already been done he proposed to Suárez de Puga that another location be found for the monument designed by Juan de Ávalos. According to Suárez de Puga's report, García-Mazas argued that "if the architects of the Ciudad Universitaria do not want to approve the monument of Ávalos, [we can] find another place in Madrid where it can be located, and the problem is over."[77] This would at least have been an honorable way out of the conflicts developing in the commission.

As time went by, and no further progress was made, García-Mazas was still not prepared to sit back with his arms crossed in the face of the lack of response from the Spanish authorities and the endless difficulties in finding a solution. He had spent years trying to bring about a monument to the Huntingtons, which in the end would not be erected; he may also have wished to demonstrate his commitment again to Anna Huntington, given a growing gap between them. For several years, as their abundant correspondence reveals, García-Mazas had acted for the Huntingtons as a kind of personal secretary for Spanish affairs. He had regularly asked Anna Huntington for money to cover his personal expenses and to send to his family, but from a certain point this attitude

76. Enrique Suárez de Puga, "Informe del Secretario General sobre su viaje a Estados Unidos," report, Feb. 15, 1965, box 54, file 3811, AECID.

77. Suárez de Puga, "Informe del Secretario General sobre su viaje a Estados Unidos."

22. Pascual Bravo, drawing of the prospective Huntington Monument in Madrid, 1965. *Source*: Fondo Pascual Bravo, Biblioteca de la Escuela Técnica Superior de Arquitectura de la Universidad Politécnica de Madrid, BRAVO_764P_CR001-01_005. By permission of Biblioteca Histórica de la Universidad Politécnica de Madrid, Escuela Técnica Superior de Arquitectura, and Archivo Histórico Digital de la Biblioteca de la Universidad Politécnica de Madrid.

had undermined her confidence in him. Nevertheless, for the Spanish authorities García-Mazas remained the natural point of contact with the elderly sculptor.

Amid this situation, in 1966 García-Mazas wrote an article highly critical of the Spanish authorities for the Sunday supplement of the New York Spanish-language newspaper *El Diario–La Prensa* under the title "Hispanos of New York Have a Debt of Gratitude toward the Huntingtons." It is interesting here to reproduce some of its most polemical paragraphs because they explain why it provoked the intervention of Franco's minister of information and tourism, Manuel Fraga Iribarne.

What is Spain waiting for to show its gratitude to the Huntingtons? Juan de Ávalos, the world-famous Spanish sculptor, received a commission to create a monument[.] . . . [W]hen the sculptor had the work almost finished, he received an order not to continue. . . . It appears to be the case that, in the opinion of those who form part of the [Interministerial] Commission, the sculpture is too big. On the other hand, we hear that the Institution that was due to meet the costs of the monument does not have the money to pay the sculptor . . . [so] a lawsuit. And so we wait! Another twelve years?

Spain, which had seven million dollars to put up a temporary pavilion at the New York World's Fair, does not have $45,000 to pay a debt of gratitude? . . . I propose to the Spanish Societies of New York, and to the Puerto Rican and Hispano-American Societies, that they cooperate and join forces to raise the funds needed to install, here in New York, the monument that Spain has not been able to pay for . . . the monument that Spain has not wanted to pay for.[78]

For the Spanish authorities, García-Mazas had gone much too far, especially by publishing such an article in New York, and a response from the minister of information and tourism was considered necessary. How was it possible, the members of the Spanish government asked, that the proposal to pay tribute to the Huntingtons could have been turned so much against them that they were now labeled ungrateful? A week after the article appeared, a letter from Minister Fraga Iribarne to Gregorio Marañón Moya, who as director of the Institute of Hispanic Culture was considered most directly responsible for the commission, demanded a solution that would remedy the accusations made against the Spanish government. "This article does not mention this Institute [of Hispanic Culture]," observed Fraga Iribarne, "although it does mention the Interministerial Commission constituted under your presidency, and of which the Director General of Information is a member. It would perhaps be

78. José García-Mazas, "Hispanos de Nueva York tienen una deuda de gratitud con los Huntington," *El Diario–La Prensa* (New York), Oct. 2, 1966.

convenient if, once a solution to this matter has been decided, the measures taken to honor the memory of Huntington are communicated to the same newspaper."[79]

An official response came nearly three months later, at the end of December 1966, and not in New York but in the shape of an article in *ABC* of Madrid, which enumerated the decisions approved by the Interministerial Commission. It also gave news of the imminent construction in Madrid of the monument proposed by Pascual Bravo, into which would be incorporated the bronze figures of the two Huntingtons sculpted by Juan de Ávalos. This was an eminently Solomonic solution to the problem.[80]

In the meantime, however, the controversy was not limited to García-Mazas's outburst. A month after his article had appeared in New York, an interview with Juan de Ávalos by the well-known journalist Jesús Hermida was published in the Madrid newspaper *Pueblo*, in which the sculptor explained in considerable detail the process through which he had been commissioned to create the monument, the subsequent rejection of his design, and his legal efforts to reclaim the expenses he had already incurred, amounting to 1,726,000 pesetas (equivalent to $484,328 today). Hermida concluded his article with a reflection: "*Momentum habemus*. This business of the statues is getting difficult. So, too, is that of the Huntingtons. It is a shame because the Huntingtons—Archer and Anna, two great American sculptors, and Spaniards by vocation—do not deserve these controversies."[81]

In effect, the Huntingtons did not deserve such polemics. Their work in and around Spain had been unimpeachable, and they had never looked for but rather had openly refused personal tributes. This interview with Ávalos prompted a further letter from Fraga Iribarne to Gregorio Marañón Moya, who in response committed himself to convening a seventh and last meeting of the Interministerial Commission on December 19,

79. Manuel Fraga Iribarne to Gregorio Marañón Moya, Oct. 8, 1966, box 54, file 3811, AECID.
80. *ABC*, Dec. 27, 1966, press clipping, box 54, file 3811, AECID.
81. Jesús Hermida, "Juan de Avalos: Iré a los tribunales," *Pueblo*, Nov. 1, 1966, press clipping, box 54, file 3811, AECID.

1966. The atmosphere was tense because of the controversies that had been made public over its members' decisions and the need to resolve the financial dispute with Juan de Ávalos.

Marañón Moya, who had a good relationship with Ávalos, had not succeeded up to that point in finding a suitable solution because of a series of questions that seemed impossible to answer. Faced with the sculptor's continuing demands, and unable to delay a resolution any longer, in February 1967 he asked the secretary of the Institute of Hispanic Culture, Suárez de Puga, to see to it that the institute pay some of the amounts still owing. "Last night I was visited by the sculptor Sr. Ávalos," he wrote to his colleague. "Of the payments that he says he is owed by the Institute [Interministerial Commission], of 1,410,000 pesetas [$395,656 today], he humbly asked if it would be possible for us to advance him 170,000 [$47,703 today], which has been demanded of him by the Banco Coca without any possibility of deferral. If it were also possible, in addition, he asks for another 300,000 pesetas [$84,182 today] for two accounts for which he has also received demands. I ask that you come to a decision urgently and inform me on this matter."[82]

One could say that at this point the dispute with Juan de Ávalos was thus more or less resolved, but the monument to the Huntingtons had become an impossibility. In contrast to the apparent ease and simplicity of unveiling a memorial to Archer and Anna Huntington in the Pedralbes Gardens in Barcelona in 1954, the creation of a monument to them in the Ciudad Universitaria of Madrid ten years later revealed itself to be a conflictive project. To understand why, we need to ask what had happened in Spain to bring about such a change in attitude toward the Huntingtons' legacy.

The political context in 1954 had been very different from that of ten years later, the year in which the Interministerial Commission was created to decide on a monument to the Huntingtons. By the end of the 1950s, the Franco regime was comfortably established in power. The official visit of President Eisenhower to Madrid in December 1959 provided definitive

82. Gregorio Marañón Moya to Enrique Suárez de Puga, Feb. 7, 1967, box 54, file 3811, AECID.

confirmation of US support for Franco and his government. As a consequence, the US aspect of Spain's international diplomacy was no longer the sole priority for the regime, and Spain began to look toward Europe with interest. A certain "pro-Europeanism," as Antonio Moreno Juste has called it, began to gain ground not only among ordinary people but also among Spain's elites, which in these years were still impregnated, to varying degrees, with different forms of anti-Americanism.[83]

The moment had come to modernize the country's economy, which, after years of virtual autarchy, exhibited abysmal macroeconomic statistics. A group of technocrats took charge of the Ministerios de Economía y Finanzas (Ministries of the Economy and Finance) with a goal of dragging Spain out of its economic and industrial backwardness, while on a political level the regime had to adapt to the first moves toward European unity with the signing of the Treaty of Rome in 1957 and the formation of the European Economic Community. After years of tight economic restrictions, the initiation of the Plan de Estabilización in 1959 led to Spain's supposed "economic miracle." During the 1960s, the country registered annual growth rates of more than 7 percent. Tourism became a major source of income as the regime constantly exploited the old romantic image of exotic and picturesque Spain with the slogan "Spain Is Different."

In February 1962, Spain formally requested the opening of negotiations to become a member of the European Economic Community. The request was immediately refused because Spain was not a democracy, but nevertheless the regime began to make significant efforts to move closer to the European bloc. However, this desire to open the country economically coexisted with the regime's continuing fierce repression of any movements of opposition to it. In 1962 and 1963, the regime emphatically suppressed labor agitation and strikes, student movements, minority nationalist protests, and notably the attempt by liberal conservatives, the Left, and a broad range of opinion to form a cross-party movement for democracy at a meeting in Munich in June 1962.

83. Antonio Moreno Juste, "Las relaciones España–Europa en el siglo XX: Notas para una interpretación," *Cuadernos de historia contemporánea*, no. 22 (2000): 115.

With these events in the background, a large monument to the Huntingtons such as the one proposed by Juan de Ávalos was of questionable use to the regime, and it was difficult to see what interests it could serve. The year 1959 had seen the inauguration of the Valle de los Caídos (Valley of the Fallen), the vast monument to the Nationalist dead of the Civil War in the mountains north of Madrid, which was intended to become Franco's tomb. It included several works of sculpture by Ávalos, who was then regarded as one of the finest sculptors in Spain. His work on the monument opened many doors to him, and he received major commissions in Spain and abroad as well as many honors in the following years.[84] At first sight, his selection as the sculptor for a monument to the Huntingtons could not have been more ideal, given the sculptural style of Anna Hyatt Huntington and her traditional tastes. Anna admired his work and in fact had already cooperated with him since 1961, with García-Mazas as intermediary, on the production of the new castings of her sculptures *El Cid* and *The Torch Bearers* for the city of Valencia. Nevertheless, it seems clear that the Interministerial Commission did not share this opinion of Ávalos, at least not regarding a monument that was to occupy a prominent location in the Ciudad Universitaria in 1964.

In addition to this political and economic background, it is also necessary to consider the always determined but sometimes misguided actions of José García-Mazas as primary interlocutor between an Anna Huntington in her late eighties and the Spanish authorities. The surviving correspondence reveals the extent to which García-Mazas went back and forth between the various official bodies and the elderly sculptor in his tireless attempts to gather sufficient support for a monument to the Huntingtons that he had committed himself to creating when Archer Huntington was still alive, even against Archer's own wishes.[85] García-Mazas was fully aware that, as he wrote in 1966, had Huntington still been alive, he would

84. Juan de Ávalos was awarded the Gold Medal at the National Exhibition of Art in 1957 and had also been selected for the first Bienal Panamericana.

85. Anna Hyatt Huntington lived on at Stanerigg Farm, continuing to produce large-scale sculptures well into her nineties. She died on October 4, 1973, and is buried next to Archer Huntington in New York.

not have authorized the Spaniard's constant petitions for such a monument and would have disowned his efforts.[86] Moreover, his determination to honor the Huntingtons made him unable to understand the reasons the commission might have for rejecting the design by Juan de Ávalos. His attempts to exert pressure did little to help find solutions, and his criticisms in the press exhausted the patience of the minister of information and tourism, Fraga Iribarne, who wished only to see the matter ended as discreetly as possible.

The Spain of the late 1960s had largely forgotten the great philanthropist and Hispanist at a time when a range of conflicts were generating ever more disaffection among intellectuals and broad sections of society. The opposition to the monument had coincided with a situation in which Spanish society was increasingly calling for cultural openness of a kind that no one could identify with Archer Huntington. The Franco regime itself had for years presented only a one-sided image of this "American friend" to adapt his legacy to its own interests, and this image would eventually become the accepted one in a country that was urgently seeking means of connection with the democratic world. There was no room in this Spain for the complexities of Archer Huntington. His own long shadow, consigned to obscurity for several decades, would not be seen clearly again in Spain until years later, thanks to the unquestionable value of his legacy for Hispanic culture.

86. José García-Mazas, "Sin ánimo de polémica," unpublished text, Oct. 1966, Bravo-76-CO28-02, Huntington Correspondence, Fondo Documental Pascual Bravo, Archivo de la Facultad de Arquitectura, Universidad Politécnica de Madrid.

Bibliography ♦ *Index*

Bibliography

Archives and Documentary Sources Consulted and Abbreviations Used

Agencia Española de Cooperación Internacional para el Desarrollo (AECID), Archivo Central, Instituto de Cultura Hispánica, Madrid.
Archer Milton Huntington Archives (AMHA), Hispanic Society of America, New York.
Archive of the International Institute, Madrid.
Archivo de la Facultad de Arquitectura, Universidad Politécnica de Madrid.
Archivo del Ministerio de Asuntos Exteriores y Cooperación (AMAEC), Madrid.
Archivo del Museo Sorolla, Madrid.
Archivo General de la Administración (AGA), Madrid.
Archivo General de Palacio (AGP), Madrid.
Archivo General de la Universidad Complutense de Madrid.
Biblioteca Menéndez y Pelayo (BMP), Santander.
Biblioteca Virtual Miguel de Cervantes. At https://www.cervantesvirtual.com.
Casa-Museo Unamuno (CMU), Salamanca.
Fundación Antonio Maura, Madrid.
Fundación Menéndez Pidal (FMP), Madrid.
Special Collections Research Center (SCRC), Syracuse Univ. Libraries, Syracuse, NY.
 Huntington, Anna Hyatt, Papers (AHHP).

Exhibition Catalogs

Almarcha Núñez-Herrador, Esther, Patrick Lenaghan, and Isidro Sánchez Sánchez, eds. *Viaje de ida y vuelta: Fotografías de Castilla–La Mancha en the Hispanic Society of America.* Toledo: Empresa Pública Don Quijote de la

Mancha, 2007. Touring exhibition, Toledo and various towns in Castilla–La Mancha, Oct. 8, 2007–Oct. 9, 2016.

Años treinta: Teatro de la crueldad, lugar de encuentro. Madrid: Museo Nacional Centro de Arte Reina Sofía, 2013. Exhibition, Oct. 2, 2012–Jan. 7, 2013.

Arte en guerra. Francia, 1938–1947: De Picasso a Dubuffet. Bilbao: Museo Guggenheim, 2012. Exhibition, Mar. 16–Sept. 8, 2013.

Arte salvado: 70 aniversario del salvamento del patrimonio artístico español y de la intervención internacional. Madrid: Sociedad Estatal de Conmemoraciones Culturales, 2010. Touring exhibition, first held at Paseo del Prado, Madrid, Jan. 25–Mar. 21, 2010.

Bolaños Atienza, María, and Miguel Cabañas Bravo, eds. *Visite España: La memoria rescatada.* Madrid: Museo Nacional del Romanticismo, 2014. Joint exhibition, Biblioteca Nacional and Museo Nacional del Romanticismo, Madrid, Feb. 20–May 18, 2014.

Catalogue of Paintings by Ignacio Zuloaga. New York: Hispanic Society of America, 1909. Exhibition, Mar. 21–Apr. 11, 1909.

Catalogue of Paintings by Joaquin Sorolla y Bastida. New York: Hispanic Society of America, 1909. Exhibition, Feb. 8–Mar. 8, 1909.

De Goya a Zuloaga: La pintura española de los siglos XIX y XX en the Hispanic Society of America. Madrid: Fundación BBVA, 2000. Exhibition, Oct.–Dec. 2000.

España fin de siglo 1898. Barcelona: Fundación la Caixa, 1997. Exhibition, Madrid, Jan. 13–Mar. 29, 1998.

El Greco: Toledo, 1900. Madrid: Ministerio de Cultura, 2009. Exhibition, Toledo, Mar. 9–July 12, 2009.

Guerrero, Salvador, ed. *El arte de saber ver: Manuel B. Cossío, la Institución Libre de Enseñanza y El Greco.* Madrid: Institución Libre de Enseñanza, Fundación Francisco Giner de los Ríos, 2016. Exhibition, Dec. 1, 2016–Apr. 23, 2017.

Ignacio Zuloaga y Manuel de Falla, historia de una amistad. Madrid: CentroCentro Cibeles, 2015. Exhibition, Sept. 25, 2015–Jan. 31, 2016.

Joaquín Sorolla, 1863–1923. Madrid: Museo Nacional del Prado, 2009. Exhibition, May 26–Sept. 13, 2009.

José Maria Sert, le Titan à l'oeuvre. Paris: Paris Musées, 2012. Exhibition, Petit Palais, Paris, Mar. 8–Aug. 5, 2012.

Puig-Samper, Ángel, and Sandra Rebok, eds. *Traspasar fronteras: Un siglo de intercambio científico entre España y Alemania.* Madrid: Consejo Superior

de Investigaciones Científicas; Bonn, Germany: Deutscher Akademischer Austausch Dienst, 2010. Exhibition, Madrid, June 19–Sept. 1, 2010.
Sargent/Sorolla. Madrid: Museo Thyssen-Bornemisza, Caja Madrid, 2006. Exhibition, Oct. 3, 2006–Jan. 7, 2007.
Sculpture by Anna Hyatt Huntington. New York: Hispanic Society of America, 1957. Exhibition, Oct. 15, 1957–Mar. 15, 1958.
Sorolla, an 80th Anniversary Exhibition. New York: Hispanic Society of America, 1989. Exhibition, Mar. 16–May 14, 1989.
Sorolla. Visión de España: Colección de la Hispanic Society of America. Valencia: Fundación Bancaja, 2007. Touring exhibition, Valencia, Seville, Málaga, Bilbao, and Barcelona, Nov. 7, 2007–May 3, 2009.
Sorolla y la Hispanic Society: Una vision de la España de entresiglos. Madrid: Museo Thyssen-Bornemisza, 1998. Exhibition, Nov. 4, 1998–Jan. 17, 1999.
Sorolla y Zuloaga, dos visions para un cambio de siglo. Bilbao: Museo de Bellas Artes de Bilbao, Fundación Cultural Mapfre Vida, 1997. Exhibition, Dec. 19, 1997–Feb. 22, 1998.
Spain, Espagne, Spanien: Foreign Artists Discover Spain, 1800–1900. New York: Spanish Institute, 1993. Exhibition, July 2–Sept. 18, 1993.
Tesoros de la Hispanic Society of America: Visiones del mundo hispánico. Madrid: Museo Nacional del Prado, Hispanic Society of America, 2017. Exhibition, Apr. 4–Sept. 10, 2017.
Velázquez in New York Museums. New York: Frick Collection, 1999. Exhibition, Nov. 16, 1999–Jan. 30, 2000.

General Bibliography

Abellán, José Luis. *Rafael Altamira y el americanismo: Un eslabón de la revolución modernista*. Alicante: Biblioteca Virtual Cervantes, 2005. At https://www.cervantesvirtual.com/nd/ark:/59851/bmcxh003.
Adams, Don, and Arlene Goldbard. "New Deal Cultural Programs: Experiments in Cultural Democracy." [1986] 1995. Webster's World of Cultural Democracy. At http://www.wwcd.org/policy/US/newdeal.html.
Adler, Jerry. "1934: The Art of the New Deal." *Smithsonian Magazine*, June 2009. At https://www.smithsonianmag.com/arts-culture/1934-the-art-of-the-new-deal-132242698/.
Agulhon, Maurice. *Política, imágenes, sociabilidades: De 1789 a 1989*. Zaragoza: Prensas de la Universidad de Zaragoza, 2016.

Álamo, Constancio del. "Las excavaciones de Archer M. Huntington en Itálica." In *El tesoro arqueológico de la Hispanic Society of America*, edited by Manuel Bendala, Constancio del Álamo, Sebastián Celestino, and Lourdes Prados, 152–70. Madrid: Museo Arqueológico Regional, 2009.

Álamo, Constancio del, Manuel Bendala, and Jorge Maier Allende. "Archer Milton Huntington, hispanista y coleccionista." In *El tesoro arqueológico de la Hispanic Society of America*, edited by Manuel Bendala, Constancio del Álamo, Sebastián Celestino, and Lourdes Prados, 18–38. Madrid: Museo Arqueológico Regional, 2009.

Albert Robatto, Matilde. "Federico de Onís entre España y Estados Unidos (1920–1940)." In *Los lazos de la cultura: El Centro de Estudios Históricos de Madrid y la Universidad de Puerto Rico, 1916–1939*, edited by Consuelo Naranjo, María Dolores Luque, and Miguel Ángel Puig-Samper, 237–65. Madrid: Consejo Superior de Investigaciones Científicas; Puerto Rico: Centro de Investigaciones Históricas de la Universidad de Puerto Rico, 2002.

Allendesalazar, José Manuel. "España y Estados Unidos en el siglo XX." *Política exterior* 15, no. 81 (2001): 136–50.

Álvarez Junco, José. *Mater Dolorosa: La idea de España en el siglo XIX*. Madrid: Taurus, 2009.

Álvarez Vallejo, Ignacio, and Mencía Figueroa Villota, eds. *Tesoros taurinos: The Hispanic Society of America*. Madrid: El Viso, 2005.

"Apéndice: Correspondencia entre Sorolla, Huntington y la Hispanic Society, con selecciones del diario de Huntington." In *Sorolla y la Hispanic Society: Una vision de la España de entresiglos*, 371–423. Madrid: Museo Thyssen-Bornemisza, 1998.

Ara Torralba, Juan Carlos, and José Carlos Mainer Baque. *Los textos del 98*. Valladolid: Universidad de Valladolid, 2002.

Arias de Cossío, Ana María, and Covadonga López Alonso. *Manuel B. Cossío a través de su correspondencia, 1879–1934*. Madrid: Fundación Francisco Giner de los Ríos, Publicaciones de la Residencia de Estudiantes, 2014.

Aróstegui, Julio. *La Europa de las Grandes Guerras (1914–1945)*. Madrid: Anaya, 1994.

Arranz Notario, Luis. "El estallido patriótico." In *España fin de siglo 1898*, 334–42. Barcelona: Fundación la Caixa, 1997.

Arroyo Vázquez, María Luz. "La prensa como fuente histórica: La percepción del modelo estadounidense." In *Actas del IV Simposio de Historia Actual*

(Logroño, 17–19 de octubre de 2002), vol. 1, edited by Carlos Navajas Zubeldia, 435–46. Logroño: Instituto de Estudios Riojanos, 2004.

Artola Blanco, Miguel. "Manuel Escandón y Barrón, marqués de Villavieja." In *Trayectorias transatlánticas (siglo XX): Personajes y redes entre España y América*, edited by Manuel Pérez Ledesma, 13–40. Madrid: Polifemo, 2013.

Avilés Farré, Juan. "La mission del duque de Alba en Londres (1937–1945)." In *Propagandistas y diplomáticos al servicio de Franco (1936–1945)*, edited by Antonio César Moreno Cantano, 55–80. Gijón: Trea, 2012.

Balfour, Sebastian. "El hispanismo británico y la historiografía contemporánea en España." In *España: La mirada del otro*, edited by Ismael Saz, 163–82. Madrid: Marcial Pons, 1998.

Barker, Granville. *The Unknown Granville Barker: Letters to Helen & Other Texts 1915–1918*. Edited by Simon Shepherd. London: Society for Theatre Research, 2021.

Barnadas, Josep. "Lewis U. Hanke, 1905–1993: Algunos rasgos de su obra historiográfica." *Boletín del Instituto Riva-Agüero*, número especial 23 (1996): 383–95.

Barón, Javier. "Cossío y Sorolla." In *El arte de saber ver: Manuel B. Cossío, la Institución Libre de Enseñanza y El Greco*, edited by Salvador Guerrero, 193–210. Madrid: Institución Libre de Enseñanza, Fundación Francisco Giner de los Ríos, 2016.

Barrio Marco, José Manuel. "El Quijote y la prosa en Norteamérica, su influencia en Washington Irving: The Sketch Book." In *La huella de Cervantes y del Quijote en la cultura anglosajona*, edited by José Manuel Barrio Marco and María José Crespo Allué, 321–34. Valladolid: Universidad de Valladolid, 2007.

Barrio Marco, José Manuel, and María José Crespo Allué, eds. *La huella de Cervantes y del Quijote en la cultura anglosajona*. Valladolid: Universidad de Valladolid, 2007.

Barrio Moya, José Luis. "Un coleccionista atípico: Don Guillermo Joaquín de Osma." *Goya: Revista de arte*, no. 267 (1998): 364–74.

Bassegoda, Bonaventura. "Josep Pijoan y la Institución Libre de Enseñanza." In *El arte de saber ver: Manuel B. Cossío, la Institución Libre de Enseñanza y El Greco*, edited by Salvador Guerrero, 220–23. Madrid: Institución Libre de Enseñanza, Fundación Francisco Giner de los Ríos, 2016.

Bastida de la Calle, María Dolores. "Fenway Court: Le plaisir de Isabella Stewart Gardner." *Goya: Revista de arte*, no. 273 (1999): 370–74.

Bendala, Manuel, Constancio del Álamo, Sebastián Celestino, and Lourdes Prados, eds. *El tesoro arqueológico de la Hispanic Society of America*. Madrid: Museo Arqueológico Regional, 2009.

Bennett, Shelley M. *The Art of Wealth: The Huntingtons in the Gilded Age*. San Marino, CA: Huntington Library Press, 2013.

Bertrand Dorléac, Laurence, and Jacqueline Munck. "La exposición como lugar de investigación." In *Arte en guerra, Francia, 1938–1947: De Picasso a Dubuffet*, 13–17. Bilbao: Museo Guggenheim, 2012.

Beruete, Aureliano de. *Velázquez*. Paris: Librairie Renouard, 1898. First English edition: *Velázquez*. Translated by Sir Hugh Poynter. London: Methuen, 1906.

Beruete, Aureliano de, Camille Mauclair, Henri Rochefort, Leonard Williams, Elisabeth Luther Cary, James Gibbons Huneker, Christian Brinton, and William E. B. Starkweather. *Ocho ensayos sobre Joaquín Sorolla y Bastida*. 1909. Special edition reproduced to mark the centenary of the Sorolla exhibition at the Hispanic Society of America in 1909. Oviedo: Ediciones Nobel, 2009.

Birmingham, Stephen. *The Grandes Dames*. New York: G. K. Hall, 1982.

Boissevain, Jeremy. *Friends of Friends: Networks, Manipulators and Coalitions*. Oxford: Blackwell, 1974.

Bolaños Atienza, María. "Una edad de plata para los museos." In *En el frente del arte: Ricardo de Orueta, 1868–1939*, edited by María Bolaños Atienza and Miguel Cabañas Bravo, 81–112. Madrid: Acción Cultural Española, 2014.

Bolaños Atienza, María, and Miguel Cabañas Bravo, eds. *En el frente del arte: Ricardo de Orueta, 1868–1939*. Madrid: Acción Cultural Española, 2014.

Boone, Elizabeth M. *Vistas de España: American Views of Art and Life in Spain, 1860–1914*. New Haven, CT: Yale Univ. Press, 2007.

Botrel, Jean François. "Los libreros y las librerías: Tipologías y estrategias comerciales." In *Historia de la edición en España, 1863–1914*, edited by Jesús Martínez Martín, 135–64. Madrid: Marcial Pons, 2001.

Bourdieu, Pierre. *La distinción: Criterio y bases sociales del gusto*. Translated by María del Carmen Ruiz de Elvira. Madrid: Taurus, 2006.

———. *El sentido práctico*. Translated by Ariel Dilon. Madrid: Taurus, 1992.

Boyd, Carolyn P. "El hispanismo norteamericano y la historiografía contemporánea de España en la dictadura franquista." *Historia contemporánea*, no. 20 (2000): 103–16.

Bozal, Valeriano. *Arte del siglo XX en España*. Madrid: Espasa Calpe, 1995.

Brown, Jonathan. "Los cuadros de la Hispanic Society, 1550–1800." In *The Hispanic Society of America: Tesoros*, edited by Patrick Lenaghan, Mitchell Codding, Mencía Figueroa Villota, and John O'Neill, 69–93. Madrid: El Viso, 2000.

———. *Reflexiones de un hispanista a la sombra de Velázquez*. Madrid: Museo Nacional del Prado, 2015.

Burdiel, Isabel. "La construcción de la 'Gran Mujer de Letras Española': Los desafíos de Emilia Pardo Bazán (1851–1921)." In *La historia biográfica en Europa: Nuevas perspectivas*, edited by Isabel Burdiel and Roy Foster, 343–71. Zaragoza: Instituto Fernando el Católico, 2015.

Burke, Marcus B. "Comentarios sobre algunos cuadros." In *Sorolla: The Hispanic Society of America*, edited by Priscilla E. Muller and Marcus B. Burke, 208–35. Madrid: El Viso, 2003.

———. "Velázquez and New York." In *Velázquez in New York Museums*, 13–18. New York: Frick Collection, 1999.

Caballé, Anna, and Randolph D. Pope. *¿Por qué España? Una memoria del hispanismo estadounidense*. Barcelona: Galaxia Gutemberg, 2015.

Cabañas Bravo, Miguel. "Ricardo de Orueta, guardián del arte español: Perfil de un trascendente investigador y gestor político del patrimonio artístico." In *En el frente del arte: Ricardo de Orueta, 1868–1939*, edited by María Bolaños Atienza and Miguel Cabañas Bravo, 21–77. Madrid: Acción Cultural Española, 2014.

———. "La Segunda República Española ante la salvaguarda del patrimonio artístico y la Guerra Civil." In *Arte salvado: 70 aniversario del salvamento artístico español y de la intervención internacional*, 30–41. Madrid: Sociedad Estatal de Conmemoraciones Culturales, 2010.

Cabrera, Mercedes, ed. *José Ortega Spottorno (1916–2016): Un editor, puente entre generaciones*. Madrid: Alianza Editorial, 2016.

Campos Setién, José María de. *La aventura del marqués de la Vega-Inclán*. Valladolid: Ámbito, 2007.

Cañellas Mas, Antonio. *Alfredo Sánchez Bella, un embajador entre las Américas y Europa: Diplomacia y política informativa en la España de Franco (1936–1973)*. Gijón: Trea, 2015.

———. "Caballeros de la Hispanidad: La diplomacia paralela de Alfredo Sánchez Bella." In *Propagandistas y diplomáticos al servicio de Franco (1936–1945)*, edited by Antonio César Moreno Cantano, 273–302. Gijón: Trea, 2012.

———. "Las políticas del Instituto de Cultura Hispánica, 1947–1953." *Historia Actual Online*, no. 33 (2014): 77–91. At https://doi.org/10.36132/hao.v0i33.970.

Capel Martínez, Rosa María. "El archivo de la Residencia de Señoritas." *CEE Participación Educativa*, no. 11 (2009): 156–61. At https://redined.educacion.gob.es/xmlui/bitstream/handle/11162/91781/00820113014342.pdf.

Carnegie, Andrew. "Wealth." *North American Review* 148, no. 391 (1889): 653–64. At https://archive.org/details/8906CarnegieWealth.

Carrasco Martínez, Adolfo. "La trama del tiempo: Algunas consideraciones en torno a lo narrativo en historia." *Cuadernos de historia moderna*, no. 20 (1998): 87–109.

Castillejo, José. "Castillejo visita los Estados Unidos." In *Epistolario de José Castillejo*, vol. 3: *Fatalidad y porvenir, 1913–1937*, edited by David Castillejo Claremont, 411–34. Madrid: Castalia, 1999.

Castillo Gómez, Antonio, ed. *Culturas del escrito en el mundo occidental: Del Renacimiento a la contemporaneidad*. Madrid: Casa de Velázquez, 2015.

Catalán, Diego. "A propósito de una obra truncada de Ramón Menéndez Pidal en sus dos versiones conocidas: Notas históricas y críticas de Diego Catalán." Introduction to Ramón Menéndez Pidal, *Reliquias de la poesía épica hispánica*, xliii–xliv. Madrid: Cátedra-Seminario Menéndez Pidal-Gredos, 1980.

———. *El archivo del Romancero: Patrimonio de la humanidad. Historia documentada de un siglo de historia*. 3 vols. Madrid: Fundación Menéndez Pidal, 2001.

"Catálogo. Retratos: 82. José Echegaray y Eizaguirre." In *Sorolla y la Hispanic Society: Una vision de la España de entresiglos*, 352. Madrid: Museo Thyssen-Bornemisza, 1998.

"Catálogo. Retratos: 87. Juan Ramón Jiménez." In *Sorolla y la Hispanic Society: Una vision de la España de entresiglos*, 352. Madrid: Museo Thyssen-Bornemisza, 1998.

"Catálogo. Fernando Álvarez de Sotomayor, *El duque de Alba*, 1929" (painting). In *De Goya a Zuloaga: La pintura española de los siglos XIX y XX en the Hispanic Society of America*, 154. Madrid: Fundacion BBVA, 2000.

"Catálogo. Miguel Viladrich Vilá: *Frutos de Fraga*, 1914–1923." (painting). In *De Goya a Zuloaga: La pintura española de los siglos XIX y XX en the Hispanic Society of America*, 122. Madrid: Fundacion BBVA, 2000.

Celestino Pérez, Sebastián. "El coleccionismo español de principios del siglo XX: Antonio Vives Escudero." In *El tesoro arqueológico de la Hispanic Society of America*, edited by Manuel Bendala, Constancio del Álamo, Sebastián Celestino, and Lourdes Prados, 88–106. Madrid: Museo Arqueológico Regional, 2009.

Chías Navarro, Pilar. *La Ciudad Universitaria: Génesis y realización*. Madrid: Servicio de Publicaciones de la Universidad Complutense, 1986.

Chislett, William. "El antiamericanismo en España: El peso de la historia." Working document 47/2005. Real Instituto Elcano de Estudios Internacionales y Estratégicos, Madrid, Nov. 15, 2005.

Cicero. *On Old Age, On Friendship, On Divination*. Cambridge, MA: Loeb Classical Library, Harvard Univ. Press, 1923.

Ciplijauskaité, Biruté. "La construcción del yo y la historia de los epistolarios." *Monteagudo*, no. 3 (1998): 61–72.

Codding, Mitchell. "El alma de España en un museo: Archer Milton Huntington y su vision de la Hispanic Society of America." In *The Hispanic Society of America: Tesoros*, edited by Patrick Lenaghan, Mitchell Codding, Mencía Figueroa Villota, and John O'Neill, 15–37. Madrid: El Viso, 2000.

———. "Archer Milton Huntington, Champion of Spain in the United States." In *Spain in America: The Origins of Hispanism in the United States*, edited by Richard L. Kagan, 142–70. Urbana: Univ. of Illinois Press, 2002.

———. "Escribir un poema con un museo: Archer M. Huntington y la Hispanic Society of America." *Goya: Revista de arte*, no. 273 (1999): 375–86.

———. "Visiones del mundo hispánico: Archer M. Huntington y la Hispanic Society, Museo y Biblioteca." In *Tesoros de la Hispanic Society of America: Visiones del mundo hispánico*, 21–38. Madrid: Museo Nacional del Prado, Hispanic Society of America, 2017.

Collins, Randall. *Cadenas de rituales de interacción*. Barcelona: Anthropos, 2009.

Colomer, José Luis. "Competing for a Velázquez: New York Collectors after the Spanish Master." In *Collecting Spanish Art: Spain's Golden Age and America's Gilded Age*, edited by Inge Reist and José Luis Colomer, 251–77. Madrid: Frick Collection, Centro de Estudios Europa Hispánica, 2012.

Colorado Castellary, Arturo. "Arte salvado: Los antecedentes de una deuda histórica." In *Arte salvado: 70 aniversario del salvamento artístico español y de la intervención internacional*, 6–19. Madrid: Sociedad Estatal de Conmemoraciones Culturales, 2010.

———. *Arte y caja de reparaciones: La incautación republicana, la evacuación a México y Ginebra y la gestión franquista*. Madrid: Cátedra, 2023.

Cortés Ibáñez, Emilia. "José Camprubí y *La Prensa*, pilar del hispanismo en Nueva York." *Océanide*, no. 5 (2013). At https://dialnet.unirioja.es/servlet/articulo?codigo=4218251.

Crespo, Lucía, and Enrique Ramírez. *El espíritu del regeneracionismo*. Madrid: Accenture, 2012.

Cruset, Sebastián. "La exposición de Zuloaga en Nueva York." *La ilustración artística*, no. 1433 (1909): 398.

Cucó i Giner, Josepa. *La amistad*. Barcelona: Icaria, 1995.

Cueva Merino, Julio de la. "El rey católico." In *Alfonso XIII: Un político en el trono*, edited by Javier Moreno Luzón, 277–306. Madrid: Marcial Pons, 2003.

De la Cueva, Almudena, and Margarita Márquez Padorno, eds. *Mujeres en vanguardia: La Residencia de Señoritas en su centenario (1915–1936)*. Madrid: Acción Cultural Española, Publicaciones de la Residencia de Estudiantes, 2015.

Delgado Gómez-Escalonilla, Lorenzo. "¿El amigo americano? España y Estados Unidos durante el franquismo." *Studia historica: Historia contemporánea*, no. 21 (2003): 231–76.

———. "Cooperación cultural y científica en clave política: Crear un clima de opinion favorable para las bases USA en España." In *España y Estados Unidos en el siglo XX*, edited by Lorenzo Delgado Gómez-Escalonilla and María Dolores Elizalde Pérez-Grueso, 207–43. Madrid: Consejo Superior de Investigaciones Científicas, 2005.

———. "La diplomacia pública en Estados Unidos: Una perspectiva histórica." *Revista Complutense de Historia de América*, no. 40 (2014): 277–301.

———. *Imperio de papel: Acción cultural y política exterior durante el primer franquismo*. Madrid: Consejo Superior de Investigaciones Científicas, 1992.

———. "Las relaciones culturales de España en tiempos de crisis: De la II República a la Guerra Mundial." *Espacio, tiempo y forma, Serie V: Historia contemporánea*, no. 7 (1994): 259–94.

———. "Las relaciones culturales entre España y Estados Unidos: De la [Segunda] Guerra Mundial a los pactos de 1953." *Cuadernos de historia contemporánea*, no. 25 (2003): 35–59.

Delgado Gómez-Escalonilla, Lorenzo, and María Dolores Elizalde Pérez-Grueso, eds. *España y Estados Unidos en el siglo XX*. Madrid: Consejo Superior de Investigaciones Científicas, 2005.

Spanish Department, Wellesley College. Introduction to *Estudios Hispánicos: Homenaje a Archer M. Huntington*, n.p. Mexico City: Wellesley College, 1952.

D'Ors, Pablo. *Biografía del silencio*. Madrid: Siruela, 2013.

Dosse, François. *La apuesta biográfica: Escribir una vida*. Valencia: Universitat de València, 2007.

Elizalde Pérez-Grueso, María Dolores. "Las relaciones entre España y Estados Unidos en el umbral de un nuevo siglo." In *España y Estados Unidos en el siglo XX*, edited by Lorenzo Delgado Gómez-Escalonilla and María Dolores Elizalde Pérez-Grueso, 19–56. Madrid: Consejo Superior de Investigaciones Científicas, 2005.

Espadas Burgos, Manuel. *La Escuela Española de Historia y Arqueología en Roma: Un guadiana junto al Tíber*. Madrid: Consejo Superior de Investigaciones Científicas, Universidad de Castilla-La Mancha, Publicaciones de la Residencia de Estudiantes, 2000.

Espina, Concha. *Esclavitud y libertad: Diario de una prisionera*. Valladolid: Reconquista, 1938.

———. *Singladuras: Viaje americano*. 1932. Reprint. Madrid: Evohé, 2012.

Espinosa Fernández, Noemí. "La fotografía en los fondos de la Hispanic Society of America: Ruth Matilda Anderson." PhD diss., Universidad de Castilla–La Mancha, 2011.

Espuny Rodríguez, Víctor. "Una conferencia de Rodríguez Marín: M. Pierre Paris en Andalucía." *Cuadernos de los Amigos de los Museos de Osuna*, no. 11 (2009): 25–27.

Faber, Sebastiaan. *Anglo-American Hispanists and the Spanish Civil War: Hispanophilia, Commitment, and Discipline*. New York: Palgrave Macmillan, 2005.

———. "El hispanismo anglosajón y la Guerra Civil Española." *Revista de erudición y crítica*, no. 4 (2007): 101–6.

Fagoaga, Concha. "La relación del grupo de señoritas de la Residencia de Estudiantes con el Lyceum Club." In *Mujeres en vanguardia: La Residencia de Señoritas en su centenario (1915–1936)*, edited by Almudena de la Cueva and Margarita Márquez Padorno, 318–29. Madrid: Acción Cultural Española, Publicaciones de la Residencia de Estudiantes, 2015.

Fernández, James D. "'Longfellow's Law': The Place of Latin America and Spain in U.S. Hispanism, circa 1915." In *Spain in America: The Origins of Hispanism in the United States*, edited by Richard L. Kagan, 122–41. Urbana: Univ. of Illinois Press, 2002.

Fernández Armesto, Felipe. *Nuestra América: Una historia hispana de Estados Unidos*. Madrid: Galaxia Gutenberg, Círculo de Lectores, 2014.

Fernández Bahillo, Hector Odín. "Archer Milton Huntington y Cervantes: Esbozos de un hispanista norteamericano." In *La huella de Cervantes y del Quijote en la cultura anglosajona*, edited by José Manuel Barrio Marco and María José Crespo Allué, 353–65. Valladolid: Universidad de Valladolid, 2007.

———. "España en la vida y obra de Archer Milton Huntington, 1870–1955." PhD diss., Universidad de Valladolid, 2010.

Fernández de Sevilla Morales, Miguel. "Historia jurídico-administrativa de la Ciudad Universitaria de Madrid." PhD diss., Universidad Complutense, Madrid, 1995.

Fernández Lera, Rosa, and Andrés del Rey Sayagués. *El marqués de Jerez de los Caballeros y el duque de T'Serclaes: Una broma bibliográfica*. Santander: Biblioteca Menéndez Pelayo, 2007.

Fernández Rodríguez, Manuel. "Don Elías Tormo y Monzó: Un gran maestro." *Academia: Boletín de la Real Academia de Bellas Artes de San Fernando*, no. 76 (1993): 419–32.

Filreis, Alan. *Counter-Revolution of the Word: The Conservative Attack on Modern Poetry, 1945–1960*. Chapel Hill: Univ. of North Carolina Press, 2008.

Finkebine, Roy E. "Law, Reconstruction and African-American Education." In *Charity, Philanthropy and Civility in American History*, edited by Lawrence J. Friedman and Mark D. McGarvie, 161–78. New York: Cambridge Univ. Press, 2002.

Fontbona de Vallescar, Francesc. "La pintura catalana moderna en la Hispanic Society of America." *e-Art Documents: Revista sobre col.leccions i col.leccionistes*, no. 7 (2014): 139–55. At https://dialnet.unirioja.es/servlet/articulo?codigo=5345763.

Fox Maura, Soledad. "Miradas opuestas: La Casa Blanca y la opinión pública estadounidense ante la Guerra de España." *Circunstancia*, no. 19 (2009). At https://ortegaygasset.edu/wp-content/uploads/2019/05/Circunstancia_Numero_19_Mayo_2009.pdf.

Friedman, Lawrence J. "Philanthropy in America: Historicism and Its Discontents." In *Charity, Philanthropy and Civility in American History*, edited by Lawrence J. Friedman and Mark D. McGarvie, 1–21. New York: Cambridge Univ. Press, 2002.

Friedman, Lawrence J., and Mark D. McGarvie, eds. *Charity, Philanthropy and Civility in American History*. New York: Cambridge Univ. Press, 2002.

Fusi Aizpurúa, Juan Pablo. "Los fundamentos culturales del franquismo." In *España: Sociedad, política y civilización*, edited by José María Jover Zamora, Guadalupe Gómez Ferrer, and Juan Pablo Fusi Aizpurúa, 723–32. Madrid: Areté, 2001.

———. *Historia mínima de España*. Madrid: Turner, 2012.

———. "La república de los intelectuales." In *La España del siglo XX*, edited by Santos Juliá, José Luis García Delgado, Juan Carlos Jiménez, and Juan Pablo Fusi Aizpurúa, 589–613. Madrid: Marcial Pons, 2007.

———. *Un siglo de España: La cultura*. Madrid: Marcial Pons, 1999.

Gaddis, John Lewis. *El paisaje de la historia: Cómo los historiadores representan el pasado*. Barcelona: Anagrama, 2004.

García Felgueira, María de los Santos. *Viajeros, eruditos y artistas: Los europeos ante la pintura española del Siglo de Oro*. Madrid: Alianza Editorial, 1991.

García López, Sonia. "Estados Unidos y la Guerra Civil Española." In *España en armas: El cine de la Guerra Civil Española*, edited by Vicente Sánchez Biosca, 45–52. Valencia: Diputación Provincial de Valencia, 2007.

García-Mazas, José. *El poeta y la escultora: La España que Huntington conoció*. Madrid: Revista de Occidente, 1963.

———. *Spain, Enigma and Reality*. Buenos Aires: Sur Americana, 1954.

———. *Vida y cultura hispánica*. Vol. 4: *De la ilustración al 98*. New York: Eliseo Torres & Sons, 1976.

García-Mazas, José, and Hipólito Escolar, eds. *Primera antología sonora de autores españoles contemporáneos*. New York: Chilton Books Educational Division, 1965.

García Monzón, Isabel. *Viaje a la modernidad: La visión de los Estados Unidos en la España finisecular*. Madrid: Verbum, 2002.

García Muñoz, César. *Historia de un estereotipo: Intelectuales españoles en Estados Unidos (1885–1936)*. Madrid: Langre, 2008.

García Velasco, José. "Un precedente en la Europa del conocimiento: La Junta de Ampliación de Estudios e Investigaciones Científicas (1907–1939)." In *Traspasar fronteras: Un siglo de intercambio científico entre España y Alemania*, edited by Ángel Puig-Samper and Sandra Rebok, 139–68. Madrid: Consejo Superior de Investigaciones Científicas, Deutscher Akademischer Austausch Dienst, 2010.

———, ed. *Redes internacionales de la cultura española, 1914–1939*. Madrid: Publicaciones de la Residencia de Estudiantes, 2014.

———. "El reencuentro con la modernidad: Estrategias y redes internacionales de la cultura española (1914–1939)." In *Redes internacionales de la cultura española, 1914–1939*, edited by José García Velasco, 29–75. Madrid: Publicaciones de la Residencia de Estudiantes, 2014.

García Velasco, José, and Antonio Morales Moya. *La Institución Libre de Enseñanza y la cultura española*. Vol. 2: *La Institución Libre de Enseñanza y Francisco Giner de los Ríos: Nuevas perspectivas*. Madrid: Fundación Francisco Giner de los Ríos, Acción Cultural Española, 2012.

García Zabaleta, Ignacio. "Una gran obra de Zuloaga, Santiago-Echea." *Cuadernos de Ignacio Zuloaga*, no. 1 (1995): 91–102.

Garín, Felipe, and Facundo Tomás. "Joaquín Sorolla y la Generación del 98: El debate después de la modernidad." In *Sorolla y la Hispanic Society: Una vision de la España de entresiglos*, 33–75. Madrid: Museo Thyssen-Bornemisza, 1998.

Generation of '98: Twelve Portraits, Twelve Texts. New York: Hispanic Society of America, 1975.

Gkozgkou, Dimitra. "El matrimonio Byne: Dos hispanistas al servicio de Huntington." *e-Art Documents: Revista sobre Collections i col.leccionistes*, no. 7 (2014): 123–38.

Gómez de la Serna, Ramón. *Some Greguerías*. Translated by Helen Granville-Barker. New York: Rudge's Sons, 1944.

González, María Jesús, and Javier Ugarte, eds. *Juan Pablo Fusi: El historiador y su tiempo*. Madrid: Taurus, 2016.

González Bernaldo de Quirós, Pilar. "La sociabilidad y la historia política." In *Conceptuar lo que se ve, François Xavier Guerra, historiador: Homenaje*, edited by Erika Pani, 1–44. Mexico City: Instituto Mora, 2004.

Gracia, Jordi. "Proceso evolutivo o crisis y conversiones: Los años cincuenta y el viejo falangismo." In *Memoria de la guerra y del franquismo*, edited by Santos Juliá, 319–44. Madrid: Taurus, 2006.

Grattan Doyle, Henry. "Huntington and His Contribution to Hispanic Scholarship." In *Huntington, 1870–1955*, 26–31. Washington, DC: Organization of American States, Comité Interamericano de Bibliografía, Pan American Union, 1957.

Guardia Herrero, Carmen de la. "Diásporas culturales: Los republicanos españoles y la transformación del hispanismo estadounidense." *Miríada hispánica*, no. 1 (2010): 117–28.

———. "Las relaciones entre Estados Unidos y España en la época de Huntington." In *El tesoro arqueológico de la Hispanic Society of America*, edited by Manuel Bendala, Constancio del Álamo, Sebastián Celestino, and Lourdes Prados, 50–62. Madrid: Museo Arqueológico Regional, 2009.

———. *Victoria Kent y Louise Crane en Nueva York: Un exilio compartido*. Madrid: Silex, 2015.

Habermas, Jürgen. "L'espace public, 30 ans après." *Quaderni*, no. 18 (1992): 161–91.

Hall, Morgan. "El rey imaginado: La construcción política de la imagen de Alfonso XIII." In *Alfonso XIII: Un politico en el trono*, edited by Javier Moreno Luzón, 59–82. Madrid: Marcial Pons, 2003.

Hammack, David. "Failure and Resilience: Pushing the Limits in Depression and Wartime." In *Charity, Philanthropy and Civility in American History*, edited by Lawrence J. Friedman and Mark D. McGarvie, 263–80. New York: Cambridge Univ. Press, 2002.

Harris, Jonathan. *Federal Art and National Culture: The Politics of Identity in New Deal America*. New York: Cambridge Univ. Press, 1995.

Harris, Neil. *The Artist in American Society: The Formative Years, 1790–1860*. Chicago: Univ. of Chicago Press, 1982.

Hébert, John R. *The Hispanic and Portuguese Collections: An Illustrated Guide*. Washington, DC: Library of Congress, 1996.

Hernández Barral, José Miguel. "Duques, marqueses y condes: Un grupo social de otro tiempo a principios del siglo XX." In *No es país para jóvenes: Actas del Encuentro de Jóvenes Investigatores*, edited by Alejandra Ibarra Aguirregabiria. Valencia: Instituto Valentín Foronda, 2012. Online version at https://dialnet.unirioja.es/servlet/articulo?codigo=4721375.

———. "Luchando por la exclusividad: Grandes de España y concesiones nobiliarias, 1914–1931." In *Nuevos horizontes del pasado: Culturas políticas, identidades y formas de representación. Actas del X Congreso de la Asociación de Historia Contemporánea*, edited by Ángeles Barrio Alonso, Jorge de Hoyos Puente, and Rebeca Saavedra Arias. Santander: Ediciones de la Universidad de Cantabria, 2011.Online version at https://nobles.unican.es/index.php-option=com_phocadownload&view=category&download=61-hernandez-jose-luchando-por-la-exclusividad&id=3-estudios&Itemid=525.pdf.

———. *Perpetuar la distinción: Grandes de España y decadencia social, 1914–1931*. Madrid: Ediciones 19, 2014.

———. "Ser noble en la España de Alfonso XIII." *Cuadernos de historia contemporánea*, no. 32 (2010): 175–95.

Hilton, Sylvia. "Estudio introductorio. Relaciones históricas hispano-estadounidenses: Visions del siglo XX en clave cultural." *Revista Complutense de Historia de América*, no. 36 (2010): 13–35.

———. "República e imperio: Los federalistas españoles y el mito americano, 1895–1898." *Ibero-America Pragensia*, no. 34 (1998): 11–29.

"Hispanic Division Celebrates 65 Years." *Library of Congress Information Bulletin*, Dec. 2004. At https://www.loc.gov/loc/lcib/0412/index.html.

A History of the Hispanic Society of America: Museum and Library, 1904–1954. New York: Hispanic Society of America, 1954.

Hobsbawm, Eric. *Fractured Times: Culture and Society in the Twentieth Century*. London: Little, Brown, 2013.

Hughes, Robert. *Culture of Complaint: The Fraying of America*. New York: Oxford Univ. Press, 1993.

Huntington, Archer Milton. *A Note-book in Northern Spain*. New York: Putnam, 1898.

Huntington, 1870–1955. Washington, DC: Organization of American States, Comité Interamericano de Bibliografía, Pan American Union, 1957.

Hyatt Mayor, Alpheus. Introduction to *A Century of American Sculpture: Treasures from Brookgreen Gardens*, edited by Walton H. Rawls, 24–30. New York: Abbeville Press, 1981.

Iglesias, María del Carmen. "La marca de lo nuevo." In *España fin de siglo 1898*, 368–72. Barcelona: Fundación La Caixa, 1997.

Imízcoz Beunza, José María, and Lara Arroyo Ruiz. "Redes sociales y correspondencia escolar: Del análisis cualitativo de las relaciones personales a la reconstrucción de redes egocentradas." *Redes*, no. 21 (2011): 98–138.

Innerarity, Daniel. *El nuevo espacio público*. Madrid: Espasa Calpe, 2006.

Irujo, Xabier. *Gernika: The Market Day Massacre*. Reno: Univ. of Nevada Press, 2015.

Jackson, Gabriel. "II República, New Deal y Guerra Civil." In *España y Estados Unidos en el siglo XX*, edited by Lorenzo Delgado Gómez-Escalonilla and María Dolores Elizalde Pérez-Grueso, 113–23. Madrid: Consejo Superior de Investigaciones Científicas, 2005.

Jaksic, Ivan. *Ven conmigo a la España lejana: Los intelectuales norteamericanos ante el mundo hispano, 1820–1880*. Santiago de Chile: Fondo de Cultura Económica, 2007.

Jiménez, Juan Ramón. *Diario de un poeta recién casado*. Madrid: Casa Editorial Calleja, 1917.

Jiménez Blanco, María Dolores. "Archer Milton Huntington y el viaje del arte español." In *El arte y el viaje*, edited by Miguel Cabañas Bravo, Amelia López-Yarto Elizalde, and Wilfredo Rincón García, 673–82. Madrid: Consejo Superior de Investigaciones Científicas, 2011.

———. "Descubrimientos. Coleccionistas americanos y arte español: Historias de una atracción." In *Tesoros de la Hispanic Society of America: Visiones del mundo hispánico*, 39–60. Madrid: Museo Nacional del Prado; New York: Hispanic Society of America, 2017.

———. "Spanish Art and American Collections." In *When Spain Fascinated America*, edited by Ignacio Suárez-Zuloaga, 61–77. Madrid: Fundación Zuloaga, Ministerio de Cultura del Gobierno de España, 2010.

Jiménez Blanco, María Dolores, and Cindy Mack. *Arte español en Nueva York*. Madrid: El Viso, 2004.

Jimenez-Landi Martínez, Antonio. *Breve historia de la Institución Libre de Enseñanza, 1896–1939*. Madrid: Tebar D.L., 2010.

Jover Zamora, José María. *Los 98 Ibéricos y el mar*. Vol. 1: *La Península Ibérica en sus relaciones internacionales*. Madrid: Sociedad Estatal Lisboa 98, 1998.

Jover Zamora, José María, and Guadalupe Gómez-Ferrer. "La política del recogimiento y la pérdida de las islas de ultramar." In *España: Sociedad, política y civilización*, edited by José María Jover Zamora, Guadalupe Gómez Ferrer, and Juan Pablo Fusi Aizpurúa, 429–52. Madrid: Areté, 2001.

Juan Bolufer, Amparo de. "Ramón Pérez de Ayala y la Hispanic Society: Nueva documentación y un poema inédito." *Moenia*, no. 18 (2012): 175–99.

Juliá, Santos. "Los intelectuales y el rey." In *Alfonso XIII: Un politico en el trono*, edited by Javier Moreno Luzón, 307–36. Madrid: Marcial Pons, 2003.

———. "Memoria, historia y política de un pasado en guerra y dictadura." In *Memoria de la guerra y del franquismo*, edited by Santos Juliá, 27–77. Madrid: Taurus, 2006.

———, ed. *Memoria de la guerra y del franquismo*. Madrid: Taurus, 2006.

Juliá, Santos, José Luis García Delgado, Juan Carlos Jiménez, and Juan Pablo Fusi Aizpurúa, eds. *La España del siglo XX*. Madrid: Marcial Pons, 2007.

Kagan, Richard L. "El marqués de la Vega-Inclán y el patrimonio artístico español: ¿Protector o expoliador?" In *Nuevas contribuciones en torno al mundo del coleccionismo de arte hispánico en los siglos XIX y XX*, edited by Immaculada Socias and Dimitra Gkozgkou, 193–203. Gijón: Trea, 2013.

———. "El paradigma de Prescott: La historiografía norteamericana y la decadencia de España." *Manuscrits: Revista d'història moderna*, no. 16 (1998): 229–53.

———, ed. *Spain in America: The Origins of Hispanism in the United States*. Urbana: Univ. of Illinois Press, 2002.

———. *The Spanish Craze: America's Fascination with the Hispanic World, 1779–1939*. Lincoln: Univ. of Nebraska Press, 2019.

———. "The Spanish Craze: The Discovery of Spanish Art and Culture in the United States." In *When Spain Fascinated America*, edited by Ignacio Suárez-Zuloaga, 25–46. Madrid: Fundación Zuloaga, Ministerio de Cultura del Gobierno de España, 2010.

Kohlstedt, Sally Gregory. "Innovative Niche Scientists: Women's Role in Reframing American Museums, 1880–1930." *Centaurus* 55, no. 2 (2013): 153–74.

Laín Entralgo, Pedro. *Descargo de conciencia, 1930–1960*. Barcelona: Seix Barral, 1976.

Lavín Berdonces, Ana Carmen. "La consagración del mito del Greco en Toledo: Vega-Inclán, el museo del Greco y el homenaje de 1914." In *El Greco: Toledo, 1900*, 171–209. Madrid: Ministerio de Cultura, 2009.

Lea, Henry Charles. "The Decadence of Spain." *Atlantic Monthly*, July 1898.

Le Breton, David. "Por una antropología de las emociones." *Revista Latinoamericana de estudios sobre cuerpos, emociones y sociedad*, year 4, no. 10 (2012): 69–79. At https://www.relaces.com.ar/index.php/relaces/article/view/239/236.

Le Goff, Jacques. *Lo maravilloso y lo cotidiano en el Occidente medieval*. Translated by Alberto Luis Bixio. Barcelona: Gedisa, 2008.

Lenaghan, Patrick. "Archer M. Huntington y las fotografías sobre arqueología española." In *El tesoro arqueológico de la Hispanic Society of America*, edited by Manuel Bendala, Constancio del Álamo, Sebastián Celestino, and Lourdes Prados, 210–25. Madrid: Museo Arqueológico Regional, 2009.

———. "El Greco de Toledo en la Nueva York de Archer Huntington." In *El Greco: Toledo, 1900*, 141–55. Madrid: Ministerio de Cultura, 2009.

———. "Un retrato de España: Huntington, Sorolla y Zuloaga en la Hispanic Society of America." In *Tesoros de la Hispanic Society of America: Visiones del mundo hispánico*, 61–83. Madrid: Museo Nacional del Prado, Hispanic Society of America, 2017.

Lenaghan, Patrick, Mitchell Codding, Mencía Figueroa Villota, and John O'Neill, eds. *The Hispanic Society of America: Tesoros*. Madrid: El Viso, 2000.

Lenaghan, Patrick, and Noemí Espinosa Fernández. *Visiones de Latinoamérica en la Hispanic Society of America: Vistas urbanas*. Madrid: El Viso, 2018.
León Aguinaga, Pablo. "Los canales de la propaganda norteamericana en España, 1946–1960." *Ayer*, no. 75 (2009): 133–58.
López Fernández, María. *Arte y estética de fin de siglo (1890–1914)*. Madrid: Instituto de Cultura, Fundación Mapfre, 2008.
López Sánchez, José María. *Heterodoxos españoles: El Centro de Estudios Históricos, 1910–1936*. Madrid: Marcial Pons, Consejo Superior de Investigaciones Científicas, 2006.
López Vega, Antonio. *1914: El año que cambió la historia*. Madrid: Taurus, 2014.
———. *Epistolario inédito: Marañón, Ortega, Unamuno*. Madrid: Espasa, 2008.
———. *Gregorio Marañón: Radiografía de un liberal*. Madrid: Taurus, 2011.
López Vega, Antonio, and José Antonio Montero Jiménez. "España–Estados Unidos: 200 años de miradas cruzadas." *Revista de Occidente*, no. 389 (2013): 61–77.
López Vidriero, María Luisa. "La biblioteca de the Hispanic Society of America." In *The Hispanic Society of America: Tesoros*, edited by Patrick Lenaghan, Mitchell Codding, Mencía Figueroa Villota, and John O'Neill, 39–68. Madrid: El Viso, 2000.
López Zapico, Misael Arturo. "Against All Odds: El diplomático Juan Francisco de Cárdenas durante la Guerra Civil Española y el primer franquismo." In *Propagandistas y diplomáticos al servicio de Franco (1936–1945)*, edited by Antonio César Moreno Cantano, 303–30. Gijón: Trea, 2012.
Loriga, Sabina. "La biographie comme problème." In *Jeux d'échelles*, edited by Jacques Révél, 209–31. Paris: Gallimard, Le Seuil, 1996.
———. "La escritura biográfica y escritura histórica de los siglos XIX y XX." In *La historia biográfica en Europa: Nuevas perspectivas*, edited by Isabel Burdiel and Roy Foster, 15–45. Zaragoza: Instituto Fernando el Católico, 2015.
Luna Fernández, Juan J. "Introducción al itinerario pictórico español." In *De Goya a Zuloaga: La pintura española de los siglos XIX y XX en the Hispanic Society of America*, 27–37. Madrid: Fundación BBVA, 2000.
Maher, Neil M. *Nature's New Deal: The Civilian Conservation Corps and the Roots of the American Environmental Movement*. New York: Oxford Univ. Press, 2007.
Maier Allende, Jorge. "Archer Milton Huntington, Jorge Bonsor y la arqueología andaluza." In *El tesoro arqueológico de la Hispanic Society of America*,

edited by Manuel Bendala, Constancio del Álamo, Sebastián Celestino, and Lourdes Prados, 108–33. Madrid: Museo Arqueológico Regional, 2009.

———. *Epistolario de Jorge Bonsor (1886–1930)*. Madrid: Real Academia de Historia, 1999.

Mainer Baque, José Carlos. *La Edad de Plata (1902–1939): Ensayo de interpretación de un proceso cultural*. Madrid: Cátedra, 1981.

Márquez Macías, Rosario. "Los Huntington en la España de 1929: Una crónica a través de la correspondencia privada." In *Diplomacia y acción cultural americana en la España de Primo de Rivera*, edited by Pilar Cagiao Vila, 115–33. Madrid: Marcial Pons, Universidad Michoacana de San Nicolás de Hidalgo, 2020.

Martínez Ruiz, María José. *La enajenación del patrimonio en Castilla y León, 1900–1936*. Vol. 2. Valladolid: Consejería de Cultura y Turismo de la Junta de Castilla y León, 2008.

———. "Gusto cortesano de los magnates estadounidenses: El impulse para el comercio de tapices antiguos entre España y Estados Unidos." In *Nuevas contribuciones en torno al mundo del coleccionismo de arte hispánico en los siglos XIX y XX*, edited by Immaculada Socias and Dimitra Gkozgkou, 217–47. Gijón: Trea, 2013.

Mathews, Marcia M. "George Biddle's Contribution to Federal Art." *Records of the Columbia Historical Society* 49 (1973–74): 493–520.

McAllister, Samuel Ward. *Society as I Have Found It*. New York: Cassel, 1890.

McCarthy, Jane, and Laurily Keir Epstein. *A Guide to the Sculpture Parks and Gardens of America*. New York: Michael Kesend, 1996.

McCarthy, Kathleen. "Women and Political Culture." In *Charity, Philanthropy and Civility in American History*, edited by Lawrence J. Friedman and Mark D. McGarvie, 179–98. New York: Cambridge Univ. Press, 2002.

Mendoza Díaz-Maroto, Francisco. *La pasión por los libros: Un acercamiento a la bibliofilía*. Madrid: Espasa, 2002.

Menéndez Pidal, Ramón. "Un recuerdo de juventud." In *Estudios Hispánicos: Homenaje a Archer M. Huntington*, 1–13. Mexico City: Wellesley College, 1952.

Menéndez Robles, María Luisa. "El Greco, Vega-Inclán y Huntington." *e-Art Documents: revista sobre col.leccions i col.leccionistes* no. 7 (2014). At http://www.fuesp.com/pdfs_revistas/cai/47/cai-47-5.pdf.

———. *El marqués de la Vega-Inclán y los orígenes del turismo en España*. Madrid: Ministerio de Industria y Comercio, 2006.

———. "Un mecenas atípico: El II marqués de la Vega-Inclán." In *El reverso de la la historia del arte: Exposiciones, comercio y coleccionismo (1850–1950)— el revers de la història de l'art: Exposicions, comerç i col.leccionisme (1850– 1950)*, edited by Esther Alsina Galofré and Clara Beltrán Catalán, 201–12. Gijón: Trea, 2015.

———. "Un mecenas en la España alfonsina: El II marqués de la Vega-Inclán, 1858–1942." PhD diss., Universidad Nacional de Educación a Distancia, Madrid, 2004.

Merino de Cáceres, José María, and María José Martínez Ruiz. *La destrucción del patrimonio artístico español: W. R. Hearst, el gran acaparador.* Madrid: Cátedra, 2013.

Messent, Peter. *Mark Twain and Male Friendship: The Twitchell, Howells, and Rogers Friendships.* Oxford: Oxford Univ. Press, 2009.

Millás Vallicrosa, José María. *Breve semblanza de Mr. Archer M. Huntington.* Barcelona: Ayuntamiento de Barcelona, 1954.

Mitchell, Mary, and Albert Goodrich. *The Remarkable Huntingtons, Archer and Anna: Chronicle of a Marriage.* Pawleys Island, SC: Litchfield, 2008.

Montero Jiménez, José Antonio. *El despertar de la gran potencia: Las relaciones entre España y los Estados Unidos (1898–1930).* Madrid: Biblioteca Nueva, 2011.

———. "Diplomacia pública, debate politico e historiografía en la política exterior de los Estados Unidos (1938–2008)." *Ayer*, no. 75 (2009): 63–95.

———. "Estados Unidos y España frente a la Primera Guerra Mundial." *Historia y política*, no. 32 (2014): 71–104.

Moradiellos García, Enrique. "Más allá de la leyenda negra y del mito romántico: El concepto de España en el hispanismo británico contemporaneísta." In *España: La mirada del otro*, edited by Ismael Saz, 183–200. Madrid: Marcial Pons, 1998.

Moreno Cantano, Antonio César, ed. *Propagandistas y diplomáticos al servicio de Franco (1936–1945).* Gijón: Trea, 2012.

———. "Proyección propagandística de la España franquista en Norteamérica (1936–1945)." *Hispania Nova: Revista de historia contemporánea*, no. 9 (2009): 1–26.

Moreno Garrido, Ana. *Historia del turismo en España en el siglo XX.* Madrid: Síntesis, 2007.

Moreno Juste, Antonio. "Los católicos españoles y la política europea en los años cuarenta y cincuenta." In *La internacional Católica: Pax Romana en*

la política europea, edited by Glicerio Sánchez Recio, 169–206. Alicante: Biblioteca Nueva, 2005.

———. "España y el espacio público europeo: Entre la herencia del franquismo y la nueva identidad democrática." *Revista de estudios europeos* 44 (2006): 97–115.

———. "Proyecto europeo, espacio público e historia de la integración europea: Notas para un debate." *Ayer*, no. 77 (2010): 21–54.

———. "Las relaciones España–Europa en el siglo XX: Notas para una interpretación." *Cuadernos de historia contemporánea*, no. 22 (2000): 95–133.

Moreno Luzón, Javier, ed. *Alfonso XIII: Un político en el trono*. Madrid: Marcial Pons, 2003.

———. "Alfonso 'el Regenerador': Monarquía escénica e imaginario nacionalista en perspectiva comparada (1902–1931)." *Hispania* 73, no. 244 (2013): 319–48.

———. "Condensar el alma de España: Archer M. Huntington y la internacionalización de la cultura española." In *Redes internacionales de la cultura española, 1914–1939*, edited by José García Velasco, 267–74. Madrid: Publicaciones de la Residencia de Estudiantes, 2014.

———. "Mitos de la España inmortal: Conmemoraciones y nacionalismo español en la España del siglo XX." *Claves de razón práctica*, no. 174 (2007): 26–35.

———. "El rey de papel: Textos y debates sobre Alfonso XIII." *Claves de razón práctica*, no. 133 (2003): 42–55.

———. *El rey patriota: Alfonso XIII y la nación*. Madrid: Galaxia Gutenberg, 2023.

Muller, Priscilla E. "La España amada de Huntington en América: Los tipos, los trajes y el pueblo." In *De Goya a Zuloaga: La pintura española de los siglos XIX y XX en the Hispanic Society of America*, 15–26. Madrid: Fundación BBVA, 2000.

———. "Sorolla y América." In *Sorolla: The Hispanic Society of America*, edited by Priscilla E. Muller and Marcus B. Burke, 9–41. Madrid: El Viso, 2003.

———. "Sorolla y Huntington: Pintor y patrono." In *Sorolla y la Hispanic Society: Una vision de la España de entresiglos*, 119–46. Madrid: Museo Thyssen-Bornemisza, 1998.

Musicant, Ivan. *Empire by Default*. New York: Holt, 1998.

Naranjo, Consuelo. "Compromiso y voluntad: Federico de Onís y la creación del Instituto de las Españas (Nueva York, 1920–1936)." In *Redes internacionales*

de la cultura española, 1914–1939, edited by José García Velasco, 352–58. Madrid: Publicaciones de la Residencia de Estudiantes, 2014.

Naranjo, Consuelo, María Dolores Luque, and Miguel Ángel Puig-Samper, eds. *Los lazos de la cultura: El Centro de Estudios Históricos de Madrid y la Universidad de Puerto Rico, 1916–1939*. Madrid: Consejo Superior de Investigaciones Científicas; Puerto Rico: Centro de Investigaciones Históricas de la Universidad de Puerto Rico, 2002.

Naranjo, Consuelo, and Miguel Ángel Puig-Samper. "Los lazos de la cultura se convierten en lazos de solidaridad: Los inicios del exilio español." In *Los lazos de la cultura: El Centro de Estudios Históricos de Madrid y la Universidad de Puerto Rico, 1916–1939*, edited by Consuelo Naranjo, María Dolores Luque, and Miguel Ángel Puig-Samper,307–19. Madrid: Consejo Superior de Investigaciones Científicas; Puerto Rico: Centro de Investigaciones Históricas de la Universidad de Puerto Rico, 2002.

Narbona, Cristina. "Prólogo." In Concha Espina, *Singladuras: Viaje americano*, 4–9. Madrid: Evohé, 2012.

Navarrete Martínez, Esperanza. "Archer Milton Huntington y Anna Hyatt Huntington, miembros de la Real Academia de Bellas Artes de San Fernando de Madrid." *Cuadernos de arte e iconografía* 24, no. 47 (2015): 295–310.

Niño, Antonio. *Cultura y diplomacia: Los hispanistas franceses y España, 1875–1931*. Madrid: Consejo Superior de Investigaciones Científicas, 1988.

———. "España y el 98." In *Juan Pablo Fusi: El historiador y su tiempo*, edited by María Jesús González and Javier Ugarte, 137–44. Madrid: Taurus, 2016.

———. "Las relaciones culturales como punto de reencuentro hispano-estadounidense." In *España y Estados Unidos en el siglo XX*, edited by Lorenzo Delgado Gómez-Escalonilla and María Dolores Elizalde Pérez-Grueso, 57–94. Madrid: Consejo Superior de Investigaciones Científicas, 2005.

———. "El rey embajador: Alfonso XIII en la política internacional." In *Alfonso XIII: Un politico en el trono*, edited by Javier Moreno Luzón, 239–76. Madrid: Marcial Pons, 2003.

———. "La rivalidad entre la *Révue Hispanique* and the *Bulletin Hispanique*." In *Cultura y diplomacia: Los hispanistas franceses y España, 1875–1931*, 154–74. Madrid: Consejo Superior de Investigaciones Científicas, 1988.

Niño, Antonio, and José Antonio Montero Jiménez, eds. *Guerra Fría y propaganda: Estados Unidos y su cruzada cultural en Europa y América Latina*. Madrid: Biblioteca Nueva, 2012.

Nogués Blasco, Paloma. *Alfonso XIII: Biografía histórica*. Madrid: Sílex, 1995.
Novo González, Javier. "Ignacio Zuloaga y su utilización por el franquismo." *Ondare: Cuadernos de artes plásticas y documentales*, no. 25 (2006): 233–43.
Núñez Florencio, Rafael. *El peso del pesimismo: Del 98 al desencanto*. Madrid: Marcial Pons, 2010.
Núñez Pérez, María Gloria. "La biografía en la actual historiografía contemporánea española." *Espacio, tiempo y forma, Serie V: Historia contemporánea*, no. 10 (1997): 407–39.
Nykl, Alois Richard, ed. *Archer Milton Huntington, 10 March, 1870–11 December, 1955. In Memoriam*. Bethel, NY: Hispanic Society of America, 1956.
Obenzinger, Hilton. "Peter Messent, *Mark Twain and Male Friendship: The Twitchell, Howells, and Rogers Friendship*" (book review). *Journal of American Studies* 44, no. 3 (Aug. 2010)–. At https://doi.org/10.1017/S0021875810001581.
Ojeda, Jaime de. "La guerra del 98: Una visión americana." *Claves*, no. 84 (1998): 30–37.
Olmos Romera, Ricardo, Trinidad Tortosa, and Juan Pedro Bellón Ruiz, eds. *Repensar la escuela del CSIC en Roma: Cien años de memoria*. Madrid: Consejo Superior de Investigaciones Científicas, 2011.
Onís, Federico de. "Huntington y la cultura hispánica." In *Huntington, 1870–1955*, 18–24. Washington, DC: Organization of American States, Comité Interamericano de Bibliografía, Pan American Union, 1957.
Ordieres, Isabel. *Historia de la restauración monumental en España (1835–1935)*. Madrid: Instituto de Conservación y Restauración de Bienes Culturales, 1995.
Ortega Fernández, Isabel. *Benigno Vega-Inclán, marqués de la Vega-Inclán: Mariano Benlliure Gil, 1931*. Madrid: Museo del Romanticismo, 2013.
Ortega y Gasset, José. "Zuloaga." In *La pintura Vasca, 1909–1919*, 13–40. Bilbao: Biblioteca de los Amigos del País, 1919.
Ortíz García, Carmen. "Raíces hispánicas y culturas americanas: Folkloristas de Norteamérica en el Centro de Estudios Históricos." *Revista de Indias* 67, no. 239 (2007): 125–62.
"El padre David Rubio, O.S.A., y la Fundación Hispánica de la Biblioteca del Congreso de Washington." *Revista nacional de educación*, no. 70 (1947): 75–81.
Palacio, Celia de. *La prensa como fuente para la historia*. Mexico City: Universidad de Guadalajara, 2006.
Pando, Juan. *Un rey para la esperanza: La España humanitaria de Alfonso XIII en la Gran Guerra*. Madrid: Temas de Hoy, 2002.

Patterson, Augusta Owen. *American Homes of To-day: Their Architectural Style, Their Environment, Their Characteristics.* New York: Macmillan, 1924.

Payne, Stanley G. "The Reencounter between the United States and Spain after 1898." In *When Spain Fascinated America*, edited by Ignacio Suárez-Zuloaga, 11–24. Madrid: Fundación Zuloaga, Ministerio de Cultura del Gobierno de España, 2010.

Pereira Castañares, Juan Carlos, and Antonio Moreno Juste. "España ante el proceso de integración europea desde una perspectiva histórica: Panorama historiográfico y líneas de investigación." *Studia historica: Historia contemporánea*, no. 9 (1991): 129–52.

Pereira Castañares, Juan Carlos, José Luis Neila, and Antonio Moreno Juste. *Atlas histórico de la Guerra Fría.* Madrid: Síntesis, 2013.

Pérez Ledesma, Manuel, ed. *Trayectorias transatlánticas (siglo XX): Personajes y redes entre España y América.* Madrid: Polifemo, 2013.

Pérez Segura, Javier. "Rastreando algunos frentes del arte: Trincheras, París y la supervivencia de la vanguardia." In *Revistas, modernidad y guerra*, edited by Jordana Mendelson, 39–52. Madrid: Museo Nacional Centro de Arte Reina Sofía, 2008.

Pérez-Villanueva Tovar, Isabel. "María de Maeztu en la Residencia de Señoritas: Educación y feminismo." In *Mujeres en vanguardia: La Residencia de Señoritas en su centenario (1915–1936)*, edited by Almudena de la Cueva and Margarita Márquez Padorno, 235–45. Madrid: Acción Cultural Española, Publicaciones de la Residencia de Estudiantes, 2015.

La pintura vasca, 1909–1919. Bilbao: Biblioteca de los Amigos del País, 1919.

"Politics: The Hispanic Institute in Spanish Civil War and WWII." Columbia University Libraries online, n.d. At https://exhibitions.library.columbia.edu/exhibits/show/the_hispanic_institute_between/politics.

Pons, Anaclet. "Vidas cruzadas: Biografía y microhistoria en un mundo global." In *La historia biográfica en Europa: Nuevas perspectivas*, edited by Isabel Burdiel and Roy Foster, 47–71. Zaragoza: Instituto Fernando el Católico, 2015.

Pons Sorolla, Blanca. *Joaquín Sorolla: Vida y obra.* Madrid: Fundación de Apoyo a la Historia del Arte Hispánico, 2001.

Portús, Javier. "Manuel B. Cossío y el Greco." In *El arte de saber ver: Manuel B. Cossío, la Institución Libre de Enseñanza y El Greco*, edited by Salvador Guerrero, 81–119. Madrid: Institución Libre de Enseñanza, Fundación Francisco Giner de los Ríos, 2016.

Prados Torreira, Teresa. "Archer Milton Huntington y el movimiento esteticista americano." In *El tesoro arqueológico de la Hispanic Society of America*, edited by Manuel Bendala, Constancio del Álamo, Sebastián Celestino, and Lourdes Prados, 64–87. Madrid: Museo Arqueológico Regional, 2009.

Pro Ruiz, Juan. "Aristócratas en tiempos de Constitución." In *Antiguo régimen y liberalismo: Homenaje a Miguel Artola*, vol. 2: *Economía y sociedad*, edited by Javier Donézar and Manuel Pérez Ledesma, 615–30. Madrid: Ediciones de la Universidad Autónoma de Madrid, Alianza Editorial, 1994.

Proske, Beatrice G. *Archer Milton Huntington*. New York: Hispanic Society of America, 1963.

Quodbach, Esmée, ed. *What's Mine Is Yours: Private Collecting and Public Patronage in the United States*. Madrid: Centro de Estudios Europa Hispánica, 2021.

Rafael Altamira, biografía de un intelectual (1866–1951). Alicante: Instituto de Estudios Juan Gil-Albert, Diputación Provincial de Alicante, 1987.

Remeseira, Claudio. "A Splendid Outsider: Archer Milton Huntington and the Hispanic Heritage in the United States." In *Hispanic New York: A Sourcebook*, edited by Claudio Remeseira, 443–60. New York: Columbia Univ. Press, 2010.

Requena, Félix. *Amigos y redes sociales: Elementos para una sociología de la amistad*. Madrid: Consejo Superior de Investigaciones Científicas, 2001.

"Retratos de hombres ilustres: 83, Alfonso XIII, rey de España." In *Sorolla y la Hispanic Society: Una vision de la España de entresiglos*, 341–44. Madrid: Museo Thyssen-Bornemisza, 1998.

Revel, Jacques, ed. *Jeux d'échelles*. Paris: Gallimard, Le Seuil, 1996.

Rey García, Marta. "Fernando de los Ríos y Juan Francisco de Cárdenas: Dos embajadores para la guerra de España (1936–1939)." *Revista española de estudios norteamericanos*, no. 11 (1996): 129–50.

Ribagorda, Álvaro. "Los frutos perdidos: Los intelectuales de la Residencia de Estudiantes en el exilio." *Arbor*, no. 735 (2009): 13–28.

———. "La Residencia de Estudiantes: Pedagogía, cultural y proyecto social." Featured presentation at the Seminario de Investigación de Historia Contemporánea, Universidad Complutense, Madrid, Apr. 3, 2008.

Ribera Blanco, Javier. "El sueño de un visionario." In *Visite España: La memoria rescatada*, edited by María Bolaños Atienza and Miguel Cabañas Bravo, 149–59. Madrid: Museo Nacional del Romanticismo, 2014.

Rodríguez Fernández-Salguero, Carmen. "Cossío y el Museo Ambulante de las Misiones Pedagógicas: Memoria de un idilio." In *El arte de saber ver: Manuel B. Cossío, la Institución Libre de Enseñanza y El Greco*, edited by Salvador Guerrero, 273–83. Madrid: Institución Libre de Enseñanza, Fundación Francisco Giner de los Ríos, 2016.

Rodríguez-López, Carolina, ed. *Paisajes de una guerra: La Ciudad Universitaria de Madrid*. Madrid: Servicio de Publicaciones de la Universidad Complutense, 2015.

Rodríguez-López, Carolina, and Daniel Ventura Herranz. "De exilios y emociones." *Cuadernos de historia contemporánea*, no. 36 (2014): 113–38.

Rodríguez Moñino, Antonio. *El marqués de Jerez de los Caballeros: Un gran bibliófilo*. Badajoz: Diputación Provincial de Badajoz, 1989.

Rosenwein, Barbara. *Emotional Communities in the Early Middle Ages*. Ithaca, NY: Cornell Univ. Press, 2007.

Rubin, Lilian. *Just Friends: The Role of Friendship in Our Lives*. New York: Harper & Row, 1985.

Rubio, David. "Mementos." In *Huntington, 1870–1955*, 34–37. Washington, DC: Organization of American States, Comité Interamericano de Bibliografía, Pan American Union, 1957.

Rubio, Javier. "Los dos primeros decenios de la España de la Restauración en el escenario internacional (1875–1895)." *Historia contemporánea*, no. 34 (2007): 43–64.

———. *El tránsito del siglo XIX al XX: Del Desastre de 1898 al principio del reinado de Alfonso XIII*. Madrid: Área de Documentación y Publicaciones del Ministerio de Asuntos Exteriores y de Cooperación, 2011.

Rubio Cremades, Enrique. "Rafael Altamira, crítico literario de Vicente Blasco Ibáñez." In *Actas del XVI Congreso de la Asociación Internacional de Hispanistas: Nuevos caminos del hispanismo, Paris, 9 al 13 de julio 2007*, vol. 2, edited by Pierre Civil and Françoise Crémoux. Madrid: Iberoamericana; Frankfurt: Vervuert, 2010. Online version at https://cvc.cervantes.es/literatura/aih/pdf/16/aih_16_2_197.pdf.

Ruiz Manjón, Octavio. "Federico de Onís, cónsul de las Españas." In *Redes internacionales de la cultura española, 1914–1939*, edited by José García Velasco, 345–51. Madrid: Publicaciones de la Residencia de Estudiantes, 2014.

Saenz de la Calzada, Margarita. *La Residencia de Estudiantes: Los residentes*. Madrid: Residencia de Estudiantes, 2011.

Sánchez Cantón, Francisco. "Necrológica: Mr. Archer Milton Huntington." *Academia: Boletín de la Real Academia de Bellas Artes de San Fernando*, no. 5 (1956): 9–20.

Sánchez de Madariaga, Elena. "Escritura epistolar y redes sociales: Pilar de Madariaga, Vassar College y exilio." *Ayer*, no. 105 (2017): 129–54.

Sánchez Illán, Juan Carlos. *La nación inacabada: Los intelectuales y el proceso de construcción nacional (1900–1914)*. Madrid: Biblioteca Nueva, 2002.

Sánchez Mantero, Rafael. "La mirada americana: La evolución de un estereotipo." In *España: La mirada del otro*, edited by Ismael Saz, 229–36. Madrid: Marcial Pons, 1998.

Sánchez Sánchez, Isidro. "Contra el paradigma Prescott." In *Viaje de ida y vuelta: Fotografías de Castilla–La Mancha en the Hispanic Society of America*, edited by Esther Almarcha Núñez-Herrador, Patrick Lenaghan, and Isidro Sánchez Sánchez, 36–55. Toledo: Empresa Pública Don Quijote de la Mancha, 2007.

Santos Quer, María Ángeles. "La correspondencia epistolar de Archer M. Huntington con Guillermo de Osma y Javier García de Leaniz." *Cuadernos de arte e iconografía* 14, no. 47 (2015): 209–93.

Sarno, Enma. "Análisis de redes sociales e historia contemporánea." *Ayer*, no. 105 (2017): 23–50.

Saz, Ismael, ed. *España: La mirada del otro*. Madrid: Marcial Pons, 1998.

Schulze Schneider, Ingrid. "1898: Apuntes sobre la diplomacia internacional y la opinion pública." *Historia y comunicación social*, no. 3 (1998): 223–38.

Sealander, Judith. "Curing Evils and Their Source: The Arrival of Scientific Giving." In *Charity, Philanthropy and Civility in American History*, edited by Lawrence J. Friedman and Mark D. McGarvie, 217–40. New York: Cambridge Univ. Press, 2002.

Seckler, Dorothy. "Oral History Interview with Anna Hyatt Huntington, circa 1964." Smithsonian Archives of American Art, At https://www.aaa.si.edu/collections/interviews/oral-history-interview-anna-hyatthuntington-11738.

Seco Serrano, Carlos. *Estudios sobre el reinado de Alfonso XIII*. Madrid: Real Academia de la Historia, 1998.

Serís, Homero. *La colección cervantina de la Sociedad Hispánica de América: Ediciones de Don Quijote, con introducción, descripción de nuevas ediciones, anotaciones y nuevos datos bibliográficos*. Urbana: Univ. of Illinois, 1918.

———, ed. *Nuevo ensayo de una biblioteca española de libros raros y curiosos: Formado en presencia de los ejemplares de la biblioteca de the Hispanic*

Society of America en Nueva York y de la Ticknor Collection en la Biblioteca Pública de Boston*. New York: Hispanic Society of America, 1964.
Serrano Sánchez, Carmen. "Espejos del alma: La evocación del ausente en la escritura epistolary aúrea." In *Culturas del escrito en el mundo occidental: Del Renacimiento a la contemporaneidad*, edited by Antonio Castillo Gómez, 67–80. Madrid: Casa de Velázquez, 2015.
Serviddio, Fabiana. "Los murales de Portinari en la Sala Hispánica de la Biblioteca del Congreso de Estados Unidos: Construcción plástica de una identidad panamericana." *Cuadernos del CILHA: Centro Interdisciplinario de Literatura Hispanoamericana* 12, no. 14 (2011): 124–52.
Sierra, María. "Entre emociones y política: La historia cruzada de la virilidad romántica." *Rúbrica contemporánea* 4, no. 7 (2015): 11–25.
Sierra Blas, Verónica. "Cartas para todos: Discursos, prácticas y representaciones de la literatura epistolar en la época contemporánea." In *Culturas del escrito en el mundo occidental: Del Renacimiento a la contemporaneidad*, edited by Antonio Castillo Gómez, 99–120. Madrid: Casa de Velázquez, 2015.
Slipek, Edwin. "Beyond the Boudoir: How Richmond Courtesan Arabella Huntington Became the Richest Woman in the World." *Style Weekly*, Jan. 10, 2012. At https://www.styleweekly.com/beyond-the-boudoir/.
Socias, Immaculada. "Archer Milton Huntington (1870–1955): Mecenazgo, coleccionismo y comercio de arte." *Cuadernos de arte e iconografía* 24, no. 47 (2015): 13–44.
———. "Contribución al conocimiento del período americano de Josep Pijoan Soteras (1881–1963)." In *Repensar la escuela del CSIC en Roma: Cien años de memoria*, edited by Ricardo Olmos Romera, Trinidad Tortosa, and Juan Pedro Bellón Ruiz, 255–64. Madrid: Consejo Superior de Investigaciones Científicas, 2011.
———. *La correspondencia entre Isidre Bonsoms Sicart y Archer Milton Huntington: El coleccionismo de libros antiguos y objetos de arte*. Barcelona: Reial Acadèmia de Bones Lletres, 2010.
———. "El memorial de Barcelona a Archer Milton Huntington, el fundador de la Hispanic Society of America, y a su esposa, la escultora Anna Hyatt Huntington." In *Conflictes bèl.lics, espoliacions, col.leccions*, edited by Immaculada Socias. Barcelona: Publicacions i Edicions de la Universitat de Barcelona, 2009. Online version at https://diposit.ub.edu/dspace/bitstream/2445/8764/3/MemorialHuntington2003esp.pdf.

Socias, Immaculada, and Dimitra Gkozgkou, eds. *Nuevas contribuciones en torno al mundo del coleccionismo de arte hispánico en los siglos XIX y XX.* Gijón: Trea, 2013.

Stearns, Peter N., and Carol Z. Stearns. "Emotionology: Clarifying the History of Emotions and Emotional Studies." *American Historical Review* 90, no. 4 (1985): 813–36.

Stein, Gertrude. *Ser americanos.* Translated by Vicenta Aragón. Madrid: Memorias Clementine, 2005.

Stratton, Suzanne L. "Ignacio Zuloaga in America, 1909–1925." In *When Spain Fascinated America,* edited by Ignacio Suárez-Zuloaga, 153–87. Madrid: Fundación Zuloaga, Ministerio de Cultura del Gobierno de España, 2010.

Suárez-Zuloaga, Ignacio. "Antonio Zuloaga Dethomas: Una vida entre Francia y España." In *Propagandistas y diplomáticos al servicio de Franco (1936–1945),* edited by Antonio César Moreno Cantano, 121–47. Gijón: Trea, 2012.

———. "Huntington, Zuloaga y la divulgación de España en los Estados Unidos." *Cuadernos de arte e iconografía* 24, no. 47 (2015): 63–103.

———, ed. *When Spain Fascinated America.* Madrid: Fundación Zuloaga, Ministerio de Cultura del Gobierno de España, 2010.

Tappert, Tara Leigh. *Cecilia Beaux and the Art of Portraiture.* Washington, DC: Smithsonian Institution, 1995.

Termis Soto, Fernando. "Algunas consideraciones en torno a las relaciones hispano-norteamericanas en los años cincuenta." *Espacio, tiempo y forma, Serie V: Historia contemporánea,* no. 8 (1995): 195–245.

———. *Renunciando a todo: El régimen franquista y los Estados Unidos desde 1945 hasta 1963.* Madrid: Biblioteca Nueva, 2005.

Ticknor, George. *George Ticknor: Letters to Pascual de Gayangos in the Collection of the Hispanic Society of America.* New York: Hispanic Society of America, 1927.

Toboso, Pilar, ed. "Las redes de poder en el mundo contemporáneo." *Ayer,* no. 105 (2017): 13–22.

Tomás, Facundo, and Felipe Garín. "Los retratos de Joaquín Sorolla en el Museo de Bellas Artes de Bilbao." *Boletín del Museo de Bellas Artes de Bilbao,* no. 5 (2010): 219–54.

Torre, Hipólito de la. "El destino de la regeneración internacional de España, 1898–1918." *Proserpina,* no. 1 (1984): 9–22.

Torre del Río, Rosario de la. "1895–1898: Inglaterra y la búsqueda de un compromiso internacional para frenar la intervención norteamericana en Cuba." *Hispania* 57, no. 196 (1997): 515–49.

———. "La diplomacia en conflicto." In *Imágenes y ensayos del 98*, edited by Carlos Dardé, 47–74. Valencia: Fundación Cañada Blanch, 1998.

Torres González, Begoña. "El marqués de la Vega-Inclán, coleccionista." *Goya: Revista de arte*, no. 267 (1998): 333–43.

Torres-Ullauri, M. Isabel. *El Quijote Gladiador / The Quijote Gladiator*. N.p.: Privately published, 2022.

Tortosa, Trinidad. "Josep Pijoan (Barcelona, 1881–Lausanne, 1963)." In *Repensar la escuela del CSIC en Roma: Cien años de memoria*, edited by Ricardo Olmos Romera, Trinidad Tortosa, and Juan Pedro Bellón Ruiz, 229–53. Madrid: Consejo Superior de Investigaciones Científicas, 2011.

Trask, David F. *The War with Spain in 1898*. Lincoln: Univ. of Nebraska Press, 1996.

Tusell, Javier. "Joaquín Sorolla en los ambientes políticos y culturales de su tiempo." In *Sorolla y la Hispanic Society: Una vision de la España de entresiglos*, 19–31. Madrid: Museo Thyssen-Bornemisza, 1998.

Tusell García, Genoveva. "La internacionalización del arte abstracto español: El intercambio de exposiciones con los Estados Unidos (1950–1964)." *Espacio, tiempo y forma, Serie VII: Historia del arte*, no. 16 (2003): 223–32.

Twain, Mark, and Charles Dudley Warner. *The Gilded Age: A Tale of Today*. 1873. Reprint. New York: Penguin Classics, 2001.

Unamuno, Miguel de. *Andanzas y visiones españolas*. 1922. Reprint. Madrid: Alianza Editorial, 1988.

———. *Cancionero, diario poético*. Buenos Aires: Losada, 1953.

———. "La labor patriótica de Zuloaga." *Cuadernos de Ignacio Zuloaga*, no. 1 (1995): 65–68.

———. "Sobre la europeización." *La España moderna*, Dec. 1906.

Upham Pope, Arthur. *Archer Milton Huntington: Last of the Titans, 1870–1955*. 1957. Reprint. Palm Beach, CA: Comité Interamericano de Bibliografía, Franklin Classics, 2018.

U.S. History.org. "The American Home Front." US History: Pre-Columbian to the New Millennium, n.d. At https://www.ushistory.org/us/51b.asp.

———. "The Gilded Age. The New Tycoons: John D. Rockefeller." N.d. At https://www.ushistory.org/us/36.asp.

———. "The Great Depression: Sinking Deeper and Deeper, 1929–1933." U.S. History: Pre-Columbian to the New Millennium, n.d. At https://www.ushistory.org/us/48b.asp.

Varela Ortega, José. "El mundo político de fin de siglo." In *España fin de siglo 1898*, 26–49. Barcelona: Fundación la Caixa, 1997.

Varela Ortega, José, Fernando Rodríguez de la Fuente, and Andrea Donofrio, eds. *La mirada del otro: La imagen del España, ayer y hoy*. Madrid: Fórcola, Fundación José Ortega y Gasset-Gregorio Marañón, 2016.

Vergniolle Delalle, Michelle. *La palabra en silencio: Pintura y oposición bajo el franquismo*. Valencia: Universidad de Valencia, 2008.

Villacañas, José Luis. *Ramiro de Maeztu y el ideal de la burguesía en España*. Madrid: Espasa Calpe, 2000.

Viñas, Ángel. *En las garras del águila: Los pactos con Estados Unidos, de Francisco Franco a Felipe González (1945–1995)*. Barcelona: Crítica, 2003.

———. "La negociación y renegociación de los acuerdos hispano-norteamericanos, 1953–1988: Una visión structural." *Cuadernos de historia contemporánea*, no. 25 (2003): 83–108.

White, Richard. *Railroaded: The Transcontinentals and the Making of Modern America*. New York: Norton, 2011.

Wright, John Kirtland. *The History of the American Geographical Society*. New York: American Geographical Society, 1954.

Yllán Calderón, Esperanza. *El franquismo (1939–1975)*. Madrid: Marenostrum, 2006.

Zamora Bonilla, Javier, "Revista de Occidente: La sensibilidad de un nuevo tiempo." In *Redes internacionales de la cultura española, 1914–1939*, edited by José García Velasco, 334–43. Madrid: Publicaciones de la Residencia de Estudiantes, 2014.

Zuleta, Carmen de. *Compañeros de paseo*. Seville: Renacimiento, 2001.

———. *Ni convento ni college: La Residencia de Señoritas*. Madrid: Consejo Superior de Investigaciones Científicas, Asociación de Amigos de la Residencia de Estudiantes, 1993.

Zweig, Stefan. *El legado de Europa*. A translation of Stefan Zweig, *Europäisches Erbe*, by Claudio Gancho. Barcelona: Acantilado, 2008.

Index

Aguilar, Florestán de, 62, 81
Aguirre, Juan José, 270
Alberti, Rafael, 218
Alcalá-Zamora, Niceto, 220, 225n39
Alfonso XIII, King, 27n36, 55, 61–63, 65–68, 71–74, 78, 82–83, 86, 90, 105, 113, 117, 134, 172, 190, 206, 208, 212, 222, 232, 308, 316, 322, 358
Allison Peers, E., 267n121
Alonso Cortés, Narciso, 331
Alonso, Dámaso, 178, 257–58
Altamira y Crevea, Rafael, 62, 109, 109n125, 110, 110nn126–29, 111, 131, 174, 177, 329
Álvarez de Sotomayor, Fernando, 93
Altman, Benjamín, 49
Amo, Gregorio del, 219
Anderson, Ruth Matilda, 155, 164n36, 165
Andino, count of, 62, 66
Anglada Camarasa, Hermenegildo, 62, 132
Areilza, José María de, 351
Arrom, José Juan, 350
Artigas, Miguel, 265
Asín Palacios, Miguel, 62, 96, 156, 174
Atkinson, Alice D., 165
Ávalos, Juan de, 353, 355, 355n71, 356–60, 362–64, 366–67

Avenol, Joseph, 291
Azaña, Manuel, 220, 223, 225, 249, 255

Bailey, Vernon Howe, 155
Baraibar, Germán, 303n50
Bárcenas, Juan de, 315, 319
Baroja, Pío, 38, 62, 108, 178
Baroja, Ricardo, 210
Barr, Alfred H., 283
Barsky, Edward K., 263
Bataillon, Marcel, 331
Beaux, Cecilia, 167
Bela y Armada, Ramón, 351
Bell, Aubrey Fitzgerald, 156, 174
Belmont, August Jr., 179
Benavente, Jacinto, 62, 108, 178
Benlliure y Gil, Mariano, 60–62, 88, 106–7, 210, 216, 254, 255, 260, 303
Bennett, Shelley M., 4
Berenguer, Dámaso, 212
Beruete, Aureliano de, 62, 68n23, 107
Biddle, George, 236n58
Bingham, Hiram, 110
Blasco Ibáñez, Vicente, 62, 107–8, 178, 180, 254–55
Blecua, José Manuel, 331
Bliss, Lillie Plummer, 229n43
Bonsor, George or Jorge, 34, 44, 62, 132–33, 174, 211

Borbón, Alicia de, 75
Bori, Lucrezia, 79
Borrow, George, 11
Bowers, Claude, 206
Bowman, Isaiah, 141, 255–58
Bravo, Pascual, 359, 361, 363
Brenan, Gerald, 267n121
Brown, Jonathan, 47
Butler, Nicolas Murray, 95, 142, 149, 177–78, 191–98, 304
Byne, Arthur, 62, 125–26
Byne, Mildred Stapley, 62, 125

Callejo, Eduardo, 121
Calvo Sotelo, José, 226
Camón Aznar, José, 355, 358
Campoamor, Clara, 223
Camprubí, José, 131, 264–65, 269
Camprubí, Zenobia, 62, 124–25, 127, 131, 180
Canalejas, José, 86
Cárdenas, Juan Francisco de, 244, 249, 251, 261–63, 355n71
Carnegie, Andrew, 33, 190
Carvajal, Javier, 354
Casalduero, Joaquín, 331
Casals, Pau, 329
Casares, Julio, 62, 130
Casares Quiroga, Santiago, 226
Casas, Bartolomé de las, 36, 300
Cassat, Mary, 13n18, 20
Castiella, Fernando, 354
Castillejo, José, 62, 126
Castro, Américo, 56, 129, 257–58
Cernuda, Luis, 57
Cervantes y Saavedra, Miguel de, 70–71, 86, 99, 113, 124, 155, 353
Chase, William Merritt, 21
Christian, Anna, 155

Churruca, Pablo de, marquis of Aycinena, 292
Cid Campeador, El, 24, 26–27, 79, 80n50, 82–83, 88, 101, 103, 120, 171, 185, 334, 338–39, 353, 366
Claparols, Manuel, 320
Clapp, Margaret, 330
Clavería, Carlos, 331
Cleveland, Groover, 28, 30
Cline, Howard F., 350
Coester, Alfred, 267
Coello, Claudio, 9
Colman, Samuel, 21
Contreras y López de Ayala, Juan de, marquis of Lozoya, 355
Cossío, Manuel Bartolomé, 62, 68, 68n23, 85, 111–12, 210, 216
Cotarelo, Emilio, 62, 77
Cret, Paul-Philippe, 296
Crocker, Charles, 6

Daladier, Édouard, 237
Darío, Rubén, 62, 127–28, 156, 177, 185
Darrau-Dihigo, Louis, 174
David-Weill, David, 291
Díaz, Porfirio, 149
Domingo, Marcelino, 209
Doyle, Henry Grattan, 144, 182, 350
Duke, Angier Biddle, 315n8
Dunn, James C., 321
Duveen, Joseph, 44, 159, 252, 291

Eakins, Thomas, 13n18, 21
Echegaray, José, 62, 108–9
Echegaray, Miguel, 261n108
Edward VII, King, 237
Eisenhower, Dwight D., 314, 364
Engel, Arthur, 34, 62, 99, 174

Escandón, Pomposa de, 79
Espina, Concha, 62, 128, 129n181, 131, 167, 171, 220, 223, 253, 303, 308, 315, 326, 338–39

Faber, Sebastiaan, 266
Falla, Manuel de, 131
Fernández, James D., 181
Ferguson, Homer L., 230, 231
Filreis, Alan, 310
Finat Escrivá de Romaní, José, 355
Fitz-James Stuart, Cayetana, 93
Fitz-James Stuart, Jacobo, duke of Alba, 55, 62, 91–92, 94, 97, 131, 211–12, 218, 221, 225, 232, 244–46, 248, 260–61, 277, 280, 291, 303, 308
FitzGerald Bell, Aubrey, 156, 174, 256
Fitzmaurice-Kelly, James, 149, 174–75, 177
Font, Eleanor Sherman, 164n37, 165
Font, Margaret Sherman, 165
Ford, Henry, 228–29
Ford, John, 243
Fortuny, Mariano, 132
Foulché-Delbosc, Raymond, 149, 173–75
Fraga Iribarne, Manuel, 361–63, 367
Franco, Francisco, 3n1, 241, 242, 248–49, 250n78, 253, 255, 262, 300, 303, 311–12, 329, 334, 344–45, 349, 361, 364–65
Frick, Henry Clay, 49
Frothingham, Alice Wilson, 164, 164n37, 165, 302
Fusi, Juan Pablo, 135, 205n3, 282

Garay, José María, 350
García-Conde, Rodrigo, 343

García Lomas, Miguel, 355
García Lorca, Federico, 57, 129, 178, 217–18, 268, 329
García-Mazas, José, 22, 60, 90, 116, 168, 286n19, 305, 316–17, 322–23, 326, 333–34, 336–39, 340–45, 349, 352–54, 359, 360–63, 366
García Olay, Pelayo, 331
Gardner, Isabella Stewart, 47, 49, 152
Garrigues Díaz-Cañabate, Antonio, 352–53
Garrigues Walker, Antonio, ix
Gates, Frederik J., 191
Gates, Helen, Huntington Helen, Granville-Barker Helen, 14–15, 58, 76, 105, 159, 168
Gayangos, Pascual de, 20, 75
Gestoso y Pérez, José, 62, 135, 156
Gilbert, Cass, 137
Giménez Caballero, Ernesto, 212
Giner de los Ríos, Francisco, 56, 62, 111–12, 112nn135–36
Giner de los Ríos, Hermenegildo, 112n136
Giral, José, 226
Gómez Moreno, Manuel, 210
González, Julio, 283
González de Amezúa, Agustín, 331
Goya, Francisco de, 21, 43, 55, 102, 113, 140, 159, 252, 294
Granados, Enrique, 131
Granda, Félix, 72
Granville-Barker, Harley, 168
Griffis, Stanton, 314
Guggenheim, Solomon R., 229n43
Guillén, Jorge, 57, 329

Hadley, Arthur Twining, 149
Hanke, Lewis U., 297, 300

Hatzfeld, Clara, 9n12, 75
Havemayer, Henry O., 44, 49
Havemayer, Louisine, 44, 49
Hay, John Milton, 149, 151
Hearst, William Randolph, 35, 49, 126, 214
Heisserman, Karl W., 92
Hemingway, Ernest, 243
Hermida, Jesús, 363
Heye, George Gustav, 141
Hilton, Sylvia, 186
Hitler, Adolf, 203, 236
Hoover, Herbert, 205, 226–27
Hopkins, Mark, 6
Howley, Frank, 354
Hull, Cordell, 263
Huntington, Arabella, 4–6, 6n5, 8–10, 11–12, 14, 17, 75, 159, 161n31, 163, 172, 291
Huntington, Charles Pratt, 137
Huntington, Collis Potter, 4–9, 9n12, 10, 10n13, 12–15, 17, 22–23, 28, 31–33, 136n1, 231, 285
Huntington, Henry E., 4, 10n13, 14, 23
Hyatt Mayor, Alpheus, 5, 170, 341–42, 345–46
Hyatt, Anna, Huntington Anna, 5, 13n17, 58, 79, 82–83, 88, 90, 93, 128–29, 168–69, 171, 207, 233–34, 236, 239, 263, 277, 285, 286, 301, 309–10, 315, 318–22, 325, 334, 338–40, 344–46, 348, 352–54, 358–60, 363–64, 366

Irving, Washington, 9, 18, 20

James, Henry, 7, 13n18
Jackson, Margaret, 166

Jesup, Morris K., 23
Jiménez Fraud, Alberto, 91, 218–19
Jiménez, Juan Ramón, 3, 62, 124–25, 131, 156, 178, 180, 218, 329
Johnson, Ada Marshall, 164n37, 165

Kagan, Richard, 8, 19, 19n23, 21n26, 45n68
Kendall, William M., 137
King, Georgiana Goddard, 155, 167
Knapp, William Ireland, 24
Krappe, Alexander Haggerty, 174

Laín Entralgo, Pedro, 324–25, 341
Lancaster, H. Carrington, 257
Lapesa, Ramón, 331
Lea, Henry Charles, 37, 37n49
Lehman, Philip, 49
Lenaghan, Patrick, 69, 140n5
Lockman, De Witt M., 311
Lodge, John Davis, 333, 335, 343
Longfellow, Henry W., 18, 20
López de Ayala y Álvarez de Toledo y del Hierro, Jerónimo, count of Cedillo, 68n23
López Mezquita, José María, 48, 60–62, 92–93, 131, 218, 220, 222, 224–25, 227, 231, 248–49, 308
López Otero, Modesto, 79
López Vega, Antonio, 159

MacLeish, Archibald, 297–98
Macià, Francesc, 221
Machado, Antonio, 38, 209, 218
Madrazo, Federico de, 132
Madrazo, Raimundo de, 62, 132
Maeztu, María de, 62, 127, 129, 179, 190

Maeztu, Ramiro de, 38
Marañón Moyá, Gregorio, 352–53, 355, 355n71, 358, 362–64
Marañón y Posadillo, Gregorio, 60, 84, 116–17, 208, 210, 236, 239, 329, 354n71
Martín-Artajo, Alberto, 312, 326, 333, 337, 339
Martínez Ruíz, José, Azorín, 38, 178
Mateu, Miguel, 320
Maura, Antonio, 62, 77, 97
May, Florence Lewis, 165
McCarthy, Joseph, 310
McKinley, William, 34–35
Mélida, José Ramón, 62, 68n23, 134, 210
Menéndez Pelayo, Marcelino, 62, 99–102, 129, 149, 174, 211
Menéndez Pidal, Ramón, 62, 88, 120–22, 124, 130, 156, 174, 177–78, 224–56, 258–259, 294, 300, 330, 355n71
Melián y Pavía, Antonio, Count of Peracamps, 192n84
Mellon, Andrew, 49
Merimée, Ernest, 173
Meyer, Adelaide Maria, 164n37, 165
Miaja, José, 254–55
Millás Vallicrosa, José María, 321
Miró, Joan, 283
Mistral, Gabriela, 131
Mitre, Bartolomé, 149
Monjó, Enrique, 320
Montero Jiménez, José Antonio, 82n55
Mora, José Antonio, 350
Moreno Juste, Antonio, 365
Moreno Luzón, Javier, 158,
Morgan, Jean Pierpont, 72
Morel-Fatio, Alfred, 173, 175
Moro, Antonio, 9
Muller, Priscilla, 69

Murillo, Bartolomé Esteban, 21, 159
Mussolini, Benito, 203, 238

Navarro Tomás, Tomás, 178, 265n116, 266, 331
Navas, Count of, 62, 65, 67
Negrín, Juan, 291
Nieto, Gratiniano, 355
Niño, Antonio, 173n58
Nye, Gerald P., 250

Oakley, Thornton, 269
Obermaier, Hugo, 92, 156, 211
Onís, Federico de, 62, 119, 124, 129, 131, 148, 158, 178, 180, 190, 192, 198n97, 217–18, 258, 264–65, 350
Orleans y Borbón, Alvaro, 79
Orleans, Alfonso de, 79
Ortega y Gasset, José, 50, 56, 62, 71, 116–17, 208, 329, 340
Orueta, Ricardo de, 62, 126, 209, 210–11, 215, 251n79
Osma, Guillermo de, count of Valencia de Don Juan, 62, 77, 86, 94–96, 106, 126, 130, 211, 232

Padilla, Alejandro, 81
Palmer, Russell, 261n108
Pardo Bazán, Emilia countess of, 62, 78n45, 109, 109n123
Paris, Pierre, 62, 134n190, 174
Parker, William Belmont, 176
Paz y Espeso, Julián, 156
Paz y Meliá, Antonio, 174
Peers, E. Allison, 175
Peixotto, Ernest Clifford, 155
Penney, Clara Louisa, 164, 164n37

Index

Pérez de Ayala, Ramón, 62, 118, 180, 208, 209, 210, 211, 293, 329
Pérez de Guzmán y Boza, Juan, duke of T'Serclaes, 62, 98n94
Pérez de Guzmán y Boza, Manuel, marquis of Jerez de los Caballeros, 55, 62, 97–100
Pérez Galdós, Benito, 62, 109n124
Pérez Rubio, Timoteo, 251n79, 293
Picasso, Pablo, 255, 283
Pidal y Mon, Alejandro, 62, 103
Pijoan, Josep, 62, 94, 122–24, 152, 156, 175, 272–76, 287, 288–89, 304, 308
Piñar, Blas, 351
Polo, Carmen, 333
Pope, Arthur Upham, 145, 190, 191
Portinari, Candido, 297, 298
Prescott, Willian H., 18, 19
Presilla, Román de la, 315, 316, 318, 320
Primo de Rivera, Miguel, 57, 88, 117, 121–22, 212
Proske, Beatrice Gilman, 164, 164n37, 166, 166n40
Pursche, Anna, 164, 164n37
Putnam, Herbert, 184–85, 296

Quiñones de León, José María, 71n26

Rebay, Hilla, 229n43
Reid, John F., 343
Rennert, Hugo Albert, 149
Riaño y Gayangos, Juan de, 62, 74–76, 78, 112n136, 172, 184–86, 193n85, 198n97, 211, 250, 296, 308
Riaño y Montero, Juan Facundo, 74
Ribera y Tarragó, Julián, 62, 97, 156

Rivera, Diego, 236n58
Rico, Martín, 48, 132
Ríos, Fernando de los, 209, 262, 263, 265, 269, 270, 299
Robles Piquer, Carlos, 352, 353, 355
Rockefeller, Abby Aldrich, 229n43
Rockefeller, John D., 6n7, 9, 190, 191
Rockefeller Jr, John D., 229
Rockefeller, Nelson, 295, 297
Rodríguez Carracido, José, 62, 75–76, 78
Rodríguez Marín, Francisco, 99–102, 259, 308
Rolland, Romain, 57
Romero de Torres, Julio, 216
Roosevelt, Eleanor, 167, 263
Roosevelt, Franklin D., 206, 227, 234, 239
Roosevelt, Theodore, 149
Rowe, L.S, 110
Royo Villanova, Segismundo, 341, 343, 355
Rubio, David, 185, 201, 296, 299, 300
Rubio, Jesús, 341, 344
Ruiz-Giménez, Joaquín, 307, 312, 313, 325, 331, 333, 340, 341
Ruiz Morales, José Miguel, 351
Rusiñol, Santiago, 68, 216

Sala, Emilio, 105
Salinas, Pedro, 178, 257, 258, 265, 330
Sánchez Albornoz, Claudio, 265
Sánchez-Bella, Alfredo, 312, 313, 322, 323, 325, 326, 332, 335, 337, 340, 341, 342, 345, 346, 347, 348, 349
Sánchez Cantón, Francisco Javier, 45, 62, 130, 210, 214–15, 218–20, 292–94, 309, 324, 329, 353, 355n71

Sargent, John Singer, 13n18, 21
Seldemeyer, Charles, 159
Seligman, Jacques, 44
Serís, Homero, 62, 124, 330
Serna, Alfonso de, 355
Serna, Ramón de la, 223
Serrano Aguilar, Antonio, 351
Serrano, Pablo, 346
Sert, José María, 62, 132, 251, 252, 291, 292
Shepherd, William R., 110
Simarro, Antonio, 320
Smith, Robert C., 295
Sorolla, Clotilde, 105, 215
Sorolla, Joaquín, 44, 48, 55, 60–62, 67–68, 68n21, 69–70, 80, 86, 92, 102–8, 111, 114–15, 153, 155, 164n37, 211, 215–16, 221–22, 230, 255, 262, 274, 282–83, 303, 303n49
Souvirón, José María, 328
Spalding, Frances, 155, 164n37, 165
Spitzer, Leo, 257, 258, 331
Stanford, Leland, 6
Stoddard, Elisabeth, 5
Suárez de Puga, Enrique, 354, 355, 359, 360, 364
Sullivan, Mary Quinn, 229n43

Talleyrand, Charles Maurice de, 246
Theotokópoulos, Doménikos, el Greco, 21, 43–44, 55, 68, 69, 85, 111–13, 116, 134, 140, 159, 164, 222, 353
Ticknor, George, 18–20, 75, 124
Tiffany, Louis Comfort, 13n18
Tormo y Monzó, Elías, 62, 77, 212, 215
Torres y González-Arnán, Emilio María de, marquis of Torres de Mendoza, 62, 71n26, 75n36, 76–77

Trapier, Elizabeth du Gué, 164, 164n37, 165
Trend, John Brade, 156, 267n121, 329, 331
Tusell, Javier, 105n110
Twain, Mark, 4n2, 13n18, 16–17

Unamuno, Miguel de, 38, 62, 71, 114–15, 119–20, 173, 178, 209, 218, 260, 276, 278, 287

Valle-Inclán, Ramón del, 62, 127, 178, 210
Vanderbilt, Frederick, 72
Vanderbilt Whitney, Gertrude, 229n43
Vega-Inclán y Flaquer, Benigno, Marqués de la Vega Inclán, 55, 60, 62–63, 68, 83–84, 86–87, 90, 106–7, 111, 113, 116, 198n87, 210n8, 211, 212, 214, 218, 220, 222, 231, 237, 255, 292, 303, 308
Velázquez, Diego de, 21, 43, 55, 107, 140, 159, 164, 283, 293
Veragua, duke of, 91
Viladrich, Miquel, 48, 62, 131–32, 259, 260
Villacieros, Antonio, 345
Villavieja, marquis of, 79
Villegas, José, 68n23
Vindel, Pedro, 62, 65–66
Vives y Escudero, Antonio, 62, 96, 134
Von Hatzfeldt de Wildenburg, Francis, 9n12

Wilkins, Lawrence A., 180
Willard, Joseph E., 179

Whistler, James, 13n18
Whitehouse, Vera, 163
Whitman, Walt, 13n18
Woodward, Robert, 355
Wright, John Kirtland, 51
Wykeham, George, 176, 176n63

Zuloaga, Ignacio, 48, 55, 60, 62, 68, 112–15, 131, 153, 210, 211, 220, 224, 252, 261, 268, 269, 270, 282, 283, 303, 308
Zurbarán, Francisco de, 159
Zweig, Stephan, 57

Patricia Fernández Lorenzo is legal adviser at Art and Cultural Heritage Law in the Spanish law firm Ramón y Cajal Abogados With a BA in law and economics, an MA in art law, and a PhD in contemporary history, she currently combines her professional activity as legal adviser with academic research and education as visiting lecturer at the Universidad Complutense in Madrid and art law teacher at the Instituto de Empresa and Carlos III University. For several years, she pursued a career in business in Bilbao, Lisbon, and Brussels and in the public sector as director general of European affairs for the provincial government of Bizkaia (Basque Country, Spain). The mother of three sons, she has lectured at Oxford University, Cambridge University, Dartmouth College, the Benjamin Franklin Institute, the Cervantes the Institute, Reina Sofia National Art Museum, and the Sorolla Museum, among other institutions. This biography of Archer M. Huntington is the product of her PhD thesis and the result of her passion for cultural relations between Spain and the United States.

Printed in the USA
CPSIA information can be obtained
at www.ICGtesting.com
CBHW020445201124
17613CB00001B/1